Reporting World War II

World War II: The Global, Human, and Ethical Dimension

G. Kurt Piehler, *series editor*

Reporting World War II

G. Kurt Piehler and Ingo Trauschweizer, Editors

Fordham University Press | New York 2023

Copyright © 2023 Fordham University Press

All rights reserved. No part of this publication may be reproduced, stored in a retrieval system, or transmitted in any form or by any means—electronic, mechanical, photocopy, recording, or any other—except for brief quotations in printed reviews, without the prior permission of the publisher.

Fordham University Press has no responsibility for the persistence or accuracy of URLs for external or third-party Internet websites referred to in this publication and does not guarantee that any content on such websites is, or will remain, accurate or appropriate.

Fordham University Press also publishes its books in a variety of electronic formats. Some content that appears in print may not be available in electronic books.

Visit us online at www.fordhampress.com.

Library of Congress Cataloging-in-Publication Data available online at https://catalog.loc.gov.

Printed in the United States of America

25 24 23 5 4 3 2 1

First edition

Contents

Foreword
Max D. Lederer Jr. vii

Introduction
G. Kurt Piehler and Ingo Trauschweizer 1

1. **Learning and Adapting: The American Media and the "Phony War," September 1939–April 1940**
Steven Casey 15

2. **Helen Kirkpatrick's Reporting to Undercut Irish Neutrality Policy, 1939–1942**
Karen Garner 34

3. **Miss Bonney Reporting from the Arctic Front**
Henry Oinas-Kukkonen 55

4. **Reporting from the Bureaus: The Lesser-Known World War II Correspondents**
Kendall Cosley 85

5. **Two African American Journalists Confront World War II: Perspectives on Nationalism, Racism, and Identity**
Larry A. Greene and Alan Delozier 107

6. **Bylines and Bayonets: How United States Marine Corps Combat Correspondents in World War II Blended Journalism and Public Relations**
Douglass K. Daniel 132

vi | Contents

7. **Reporting Reconnaissance to the Public: A Comparative Analysis of Canadian and American Strategies**
Victoria Sotvedt 159

8. **Outstanding and Conspicuous Service: Iris Carpenter, Lee Carson, and Ann Stringer in the European Theater**
Carolyn M. Edy 172

9. **A "Butcher and Bolt" Force: Commandos, Rangers, and Newspaper Dramatics in World War II**
James Austin Sandy 193

10. **"A Major Readjustment": Omar Bradley's War against the *Stars and Stripes***
Alexander G. Lovelace 213

11. **After the Shooting Stopped: Justice and Journalism at Nuremberg**
Nathaniel L. Moir 234

Acknowledgments 259
List of Contributors 261
Index 265

Foreword

Prior to cell phones, digital cameras, social media, and instant messaging, the public relied on the reporting of correspondents. During the World War II era, combat correspondent reporting was often the only reliable information the public received about world events that affected people everywhere. The dangers of a war-torn area and disruption of communications left coverage of the political, social, and military actions to courageous individuals willing to risk their lives to tell the story.

Stars and Stripes was at the forefront of the coverage of U.S. participation in the war and its immediate aftermath. I had the honor, as the publisher of *Stars and Stripes*, to spend significant time with Colonel Bill McNamara learning about his experiences with *Stars and Stripes* during World War II. Bill was a young captain in 1942 when General George Marshall and General Dwight Eisenhower directed the reestablishment of the *Stars and Stripes* newspaper. Bill was directed to lead the *Stars and Stripes* team in delivering the newspaper to the soldiers, sailors, Marines, and airmen of the Army Air Corps. Bill told me about the harrowing events of the *Stars and Stripes* distribution team arriving on the Normandy beaches shortly after the invasion began to produce the *Beachhead Bulletin*, of following the invasion forces through France and Germany to continue to provide GIs news from home, and of the actions on other fronts of the war. Bill told about the difficulties of establishing printing and distribution capacity in the midst of war-torn cities and at times being overrun by counterattacks and escaping with the last Allied troops.

The essential morale newspaper would not have been produced without the bravery to face terrifying risks taken by the combat correspondents of *Stars and Stripes* and other media organizations. Correspondents such as Ernie Pyle, Bill Mauldin, Andy Rooney, Bud Hutton, Dave Berger, Charles Kiley, and many, many more. The combat correspondents rode in the bombers flying over Germany, which suffered a horrific casualty rate. The correspondents told the world about the invasion of Africa and Sicily from

the perspective of the person holding a gun. The correspondents were there to share the desperate conditions and bravery of the U.S. forces surrounded in Bastogne and their amazing relief by the United States Third Army in the dead of winter. These same journalists were present at Nuremberg to explain the administration of justice by the victors to the losers for their misdeeds. The correspondents brought the experience of war to life—the comical, the dangerous, the tedious, the nightmares. Some of these correspondents gave the ultimate sacrifice to tell the story. During my time as a soldier in combat, in the Gulf War of 1990 to 1991, the *Stars and Stripes* was an essential lifeline to the rest of the world and what was happening on my left and right flanks.

Surprisingly, there has been little coverage of what the combat correspondents of World War II accomplished and the impact of their reporting on the lives of others during that time and the impact their reporting still has today. The anthology *Reporting World War II*, produced by the editors G. Kurt Piehler and Ingo Trauschweizer, exposes many aspects not given serious consideration before. Kurt and Ingo assembled a team of scholars to open the conversation to understudied aspects of combat journalism. What role did the media have in maintaining U.S. neutrality and then later in providing the forum to amplify the call to mobilize? The anthology reveals the role that African American and women journalists played—it was not all white males. The anthology also addresses the techniques by civilian and military leaders to control *Stars and Stripes* and other media from reporting unfavorable news, efforts to shape the story journalists were permitted to tell, and the difficult relationship with the military public relations community.

The anthology is an essential primer to spur additional scholarly research and conversation about the unique role of frontline journalism. The balance between reporting the horrific nature of war with supporting the nationalistic goals of nations. The need to balance the right of the public to understand the conduct of the military at war with the need to not place military personnel or noncombatants at greater risk. Kurt and Ingo's team forces a reevaluation of how and why frontline journalism was conducted in the past to foster a debate today about how frontline journalism should be conducted in this time. The current management of the battlefield by combatants makes combat reporting as dangerous as it has ever been. It is necessary to have a transparent debate about access to reduce the reliance on official communiqués and press conferences. As technology has changed and the demand for information has increased,

what is or is not proper to report and by whom is an essential topic to be addressed.

Max D. Lederer Jr.
Publisher
Stars and Stripes News Organization

Reporting World War II

Introduction

G. Kurt Piehler and Ingo Trauschweizer

For Americans, wartime journalists played a pivotal role in shaping how they perceived World War II. During the war, millions read daily newspapers and regularly listened to radio news reports from Europe and the Pacific. Photojournalists such as Robert Capra, Margaret Bourke-White, and Joseph Rosenthal produced some of the most iconic images of the conflict. After 1945, a number of journalists wrote memoirs of their experiences that allowed them to discuss more openly what they had witnessed. Several wrote highly regarded histories, including Cornelius Ryan's the *Longest Day: June 6, 1944* (1959), William L. Shirer's *The Rise and Fall of the Third Reich* (1960), and Harrison Salisbury's *The 900 Days: The Siege of Leningrad* (1969).

The editors of this volume had planned to hold a two-day conference in April 2020 at the Intrepid Naval, Air, and Space Museum in New York City focusing on wartime reporting by American correspondents. We envisioned this conference, and the digitization of large parts of the Cornelius Ryan Collection held at Ohio University,[1] as spurring greater scholarship focusing on frontline journalism and were especially interested in contributions examining the role of women and African American reporters. Although we were forced to cancel the conference as a result of the Covid-19 pandemic, fortunately, most of those who planned to participate provided chapters for this anthology.

Ryan, of course, powerfully shaped perceptions of entire generations of readers and audiences of motion pictures based on his books. His *The Longest Day*, published in 1959, presents one of the most successful popular histories of D-Day, and became the basis of the 1962 movie of the same title. The same could be said for his late-in-life book *A Bridge Too Far* (1974), which depicts in great detail and with epic sweep the successes (at Eindhoven and Nijmegen) and the ultimate failure (at Arnhem) of Allied forces to cross the Rhine River in September 1944. By the time *A Bridge Too Far* had been made into a major motion picture (1977), Ryan had been dead for three years—he died from prostate cancer some two months after the publication

of the book.[2] The Dublin-born Ryan was both a war reporter and a historian, though he achieved greater effect in the latter genre. He had worked as a war correspondent in London from 1941, directly observed and reported on U.S. Army Air Forces bombing missions, and ended his reporting of war in Germany among General George S. Patton's soldiers, but he had not been present in Normandy during D-Day or during Operation Market Garden at any of the key bridges.[3] His histories rested on painstaking research, primarily conducted in interviews and by questionnaires. His narratives imparted a heroic and, at Arnhem, also a tragic picture of the war that still underpins how we approach the Second World War in western Europe. Yet beneath that superstructure of strategy and operations and beyond the well-known battlefields of Normandy, Holland, or the Ardennes, many more reporters presented different pieces of a fuller picture while the fighting still raged. This book attempts to bring some of them out of the shadows.

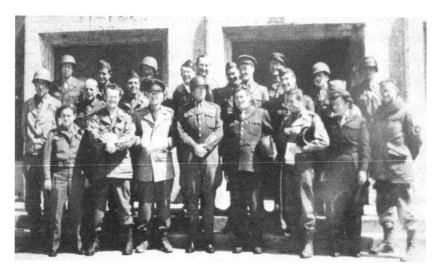

3rd Army Press Camp—Caption 3rd Army Press Camp, Regensburg, Germany, Man 1945. Left to right front row—Mains, Reuter, Newman, INS., Tyrell, *Newsweek*, Gen. George Patton, Jr., Packard, UP, Rita Vandergrift, Lee Mc Cardell, *Baltimore Sun*. Middle Row—Griffen, *Worcester Tel. Gazette*, Wallenstein, *Kansas City Star*, Leseur, CBS, Wiant, AP, Wilkenson, *London Daily Express*, Connie Ryan, Colliers, Ball, AP. Rear Row—Lt. Col. James Quirk, Bro Third Army, Richards, UP, Foust, *Chicago Tribune*, Currivan, *New York Times*, Priestly, ACME, Wilhelm, *Newsweek*, Driscoll, *New York Herald Tribune*, Gen. Hobart Gay, Chief of Staff, 3rd Army. Cornelius Ryan Collection, Alden Library, Ohio University.

Introduction | 3

One of the challenges and opportunities posed by writing a history of wartime reporting is the sheer abundance of sources. Hundreds of American journalists were officially accredited by the War and Navy departments to serve as war correspondents, and they produced millions of words. For some major campaigns, such as the Cross Channel invasion of France on June 6, 1944, hundreds of correspondents were accredited to cover the story, including a select few who landed on the beach with attacking forces. In other instances, only a handful of journalists or even a single reporter might be present for a crucial engagement. During the Battle of the Bulge, Fred MacKenzie of the *Buffalo Evening News* was the sole correspondent with the 101st Airborne Division when they were under siege in Bastogne by German forces in December 1944.[4]

Journalists not only left behind scores of memoirs, but many of their papers survive in research libraries and museums. Declassification of military records has meant we have a much better understanding of how public relations officers and censors sought to shape the image of the armed forces and reporting. In his seminal study of photojournalism George H. Roeder Jr. in *The Censored War: American Visual Experience during World War Two* underscored how the armed forces and civilian agencies manipulated the images Americans were able to view during the war. Not only were graphic images of combat often consigned to the unpublishable "chambers of horror" file, but also ones that showed white women and Black GIs dancing together and similar photographs that might suggest any endorsement of racial integration.[5]

Compared with other fields of scholarly inquiry related to World War II, wartime journalism has received far less attention from historians and media scholars. Except for the life and times of Edward R. Murrow, the famed CBS radio and later television journalist, even many key wartime reporters attracted few biographies.[6] For instance, many major wartime journalists, such as Herbert Mitgang, Andy Rooney, and Don Whitehead, still await a biographer. Despite his recognized importance, Ernie Pyle has garnered only one scholarly biography, James Tobin's *Ernie Pyle's War: American Eyewitnesses in World War II* (New York: Free Press, 1997). Only recently have the careers of two of the most influential Pacific War correspondents, Robert Sherrod and Richard Tregaskis, gained a biographer.[7]

Bill Mauldin's *Up Front* is part of the canonical two-volume *Reporting World War II* (New York: Library of America, 1995), and he finally garnered a well-received biography by the independent historian Todd DePastino, *Bill Mauldin: A Life Up Front* (New York: Norton, 2009). The Pritzker Military Museum and Library in Chicago organized a major exhibit on Bill

Mauldin's wartime and postwar career and has already published a catalogue to complement it, Todd DePastino's *Drawing Fire: The Editorial Cartoons of Bill Mauldin* (Chicago: Pritzker Military Museum and Library, 2020). We sorely need a comprehensive scholarly history of the U.S. Army–sponsored *Stars and Stripes* and *Yank* magazine. Holding back scholarship is the limited accessibility of many newspapers. While microfilm and even digital editions of major national newspapers such as the *New York Times, Wall Street Journal,* and the *Washington Post* can be found in many colleges and universities, second-tier publications remain more difficult to obtain.

Scholars writing on the history of wartime reporting remain indebted to Phillip Knightley's insightful study, *The First Casualty.* His transnational history of wartime reporting begins by examining the Crimean War, the first conflict that attracted frontline correspondents, and takes the story through the fall of South Vietnam to communist forces in 1975. Knightley stresses the degree to which governments and generals use various techniques to suppress unfavorable news and seek to shape the story journalists are permitted to tell. Often getting to the battlefield is impossible for reporters with many governments limiting access to it and forcing correspondents to rely on official communiqués and press conferences. In the case of World War II, American and British correspondents bristled at the unwillingness of the Kremlin to offer regular opportunities to visit the front lines, even when the United States joined the Grand Alliance.[8]

Several contributors to this volume build on Knightley's assessment regarding the degree to which governments manipulate war reporters. Steven Casey considers the efforts of American journalists during the Phony War trying to cover the invasion of Poland and the Russo-Finnish War. The Polish military and government prohibited them from visiting the battlefields, offered briefings only in Polish, and established convoluted systems for censoring and transmitting their stories through the post office. Echoing Knightley, Casey noted that Polish restrictions made Western news outlets more dependent on German reporting to fill the void. As long as the Finns were winning in their winter war against the Soviet Union in late 1939, they permitted greater access to the front lines, but this changed as the conflict turned in the Red Army's favor. For the ambitious journalist, war reporting could be difficult and dangerous. In the case of Finland, reporters had to endure air raids in Helsinki, long train rides to the battlefield, and subzero temperatures.

The theme of censorship runs through all the essays, but also the related question of which stories journalists consider important to report on and

which are not.[9] In Kendall Cosley's chapter focusing on bureau reporters stationed in European capitals, she describes the pressures placed on American correspondents in Germany to avoid writing stories that could lead to their expulsion from the country. Official restrictions often led to self-censorship, and many reporters took this approach in order to avoid expulsion. In the case of Germany, one result is that relatively few stories regarding the anti-Semitic policies of the regime received coverage, including Kristallnacht.

Even before the United States entered the war, many of the American correspondents were hardly neutral. Edward R. Murrow was among a host of journalists reporting from London on the Blitz in 1940 who made clear their bias in favor of Britain and cast Germany as the villain. Karen Garner's contribution to this anthology describes how Helen Kirkpatrick used her war reporting to try to prod Ireland to abandon neutrality and take up the fight against Nazi Germany.

After the United States joined the fight following the Japanese attack on Pearl Harbor, relatively few journalists questioned the wisdom of the Allied cause and often saw themselves as team players, especially when commanders such as Dwight Eisenhower took them into their confidence. In perhaps the most famous case, overseas correspondents' self-censorship is reflected when some of them learned that General George Patton had abused mentally traumatized GIs in two army hospitals. Instead of trying to break the story, they gained an audience with Eisenhower urging him to discipline Patton. Only several months later, when Washington, DC–based columnist Drew Pearson broke the story in the United States, did American war reporters publish accounts of the incident. Most American journalists covering the Army Air Force seldom sought to report on the impact of aerial bombing campaigns on Axis civilians; they largely accepted the official line that the United States engaged in precision bombing. Only as American forces started entering Germany did American journalists gain an inkling that the Allied bombing campaign had not spared civilians, and stories started appearing in American newspapers.

At the same time, many reporters refused to serve as mere ciphers for the American military. As Steven Casey observed, reporters strived to scoop their colleagues on fast-breaking news, especially in the case of the Associated Press and other wire services. Radio journalists and their bosses in the field wanted to be at the front line in order to capture the sounds of war in their broadcasts. And even supporters of the cause differed over the conduct of the war, especially during major friendly fire incidents and when it was clear that Allied strategic choices had run into problems, such as the

stalemate at the Anzio beachhead in 1944 during the Italian campaign. Even Ernie Pyle, whose stock and trade centered on human interest stories, wrote a column critical of the American high command's dealing with a French Vichy official in North Africa in 1943, a sentiment shared by many of his colleagues.[10]

Other journalists remained fierce partisans of the country they covered in their reporting. As a freelance photojournalist, Thérèse Mabel Bonney arrived in Finland on the eve of the country's invasion by the Soviet Union. With her trip funded by a Finnish organization with connections to the military, Bonney was hardly a detached observer. After the outbreak of fighting, her photographs became a regular feature of *Life* Magazine for the duration of the conflict. Bonney left Finland for Belgium just before Germany ended the Phony War with the invasion of the Low Countries and France in May 1940. In 1942, Bonney returned to Finland, ostensibly as a photojournalist but also as an agent for the Office of Strategic Services (OSS) and the U.S. State Department, to open up an informal channel with governmental officials whom Bonney had met during her first sojourn in the country. Despite the Finns participating as an ally of Germany, the United States had not broken diplomatic relations with this country.

As Henry Oinas-Kukkonen's chapter makes clear, even when in the pay of the OSS, Bonney remained a fierce partisan of the Finnish cause. Because of her earlier contacts with Finnish leaders, Bonney gained unprecedented access to the battlefield and was granted permission to journey to the northern front and observe Finnish and German troops fighting against Soviet forces. Once back in the United States, Bonney remained an outspoken supporter of Finland and publicly called on Americans to overlook the country's alliance with Germany.

One trend that remained ubiquitous and runs through much of the frontline reporting is a focus on the human-interest story. Part of this trend reflected the fact that censorship often circumscribed what journalists could report. For instance, in the opening days of Operation Overlord, the Allied headquarters wanted to keep the extent of the landing vague in effort to convince the Germans that the major landing would still occur at Pas de Calais. It also reflected the limitations of what a single correspondent could learn from serving on the front line, given the vast expansion of the battlefield that stretched often for hundreds of miles. Reporters based at major army headquarters often had a much better overall view of the course of the fighting, albeit filtered through the prism of the official communiqués, press conferences, interviews with officers, and unsubstantiated rumors that circulated.

The widespread use of the human-interest genre spoke to the desire of the American public to know what their sons and daughters, husbands and wives, and neighbors were experiencing.[11] Ernie Pyle gained enormous fame and recognition for his columns that often focused on the mundane and the weighty. Although he did report on aviators and spent some time on naval vessels, his focus remained the infantry and an effort to interpret their travails. His anointing of Omar Bradley as the "GI General" proved pivotal in shaping this leader's image with his public relations officers seeking to burnish it, even though Bradley also had rather tense relationships with reporters, including, as Alexander Lovelace shows, those working for *Stars and Stripes*.

The human-interest story would not be confined to American newspapers and magazines. Victoria Sotvedt provides a comparative analysis of how American and Canadian journalists covered the role of reconnaissance units from their respective countries and often took this angle in their reporting. In one story, Sotvedt notes on the level of detail that Gerald Clark, a reporter for a major Montreal paper, provides when covering a

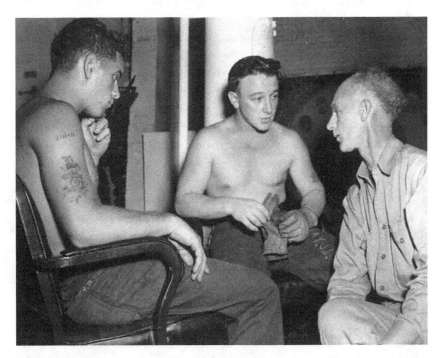

Ernie Pyle, war correspondent, interviewing Joe J. Ray S1/C and Charles W. Page S1/C on board the USS I (CV-10), February 5, 1945. Taken from https://unwritten-record.blogs.archives.gov/2018/04/18/spotlight-remembering-ernie-pyle/.

reconnaissance unit's role in the attack on the city of Caen in July 1944. Despite being a paper for one of Canada's largest cities, the *Standard* published the names and addresses of the four men photographed in the armored car that Clark rode into battle. As Sotvedt notes, this level of micro-reporting replaced much of what this reporter could not pass through the censor regarding the effort to take the city.

Knightley's classic work on war reporting largely ignores the experiences of reporters of color. His bias reflects the fact that the overwhelming majority of American correspondents were white and seldom wrote stories related to the service of African Americans, as Steve Casey has observed.[12] Even the pathbreaking decision by Eisenhower to temporarily integrate some infantry units during the Battle of the Bulge garnered little attention. An even cursory reading of the Black press during the war offers a different view of the war, with much of the coverage noting the failure of the United States to live up to the ideals of the Four Freedoms and promoting the call for the Double V against the forces of fascism abroad and racism at home. Black newspapers had to walk a fine line in their reporting with FBI director J. Edgar Hoover closely monitoring their content and eager to bring sedition charges for undermining the war effort.[13]

Larry Greene and Alan Delozier consider the contributions of two African American reporters: Roi Ottley, who reported for the white-owned liberal newspaper *PM*, and Ollie Stewart who wrote for the *Baltimore Afro-American* and for the Afro-American newspaper chain. Like white journalists, Black reporters faced the same restrictions regarding censorship and a dependence on the armed forces for feeding and sheltering them when overseas. But the Black press faced the intense scrutiny from the FBI for sedition in response to any reporting that suggested any sympathy for the Japanese and the the racial dimensions of the Pacific War.

The human-interest stories written by both Ottley and Stewart applauding the achievements of individual Black GIs and units bore similarity to those offered by white correspondents. But in the context of the massive institutional racism that African American soldiers endured, these stories had a subversive quality. Moreover, often upbeat stories of Black reporters were juxtaposed with stories written by home-front journalists documenting continued discrimination in the armed forces and industry.

Carolyn Edy, who has written widely on the experiences of women journalists, has observed that official policies remained in flux during the war. Even when regulations circumscribed access of women journalists to the front lines, individual commanders could take a more permissive attitude.[14] In her contribution to this volume she offers a collective biography

of three women journalists in the European Theater and notes that they were not above ignoring or skirting the rules to get a good story. For instance, one correspondent while receiving treatment in an army hospital managed to transfer to one that was going to treat the casualties of the Battle for Aachen, allowing this intrepid reporter a chance to cover the first German city coming under American attack by ground forces.

One of the distinctive contributions of this volume is that it offers insights into journalism practiced by correspondents serving in the American armed forces. To bolster morale, the War Department–sponsored *Stars and Stripes* was written and edited by enlisted men and women. Although editorial control of the monthly magazine *Yank* remained safely in the hands of the military hierarchy, official policies mandated that enlisted men and non-commissioned men would be in charge of *Stars and Stripes*. Staffed by veteran journalists and those new to the trade, this paper enjoyed an avid readership among average GIs in the European and North African Theaters.[15]

Alexander Lovelace's chapter shows that Patton was not the only commander critical of *Stars and Stripes*. Omar Bradley, despite his reputation as a GIs' general, bristled at the positive reporting of *Stars and Stripes* regarding the role of British General Bernard Montgomery as he assumed command of two of Bradley's armies during the Battle of the Bulge. Montgomery, seldom one to hold his tongue, at this turn of events offered such corrosive comments about American commanders' conduct of the war that Eisenhower threatened to remove him. Lovelace provides convincing evidence that Bradley launched a campaign to rein in *Stars and Stripes* and may have played a part in encouraging Patton to attack the paper and the editorial cartoons of Bill Mauldin.

The animosity of General George Patton toward *Stars and Stripes* has been well documented. Patton threatened to ban the paper in his army and threatened the unkempt and irreverent Mauldin with arrest if he came within jurisdiction of his command. In response to this controversy, Eisenhower's aide Henry Butcher, brokered a meeting between Mauldin and Patton. Eisenhower also affirmed his support of *Stars and Stripes* and ordered that no subordinate commander should interfere with the editorial independence of this paper without explicit authorization. Bradley lost the battle to rein in the *Stars and Stripes* and after the war largely covered up his efforts.

The line between journalism, public relations, and propaganda can be a tenuous one. As Phillip Knightley notes, Joseph Goebbels, Germany's propaganda minister, drafted all correspondents into the military and explicitly

tasked them with serving the needs of the military and the state. When Germany was winning, this journalism, while selective in what was reported, still often conveyed more factual news than highly censored reports emanating from the British and French military during the battle for France in 1940. Germany was not alone in inducting journalists into the military. Douglass Daniel's chapter examines how the U.S. Marine Corps recruited journalists and tasked them with serving as correspondents. Trained to fight as Marines, these correspondents were assigned to individual units and submitted their copy to a central newsroom established in Washington, DC, for censorship and editing. Newspapers and magazines, often without attribution, used stories generated by these uniformed correspondents. Like German war reporting, official Marine correspondents' reporting remained selective, often falling back to "Joe Blow" stories celebrating the achievements and valor of average Marines.

An oft-repeated adage has declared that journalists write the first version of history. James Sandy's chapter examines why journalists provided disproportionate coverage of the exploits of British Commandos and American Rangers, especially after the fall of France and before major land campaigns could be launched by the Western Allies against Germany. As Sandy observes, senior American commanders remained skeptical of the utility of devoting resources to Ranger units and their military exploits, which while remarkable often only had a minimal impact on the course of the war. But the wartime reporting, Sandy concedes, did serve an important purpose in bolstering British and American morale until the tide of war began to turn in favor of the Allies. After the D-Day invasion of Normandy interest in the special forces operations trailed off.

Official censorship ended with V-J Day, although military commanders could still restrict access to areas under military control. For instance, journalists were initially barred from Hiroshima, and military authorities initially denied the existence of radiation sickness. But ultimately, journalists were able to visit the city, and John Hersey wrote one of the most significant and highly regarded accounts of war reporting dealing with the impact of the atomic bombing on the citizens of Hiroshima.[16]

Nathaniel Moir's examination of journalistic coverage of the Nuremberg War Crimes trials also suggests the limits of journalists in writing the first version of history. Initially, the Nuremberg trials garnered a huge bevy of American journalists, including such luminaries as Ernest Hemingway. But as the cases dragged on, the ranks thinned out, with many reporters and their readers losing interest as the court considered the mountains of

Introduction | 11

documentary evidence. In the end, crucial aspects of the trials were unreported, and many stories ended up in the back pages of most newspapers.

This volume is certainly not the last word in wartime reporting. The editors of this volume will judge this work a success if it encourages renewed interest in frontline reporting.

Notes

1. Cornelius Ryan Collection of World War II Papers, https://www.ohio.edu /library/collections/archives-special-collections/manuscripts/cornelius-ryan.

2. Michael Shapiro, "The Reporter Whom Time Forgot: How Cornelius Ryan's *The Longest Day* Changed Journalism," *Columbia Journalism Review* 49, no. 1 (2010): 50–54.

3. Ryan lacks a full-blown biography of his own. For a brief overview see https://www.ohio.edu/library/collections/archives-special-collections/manuscripts /cornelius-ryan/biography.

4. Steven Casey, *The War Beat, Europe: The American Media at War against Nazi Germany* (New York: Oxford University Press, 2017), 307–308.

5. George H. Roeder Jr. *The Censored War: American Visual Experience during World War Two* (New Haven, CT: Yale University Press, 1993).

6. Lynne Olson, *Citizens of London: The Americans Who Stood with Britain in Its Darkest, Finest Hour* (New York: Random House, 2010); Philip Seib, *Broadcasts from the Blitz: How Edward R. Murrow Helped Lead America into War* (Washington, DC: Potomac Books, 2006); Joseph E. Persico, *Edward R. Murrow: An American Original* (New York: Da Capo Press, 1997); A. M. Sperber, *Murrow: His Life and Times* (New York: Freundlich Books, 1986); and Alexander Kendrick, *Prime Time: Life of Edward R. Murrow* (Boston: Little, Brown, 1969).

7. Ray E. Boomhower, *Dispatches from the Pacific: The World War II Reporting of Robert L, Sherrod* (Bloomington: Indiana University Press, 2017), and Ray E. Boomhower, *Richard Tregaskis, Reporting under Fire from Guadalcanal to Vietnam* (Albuquerque, NM: High Road Books, 2021).

8. Phillip Knightley, *The First Casualty: From the Crimea to Vietnam: The War Correspondent as Hero, Propagandist, and Myth Maker* (New York: Harcourt, Brace, Jovanovich, 1975). More recent works include Ray Moseley, *Reporting War: How Foreign Correspondents Risked Capture, Torture and Death to Cover World War II* (New Haven, CT: Yale University Press, 2017), which examines the careers of American, Australian, and British correspondents; and Steven Casey, *The War Beat, Pacific: The American Media at War Against Japan* (New York: Oxford University Press, 2021) studies the coverage of the Pacific War. Frederick Voss's exhibition catalogue, *Reporting the War: The Journalistic Coverage of World War II* (Washington, DC: Smithsonian Press for the National

12 | G. Kurt Piehler and Ingo Trauschweizer

Portrait Gallery, 1994) still remains a standard text for those seeking an overview of American wartime journalism.

9. The standard study of the agency charged with press censorship and public propaganda efforts remains Allan M. Winkler, *The Politics of Propaganda: The Office of War Information, 1942–1945* (New Haven, CT: Yale University Press, 1978). The theme of censorship and self-censorship is examined by Michael S. Sweeney, *The Military and the Press: An Uneasy Truce* (Evanston, IL.: Northwestern University Press, 2006), and *Secrets of Victory: The Office of Censorship and the American Press and Radio in World War II* (Chapel Hill: University of North Carolina Press, 2001).

10. Casey, *The War Beat, Europe.*

11. For one example of reporting that focused on personal narratives, see William M. McBride, Carl Ek, and, Rodney L. Odell, *Anybody Here from Jersey? The Collected Stories of the Herald-News War Correspondents* (Passaic, NJ: Herald-News, 1945).

12. Casey, *The War Beat, Europe,* 314–317.

13. For an overview of the Black press in World War II, see Paul Alkebulans, *The African American Press in World War II: Toward Victory at Home and Abro*ad (Lanham, MD: Lexington Books, 2014). *Roi Ottley's World War II: The Lost Diary of an African American Journalist,* edited by Mark A. Huddle (Lawrence: University Press of Kansas, 2011), is an essential source for understanding the experiences of Black reporters.

14. Carolyn M. Edy, *The Woman War Correspondent, the U.S. Military, and the Press, 1846–1947* (Lanham, MD: Lexington Books, 2017); Carolyn M. Edy, "Trust but Verify: Myths and Misinformation in the History of Women War Correspondents," *American Journalism* 36 (Spring 2019): 242–251; and Carolyn M. Edy, "War Correspondents, Women's Interests and World War II," in *Journalism's Ethical Progression: A Twentieth-Century Journey,* ed. Gwyneth Mellinger and John Ferré (Lanham, MD: Lexington Books, 2019), 115–138. For a collective biography of six highly regarded women correspondents, see Judith Mackrell, *The Correspondents: Six Women Writers on the Front Lines of World War II* (New York: Doubleday, 2021). See also Lilya Wagner, *Women War Correspondents of World War II* (New York: Greenwood, 1989), and Nancy Caldwell Sorel, *The Women Who Wrote the War* (New York: Arcade, 1999).

15. An overview of *Stars and Stripes* is offered by Cindy Elmore, "A Unique American Newspaper's Historical Struggle against Military Interference and Control," *Media History* 16, no. 3 (2010): 301–317. Alfred Cornebise, *The Stars and Stripes: Doughboy Journalism in World War I* (Westport, CT: Greenwood, 1984) is an excellent study of the World War I incarnation of this newspaper that would be revived in 1942. Thoroughly researched, but narrow in scope, is Alfred Cornebise, *The Shanghai Stars and Stripes: Witness to the Transition to Peace, 1945–46* (Jefferson, NC: McFarland, 2010). In 2019, Adam Matthew issued the digital publication *Service Newspapers of World War II* that provides full texts of

both Allied and Axis soldiers' newspapers and magazines, including the London edition of *Stars and Stripes*. This publication, by making these service newspapers more easily accessible and key word searchable, should spur interest in soldiers' reporting.

16. John Hersey, *Hiroshima* (New York: Knopf, 1946). For a biography of Hersey, see Jeremy Treglown, *Mr. Straight Arrow: The Career of John Hersey, Author of Hiroshima* (New York: Farrar, Straus and Giroux, 2019).

1

Learning and Adapting
The American Media and the "Phony War," September 1939–April 1940

Steven Casey

Historians have treated the U.S. media's reaction to the first months of World War II in terms of public opinion, analyzing the views of columnists, editorial writers, and media bosses in order to see where they stood on the so-called "great debate" that pitted interventionists against isolationists. As a result, we have a deep knowledge of how these media voices tackled issues like President Franklin D. Roosevelt's efforts to revise neutrality legislation. But we know far less about the media's main role: that of gathering news, especially news about the battles that flared across Europe.

This dearth of knowledge is a major gap. For a start, American journalists had to adapt to a major new war in September 1939. True, they had tackled conflicts in Abyssinia, Spain, and China during the past few years, but the war that erupted in September 1939 was quite different. When Adolf Hitler marched against Poland and Joseph Stalin subsequently attacked Finland, most of the continent was plunged into a major war that altered many media routines, from communication flows to cable costs, necessitating crucial changes, many of which would remain in place for the next six years.

The campaigns in Poland and Finland also marked a new form of warfare, dubbed Blitzkrieg, a term that symbolized just how much had changed in the twenty short years since Europe had last seen a continent-wide war.[1] Back then, the battlefield had invariably been mired in a bloody trench stalemate, with the front lines scarcely moving each year. Now, the fluid fighting moved rapidly from one location to another, as the attacker penetrated miles into enemy territory each day, creating countless new problems, from locating the fast-moving battlefront to finding a friendly censor. The Phony War thus became a time of adjustment and learning at every level of America's news organizations. It started with the all-important problem of how to make the war pay.

16 | Steven Casey

The Economics of War Reporting

The scene on New York City's streets on the morning of September 1, 1939, belied the familiar caricature of an isolationist America indifferent to what was happening in the outside world. On many blocks, the large stacks of newspapers proclaiming "GERMAN ARMY ATTACKS POLAND" dwindled rapidly, as commuters handed over the three-cent cover price. A particularly dense crowd gathered between Thirty-Ninth and Forty-Seventh Streets, where the updates flashing from the Times Square bulletin board could be seen. From time to time, the traffic even came to a halt, as throngs of pedestrians jammed the sidewalks. Some clustered around taxi drivers, whose radios blared out the latest breaking news. Others swapped information or just stood reading their newspapers trying to comprehend what it all meant.[2]

High above these packed New York streets sat the editors and executives who would have to capitalize on this level of interest, while also ensuring that their own organization prevailed against its main competition. In each segment of the media market, these rivalries were fierce. The two major wire services, the Associated Press (AP) and United Press (UP), were already engaged in an aggressive battle to serve as many media clients as possible. Galvanized into action by Robert McLean, its new president, the AP was in the process of "putting more drive and oomph into its news handling than ever before." The UP retaliated with a vengeance, openly boasting about the quantity and quality of its European correspondents—five hundred and growing, declared its head, Hugh Baillie, including hard-bitten veterans of recent conflicts from World War I to the Spanish Civil War.[3]

The newspapers that purchased the agencies' output operated in an equally cutthroat environment. Like so many other areas of American life, the newspaper industry had suffered greatly during the depression. In the past two years alone, no fewer than seventy-six titles had folded or merged. Against this grim backdrop, newspaper bosses of all stripes saw the advent of war as a chance to boost circulation, which would indeed jump by more than 3 percent by the end of the year.[4] Still, only a select few would initially send reporters to cover the fighting. These were the big organizations, mostly based in New York or Chicago, who not only prided themselves on the quality of their international reporting but also used their own "special news services" to sell their foreign correspondents' stories to smaller newspapers.

In New York, the *Times* and the *Herald Tribune* catered to a similar audience: well-educated and interested in the complexities of the European situation.[5] In Chicago, by contrast, the two main titles had a very different appeal: the idiosyncratic *Tribune* attracted non-intellectual readers who favored "hot stories about battle and bandits," while the high-minded *Daily*

News enjoyed "unprecedented esteem in the most responsible financial and intellectual circles."[6] Both Chicago newspapers nevertheless shared a hard-earned reputation for strong international coverage, which they now hoped would translate into bigger sales. In the first weeks of the war, the *Chicago Daily News* flaunted its long history of eye-catching war reporting, dating back to the nineteenth century. Not to be outdone, the *Chicago Tribune* stressed that it had thirty-six "resourceful and experienced foreign correspondents" stationed around the world to cover the new crisis.[7]

Yet, as all these organizations quickly discovered, the war not only provided an opportunity to boost sales. Crucially, it also imposed substantial new costs that somehow had to be recouped. An internal audit at the *Chicago Daily News* revealed just how much the war affected the bottom line. Before Hitler marched against Poland, the *Daily News* had only a paltry nine clients for its foreign news service. Within months, this figure would shoot up to fifty, increasing revenues from $20,936 to $131,461. But the paper's outlays would balloon as well—wages by 54 percent and expenses by 72 percent, while cable costs would undergo a particularly pronounced hike, with wartime rates "running from 25 to 45 cents a word as against a maximum word rate of 8 cents" a few years before.[8]

These cable costs hit the wire services particularly hard. Because they had so many reporters using so many expensive cable facilities in so many wartime locations, the AP and UP had no choice but to invoke the "war clauses" in their contracts, so that they could pass on some of the cost to their newspaper clients.[9] But at least the wire services were operating from plans drafted from the experience they had gleaned during earlier wars. The big radio networks enjoyed no such luxury. Their news sections were so new that they had to make profound adjustments while learning almost from scratch.

On the airwaves an intense battled raged between NBC, which had started the 1930s as the clear market leader, and CBS, which, partly on the strength of its impressive news coverage, had been rapidly catching up. During the Polish crisis, both networks instinctively interrupted or canceled normal programming whenever they had a breaking-news item. This was what the public seemed to demand. Executives also hoped blanket coverage would help them establish a "position of dominance" that rivals would find difficult to shake.[10] But this policy made no economic sense. Even though the cumbersome nature of broadcasting equipment meant there was little chance of capturing the sounds of war, live broadcasts from Europe were particularly expensive to produce, while the commercial sponsors who paid the bills did not take kindly to having their adverts constantly disrupted by war news.

18 | Steven Casey

So within weeks, the main radio networks would establish a more settled routine, with regular European roundups scheduled before and after major entertainment shows.[11]

Problems in Poland

Because the war promised such massive gains, while imposing significant new costs, the media had a strong incentive to make it as dramatic and eye-catching as possible. With the United States firmly neutral, however, numerous obstacles had to be overcome before news organizations could fully exploit the war's potential.

One was the innate caution of almost all media executives. Radio, which seven out of ten Americans rated as their "preferred news source," confronted the war in a particularly circumspect frame of mind. Radio bosses knew that their sponsors disliked news shows that expressed any sort of opinion. They also recognized that newspapers felt so threatened by this relatively new medium that they stood ready to jump on any mistake, any exaggeration. During the first phase of the war, CBS and NBC therefore drafted a joint code, which included clear instructions to correspondents to "avoid horror, suspense, and undue excitement in reporting war news." If sounds from the battlefield became available, they pledged to air them as soon as possible, while taking "every effort . . . to prevent such broadcasts from giving unnecessary shocks to listeners."[12]

Newspaper bosses acted with only slightly more boldness, calling on their European-based correspondents to write stories based on hard evidence, not opinion. At the very start of the war, Colonel Frank Knox, the proprietor of the *Chicago Daily News*, sent two of his most highly experienced reporters to London with parting instructions that could not have been clearer. "All we want you to do is report the facts," Knox ordered, "and we'll write our editorials here in Chicago."[13]

Had reporters been able to gain unfettered access to the battlefield, they might have cabled back facts that told an emotive, dramatic, and essentially anti-Nazi story. But crucially, the first battles of this new era of warfare proved particularly difficult to cover. Within hours, transport on the continent was at a virtual standstill, with many air routes canceled and trains running at irregular intervals. To get into Poland, where the main story was rapidly unfolding, was almost impossible. The only routes went via Copenhagen in the north and Bucharest in the south, both of which required long hours in a lumbering Lockheed plane before a bumpy landing on a rudimentary strip in the middle of a field.[14]

The American Media and the "Phony War" | 19

For American editors, the only saving grace was that Hitler's increasingly belligerent rhetoric had given them time to prepare. The AP had led the way, beefing up its Polish presence back in April, convinced that it would "do well to keep a staffer near Warsaw, footloose to go places," in case Hitler's talk ever translated into reality.[15] The UP had followed suit in late August, interrupting the vacation of Ed Beattie, one of its preeminent foreign reporters, and hurrying him to the Polish capital when word broke of the Nazi-Soviet pact on August 23. Once there, he found a number of fellow American correspondents, including Lloyd Lehrbas of the AP, Richard Mowrer of the *Chicago Daily News*, and John Walker of the *New Herald Tribune*, all of whom had settled into the Europeiski Hotel.

It was one of "those crisis hotels," remarked Beattie, "with the usual frantic telephone switchboard, browbeaten porters, and table-top tacticians." Less than a day after the fighting started, however, this telephone switchboard was useless: Both incoming and outgoing calls were stopped. Reporters could only get their copy out via wireless, which took up to thirty-six hours. But first they had to find a story. Most correspondents spoke only English, and perhaps a smattering of German or French. They therefore gleaned nothing from the Foreign Office press briefings, which were conducted purely in Polish. They got even less from the military, which did not even establish a method of providing information to the press. "It was impossible to find out whether correspondents would be permitted, eventually, to go to the front," complained Beattie. "It was impossible, in fact, to find out where the front was." Censorship only made a bad situation much worse. The government asked correspondents to submit all copy to the central post office, but the censors provided no details on what passages they had cut, or even if and when they had transmitted any stories to America.[16]

On September 5, as the German attack gathered pace, the Polish government decided to leave Warsaw. The day dawned sunny and clear, allowing German planes to bomb the city at will. The Europeiski was particularly exposed, since it was located close to the Polish foreign office and military headquarters. Despite the danger, American reporters were not keen to depart. They all knew that during the Spanish Civil War covering the siege of the capital city had been the making of a number of correspondents, including Herbert Matthews of the *New York Times*, whom *Time* magazine had praised for his axiom "that nothing can be learned with certainty unless one goes to the spot and sees with his own eyes."[17] Yet with Nazi forces making such rapid gains, these reporters also recognized that they were likely to become trapped inside the city with no chance of cabling out an

eyewitness story. Reluctantly, therefore, Beattie, Lehrbas, Mowrer, and Walker decided to follow the Polish government to Lublin, slipping away by car just before the Germans encircled Warsaw. Although unable to report the siege, they at least had the satisfaction of covering the first great refugee story of the war: a stirring tale of dust and danger, as their motley motorcade joined the stream of cars, carts, and pedestrians on the wearying twenty-five-hour journey one hundred miles to the southeast.[18]

With little battlefield news coming out of Poland, American editors naturally turned to other locations. At first glance, London seemed to offer the ideal alternative. The British capital had the best communications network, no language barrier, and a relatively open democratic system that facilitated news gathering. All the big American news organizations had their main bureaus on or around London's Fleet Street, where, by day, their reporters could monitor developments all over the continent, and, by night, they could socialize with sources or colleagues in one of the area's countless pubs. Yet London in the fall of 1939 quickly proved a frustrating place from which to cover the combat. The British and French governments still seemed mired in the same indolence that had seen them appease Hitler for so long. Focused on waging a naval and economic war, they certainly did little to aid the Poles, who were swiftly overrun by the German army. Nor did their over-fussy censors allow much war news to be reported. By the middle of September, British censorship had become so strict that American reporters and British editors all began to complain that the Germans "were getting a much better press because of it."[19]

In fact, almost by default, Hitler's government managed to dominate coverage of the Polish war, as the victorious Wehrmacht gave every impression of openness and veracity, at least in recounting the basic facts of their rapid success. "Comically enough," remarked the *Chicago Daily News*'s Berlin bureau chief soon after Poland's defeat, "it now turns out that the German communiqués—in cases where checks are now possible—erred chiefly only on the side of modesty, and that the Allied claims were often more preposterous."[20] Even so, there were distinct limits to this candidness, as demonstrated by the manner in which the Wehrmacht provided battlefield access to a small number of American reporters. In the first days of the Polish campaign, the German military held a lottery to decide which lucky correspondents would get a place on a carefully supervised trip to a specially selected section of the front. The lucky winners soon found, however, that they only had access to a version of the war that confirmed the basic Nazi narrative of a speedy and relatively bloodless victory, with the only atrocities being carried out by the Poles on defenseless German citizens.[21]

For American editors, this was scarcely a satisfactory state of affairs. Although the vast majority of the media retained a studied neutrality, most editors really craved—and many reporters wanted to produce—graphic eyewitness accounts of fighting, rather than antiseptic or askew reports derived from communiqué rewrites or chaperoned trips to the front. They also thought that such copy would have far more punch if told from the victim's perspective: as a David-and-Goliath story of a valiant small country fighting off its aggressive big neighbor. The specific context of the Polish campaign had prevented this from happening. The next phase of the war would provide the first lessons in how to rectify this situation.

Breakthrough in Finland

After Joseph Stalin invaded neighboring Finland on November 30, the public's sympathies were clear-cut. To most Americans, Finland was not only another small country that had been attacked by a bigger neighbor—in this case, the godless hordes of the Red Army. It was also the only state that had not defaulted on its World War I debts.[22] Faced with an outpouring of public support, U.S. editors naturally sought eye-catching copy detailing how well the valiant Finns were standing up to the communist assault, but this was not their only calculation. In Finland, the American media enjoyed a number of advantages that made it much easier than it had been in Poland to get their reporters in—and the story out.

Geography was one. Since September, many U.S. news organizations had built up their Scandinavian staffs, convinced that these neutrals countries would offer an ideal base from which to cover the next phase in the German war against Britain and France. They therefore had people and equipment nearby when the fighting erupted in neighboring Finland. The wire services were particularly well prepared. Both used Copenhagen as a relay center. Here, staffers manning the telephones recorded what journalists in Helsinki, Stockholm, and Oslo had written. They then translated this into cablese before sending it to Western Europe by teleprinter, from where it was wired to the United States. If the connections all worked—as they often did—a story could be transmitted from Helsinki to New York in about forty minutes, although as more and more correspondents arrived in Finland the time started to increase to more than an hour.[23]

Of course, none of this would have been terribly useful had the Finns, like the Poles, been rapidly defeated. Crucially, however, the Finnish army unexpectedly halted the first Soviet advances, giving a number of big-name journalists the chance to reach what soon became the first media-friendly fighting event of this new war.[24]

22 | Steven Casey

Martha Gellhorn was one. On November 10, the glamorous freelancer left the United States so hurriedly that she had to miss a White House dinner, though she did come armed with a letter from President Roosevelt asking foreign-service officials to assist her.[25] Webb Miller was another. After spending a dull October and November in Paris, awaiting the Western Front battles that never happened, the veteran UP correspondent could stand it no longer. With the French "war story [having] collapsed completely," he flew out to get "himself some nice action and color copy in Finland."[26] Leland Stowe was a third. Bored with London—where it was "still a phony war and we can't get our teeth in it"—the forty-year-old *Chicago Daily News* man dashed to get an exit permit the minute he heard about clashes on the Soviet-Finnish frontier. Boarding a ship in Stockholm, he "crept down the coast under Finnish convoy," avoiding Soviet planes and submarines, before grabbing a taxi in the Finnish port of Åbo, which took him the last one hundred miles to Helsinki.[27]

What the likes of Gellhorn, Miller, and Stowe discovered on their arrival was a bitter war fought in tough conditions. Their problems began at the Kämp Hotel, which like Warsaw's Europeiski became the correspondents' new base. Built in 1887, the Kämp hardly provided an ideal shelter from Soviet bombing raids. "It is old and flimsy," wrote Frank B. Hayne, the U.S. military attaché in the city, "the lower floor is on a level with the street and completely surrounded with large plate-glass windows, while the grand staircase forms a well through the entire building which is covered with nothing more substantial than a skylight of colored glass."[28]

Still, despite its fragile structure, the Kämp, did afford a welcoming mix of warmth and whisky. Venturing outside Helsinki proved a grueling ordeal. It was 190 miles to Viipuri, the city closest to the Finns' main defensive position along the Mannerheim Line. With the constant threat of Soviet air raids, this journey took fifteen hours by wood-burning locomotive, and, as Miller recorded, "you have to sit up in a crowded compartment all night in nearly complete darkness." At least the train was warm. Outside, temperatures plunged to minus 43°F. "Cigarette butts froze between puffs," observed Miller. Although Finnish officers warned reporters to "wear all the clothes you've got including your pyjamas," nothing really kept out the "merciless" cold, which Gellhorn, like everyone else, found an "absolute torture."[29] By January, correspondents from the AP, UP, INS, *New York Times*, *New York Herald Tribune*, *Chicago Daily News*, and *Chicago Tribune* had all made trips to the battle zones. But none stayed longer than a few days, partly because conditions were so tough that reporters needed to return to Helsinki to "recuperate."[30]

The American Media and the "Phony War" | 23

Nor, crucially, was the Finnish army necessarily keen for them to linger, for it was engaged in a delicate balancing act. On the one hand, fighting for survival against such a powerful neighbor, senior Finnish officers were so keen to protect vital military secrets that they had instituted formal censorship in early November, even before the war started. Once fighting flared, however, these officers, like those in other victorious militaries, were inclined to be generous to the press when they had a winning story to tell.[31]

The U.S. reporters who the Finnish censors encountered were also more than happy to trumpet Finland's success. Donald Day was typical. The fiercely anticommunist correspondent of the *Chicago Tribune* had been highly critical of the Poles, but after his fourth trip to the Mannerheim Line he wrote to his publisher that he had "never seen such morale and discipline combined with a spirit of comradeship and real friendship such as exists between the officers and men of every military establishment in Finland that I have visited."[32] Day's rival of the *Chicago Daily News* felt the same way. "This is little Finland," Leland Stowe wired from Helsinki on December 5, "unflinching and undaunted before the mighty Red Goliath which threatens its life."[33]

As the fighting unfolded, American reporters framed their stories in ways that both kept the censors happy and appealed to their readers. "Never before," reported Stowe after a trip to the Lapland front in late January, "have thousands of men attempted to conquer simultaneously their adversaries and the fierce Arctic winters. . . . Even Jules Verne," he added, "never dreamed of Arctic winters like this." Stowe particularly relished telling tales of trying to satisfy his fierce hunger by eating reindeer stew or witnessing "'the first huskies' ever to participate in a European war—the first dog teams ever to rush arms and munitions up to any front line in any war in the world."[34] Then there were the skiing skills of Finnish fighters, which U.S. reporters tended to emphasize in the context of other traits that made the Finns seem positively American. "The Finnish soldier is an individualist fighter," argued Harold Denny of the *New York Times*, "yet is amenable to the sort of discipline which is necessary to large-scale military operations." "These men on skis," agreed Stowe, "are the Daniel Boones of the twentieth century. They know as much about the forests and the mysteries and cruel laws of nature as Daniel Boone ever knew, yet they fight with machine-guns and hand-grenades as well as knives."[35]

Back in the United States, such reports were so glowing that some media voices began to question whether these correspondents were simply regurgitating Finnish propaganda. At first the answer was reassuring. The Finns "have a good sense of publicity," believed Marcus Duffield, the day news

editor of the *New York Herald Tribune.* "I'm not the least bit suspicious." Reports from Finland, agreed Bertram Zilmer, editor of the North American Newspaper Alliance, "are pretty truthful. . . . We figure there is some exaggeration on casualties, as the Finns are probably enthusiastic. It is only a question of whether 5,000 or 2,000 Russians are killed in a certain engagement. Only in the details do we feel there is likely to be some inaccuracy."[36]

The reporters themselves were quick to stress the many practical problems they encountered. As well as the intense cold, there was the ability of modern armies to fight on numerous fronts over vast distances. "There is no well-defined battle line in this meandering warfare in a zone that takes forty hours to tour by automobile," observed Thomas F. Hawkins of the AP. Some, like Webb Miller, decided to remain in one place—in his case, the Karelian front, where he could see the distant Russian troops through periscopes on the Mannerheim Line. But what Miller gained in familiarity, he lost in overall perspective—although more peripatetic reporters suffered, too. Despite visiting four of the five fronts throughout January, Stowe returned to Helsinki in a frustrated mood. "No correspondent knows more than a fraction of what has happened in any sector," he confessed at the end of the month, and it was "impossible to give a rounded summary of this war's progress to date."[37]

Because the distances were so great, correspondents were dependent on their host army not just for accreditation and transportation, but also for tips about where the next battle was likely to flare. And while the Finns had proved cooperative at first, their enthusiasm for helping the foreign press corps rapidly started to wane. Early in the new year, Stalin shifted more men, artillery, and airplanes to the front. On the Mannerheim Line alone, the Soviets now deployed twenty-five divisions, against which the Finns could field only seven divisions plus some special units, all of them lacking key equipment. By the middle of February, these Soviet troops began gradually pushing the Finns out of their main positions to the south of Viipuri. The war had reached a crucial tipping point—a fact soon noted by American correspondents.[38]

Harold Denny of the *New York Times* was one of the first to realize that Finnish censorship became much tighter the minute the Soviets renewed their attack.[39] Stowe soon concurred. "The Finnish high command," he complained, "has taken pains that no correspondent should witness a major engagement, and not one of us has yet seen a large-scale clash between Finnish and Russian forces." In an angry dispatch, Stowe dubbed this "an almost unprecedented secret war and what correspondents see is most

The American Media and the "Phony War" | 25

carefully restricted long before anything they write comes beneath the censor's pencil."[40]

Stowe's allegations stung the Finnish government into a response. In the middle of February, it permitted two U.S. wire service reporters—Beattie of the UP and Hawkins of the AP—to visit an active part of the front. Hawkins duly produced a "graphic description" of what it was like being on the receiving end of a heavy round-the-clock Russian artillery barrage. Beattie, for his part, wrote about "piles of dead Russian soldiers, many of whom had been frozen."[41]

Finnish credibility did not escape unscathed, however. By March, American reporters were no longer lining up to praise the Finns for their light-touch censorship. Instead, they were focusing on Finnish clumsiness, which sometimes bordered on heavy-handed incompetence. Beattie, not mollified by his trip to the front, concluded that Finnish censorship was an "unreasonable, pig-headed, hide-bound affair." His UP colleague, Norman Deuel, agreed. "The Finns lacked a competent liaison man between the military and the press," Deuel insisted when he arrived back home, exhausted. The war was a "tough assignment," he continued, because of "Finnish censorship, poor communications and transportation," as well as the blackouts and extreme cold. Yet Deuel also added a final, crucial, caveat. Having covered the Soviet Union for four years, he thought the situation was far worse on the other side of the hill. "Anyone staying in Moscow any length of time," he believed, "is subject to a mental depression from the dirt, poverty, and rigorous police system."[42] Or, put another way, however bad things were in Finland, they paled next to the situation U.S. correspondents found in the USSR.

Suffering in the Soviet Union

During the late 1930s Moscow was certainly a dreary and dismal city to live and work in. Members of the small American community were prone to "a form of acute indigestion, caused by the excessive use of canned food, that mimicked the symptoms of angina pectoris."[43] Because they were deemed to be in a "hardship post," top reporters were paid well enough to rent the best apartments, but this was one of the few perks in a city where a sense of isolation predominated, as most Soviet citizens, fearful of becoming a victim of Stalin's purges, shunned any contact with foreigners.[44]

In such a miserable environment, Deuel's quip about the likelihood of suffering mental depression was not facile. Correspondents needed stamina. After five years working for the *New York Times* in Moscow, Harold Denny— who would soon become renowned for his battlefield bravery—was burnt

26 | Steven Casey

out by the time he departed. According to G. E. R. Gedye, his experienced successor, Denny "left this place as a complete nervous wreck—really in shocking condition." Gedye, who replaced Denny shortly before the Winter War began, was quick to remind his New York bosses that they would

> not get the same results out of me in Moscow as in Vienna and Prague. . . . There are not the facilities for news gathering or contacts [he explained] and if the authorities could freeze out all for correspondents they would only be pleased. . . . There is no contact with the Russians. The [Soviet] Press Bureau has been put in charge of a man whose only task is to say he "knows nothing."[45]

And this was before the fighting started to go badly for the Red Army in Finland. Throughout December and January, the Soviet government clamped down still further. Most visibly, it reintroduced strict censorship, which had technically been relaxed the previous May.[46] It also refused to allow foreign correspondents anywhere near the front. With the Press Bureau in Moscow dispensing little usable information, American correspondents were forced to begin a crash course in what would later become known as Kremlinology: the careful reading of the Soviet press to glean clues about what was really happening.

Henry Shapiro, the UP's man in Moscow, became a particularly skilled practitioner of this art. A graduate of New York's City College and Harvard Law School, Shapiro had been in the city since 1933, when he arrived as an attorney. Soon switching to journalism, he became the UP bureau chief by 1939, charged with the thankless task of providing spot news on the basis of what could be gleaned from government communiqués and official organs like *Tass* or *Izvestia*.[47] At the start of the Winter War, this inevitably meant reiterating Soviet claims that the "perfidious, shrewd, treacherous, and vicious" Finns had started the hostilities. But Shapiro's dispatches could also be much more revealing. "As far as citizenry at large is concerned," he wrote in cablese three weeks into the war,

> the campaign for liberation Finland as war euphemistically called here continues to be a matter of minor interest. There's hardly any news from the front in the press or radio other than the official communiqués. The communiqués are becoming increasingly vaguer and briefer making it difficult to form a clear day by day picture of development. Soviet authorities seem unperturbed by any of the claims issued in Helsinki and make no efforts to

The American Media and the "Phony War" | 27

rebut them . . . and decline to make any comment other than through official channels that is *Tass* or the press.[48]

In contrast, Gedye was less adept at picking his way through Moscow's maze of double-speak and denial. It did not help that the *Times* man could not speak Russian, though his bosses did not consider this a particular handicap: many of his predecessors, they pointed out, had also relied on an interpreter. Nor did it help that Gedye was convinced that these New York bosses had it in for him. Gedye even suspected that they had exiled him to Moscow as some sort of punishment for being too partisan in his earlier wartime dispatches, especially in condemning Britain's appeasement policy. A sensitive man, prone to take offense at the slightest provocation, he was soon running up exorbitant cable bills in a lengthy defense of his record—an activity that deeply alienated his editor partly because of the expense and partly because he seemed to spend more time complaining than producing usable copy.[49]

The situation came to a head in the first months of 1940. In New York, senior *Times* executives concluded that Gedye's bureau was not providing value for money. The vast majority of their Moscow-datelined Winter War stories, they concluded, had come from the wire services. On the surface, this was because Gedye was "always a day a late on the communiqués," and the text of his own dispatch merely gave a "worthless" review of what was in the Soviet press. But the senior *Times* men also recognized that the Soviets were playing a cunning game of press manipulation. For a start, they closed the censors' office between 1 a.m. and mid-morning, so that no one was around to pass the reporters' gloss on the official communiqués, which were released at 4 or 5 a.m. This simple ploy gave the AP a massive advantage, since it had an arrangement with the Soviet authorities to cable out the *Tass* story during this period. According to Gedye, *Tass* even sent out its stories in the AP's name, without the AP even seeing the content. Crucially, these stories arrived in New York "in plenty of time" for the morning editions, whereas Gedye's own censored copy came a day later—and was, in effect, obsolete by then.[50]

At first glance, the Soviets appeared to have hit on the perfect way to control foreign press coverage. And when the Red Army's gradual pressure eventually forced the Finns to sue for peace in March, Stalin could savor a double victory: The war had been won and his case had been made to the outside world. Yet these both turned out to be pyrrhic victories. The war itself created a dangerous perception of Soviet weakness, which Hitler, for

one, would remember in 1941 when he decided to invade the USSR. Far less lethally, Soviet censorship also created a major backlash in New York. The *Herald Tribune* had already withdrawn its last Moscow-based correspondent. Feeling manipulated, the *Times* now followed suit, closing its Moscow bureau in protest at the Soviet government's behavior during the Winter War. "It was a squeeze play," explained Edwin L. James, the paper's managing editor, and "things became so pestiferous we got fed up." The *New York Times* would not reopen its Moscow bureau until after the start of the German-Soviet war a couple of years later.[51]

From Phony War to Total War

The way the American media covered the first campaigns of World War II had a number of repercussions. Most immediately, Stowe made the short trip to Oslo after the guns fell silent on the Finnish front. He was therefore on hand to score a notable scoop when Vidkun Quisling betrayed Norway to the Nazis. With the British initially refusing to accredit any of its own war correspondents to the region, Stowe also led the way in covering the unsuccessful British attempt to capture Trondheim and Narvik. His stories on this debacle were so shocking that they even contributed to the fall of Prime Minister Neville Chamberlain in May.[52]

The new British government proved much more hospitable to American reporters. When the French also succumbed to the Nazi Blitzkrieg in June, Hitler's propagandists decreed that all dispatches written in France, Belgium, and the Netherlands had to be routed through Berlin, where they became subjected to ever-more stringent controls. As a result, most cable companies left the continent for London, "which became the last and largest clearing house for news for the United States." "Our last hope," one American cable company official declared in late June, "is Great Britain."[53]

Maintaining reliable communications was vital because the end of the Phony War confirmed beyond any doubt that the war was good for business. Reports from circulation managers in New York City revealed "gains ranging up to 25 percent over already high war sales" during May. To exploit this massive demand, the big news organizations not only placed their hometown staff on "bulge duty" during the biggest battles, in order to "handle the news flow from abroad up to 24 hours a day," but also deployed more reinforcements to London, just in time for the Battle of Britain and the Blitz.[54]

Once there, the task of evading German bullets and bombs had two important consequences. First, these reporters shed any vestige of impartiality. Indeed, as Beattie wrote, before long they all "stopped referring in

The American Media and the "Phony War" | 29

conversation to 'German' and 'British' planes. They had become 'theirs' and 'ours.' It was not exactly strict neutrality, but quite understandable when four-fifths of the planes in the air were aiming in our general direction, and the other fifth trying to knock them down before they could up their sights." "It was at Dover," agreed Vincent Sheean, "that the side of England became 'our side' in my eyes."[55]

Second, this baptism of fire shaped how the U.S. reporters saw their own role in the war. Having been targeted by German bombs, these veterans were eager to play a constructive role once the United States slowly began to shed its policy of neutrality. Yet, having experienced combat at first hand since the first days of the fighting, these reporters invariably believed they knew as much, if not more, about modern warfare than many in their own military. Partly for this reason, they would often question and critique their own side's judgment, both in private and in print, making them tetchy team players rather than meek mouthpieces during the long years ahead.[56]

Notes

1. On the evolution of the term "Blitzkrieg," see Karl-Heinz Frieser, *The Blitzkrieg Legend; The 1940 Campaign in the West* (Annapolis, MD: Naval Institute Press, 2012), 5–11.

2. "German Army Attacks Warsaw," and "Crisis Causes Minor Traffic Jams in Times Square as Crowds Watch Bulletins," *New York Times*, September 1 and 2, 1939.

3. Hugh Baillie to Wilson, July 10, 1939, and Edward Murrow, "Interview with Baillie," August 25, 1939, both in City File-NY-UP Assn., box 155, Roy Howard Papers, Library of Congress (hereafter LC).

4. "Possible Effect of War on Price of Paper Considered," "Dailies Circulation Up 3.24%," and "Hitler's 'Total War' Brings Biggest Task to U.S. Press," *Editor & Publisher*, October 28 and December 9, 1939, and May 18, 1940.

5. Richard Kluger, *The Paper: The Life and Death of the New York Herald Tribune* (New York: Vintage Books, 1989), 290–305; Guy Talese, *The Kingdom and the Power* (New York: World, 1969), 198–199.

6. John Maxwell Hamilton, *Journalism's Roving Eye: A History of American Foreign Reporting* (Baton Rouge: Louisiana State University Press, 2009), 156–191.

7. "How to Add Distinction to Your War Coverage," *Chicago Tribune* advert, and "Prepared and Ready Years before the War Exploded," *Chicago Daily News* advert, both in *Editor & Publisher*, October 7 and 14, 1939. On these two Chicago papers, see also James C. Schneider, *Should America Go to War? The Debate over Foreign Policy in Chicago, 1939–1941* (Chapel Hill: University of North Carolina Press, 1989), 37–64; Jerome E. Edwards, *The Foreign Policy of Col. McCormick's Tribune* (Reno: University of Nevada Press, 1971), 150–171.

8. "Comparison of the Operation of the Foreign News Department 1936–1941," undated, Chicago Daily News Documents: Financial Accounts, folder 232, box 30, Carroll Binder Papers, Newberry Library, Chicago.

9. Kent Cooper to AP Members, October 23, 1939, City File-NY-Associated Press, box 150, and Hugh Baillie to Smithton, February 14, 1941, City File—NY—UP, box 179, both in Howard Papers; "America's High War Coverage Costs," *Newspaper World*, October 28, 1939.

10. Hugh Baillie to Earl Johnson, September 15, 1939, City File-NY-UP Assn., box 155, Howard Papers; Erik Barnouw, *The Golden Web: A History of Broadcasting in the United States*, vol. 2: *1933 to 1953* (New York: Oxford University Press, 1968), 17–19, 58, 74, 80, 128–138; David H. Hosley, *As Good as Any: Foreign Correspondence on American Radio, 1930–1940* (Westport, CT: Greenwood Press, 1984), 12–13, 29, 43, 59.

11. Beville to James, October 20, 1939 File 641, World War II, NBC History Files, LC; "Network War News on Orderly Basis," *Broadcasting*, September 15, 1939; Elmer Davis, "Broadcasting the Outbreak of War, *Harper's Magazine* 179 (November 1939): 579–580.

12. National Association of Broadcasters, "Radio Networks Adopt Rules for War Broadcasts," September 11, 1939, File 641, World War II, NBC History Files, LC; "Joint Network News Coverage Policy Based Mainly on Klauber Draft," *Broadcasting*, September 15, 1939.

13. Leland Stowe, *No Other Road to Freedom* (London: Faber and Faber, 1942), 1–3.

14. Max Jordan to A. A. Schechter, "European Coverage," September 16, 1939, file 641, World War II, NBC History Files, LC.

15. [M. M. Thompson] to Alan J. Gould, April 19, 1939, and Robert B. Parker to [M. M.] Thompson, April 11, 1939, Warsaw folder, series 3: Correspondence (Foreign Bureau), AP 02A.3, box 37, AP Corporate Archives, New York.

16. Edward W. Beattie, *Passport to War* (London: Peter Davis, 1943), 119–149; "Tells How He Got Warsaw Bombing Scoop," and "Herald Tribune Man Tells of Warsaw Fight," *Editor & Publisher*, October 14 and November 11, 1939.

17. "War in Spain: Surrender with Honor," *Time*, January 17, 1938. For Matthews's coverage of the siege of Madrid, see Herbert L. Matthews, *The Education of a Correspondent* (New York: Harcourt, Brace, 1946), 94–95; Paul Preston, *We Saw Spain Die: Foreign Correspondents in the Spanish Civil War* (London: Constable, 2008), 35–36. On the prospect of Warsaw becoming a "second Madrid," see Richard Mowrer, "Warsaw Streets Barricaded," *Chicago Daily News*, September 8, 1939.

18. Richard Mowrer," and "Germans Speed Warsaw Attack," *Chicago Daily News*, September 5, 1939; UP, "Swims to Flee Poland," *New York Times*, September 21, 1939.

19. Hugh Baillie to Earl Johnson, September 15 and 19, 1939, City File-NY-UP Assn., box 155, and Roy Howard to Lord Beaverbrook, September 11 and 19, 1939,

The American Media and the "Phony War" | 31

Foreign File-Europe, box 157, all in Howard Papers; William Stoneman, "Diary Notes on London at the Beginning of the War," 1939, September 4, 6, 8, and 13, 1939, box 1, William Stoneman Papers, Bentley Library, University of Michigan; Stowe, *No Other Road*, 13; Leland Stowe, World War II Diaries, London, September 21, 1939, folder 16, box 39, Leland Stowe Papers, Wisconsin Historical Society, Madison.

20. Wallace Deuel to Carroll [Binder], October 15, 1939, CDN folder, box 6, Wallace Deuel Papers, LC.

21. Louis P. Lochner, "Germans, Plagued by Snipers, Seize All Polish Men Not in Army," *New York Herald Tribune*, September 6, 1939; Frederick C. Oechsner, "Dead Germans in Streets of City in Poland," *Chicago Daily News*, September 8, 1939.

22. William L. Langer and S. Everett Gleason, *The Challenge to Isolation* (New York: Harper, 1952), 1:329–30; Justus D. Doenecke, *Storm on the Horizon: The Challenge to American Intervention, 1939–41* (Lanham, MD: Rowman and Littlefield, 2000), 77–78; AP, "Finland Punctually Makes $432,693 Payment on Debts," *Atlanta Constitution*, December 16, 1939.

23. "Newsmen Report Finnish War at 25 to 43 Below Zero," *Editor & Publisher*, January 13, 1940; Beattie, *Passport to War*, 193–194; Assistant General Manager to Thomson, December 29, 1939, Foreign News Service folder, AP01.4B, Board President MacLean Papers, box 20, AP Corporate Archives; Donald Day to R. R. McCormick, October 4, 1939, Day folder, Robert McCormick: Foreign Correspondents, I-62, box 4, Chicago Tribune Company Archives, Cantigny, IL.

24. For background, see Jukka Nevakivi, *The Appeal That Was Never Made: The Allies, Scandinavia, and the Finnish Winter War, 1939–40* (London: Hurst, 1976), 28–40; Seppo Myllyniemi, "Consequences of the Hitler-Stalin Pact for the Baltic Republics and Finland," in *From Peace to War: Germany, Soviet Russia, and the World, 1939–1941*, ed. Bernd Wegner (Oxford: Berghahn Books, 1997), 83–84.

25. Eleanor Roosevelt to Steve [Early], September 10, 1939, and Franklin Roosevelt to All Foreign Service Officers, PPF6208 (Gellhorn), Franklin D. Roosevelt Papers, Roosevelt Presidential Library, Hyde Park, NY; Caroline Moorehead, *Martha Gellhorn: A Life* (London: Vintage, 2004), 193.

26. Ralph [M. Heinzen] to Roy [Howard], December 28, 1939, City File-NY-UP Assn. (foreign), box 155, Howard Papers.

27. Stowe, *No Other Road*, 13, 36; Leland Stowe, World War II Diaries, London, September 21, October 11, and November 29–30, 1939, folder 16, box 16, Stowe Papers; Leland Stowe, "Helsinki Now a Ghost City," *LA Times*, December 6, 1939.

28. Frank B. Hayne to Roy Howard, April 11, 1940, and enclosed memo, April 7, 1940, Foreign File-Europe, box 169, Howard Papers.

29. "Miller Describes Difficulties of Finn War Duty," *Editor & Publisher*, January 27, 1940; Stowe, *No Other Road*, 37; Martha Gellhorn to Ernest Hemingway, December 4, 1939, in *The Letters of Martha Gellhorn*, ed. Caroline Moorehead (London: Picador, 2006), 78.

30. "Newsmen Report Finnish War at 25 to 43 below Zero," and "Miller Describes Difficulties of Finn War Duty," *Editor & Publisher*, January 13 and 27, 1940; Donald Day to R. R. McCormick, January 4, 1940, Day folder, Robert McCormick: Foreign Correspondents, I-62, box 4, Chicago Tribune Company Archives.

31. For details of these battles, see Carl Van Dyke, *The Soviet Invasion of Finland, 1939–40* (London: Frank Cass, 1997), 60–91.

32. Donald Day to R. R. McCormick, January 4, 1940, Day folder, Robert McCormick: Foreign Correspondents, I-62, box 4, Chicago Tribune Company Archives.

33. Stowe, "Helsinki Now a Ghost City."

34. Leland Stowe, "Incredible War Is Being Waged in Arctic Zone," "Russians Rush to Finnish Bath and Sit on Mine," "Enlist Huskies to Help Finns' War in Forests," *Chicago Daily News*, January 26, 27, and 31, 1940; Leland Stowe, "Finn Soldiers Real Comrades," *LA Times*, January 21, 1940.

35. Harold Denny, "The Men Who Fight for Finland," *New York Times*, February 18, 1940; Stowe, *No Other Road*, 42.

36. "Newsmen Report Finnish War at 25 to 43 below Zero."

37. "Newsmen Report Finnish War at 25 to 43 below Zero."

38. Nevakivi, *Appeal That Was Never Made*, 100–101.

39. Harold Denny, "New Battle Rages in North Finland," *New York Times*, January 31, 1940.

40. Leland Stowe, "War in Finland Working Up to Crisis in March," *Chicago Daily News*, January 30, 1940; "Finns Restrict Correspondents, Stowe Declares," *Editor & Publisher*, February 3, 1940.

41. "Hawkins, Beattie Tour Finn's Mannerheim Line," *Editor & Publisher*, February 17, 1940.

42. Beattie, *Passport to War*, 200–202. "Deuel, Home from Finland, Relates Conditions There," *Editor & Publisher*, March 16, 1940.

43. John Lewis Gaddis, *George Kennan: An American Life* (New York: Penguin, 2011), 83.

44. S. J. Taylor, *Stalin's Apologist: Walter Duranty, The New York Times's Man in Moscow* (New York: Oxford University Press, 1990), 183, 228–229, 265–266, 280–281; Walter Duranty, *The Kremlin and Its People* (New York: Reynal and Hitchcock, 1941), 119.

45. G. E. R. Gedye to Arthur Hays Sulzberger, October 13, 1939, Moscow Bureau folder, box 208, New York Times Company Records: Sulzberger Papers.

46. "Russia Reimposes Censorship," *New York Times*, December 29, 1939.

47. Taylor, *Stalin's Apologist*, 244.

48. Henry Shapiro, Unipress Amsterdam via radio, 0412 [December 4, 1939], 05153 [December 5, 1939], and 18042 [December 18, 1939], UP Moscow Bureau-Wire Service Reports folder, box 31, Henry Shapiro Papers, LC.

The American Media and the "Phony War" | 33

49. Edwin L. James to G. E. R. Gedye, November 2, 1939; Arthur Hays Sulzberger to G. E. R. Gedye, November 3, 1939, Moscow Bureau folder, box 208, New York Times Company Records: Sulzberger Papers. Gedye had reported from Austria between 1925 and 1938, representing both the *Daily Telegraph* and the *New York Times* in Vienna until his resignation from the former in early 1939, having referred to the British Prime Minister as "Gauleiter Chamberlain." See "G. E. R. Gedye Leaves the Telegraph," *Newspaper World*, March 4, 1939; G. E. R. Gedye, *Fallen Bastions: The Central European Tragedy* (London: Faber and Faber, 2009), 133, 240, 368, 381, 421.

50. Edwin L. James to Arthur Hays Sulzberger, January 11 and 13, and March 21, 1940; Arthur Hays Sulzberger to Laurence A. Steinhardt, April 8, 1940; all in Moscow Bureau folder, box 208, New York Times Company Records: Sulzberger Papers.

51. "Moscow News Ban Forces *N.Y. Times* to Withdraw," *Editor & Publisher*, September 14, 1940.

52. "Leland Stowe Tells the Story of Oslo's Fall," *Editor & Publisher*, April 20, 1940; Stowe, *No Other Road*, 64–119. On the British policy toward the press, see War Office to Rupert, Maurice, and Sickle, Desp.1555, April 29, 1940, War Correspondent and Press (Norway), file no. 27, WO106/1953, UK-National Archives, Kew.

53. "Crucial Times Facing War News Transmission," *Editor & Publisher*, June 29, 1940.

54. "Hitler's 'Total War' Brings Biggest Task to U.S. Press," and "War Coverage at New Peak of Efficiency," *Editor & Publisher*, May 18 and 25, 1940; Karl D. Baker to Ray Huber, August 9, 1940, City File-Washington-Washington Daily News, box 179, Howard Papers.

55. Beattie, *Passport*, 292; Vincent Sheean, *Between the Thunder and the Sun* (London: Macmillan, 1943), 157.

56. This point is developed in Steven Casey, *The War Beat, Europe: The American Media at War against Nazi Germany* (New York: Oxford University Press, 2017).

2

Helen Kirkpatrick's Reporting to Undercut Irish Neutrality Policy, 1939–1942

Karen Garner

Helen Paull Kirkpatrick (1909–1997), foreign correspondent for the *Chicago Daily News*, was based in London from 1937 to 1944 and in Paris from 1944 to 1945, with brief assignments that took her to Southern and Northern Ireland, where she reported on Southern Irish neutrality policy from 1939 to 1941, and on U.S. troops who were stationed in the North after January 1942. Like other more well known American reporters and broadcast journalists of her time who engaged their fellow citizens with vivid and detailed firsthand accounts of intense diplomatic disputes and fierce military battles won and lost by the belligerent powers, Kirkpatrick was thoroughly convinced of the existential threat that the European fascist powers posed to the Western democracies. Although journalistic ideals and standards of the day elevated "professionalism," "balanced reporting," and "dispassionate objectivity," that giants in the field such as Walter Lippman espoused, they also aspired to tell the "truth." According to Lippman, journalists should "develop a sense of evidence and forthrightly acknowledge the limits of available information; . . . dissect slogans and abstractions and refuse to withhold the news or put moral uplift or any cause ahead of veracity."[1] But for Kirkpatrick, truth-telling during the war against the Axis powers was far from a dispassionate exercise. As British broadcast journalist Martin Bell would assert decades after the Second World War ended in Allied victory, "There is a time for passion and a time for dispassion." Sometimes, when the distinctions between "good and evil, the victim and the oppressor" were clear, the "journalism of attachment" was justified, especially when the journalist was willing to take a stand on issues that were based on moral principles.[2] Certainly that is how Helen Kirkpatrick understood her journalistic mission during the 1930s and 1940s.

As a young journalist, Helen Kirkpatrick got her professional start reporting on the League of Nations and international politics in the 1930s. Years later,

Kirkpatrick wrote about the actions taken by the League member states during her days as a graduate student in Geneva, Switzerland, from 1931 to 1933, and marked these years, as many of her contemporaries would too, as the inception of the fascist powers' aggressive imperial projects that culminated in a Second World War.[3] Following two years spent back in the United States, from 1933 to 1935, Kirkpatrick returned to Geneva in September 1935 and was immediately drawn back into the self-serving and backroom-deal-making world of League of Nations politics.[4] In 1936, Kirkpatrick's reports from Europe focused on Germany's and Italy's provocative empire-building policies that threatened the continental peace, including German-Italian interventions in the Spanish Civil War, and German occupation of the Rhineland. Kirkpatrick also joined critics of Britain's Conservative Party and denounced the government's failures to check the fascist powers' aggressive rearmament programs or to establish a vigorous British rearmament program in response. When she moved to London to co-found the *Whitehall Letter* in 1937 together with Victor Gordon Lennox of the *Daily Telegraph* and Graham Hutton of the *Economist,* she began to write critically about Conservative Party Prime Minister Neville Chamberlain and his government's "weak" and "foolish" and "ignorant" appeasement policy toward Nazi Germany.[5] At the suggestion of Victor Gordon Lennox and other British friends, Kirkpatrick wrote two books that also focused on the follies of British appeasement and the dangers that the Nazi German Reich's imperial expansion and attacks on European Jewish people posed to world peace. Both books also intended to explain American responses to European affairs to British readers and to undermine American isolationist opinion in the United States.[6]

One less well known application of Chamberlain's appeasement policy was his government's negotiations with the Irish Free State (Eire), that is, with the government of partitioned Southern Ireland led by Taoiseach Eamon de Valera, that produced the 1938 Anglo-Irish treaty. Chamberlain aimed to improve Anglo-Irish relations on the eve of the imminent European war. He conceded to several demands of the Irish government that reduced import duties on Irish goods sold in Britain and settled debts still owed to Britain by Irish landowners based on agreements forged decades earlier. More significant in the context of the coming war between Britain and Germany, the 1938 treaty returned to Irish government control several ports at Berehaven, Queenstown (renamed Cobh), and Lough Swilly that the British Navy had retained according to the terms of the 1921 Anglo-Irish treaty.[7] But even more consequential regarding Ireland's neutral stance during the war, the 1938 treaty did not resolve the major issue from the Irish

36 | Karen Garner

perspective that would prevent an Anglo-Irish alliance: the partition of the Irish Isle into two separately governed territories.[8] Although the impasse was reached during treaty negotiations in spring 1938, de Valera continued to press Chamberlain to end partition throughout the following year, dangling the promise of improved state-to-state relations between Ireland and Britain if the major obstacle of partition was settled to Southern Ireland's satisfaction.[9]

When Britain and Germany went to war in September 1939, Kirkpatrick had little appreciation for the depth of the long-running antipathy that characterized Anglo-Irish relations, established during centuries when Britain ruled over Ireland. An unsuccessful bid for Irish independence led by Catholic nationalist revolutionaries had reached a boiling point during the First World War, culminating in the 1916 Easter Rising. Following Britain's brutal suppression of the Rising and the execution of nearly all of its leaders—revolutionary leader Eamon de Valera was the most notable exception among those few whose lives were spared—Ireland was split apart in 1921, literally and figuratively, into two separate entities, and was further torn by a violent civil war that lasted until 1923.[10] In the aftermath of the wars, a predominantly Irish Catholic population governed the Irish Free State, nominally a dominion of the British Empire, in the twenty-six counties of the Southern Irish Isle. A predominantly Anglo-Irish Protestant population governed in the six counties of Northern Ireland that remained a loyal member of the United Kingdom. Former revolutionary Eamon de Valera abandoned his militant bid for Irish independence in the mid-1920s in favor of evolution through electoral politics. He established a nationalist political party, Fianna Fáil (Soldiers of Destiny), and formed a coalition to win the majority of the seats in the Dáil Éireann (Irish Assembly) in 1932. Fianna Fáil's rivals, the militant revolutionary association Sinn Féin (Ourselves Alone) and its Irish Republican Army (IRA), continued a violent campaign for Irish independence on the far political left that went as far as declaring open "war" on Britain in January 1939, and colluding with the German *Abwehr* (military intelligence) during the Second World War.[11] This long and contentious history affected Anglo-Irish relations throughout the war, including de Valera's decision to declare Irish neutrality in order to assert Irish sovereignty and complete independence from Britain when the war broke out.

De Valera declared Irish neutrality as a principled assertion of Irish rights as a sovereign power, but neutrality was also a practical maneuver to avoid a German attack that could destroy the relatively defenseless island. In late summer 1939, when the outbreak of war in Europe was imminent, de Valera's government made friendly overtures to Germany through the German

Minister Eduard Hempel at the German Legation in Dublin. The Irish wanted to assure the Nazi government of Southern Ireland's neutrality, and to explain how the unique character of Ireland's relationship with Great Britain would, in fact, serve Germany's national interest in time of war. Ireland, while still a member of the British Commonwealth and linked through history, geography, and economy to Great Britain, was, in fact, independent of the British government and would "not . . . participate in any active form in the war against Germany" or allow Britain to use Irish territory to wage war. Germany could retain its Legation in Dublin and its formal diplomatic relations with Ireland, as Ireland would maintain its diplomatic residence in Berlin, if "the German Legation [did] not allow itself to be used in any way as part of the machinery for the prosecution of the war."[12]

De Valera maintained Eire's neutrality throughout the war despite a concerted Anglo-American campaign to bring Ireland into the anti-fascist alliance. Helen Kirkpatrick was an active player in the propaganda campaign waged through official and covert interventions that tried to persuade de Valera's government to join the anti-fascist alliance and to expel the German (and Italian and Japanese) diplomats from Eire. Anglo-American government representatives also negotiated officially and plotted behind the scenes to open the Southern Irish ports to the British Navy to facilitate the hunt for the German U-boats in the North Atlantic.

Because of her energetic anti-fascist and pro-Allied sympathies, as soon as the war broke out, Kirkpatrick began reporting war stories designed to undermine Southern Ireland's official neutrality policy. In fall 1939 her reports also aimed to mobilize American public opinion to reject isolationist politics and overturn U.S. neutrality policy as well. Kirkpatrick and other American reporters denounced the Nazis' Polish *blitzkrieg* campaign that slaughtered many Jewish peoples in the Warsaw ghetto and broadcast their enthusiastic support for Neville Chamberlain's uncharacteristically "venomous" speech that rejected Germany's one final offer of "peace" to the British and French Allies if they accepted German occupation of Poland.[13] At the end of October Chamberlain's government also released "a remarkable document," duly published by Kirkpatrick, describing the despicable treatment of Jews and other political prisoners whom the Nazis imprisoned in concentration camps at Buchenwald, Dachau, and Sachsenhausen. Kirkpatrick asserted that "neutral" reporters—"and your correspondent is one of them"—had personally seen and talked to the victims of German brutality.[14]

Included in her anti-fascist reporting, Kirkpatrick also noted that there was "increasing anti-Nazi feeling in Eire . . . causing many Irish to become

38 | Karen Garner

discontented with Eire's neutrality." Irish resistance to Nazi Germany, she speculated, was due to a theory that she would pursue with greater zeal in summer 1940 and through 1941: that Germany was planning clandestine operations in Ireland, and Nazi intervention would generate Irish resentment.[15] Here, she was not entirely mistaken; factions in Germany were making plans to invade Ireland and sent spies ahead to scout the territory, but she may have misread the nature of the reception the Nazis would receive. Although German Minister Hempel cautioned his Foreign Ministry superiors to respect Irish neutrality, Germany's *Abwehr* advocated for using the IRA to perpetrate anti-British sabotage, if not to launch an outright coup to unseat de Valera's government.[16] During the war, the IRA was a wild card that de Valera's Fianna Fáil government could not completely control.[17] In December 1939, de Valera wrote to Neville Chamberlain again urging an end to partition followed by a warning:

> A free Ireland would have every interest in wishing Britain to be strong, but when Britain's strength appears to be used to maintain the division of our island no such consideration can have any force. . . . The intensification of feeling here [in Eire] and amongst our people in the United States [i.e. the large immigrant population of Irish Americans] makes it imperative to act quickly lest it be too late to save the situation.[18]

De Valera referred to the IRA in Ireland, and to significant anti-British, anti-Semitic, pro-Nazi public opinion in the United States.[19]

Threats to de Valera's neutrality policy from whatever quarter were opposed with as much force as his government could muster. Eire's Minister for the Coordination of Defensive Measures Frank Aiken's contribution to defending neutrality came in the form of aggressive assertions of the government's Emergency Powers Act and strict application of censorship of any public speech or written communications that seemed biased in favor of any belligerent.[20] Aiken quickly shut down all challenges to the government's "undemocratic" censorship policies—from the press or elsewhere—with the justification that "neutrality" in the age of total warfare did not guarantee "peace" to the neutral power. Neutrality in the modern sense was, in fact, a condition of "limited warfare," and Ireland had to recognize that fact to defend and preserve it.[21]

Throughout fall 1939, Helen Kirkpatrick had continued to write for the *Whitehall Letter* and to freelance for U.S. newspapers. She returned to the United States at end of December to promote her just-published book, *Under*

the British Umbrella, and to secure a salaried position as a correspondent for a U.S. paper so that she could return to London and continue her war reporting. Following her meeting with *Chicago Daily News* publisher Colonel Frank Knox, a Republican who would join the Roosevelt administration as Secretary of the Navy in June 1940, Kirkpatrick convinced him to hire her as the paper's first and only female war reporter.[22] She returned to London in March 1940.

At the same time, David Gray arrived in Dublin to take up his post as U.S. Minister at the American Legation. David Gray was Franklin Roosevelt's uncle-by-marriage, as his wife was Eleanor Roosevelt's aunt. Gray completely supported FDR's foreign policy as he understood it, that is, to give as much aid to Britain as possible to fortify Britain's fight against the Germans.[23] To achieve these aims, Gray understood his mission in Dublin was to persuade de Valera's government to abandon its neutrality policy and join the Allied war efforts. Gray's lack of historical knowledge may explain why he believed at the outset of his tenure in Dublin that the major cause of Anglo-Irish enmity—the partition of Ireland—could be easily resolved, and Anglo-Irish differences could be put in the past. Most of Gray's initial encounters with de Valera, Walshe, and Aiken were focused on his proposals to trade Irish unity (and eventual full independence for the island nation) for a wartime alliance with Britain, which included expelling Axis diplomats from Dublin and granting the British Navy immediate access to Irish ports. He was not an effective negotiator because he quickly changed tactics from persuasion to intimidation.[24] Gray never respected de Valera's "moral" arguments for neutrality or accepted de Valera's suspicions of British motives, and he never appreciated how threats from Germany and the IRA also affected Eire's foreign policy.

When Kirkpatrick and Gray met in Dublin in June 1940, they soon discovered their shared opposition to Irish neutrality, a policy that they both considered misguided and dangerous in a world war that pitted "righteous", democratic, Christian nations and "Western civilization" against "evil" dictatorial, fascist, godless enemies.[25] After Germany overran the neutral powers of Denmark and Norway in April 1940, and Holland and Belgium in May, and after the shocking capitulation of France to the Nazi occupation in June, the German war machine seemed poised to overrun the Western world.[26] Both the British and Irish governments expected that Germany would launch its next attack on Britain through Ireland.[27] As British fortunes of war sank to a new low point, revelations about German spies landing in Ireland came to light. Kirkpatrick later recalled that Gray gave her

lots of stories of things that were going on, including the fact—"the fact"—he said, that the German submarines were surfacing in bays on the west coast of Ireland . . . and that the Germans had a wireless station which they used to get news to Germany—picking up information and intelligence on what happened in Britain. And, of course, Ireland was ablaze with lights—southern Ireland was ablaze with lights—whereas the north was blacked out, as the whole of the British Isles were. And the Germans were using triangulation from the south of France to Ireland, to fix on bombing targets in Britain.[28]

Kirkpatrick filed stories on Germany's covert activities in Ireland for the *Chicago Daily News* in summer 1940, defying the de Valera government's efforts to silence her "biased" war reporting.[29] Under instructions from Joseph Walshe in mid-July, Irish Minister in Washington Robert Brennan filed a protest with the *Daily News* for publishing "lying reports against us"[30]— among other claims, Kirkpatrick's reporting included the incendiary charge that "some [Catholic] priests were pro-Nazi."[31] For his part, Gray encouraged Kirkpatrick to continue reporting on German activities in Ireland, hoping these stories would get through to the Irish people via their American relatives reading U.S. newspapers; with this plan he intended to put public pressure on de Valera's government to support the British cause.[32]

Throughout the late summer and fall of 1940, as the Germans launched the Battle of Britain and focused the *Luftwaffe* bombing campaign on London, Kirkpatrick was among the American reporters documenting the devastation of war as the bombs rained down on England. She joined reporters and put herself in the line of fire in the city, and was one of two female reporters, along with Virginia Cowles, who lay in fields atop the cliffs of Dover to witness the swarms of German planes flying low across the English Channel on route to their targets in London and the Royal Air Force airfields.[33]

As the war continued into 1941, de Valera's government lobbied for U.S. government pledges to defend Ireland's neutral rights and to protect the Irish nation from an attack originating from *any* belligerent power. By this point, however, following his November 1940 reelection, Franklin Roosevelt's position as U.S. president was secured for four more years and he was ready to advocate energetically for aid to Britain in order "to save the American way of life."[34] In a radio address on December 29, FDR called for America to become the arsenal of democracy. In his State of the Union Address on January 6, he denounced isolationism, praised the "gallant," "armed defense of democratic existence" that the British-led allies were waging, and promoted his Lend-Lease aid proposals. In late January, Roosevelt called for

more speed in U.S. production of war materials, more loans to the anti-fascist allies to purchase the materials, and more personal sacrifices from the American people. Along with these appeals, Roosevelt explained what Americans were sacrificing their labor and treasure for—to protect "four essential human freedoms."[35] These were messages Roosevelt and his emissaries also presented to Eamon de Valera in spring 1941, trying to persuade him to join the anti-fascist fight. These emissaries included David Gray who asserted very openly in his conversations with de Valera and Joseph Walshe: If Britain seized the Irish ports out of military "necessity" and by force, the United States would support Britain.[36]

Kirkpatrick's reporting had taken her back to Ireland at the end of January and the beginning of February 1941, where she reported carefully to avoid Irish censure, but critically on Irish neutrality.[37] She interviewed dozens of Dubliners to ask them *why* Ireland remained neutral, "when less than thirty miles to the east, Britain is fighting for her life, and, as the British believe, for the freedom and independence not only for herself but all small nations—Eire included?" The answers she received across the board, from government officials to ordinary citizens, was that Ireland *had* to remain neutral. Kirkpatrick reported:

> When they affirm their belief in neutrality, you've heard the last affirmation you're likely to hear in the discussion. . . . And then before you really get down to discussion of present day affairs, you'll go back to Cromwell, the troubles, and the Black and Tans. . . .
>
> "Yes," you agree, "but that's over. The British have no desire to rule Ireland. They haven't interfered with you in recent years, and if they win the war, you'll be free and independent. If the Germans win, will you be?"
>
> "Ah no, who can say? Do you think the Germans would find us easier to manage than the British did? And it's by no means sure that the British will win. Where would we be, and Germany winning, if we were to come into the war on the British side?"[38]

Kirkpatrick pressed on: And what of the United States' support for Great Britain? Would the Anglo-American alliance change Irish neutrality policy? Her interviewees insisted that the United States could proclaim support for Britain and speak out against Germany because it was three thousand miles from the war zones. If Eire offered aid to Britain, the Germans would bomb Ireland again, as they had bombed the Irish coast in early January. Kirkpatrick noted: "From the German point of view, the bombings accomplished one good thing. It stiffened the resolution of the Irish against altering their

42 | Karen Garner

policy of neutrality. No more bombs for them if they can help it."[39] She even resorted to taunting the Irish government for its weak response to continued German aggression when she reported that a "Nazi Bombing of Irish Boat Stirs Dublin: Eire Not Strong Enough to Protect Neutral Status," asserting that de Valera could not get Germany to accept responsibility for sinking Irish ships in Ireland's territorial waters.[40]

Irish government censors blocked these critical press reports from appearing in Ireland, even though they couldn't restrict the contents of U.S. newspapers.[41] Joseph Walshe composed arguments to counter attacks on Irish neutrality in the American press for Frank Aiken, who was dispatched to buy weapons from the U.S. government in March. Walshe had met with Kirkpatrick when she was in country in early February,[42] and Walshe's instructions for Aiken read like a direct response to stories that Kirkpatrick wrote for the *Chicago Daily News* at the time:

> The general line adopted by anti-Irish writers and speakers in America is that we are standing aside from the great fight which is being made by the democratic countries against dictatorship and all its evils. These people chide us for attaching excessive importance to grievances of the remote past. They try to make it appear that our main reason for staying out of the war is based on historic hatred of England. They generally avoid the issue of what would happen if we handed over the ports to Great Britain or otherwise joined in the war against Germany. They pretend to assume that no particular evil for us would follow the surrender of the ports to Great Britain. . . .
>
> They assume that, if Germany wins the war, Ireland will be taken over and run by the Nazis. This assumption is intended to make their propaganda more effective. It is unfortunately also for us the most difficult point to answer owing to the anti-German atmosphere in America and the child-like belief that England is fighting for exclusively selfless aims.[43]

Even before Aiken left Ireland, it was probably clear to de Valera's government that Aiken's mission would not succeed in gaining any weapons for neutral Ireland, but Aiken could cultivate public support for Irish rights to set their own national policies.[44] Following his unsatisfying meetings with State Department officials[45] and with President Roosevelt,[46] Aiken went on the road to make Ireland's case directly to the American people. In April, May, and June 1941, Aiken toured the United States, speaking at the "American Friends of Irish Neutrality" propaganda rallies, to Irish American clergy, to the sympathetic "American First" press, to isolationist politicians—all the "anti-British elements" that opposed FDR's domestic

and foreign policies.[47] In the process, Aiken—and by association, de Valera's government—further alienated the Roosevelt administration.[48] Aiken's mission set the stage for the diplomatic dust-up that involved Helen Kirkpatrick and David Gray in a conflict with de Valera's government in Dublin in August and September 1941.

During this phase of the war, President Roosevelt and Prime Minister Churchill met face-to-face for the first time and established their personal friendship as they cemented the Anglo-American "special relationship" that characterized the wartime alliance.[49] They drafted the Atlantic Charter that articulated common Anglo-American values and shared political goals to be pursued in the postwar world.[50] Meanwhile, Irish-American relations worsened. Roosevelt and Gray had been goading Ireland regarding its defense capabilities since the end of June, even as the administration denied most of the requests for guns and other materials that de Valera's government had been making throughout the spring of 1941.[51] Additionally, Gray had continued to advise Roosevelt that access to the Irish ports was valuable to the British Navy, and would also "eventually" benefit the American Navy too.[52] Access to Irish airfields would also benefit Allied forces, aiding them in protecting ships crossing the Atlantic from German U-boat attacks, providing refueling stations for Allied attacks on the Continent, and reducing if not eliminating the substantial security risks that Germany posed to the Allies through their foothold in Ireland.[53] All these motivations factored into Gray's professed concerns about another security threat: German spies and collusion with IRA agents who engaged in anti-British sabotage. Gray supplied Kirkpatrick and other Allied journalists with a report he titled "Notes on Axis Activities in Ireland," outlining his suspicions.[54] How much Gray knew about German spying and collusion with Irish nationalists versus what was conjecture or deliberately manufactured misinformation came under Irish government scrutiny in August 1941. Gray's loose tongue and an accidental leak of an additional report written by Helen Kirkpatrick based on their shared suspicions of pro-German sympathizers within the Irish government might have caused a diplomatic incident, if the U.S. and British foreign offices' attentions were not focused elsewhere.

Kirkpatrick's report was intended to alert the U.S. ambassador in London, John Winant, to the security breaches Gray suspected in Ireland, perpetrated by "anti-American" elements in de Valera's government, including Frank Aiken and Joseph Walshe. Kirkpatrick's report described the "dangerous" level of German spying going on in Eire and suggested that the U.S. and British governments "put the screws on" de Valera's government by rationing food and fuel until de Valera opened Irish ports to the Allies, put a stop to

44 | Karen Garner

the anti-British press campaign in the United States, and lifted press restrictions on American reporters in Ireland.[55]

Kirkpatrick also filed stories, published in the *Chicago Daily News* at the end of August, focused on the minority politicians in the Dáil and Irish Senate who were criticizing the Irish neutrality policy,[56] and on the negative impact of rationing in Ireland linked to the government's stubborn adherence to its neutrality policy.[57] Fianna Fáil Director of the Government Information Bureau Frank Gallagher lashed out at Kirkpatrick after the first article appeared in print, taking "violent exception" to Kirkpatrick's characterization of de Valera's government as being "anti-American."[58] Gallagher also accused Kirkpatrick of knowing "nothing about Irish history," which rankled her. Nonetheless, she planned to file other stories she wrote about Nazi activities in Ireland, as she and Gray had agreed,[59] triggering another angry missive from Gallagher.[60]

David Gray, however, had inadvertently sent Kirkpatrick's report to Walshe.[61] He immediately wrote to Kirkpatrick to explain his diplomatic gaffe and warned her that she might suffer repercussions in terms of access to sources in Ireland:

> Usually I am pretty careful, but this was about as bad a slip as could be made. I am terribly sorry for you but do not regret having him know my own inside thoughts. I have got to capitalize on it in some way that isn't very clear yet. ... However, be assured that I will take full responsibility for everything in the memorandum, that is, that I inspired it. We must assume [Walshe] has copied it but as it was given to him confidentially for his private ear he can't very well use it.[62]

After several days elapsed and Gray had not heard from Walshe, he consulted with Sir John Maffey, representative for Britain's Dominions Office in Dublin. What should Gray do? Apologize and admit his mistake? Maffey advised Gray to "do nothing": "He said the best thing to do was to let Joe puzzle what it meant and make no admissions."[63]

Finally, Walshe wrote to David Gray on September 11, dissecting and disputing all the points Gray had speculated about in Kirkpatrick's report, and ending with the "suggestion" that Gray should consider whether he could continue in his diplomatic post.[64] Walshe hoped for Gray's resignation, but Gray had President Roosevelt's support and the Irish government knew it.[65] Moreover, the Anglo-American alliance was further threatening Eire's neutrality policy and its claims of sovereignty over the whole of the Irish Isle as the U.S. Army built up bases and air fields in Northern Ireland, adding

more "foreign troops" to the British occupying force in the North.[66] Although Franklin Roosevelt denied that the army was involved and claimed the work was being done by contract labor, paid for by Lend-Lease aid to Britain, his claims were disingenuous.[67] And after the United States entered the war as a combatant in December 1941, even more U.S. troops were sent to Northern Ireland, as Helen Kirkpatrick and others reported and as Eamon de Valera vigorously protested.

Kirkpatrick was on a weekend visit to the country home of Ronald and Nancy Tree when she heard the news of the Japanese attack on Pearl Harbor. She immediately returned to London. On December 8, she dined with U.S. Ambassador John Winant, and together they listened to Churchill's broadcast relaying the news to the British people.[68] Kirkpatrick,[69] like David Gray,[70] was convinced that de Valera's government would be forced by public opinion in Ireland and America, to give up its neutral status and join the American people in war against the fascist powers. Kirkpatrick traveled back to Ireland in mid-December to be on site to report the news she thought would soon be announced—that Ireland was breaking its neutrality to join the Allies. Instead, she broke the story of another arrest of a German spy, Hermann Goertz, on December 27.[71] Her reports put more pressure on de Valera's government to give up neutrality and expel the Germans at the Legation in Dublin, as did reports of the arrest that appeared in British newspapers.[72] She also wrote privately to her *Chicago Daily News* editor that "Dev is doing everything he can to help both the British and ourselves. He shuts his eyes to as much as he can [regarding cooperation between the Irish Army and British military planners] and has proved very helpful in many ways which cannot be made public, even if they were known."[73] But, without a formal renunciation of neutrality, Kirkpatrick continued to lean on de Valera's government by reporting on German intrigues. If the Irish people could be "enlightened" about Germany's "unneutral" and provocative actions, Kirkpatrick believed that "the people" would force their government to join the United Nations anti-fascist alliance.

Kirkpatrick, along with other American and British officials, misjudged de Valera's commitment to the neutrality policy.[74] Although the U.S. and British press had been reporting that Americans were building bases "for the British" in Northern Ireland throughout the summer and fall of 1941, the large deployment of American troops to the bases did not occur until after the United States entered the war. Nonetheless, as Kirkpatrick reported, by the time U.S. troops arrived in Belfast on January 26 and "marched down the local streets with the American flag flying," the "Yanks'" arrival was the "Worst Kept Secret of the War."[75] Many of the Northern Irish people may

46 | Karen Garner

have enthusiastically welcomed the 37,000 American soldiers who disembarked troop ships in January, as Kirkpatrick and other observers asserted,[76] but de Valera and Southern Irish nationalists immediately protested the violation of "Irish sovereignty," as did several IRA men who tried to intimidate Kirkpatrick when she followed the story into Dublin.[77]

When Sir John Maffey "officially informed" Eamon de Valera about the arrival of U.S. troops after the fact, the Taoiseach issued a statement to Washington, London, and the Holy See in Rome on January 27 that was also published in the Irish newspapers, making his case that Ireland's rights as a sovereign power had been abused. In the immediate instance, Ireland's sovereignty was disrespected when de Valera was not consulted about the placement of U.S. troops on Irish soil. In the longer term, Ireland suffered due to partition of the motherland, "one of the cruelest wrongs that can be committed against a people."[78] Irish American state-to-state relations devolved further during this episode, and never fully recovered during the war.

Conclusion

Helen Kirkpatrick's reputation for bold and brave war reporting was well established by early 1942, and she is best known for her coverage of the German *blitz* attacks on Britain in 1940 and 1941. Her *Chicago Daily News* bureau chief in London William Stoneman and fellow reporter Bill Robertson both praised Kirkpatrick's dedication to getting on-the-spot "scoops" of war news, and shared stories of Kirkpatrick's bravery in regard to her own near-misses as bombs exploded around her.[79] She earned "the confidence of many of the most famous figures in the world," was presented to the King and Queen of England,[80] and received popular recognition,[81] awards from her peers,[82] and high praise from her publisher, Secretary of the Navy Frank Knox.[83] Her reportorial status changed, however, after the U.S. entered that war and the U.S. military named official "war correspondents," who were "accredited" to cover stories about U.S. engagements with the enemy. Kirkpatrick became one of the few "exceptional" women who were awarded this status in March 1942.[84] She and other accredited correspondents, selected through a stringent application process by the U.S. War Department, agreed to accept government censorship of their news reports in exchange for privileged access to U.S. troops and high-level military officers, and permission to join selected combat missions.[85] Kirkpatrick's new status took her away from Ireland, although she returned to Northern Ireland in May 1942,[86] when King George and Queen Elizabeth paid a visit to American troops as they trained for deployment in the fall 1942 North African campaign.[87]

After 1942, Kirkpatrick went on to cover Allied campaigns in Algiers, Italy, and Corsica. From her base in London, she coordinated press reports regarding the planning for the D-Day landings of Allied troops at Normandy, and she was the first correspondent assigned to the headquarters of Free French forces inside France in the aftermath of the Western invasion. She entered Paris in August 1944 riding in a tank attached to General Leclerc's 2nd Armored Division. Continuing her historic on-the-spot war reporting, she was among the first American journalists who joined Allied troops as they liberated the Buchenwald concentration camp in 1945. When the war ended, Kirkpatrick became a foreign correspondent for the *New York Post* and reported on the Nuremberg War Crimes Trials.[88]

Helen Kirkpatrick's efforts to overturn Eire's neutrality policy and to pressure de Valera's government to join the anti-fascist alliance were never successful, even as she teamed up with U.S. Minister to Ireland David Gray and other American and British military men and diplomats. Throughout the war years, de Valera's consistent assertions of Irish neutrality despite the changing circumstances of war demonstrated his own moral certainty and diplomatic skills that enabled him to resist heavy-handed Anglo-American pressure campaigns.[89] Or, less charitably, de Valera revealed his stubbornness and inability to change the course of Irish policy, to the detriment of Ireland's best national interests.[90]

From Helen Kirkpatrick's perspective, the war against the fascist powers held the highest moral purpose. Neutrality aided the enemy. Even if Ireland's neutrality did not deliver a German victory, in Kirkpatrick's estimation it prolonged the war. Her wartime words and actions followed her heartfelt convictions rather than an abstract notion of journalistic objectivity. Elie Wiesel's well-known words, shared with the world when he accepted the Nobel Peace Prize in 1986, also provide insight into Helen Kirkpatrick's journalistic mission in Ireland during the Second World War: "We must always take sides. Neutrality helps the oppressor, never the victim. Silence encourages the tormentor, never the tormented. Sometimes we must interfere. When human lives are endangered, when human dignity is in jeopardy, national borders and sensitivities become irrelevant."[91]

Notes

1. Michael Schudson and Chris Anderson, "Objectivity, Professionalism and Truth-Seeking in Journalism," in *The Handbook of Journalism Studies*, ed. Karin Wahl-Jorgensen and Thomas Hanitzsch (New York: Routledge, 2008), 92.

2. Martin Bell, "The Truth Is Our Currency," *Press/Politics* 3, no. 1 (1998): 102–103.

48 | Karen Garner

3. "Geneva—Not in Perspective," Helen Kirkpatrick's personal reflections, c. 1933, box 7, CA-MS-01132, Helen Paull Kirkpatrick Papers, Sophia Smith Collection, Smith College, Northampton, Massachusetts, (hereafter HPK Papers).

4. Letter to Mother, September 29, 1935, box 9, HPK Papers.

5. Interview with Helen Kirkpatrick Milbank by Anne Kasper, Women in Journalism, Oral History Project of the Washington Press Club Foundation, April 3–5, 1990, 25, in the Oral History Collection of Columbia University and other repositories.

6. Helen Paull Kirkpatrick, with foreword by Victor Gordon Lennox, *This Terrible Peace* (London: Rich & Cowan, 1939); Helen Paull Kirkpatrick, *Under the British Umbrella: What the English Are and How They Go to War* (New York: Charles Scribner's Sons, 1939.

7. Alvin Jackson, *Ireland 1798–1998 War, Peace and Beyond*, 2nd ed. (Chichester, West Sussex, UK: John Wiley & Sons, 2010), 295.

8. Notes on the Sixth Meeting of the Conference between Representatives of the United Kingdom and Eire, February 23, 1938, P150/2485, Eamon de Valera Papers on microfilm, University College Dublin (hereafter EdV Papers, UCD); John Cudahy to President Roosevelt, January 22, 1938, and Eamon de Valera to Franklin Roosevelt, January 25, 1938, and John Cudahy to Franklin Roosevelt, March 1, 1938, box 40, President's Secretary's Files, Ireland 1938–1939, Franklin Delano Roosevelt Papers, Franklin Roosevelt Presidential Library, Hyde Park, New York (hereafter FDR Papers).

9. Eamon de Valera to Neville Chamberlain, May 4, 1939, P150/2548, EdV Papers, UCD.

10. Richard English, *Irish Freedom: The History of Nationalism in Ireland* (London: Pan Macmillan, 2007), 271, 317–318.

11. Thomas E. Hachey and Lawrence J. McCaffrey, *The Irish Experience since 1800: A Concise History* (New York: Routledge, 2010).

12. Joseph Walshe, Minister for External Affairs to Eamon de Valera, August 25, 1939, P150/2571, EdV Papers, UCD.

13. Robert Fisk, *In Time of War: Ireland, Ulster and the Price of Neutrality, 1939–1945* (London: Andre Deutsch, 1983), 100; Helen Kirkpatrick, "Scorns 'Peace' on Nazi Terms; Blasts Regime," *Chicago Daily News* (October 12, 1939), box 2, HPK Papers.

14. Helen Kirkpatrick, "No Peace Offer by Hitler or Any Nazi to Succeed, British Government Indicates," *Chicago Daily News*, October 31, 1939, box 2, HPK Papers.

15. Helen Kirkpatrick, "Neutrality Irks Irish as Hate of Nazis Grows," *Chicago Daily News*, October 27, 1939, box 12, HPK Papers. See also Helen Kirkpatrick, "Eire's Desire for Neutrality: Population Anti-Nazi," *Whitehall Letter*, October 27, 1939, Ref CHAR: 2/362, 01, Winston Churchill Archives [online], The Chartwell Trust.

16. The Minister in Eire [Hempel] to the Foreign Ministry, November 13, 1939, doc. 355, pp. 405–406; The Minister in Eire to the Foreign Ministry, December 16, 1939, doc. 465, p. 545; Memorandum by the Director of the Political Department [Woermann] Berlin, February 10, 1940, doc. 605, pp. 760–761, Documents on German Foreign Policy, 1918–1945, vol. 8: "The War Years, September 4, 1939—March 18, 1940" (Washington, DC: Government Printing Office, 1954). See also John P. Duggan, *Herr Hempel and the German Legation in Dublin, 1937–1945* (Dublin: Irish Academic Press, 2003), 80–81, 87–88,138–139; Fisk, *In Time of War*, 294–295.

17. Eunan O'Halpin, *Defending Ireland: The Irish State and Its Enemies since 1922* (New York: Oxford University Press, 2000), 248.

18. David McCullagh, *De Valera: Rule*, vol. 2: *1932–1975* (Dublin: Gill Books, 2018), 163.

19. Lynne Olson, *Those Angry Days: Roosevelt, Lindbergh, and America's Fight Over World War II* (New York: Random House, 2013), 239–241.

20. Ronan Fanning, *Eamon de Valera: A Will to Power* (Cambridge, MA: Harvard University Press, 2016), 190–191.

21. Fisk, *In Time of War*, 141–142.

22. Interview with Helen Kirkpatrick Milbank by Anne Kasper, Oral History, 46–48.

23. T. Ryle Dwyer, *Irish Neutrality and the USA, 1939–47* (Dublin: Gill and Macmillan, 1977), 48–49.

24. Bernadette Whelan, "Biography of David Gray," in *A Yankee in De Valera's Ireland: The Memoir of David Gray*, ed. Paul Bew (Dublin: Royal Irish Academy, 2012), 305–308.

25. Whelan, "Biography of David Gray," 305–308.

26. Duggan, *Herr Hempel and the German Legation in Dublin*, 92.

27. Carolle J. Carter, *The Shamrock and the Swastika: German Espionage in Ireland in World War II* (Palo Alto, CA: Pacific Books, 1977), 149; Fisk, *In Time of War*, 189–193; Duggan, *Herr Hempel and the German Legation in Dublin*, 116.

28. Interview with Helen Kirkpatrick Milbank by Anne Kasper, Oral History, 52.

29. Joseph Walshe to David Gray, c. July–August 1940, box 3, Coll. 03082, David Gray Papers, American Heritage Center, University of Wyoming (hereafter Gray Papers, AHC).

30. Code telegram from Joseph P. Walshe to Robert Brennan (personal) (most secret), July 21, 1940, doc. no. 234 NAI DFA Secretary's Files P2, Documents on Irish Foreign Policy vol. 6, 1939–1941.

31. Helen Kirkpatrick, "Nazi 'Blitz' to Hit Eire Next, Belief," June 12, 1940, box 12. See also "German Plans for 'Victory' Startle Irish," June 5, 1940, box 12; "Situation in Eire Continues to Be Very Serious," *Chicago Daily News*, June 6, 1940, box 12, HPK Papers.

50 | Karen Garner

32. David Gray to Franklin Roosevelt, August 14, 1940, box 3, Gray Papers, AHC.

33. Vincent Sheean, "Covering Hell's Corner: While Bombers Hurl Their Deadly Loads, Correspondents Dig In," *Current History* (October 22, 1940): 18–20.

34. Robert Dallek, *Franklin D. Roosevelt: A Political Life* (New York: Penguin, 2018), 409.

35. Franklin Roosevelt, "State of the Union (Four Freedoms)," January 6, 1941, Presidential Speeches, Franklin D. Roosevelt Presidency (University of Virginia Miller Center, 2019). https://millercenter.org/the-presidency/presidential-speeches/january-6-1941-state-union-four-freedoms (accessed March 31, 2020).

36. Dwyer, *Irish Neutrality and the USA*, 86. See also The Minister in Ireland (Gray) to the (Acting) Secretary of State (Welles), November 24, 1940, document 166, Foreign Relations of the United States Diplomatic Papers (hereafter FRUS) 1940, vol. 3 (Washington, DC: U.S. Government Printing Office, 1958); Code telegram from Joseph P. Walshe to Robert Brennan, December 4, 1940, doc. 359 NAI DFA Secretary's Files P2, Documents on Irish Foreign Policy vol. 6, 1939–1941.

37. Helen Kirkpatrick to David Gray, February 25, 1941, box 4, Gray Papers, AHC.

38. Helen Kirkpatrick, "Typed Notes for Article 'Why Is Eire Neutral?,' Dublin, January 1941," box 2, HPK Papers. See also Helen Kirkpatrick, "Neutrality Is Only Choice, Eire Contends; Ninety Pct. of Irish Back De Valera's Policy of Isolation," *Chicago Daily News*. January 30, 1941, box 12, HPK Papers.

39. Helen Kirkpatrick, "Eire Asks If Nazi Bombing Was a Mistake or Deliberate," *Chicago Daily News*, February 1, 1941, box 12, HPK Papers. See also "Typed Notes for Article 'Why Is Eire Neutral?'" and Helen Kirkpatrick, "Civil War Seen If Britain Takes Ports from Eire; Irish Fear Nazis Will Bomb Cities and That British Won't Leave," *Chicago Daily News*, January 31, 1941, box 2; "20,000 Soldiers Guard Eire Against Germans or British, Hope to Escape Invasion," *Chicago Daily News*, February 3, 1941, box 12, HPK Papers.

40. Helen Kirkpatrick, "Nazi Bombing of Irish Boat Stirs Dublin: Eire Not Strong Enough to Protect Neutral Status," *Chicago Daily News*, February 6, 1941, box 12, HPK Papers.

41. Michael Knightly, Chief Press Censor, "Press Censor's Report for January 1941," P104/3477, Frank Aiken Papers on microfilm, University College Dublin (hereafter FA Papers, UCD); Helen Kirkpatrick, "Freedom of Press Killed by Eire's 'Neutral' Policy," *Chicago Daily News*, February 4, 1941, box 12, HPK Papers.

42. Helen Kirkpatrick to Joseph Walshe, under secretary for External Affairs, 10 March 1941, box 2, HPK Papers.

43. Memorandum by Joseph Walshe for Frank Aiken, "Anti-Irish Propaganda in the United States: Our Counter Propaganda," February 28, 1941, doc. no. 15 NAI DFA Washington Embassy File 121, Documents on Irish Foreign Policy, vol. 7, 1941–1945.

44. Memorandum by Joseph Walshe for Frank Aiken, "Attitude of the State Department Towards Us," February 28, 1941, doc. no. 16 NAI DFA Secretary's Files P35, Documents on Irish Foreign Policy, vol. 7, 1941–1945.

45. Memorandum of Conversation, the Acting Secretary of State (Welles), March 20, 1941, Do. 170, FRUS vol. 3 (Washington, DC: Government Printing Office, 1959).

46. Telegram from Robert Brennan to Joseph Walshe concerning a meeting between Frank Aiken and President Franklin D. Roosevelt, April 7, 1941, doc. no. 38 NAI DFA Secretary's Files P35; and letter from Robert Brennan to Joseph Walshe (confidential), April 10, 1941, doc. no. 40 NAI DFA Secretary's Files P 35, Documents on Irish Foreign Policy, vol. 7, 1941–1945. "From Mr. Brennan on Mr. Aiken's Interview with President Roosevelt of 7th April 1941," P150/2604, EdV Papers, UCD.

47. Cablegrams received from Washington Legation, April 19, 1941, P150/2615, EdV Papers, UCD; "Irish Here Offer Prayers for Peace: If Forced into War Eire Would Become 'a Mass of Ruins,' Says Father Flanagan," *New York Times*, April 20, 1941; "Eire Will Stay Firm on Refusing Bases to Britain, Envoy Says Here: Gen. Aiken Tells Rally There is No Chance of Changing Attitude—Despite Need for Food He Sees No 'Bartering' of Neutrality," *New York Times*, April 26, 1941.

48. Brian Girvin, *The Emergency: Neutral Ireland, 1939–45* (London: Pan Macmillan, 2007), 215.

49. Carlo D'Este, *Warlord: A Life of Winston Churchill at War, 1874–1945* (New York: Harper Collins, 2008), 507.

50. "Atlantic Charter," August 14, 1941, The Avalon Project, Documents in Law, History and Diplomacy (New Haven, CT: Lillian Goldman Law Library, Yale Law School, 2008), https://avalon.law.yale.edu/wwii/atlantic.asp (accessed March 31, 2020).

51. U.S. Minister to Ireland David Gray to Franklin Roosevelt, June 26, 1941, President's Secretary's File: Ireland, 1941, box 40, FDR Papers; Dwyer, *Irish Neutrality and the USA*, 129; Press report of remarks made by President Roosevelt at a press conference on June 27, 1941, P150/2604, EdV Papers, UCD; Acting Secretary of State (Welles) to the Minister in Ireland (Gray), July 31, 1941, document 188, FRUS 1941, vol. 3 (Washington, DC: Government Printing Office, 1959.

52. David Gray to Franklin Roosevelt, August 11, 1941, box 5, Gray Papers, AHC.

53. U.S. Minister to Ireland, David Gray to Franklin Roosevelt, July 10 and 11, 1941, President's Secretary's File: Ireland 1941, box 40, FDR Papers. See also John Day Tully, *Ireland and Irish Americans 1932–1945: The Search for Identity* (Dublin: Irish Academic Press, 2010), 102–103.

54. David Gray, "Notes on Axis Activities in Ireland," July 20, 1941, box 9, David Gray Papers, Franklin Roosevelt Presidential Library, Hyde Park, New York (hereafter DG Papers, FDR Library). See also "Notes on Axis Activities in Ireland," c. July 1941, box 2, HPK Papers.

52 | Karen Garner

55. Helen Kirkpatrick to David Gray, August 25, 1941, box 4, DG Papers, FDR Library.

56. Helen Kirkpatrick, "Alarmed Irish Looking to U.S. for Protection against Nazis; Dublin Group Seeking Action," *Chicago Daily News*, August 26, 1941, box 12, HPK Papers.

57. Helen Kirkpatrick, "Eire Facing Hardest Winter since the Famine of 1847," *Chicago Daily News*, August 28. 1941, box 12, HPK Papers.

58. Frank Gallagher to Helen Kirkpatrick, August 29, 1941, box 2, HPK Papers.

59. Helen Kirkpatrick to David Gray, c. August 28, 1941, box 4, DG Papers, FDR Library; typescript for *Chicago Daily News* sent via cable, August 28, 1941, box 2, HPK Papers.

60. Frank Gallagher to Helen Kirkpatrick, September 1, 1941, box 2, HPK Papers.

61. Joseph Walshe to David Gray, September 2, 1941, box 5, Gray Papers, AHC.

62. David Gray to Helen Kirkpatrick, September 2, 1941, box 2, HPK Papers.

63. David Gray to Helen Kirkpatrick, September 5, 1941, box 2, HPK Papers.

64. Letter from Joseph Walshe David Gray, September 11, 1941, doc. no. 125 NAI DFA Secretary's Files P48A, Documents on Irish Foreign Policy, vol. 7, 1941–1945.

65. David Gray to Helen Kirkpatrick, September 18, 1941, box 2, HPK Papers.

66. David Gray to Franklin Roosevelt, July 18, 1941, box 6, DG Papers.

67. Excerpts from U.S. and Irish Press Stories re American bases being built in Northern Ireland, July 12, 1941, P150/2635, EdV Papers, UCD.

68. Nancy Caldwell Sorel, *The Women Who Wrote the War* (New York: Arcade, 1999), 148–149.

69. Helen Kirkpatrick, "People Sympathize with US but Eire Clings to Neutrality," *Chicago Daily News*, December 26, 1941, box 2, HPK Papers.

70. Tully, *Ireland and Irish Americans, 1932–1945*, 111; David Gray to Franklin Roosevelt, December 17, 1941, President's Secretary's Files: Ireland, 1941, box 40, FDR Papers; The Minister in Ireland (Gray) to the Secretary of State (Hull), December 23, 1941, Document 197, FRUS 1941, vol. 3 (Washington, DC: Government Printing Office, 1959).

71. Helen Kirkpatrick, "Eire Imprisons Masterminds of German Spy Ring; Gestapo Leader Goetz Admits Getting Funds from IRA in U.S.," *Chicago Daily News*, (December 27, 1941, box 12, HPK Papers.

72. Confidential report from John Dulanty (London) to Joseph Walshe (no. 2) (Secret) 21 January 1942, doc. no. 171 NAI DFA Secretary's Files P12/14/1, Documents on Irish Foreign Policy, vol. 7, 1941–1945.

73. Helen Kirkpatrick to Carroll Binder, foreign news editor, *Chicago Daily News*, December 29, 1941, box 2, HPK Papers.

Helen Kirkpatrick's Reporting | 53

74. Dwyer, *Irish Neutrality and the USA*, 143.

75. Helen Kirkpatrick, "Yanks are Coming to Ireland Called Worst Kept Secret of the War," *Chicago Daily News*, January 26, 1942, box 12, HPK Papers: "All of Ulster Is Prepared for Arrival; Even Nazi Consul Is Said to Have Jitters Days before Landing."

76. Helen Kirkpatrick, "Gen. Chaney, Air Expert, Heads Yanks in Britain," *Chicago Daily News*, January 27, 1942, box 3, HPK Papers. See also Anthony J. Jordan, *Churchill: A Founder of Modern Ireland* (Dublin: Westport Books, 1995), 180.

77. Interview with Helen Kirkpatrick Milbank by Anne Kasper, Oral History, 54.

78. Clear telegram from the Department of External Affairs to the Irish Legations at Washington (no. 24) and the Holy See (no. 10) and to the High Commission in London (no. 11) January 27, 1942, doc. no. 173 NAI DFA Secretary's Files P43, Documents on Irish Foreign Policy, vol. 7, 1941–1945. See also Official Statement issued in Dublin on January 27, 1942, P150/2604, EdV Papers, UCD.

79. William H. Stoneman and Helen Kirkpatrick, special section of *Chicago Daily News*, "In the Air Raids: Experience Is the Best Teacher" Air Raid Guide (July 11, 1942), box 3, HPK Papers.

80. "Helen Kirkpatrick Writes under Fire," *Chicago Daily News*, January 13, 1942, box 1, HPK Papers.

81. Inez Whitely Foster, "Guts and Glamour," *Mademoiselle* magazine, March 1942, box 1, HPK Papers.

82. Carolyn M. Edy, *The Woman War Correspondent, the U.S. Military, and the Press, 1846–1947* (Lanham, MD: Lexington Books, 2017), 58.

83. Frank Knox to Helen Kirkpatrick, January 19, 1942, box 2, HPK Papers.

84. "With AEF," *Chicago Daily News*, March 25, 1942, box 3, HPK Papers: "Two American women reporters who lived in London through its worst air attacks became today the first woman correspondents formally accredited to the United States Army" [Helen Kirkpatrick and Mary Welsh of *Time* and *Life* magazines].

85. Edy, *Woman War Correspondent*, 50–52.

86. Helen Kirkpatrick, "Somewhere in Northern Ireland with the United States Army," *Chicago Daily News*, May 19, 1942, HPK Papers, Box 3.

87. Sorel, *Women Who Wrote the War*, 174. Helen Kirkpatrick, "King, Queen, Find AEF is 'Colossal'," and "With the United States Armed Forces," *Chicago Daily News*, June 27, 1942, box 3, HPK Papers.

88. Letter from Helen Kirkpatrick to Avis Berman, who had requested biographical information on Kirkpatrick in regard to her "firsts" as a woman, letter dated November 15, 1977, box 9, HPK Papers.

89. McCullagh, *De Valera: Rule*, 169. See also Dwyer, *Irish Neutrality and the USA*, 221; Fisk, *In Time of War*, 360–361.

54 | Karen Garner

90. Dwyer, *Irish Neutrality and the USA*, 2–3; Fisk, *In Time of War*, 363; Diarmaid Ferriter, *Judging Dev: A Reassessment of the Life and Legacy of Eamon de Valera* (Dublin: Royal Irish Academy, 2007), 253–258.

91. Elie Wiesel's acceptance speech, on the occasion of the award of the Nobel Peace Prize in Oslo, December 10, 1986 (Nobel Prize Association, 2020), https://www.nobelprize.org/prizes/peace/1986/wiesel/26054-elie-wiesel-acceptance-speech-1986/ (accessed March 31, 2020).

3 Miss Bonney Reporting from the Arctic Front
Henry Oinas-Kukkonen

When Miss Bonney, as she was widely known, came to Finland, she claimed to represent tens of newspapers and several United States syndicates. Finland and the Arctic War became Bonney's first scoop. Later, the Finns regarded her as a lifelong friend due to the international coverage that she provided, even when she returned as a spy. At the same time, she was suspected of being unreliable in her own country by those who had hired and sent her again to the Arctic. Bonney's pictures of the war were regarded as "one of those things that 'must be seen.'"[1] She was presented to U.S. children as a "Photo Fighter" in *True Comics*, and her concept for a film about children displaced by war touched moviegoers in the Academy Award–winning film *The Search* in 1948. As an active photojournalist, she began her career in 1938 at the age of forty-four.[2] To Finnish government officials, Miss Bonney was an extraordinarily skilled and educated photojournalist.

Thérèse Mabel Bonney: An Educated Photojournalist

Thérèse Mabel Bonney was a highly trained photojournalist from the United States. In 1916, Bonney completed a bachelor's degree in humanities at the University of California, Berkeley;[3] in 1917, a master's degree in romance languages at Radcliffe College, Cambridge, Massachusetts, coordinated by Harvard University;[4] and, in 1921, a doctorate in philosophy at Paris-Sorbonne University.[5] Defending her dissertation "with highest honors" at the age of twenty-six, she became the youngest doctor at the Sorbonne, as well as its fourth female and eleventh U.S. doctoral graduate.[6]

During the initial steps of her career, Bonney wrote a recipe book and a guidebook.[7] Co-authored with her sister, these publications from 1929 reflect the interwar period of Bonney's life, in which one long-term influence was her participation in the American Red Cross project aiding children in Europe. In 1919, Bonney established the European branch of the American Red Cross.[8]

Bonney started her own news photo agency, Bonney Service, which was the first U.S. news photo service in Europe.[9] The agency hired photographers, whose photos were circulated to newspapers in thirty-three countries. Among other things, Bonney photographed buildings, interior design, salons, and nightclubs, as well as images for posters. Art deco and modernism are central to Bonney's images and interests of that period. After photographing inside the Vatican and subsequently publishing a book depicting the Vatican "behind the scenes" in 1939,[10] she earned a place in the spotlight as a photographer and writer.[11]

Invitation to Make a "Big Hit" in the North Becomes "War Assignment No. 1"

The Finnish government regarded Bonney as a well-educated, world-class photographer. In August 1939, the Finnish press publicized her widely, often describing on the front page how Dr. Bonney would photograph and cover Finland for the American people.[12] This was considered important because the United States had supported Finland during the years of Russian oppression and helped to conquer famine after the war of independence against Russia in 1917; moreover, more than 350,000 of approximately three million Finns had moved to the United States.[13] Many Finns, therefore, had some personal link to the United States, as could be seen in the strong U.S. impact on Finnish popular culture.[14]

At the 1939 New York World's Fair, Bonney met the head of the Newspaper Department of the Ministry for Foreign Affairs of Finland, Urho Toivola, who later also became the head of the Information Center in the Council of State, *Valtioneuvoston tiedoituskeskus*, established on October 10, 1939.[15] In New York, she also met W. K. Latvala, the head of a public relations association, *Propagandaliitto*, which was established by activists close to the armed forces in 1937.[16] The association was linked to a private news office of Finnish journalists and advertisers, *Finlandia Uutistoimisto*. Toivola and Latvala convinced Bonney, as well as a U.S. Signal Corps's expert on aerial photography, Edwin H. Cooper,[17] to travel to Finland to photograph and film the forthcoming Helsinki Olympic Games in 1940 to introduce the country to U.S. audiences to attract tourists and maintain U.S. goodwill. Bonney stated that Finland was also an interesting place because it was a focal point of world politics. She stated that she represented forty newspapers, of which twenty-five had specified themes to be covered and fifteen had simply requested interesting photographs. She planned to work for some months, take 2,000 to 4,000 pictures, and make stories of Finland a "big hit" for Americans.[18]

Bonney was employed by *Finlandia Uutistoimisto*. She received a visa from the Finnish Consulate-General in New York on June 12 and arrived in Finland on July 27, 1939.[19] Bonney's new employment was not widely covered in the U.S. media. Instead, she stated that it was more daring to be a freelancer with no guaranteed source of income, insurance, or other protection.[20] Perhaps she compared her position to that of accredited correspondents who had clear financial support. Bonney recounted her arduous journey with substantial baggage, including cameras, flashguns, reflectors, a darkroom kit, twenty cases of flashbulbs, and incidental equipment, in case her nearest source of supply was thousands of miles away. She also ordered more supplies from the United States in September,[21] probably as a precaution because World War II had already erupted in Central Europe.

As her "war assignment No. 1," she covered the Finnish military exercise in Karelia in August 1939, learning to find transportation, equip herself with sufficient flashbulbs, and keep out of the troops' way. Her first war caption was "Dress rehearsal of a great struggle." Disappointedly, it took four months for her message to be published in the United States. She decided sourly to send "all the very nice little articles and spreads" promised to U.S. editors.

A worried but determined flat-cap boy watching the parade in Viipuri in 1939. Behind him is Marshall Mannerheim in a similar appearance. Photo: Thérèse Bonney. Courtesy of the Finnish Heritage Agency. https://www.finna.fi/Record/museovirasto.E508271B9677639D4EDFA 768D9CE3A4B.

58 | Henry Oinas-Kukkonen

After the exercise in Karelia, there was a three-and-a-half-hour parade of approximately 20,000 soldiers in Viipuri on August 13, giving Bonney her chance to take pictures that became widely published.[22] She also received help from another correspondent.

In general, Bonney believed that war correspondents sleuthed about, worrying over competitors and hounding each other's footsteps.[23] For her "nice little articles and spreads," Bonney collaborated with a twenty-eight-year-old Eliot Elisofon (1911–1973), who was sent by *Life* magazine for his first foreign assignment to cover the Olympics. Bonney traced Finnish contacts for Elisofon,[24] which she had due to her Finnish employment. It has been claimed that Bonney and Elisofon traveled together to Finland, but Bonney crossed the Atlantic on the *Normandie* in July and Elisofon traveled in August.[25] However, in September, Germany and the Soviet Union attacked Poland, and World War II began. Finland faced the Soviet territorial demands and threat of invasion.[26] Finland's preparations for defense became Bonney's and Elisofon's news item.

On October 23, 1939, *Life* magazine introduced the Field Marshal of Finland, Baron Carl Gustaf Emil Mannerheim, who was the commander-in-chief of Finland's defense forces, in a double-page spread. It included photographs taken by Bonney alone and with Elisofon. Their story, and eleven-photograph spread, presented Mannerheim's career as a "liberator" in a struggle for independence, as well as his family history, depicting him as an old-style aristocrat and democratic republican whom the Soviets hated.[27] Bonney seemingly liked Mannerheim, and with this favorable story, the Bonney-Elisofon collaboration with *Life* was launched.

A week later, *Life* published a photographic essay, "Finland: Soviet Russia Crowds a Nation of Democrats," whose spread Bonney herself regarded as another major achievement in her employment. The feature offered an in-depth look at Finland, spreading across the gutter of several facing pages and emphasizing the Western democracy and fighting spirit for freedom in Finland, illustrated with seventeen grandiose pictures. In addition, an impressive seven-picture spread presented a modern country, a three-photograph series described *sauna* and honesty in a country of nearly nonexistent crime and balanced trade with the United States. A four-photograph series portrayed aged but united veterans from all parts of society of the Civil Guard. A religious commitment was brought to a climax in a full-page picture of young decisive men of the Civil Guard taking their oath next to a church altar while devout family watched from the galleries.[28] The essay praised Western, democratic, modern, and stylish Finland as

elevated above the atheist, totalitarian, and aggressive Soviet Union[29] that threatened it.

The spread has been seen as *Life*'s most influential photo essay of the 1940s with its forty pictures, including aerial photos, even though the eight-page-long essay had only a thousand words and was published before the United States joined World War II. U.S. goodwill toward Finland was promoted by this spread. When the Soviet Union attacked Finland a month later, *Life* included one section each week about Finland throughout the war. The influential spread has been considered to be carried out by Elisofon, who stated in *Life* April 1940 that he prided himself on it.[30] However, the pictures were mainly Bonney's, and the head of *Finlandia Uutistoimisto*, Ilmari Turja, recalled that Bonney directed Elisofon in selecting the pictures and even angles of views.[31] The significance of Elisofon's Finnish-hired senior mentor remained in the background because Elisofon was sent by *Life*.

Both Bonney and the Finnish authorities regarded the mobilization-era pictures and spreads as important opinion modifiers for the U.S. public. Bonney continued in this course when she photographed the evacuation of border towns before war.[32] Bonney produced spreads as her employers expected. She also produced 4,000 negatives, assisted by several mentored but overworked university students. After completing her assignments, she was without U.S. orders and annoyed about a lack of attention to "Dress rehearsal of a great struggle." Her photo series then changed to pictures of war, with her own turning point occurring at the "death bed of peace." The month preceding the Soviet-Finnish Winter War (1939–1940) was key to Bonney's understanding of sequences, tempo of events, moods, moments, and people. Instead of photographing marches, corpses, and gory scenes, she wanted to show the home front and what the war meant and did to those who live on, which allowed her to find her own way "in for war in a big way." Her photographic expeditions which carried this out she called "truth raids."[33] These began in the Arctic front.

The First Truth Raid: A Scoop in the Winter War

Bonney's baptism by fire occurred when the Soviets sneak-attacked Finland and bombed Helsinki on the morning of November 30. Bonney was on the spot and watched the first raid with the army observers.[34] However, she did not report with any photos as she had not been ready for action.

When alarms signaled a new raid and bombs hit in the afternoon, Bonney was dining in her hotel, where she remembered feeling as if the steak stuck in her throat for hours. It was her misfortune to miss photographing the

scene by ten to fifteen minutes. Bonney described photography in war like driving a car, requiring quick reflexes and equipment adjustments; but her ability did not help her that day. She also lost several negatives in the raid. It was the most devastating Soviet bombing on Helsinki during the Winter War, but Bonney had not shot her camera. Though it was not an ideal start to covering the war, Bonney did not conceal that she had missed the action and later recounted missing other scoops.[35] Nevertheless, she always emphasized being the only woman war photographer on the spot when the Winter War began.

During the first days of the war, approximately fifty foreign journalists were in Finland, and by the end of the war, the number rose to at least 303. The thirty-eight Americans made up the second-largest group of foreign journalists, including world-famous journalists; Martha Gellhorn, for example, who had gained fame following her reports on the Spanish Civil War, arrived at Helsinki only one day before the war started. Obviously, Bonney was not the only U.S. journalist at the scene, or even the only U.S. female journalist.[36] According to Bonney, other U.S. correspondents had headed for the Balkans and "shrugged their shoulders" at her Finnish trip, but following the outbreak of the Winter War, she received "a bit more respect" for her itinerary. She thanked her hunch for the first truth raid's success.[37] Yet the success also depended on her Finnish employment.

In November, *Finlandia Uutistoimisto* was transformed into the Information Office of the General Headquarters (*Puolustusvoimain tiedoituslaitos*). Bonney's Finnish contract ended, and the Finns listed her as a "wild" war correspondent.[38] However, following the Soviet attack, she finally had a U.S. audience interested in her earlier pictures. A day after the war broke out, the *New York Sun* published Bonney's pictures of Finnish President Kyösti Kallio and his wife, Kaisa. The Bonney-Elisofon photo taken of the presidential couple and Bonney sitting together comfortably in the presidential palace in Helsinki shows a peaceful interlude. Bonney's pictures also draw attention to Finnish artists, like Jean Sibelius, in the classical music magazine *Musical America*.[39] These photos contrasted sharply with the events of wartime.

Bonney's earlier photo series were also widely used to present the Finnish High Command and officials in dailies and weeklies, such as *Suomen Kuvalehti*, *Kuva*, and *Hakkapeliitta* in Finland, *Svenska Dagbladet*, *Dagens Nyheter*, and *Vecko-Journalen* in Sweden, *Aftenposten* in Norway, *Politiken* in Denmark, *Le Journal* in France, and *New York Herald Tribune* in the United States. Bonney stated that her contacts preferred her to "the cleverest and seasoned war correspondents," who were still waiting for official

President of Finland Kyösti Kallio (1873—1940) encouraging the anti-aircraft defense soldiers in 1939 or 1940. Photo: Thérèse Bonney. Courtesy of the Finnish Heritage Agency. https://www.finna.fi/Record/museovirasto.3802CE0D6910E7869 F16E866F49BED3F.

arrangements."[40] That was true: She reached areas that most other war correspondents did not.

Bonney was allowed access to the Finnish headquarters, which she photographed a few hours after its bombing by the Soviets. The Finnish headquarters in Mikkeli were bombed heavily. Her pictures were censored by the Finns with the caption "Somewhere in Finland." She complained that the U.S. editors paid nothing for her "best set of pictures" due to the unmarked location.[41] Because these pictures were of high relevance for both belligerents, the censors acted.

The censorship and delays did not bother Bonney significantly due to her experience and contact with officials in high command and some censors. She recovered her censored negatives after a necessary routine; a film would be taken to be developed hastily by a military laboratory, censored cursorily or eliminated, and accepted pictures would be edited and captions scrutinized. For her, larger challenges were cold hands hampering photography, the fight against pneumonia, a loss of physical stamina, and driving

on icy roads at night. During air raids, some films were ruined when left for too long in the developer, while others were lost when a courier was killed. Bonney found not only glamor and thrill in her work but also substantial risk.[42] She presented herself as ready and fearless to meet the danger.

In December 1939, Bonney made a trip to a military hospital in Vaasa, where the headquarters of *Finlandia Uutistoimisto* had been transferred because the location was thought to be safe. There, she caught some of her "most dramatic negatives" during a heavy bombardment when "everything went black" after a close hit tore off electric wires. She was frightened by locals who came with shotguns to check on the person speaking a foreign language, though they ended up drinking schnapps and picnicking together. The Vaasa pictures were published on the front page of the *New York Herald Tribune* roto section.[43] Several of Bonney's photos found their way to the cover pages of publications like *Newsweek* and *Harper's Bazaar*, and published books about World War II widely utilized her pictures.[44]

The international press in Europe also frequently used Bonney's photos from the front, including the Swedish photo journal *Se*, which, before Gallup polls, tried to define public opinion concerning help to Finland.[45] The largest circulation daily in Sweden, *Dagens Nyheter*, revealed that Bonney's reputation as a "great reporter" had spread internationally and that she was a writer and foreign correspondent publishing on both sides of the Atlantic.[46]

In 1940, Bonney was awarded a White Rose of Finland medal for, according to Catherine Gourley, bravery under fire, which she continued to wear as a sort of personal trademark on other fronts even after she received other awards and honors, such as the *Croix de Guerre* for her work for the French general staff and the French Legion of Honor.[47] Perhaps the reason for the White Rose was not bravery under air raids but rather achievement as a war photographer.

Throughout her career, the Winter War in Arctic Finland remained Bonney's ground-breaking truth raid and an important life experience; as late as 1967, the *Free Lance-Star* published a picture of Bonney posing with a camera and the White Rose medal and revealed that she did not allow new pictures to be taken of her.[48] While other pictures of Bonney exist, the White Rose picture is the most prevalent.

After the Winter War, Bonney published an article about her way "from the battlefields of Lapland to the retreat of the Ninth Army in France" in *Popular Photography*, March 1941. Yet many of her pictures continued to portray Finnish civilians and their resilience in the Arctic war, including a story in the *New York Times* presenting the Finnish concept of *sisu*, a kind of stoic determination, courage, and resolution in the face of extreme

Tin-hatted Thérèse Bonney and her White Rose of Finland medal in 1940. Photo: Thérèse Bonney. Courtesy of the Finnish Heritage Agency. https://www.finna.fi/Record/museovirasto.10D0F4FC8F37E4FE14865FE660B74C58.

adversity. Above all she saw children suffer in Finnish Karelia, calling it her "first vision of humanity." She claimed to dedicate her life to "making Americans aware of their responsibility"[49] and began her pictorial crusade on her way back from the Arctic front.

Celebrated Photo Exhibitions

Bonney publicly stated that she left Finland on March 20, 1940, a week after the peace treaty was signed. Actually, she had traveled to Sweden and back several times and left Finland on March 17, 1940.[50] The reason for her cross-border trips was that Bonney's pictures were also processed in Stockholm,

64 | Henry Oinas-Kukkonen

where an acclaimed exhibition of her work titled "Story of Finland . . . From Peace to War" was held in Galerie Moderne in January 1940. The exhibition by the "press photographer extraordinaire" described change and a dramatic climax: how peace is broken and war begins.[51] The topic suited her pictorial crusade.

Bonney rushed to Belgium because she "smelled another war" and wanted to save her negatives. She cited a hunch again but did not state why she had to save the negatives. It was not due to her previous Finnish employer, who regarded Bonney's work as an important asset for goodwill.[52] In April 1940, the Finnish Information Center delivered Bonney photos, posters, maps, and statistical material, as well as information concerning ceded territories and bombardment damages to civilians.[53] This delivery suggests that Bonney perhaps also received some monetary compensation from Finland for at least one project.

On May 3, 1940, Bonney organized an exhibition on Finland's path from war to peace at the Centre for Fine Arts in Brussels, Belgium, which showed until May 15. A week after the opening, Germany started an invasion of the Benelux countries and defeated France, with Bonney taking photos on the front.[54] When Bonney returned to New York, her year-long work titled "a woman with two tin hats (Finnish and French)" was presented in the *New York Herald Tribune* in photogravure, featuring her pictures from Finland, including a prewar picture of an elderly woman covering her mouth in shock while troops march by and a postwar picture of a uniformed professor staring over rows of empty desks and chairs in a gloomy lecture hall in the School of Forestry at the University of Helsinki. The work presented "the civilians—humanity stricken in the proud Twentieth Century."[55]

Bonney then began her exhibition tour in the Library of Congress in Washington, DC, with a four-week installation "To Whom the Wars are Done" on November 15,[56] followed by nearly a four-week exhibition, "War Comes to the People," in New York's Museum of Modern Art (MoMA) on December 10.[57] The editor of *Good Photography*, Norman C. Lipton, regarded the exhibition of two hundred war prints in the Library of Congress, MoMA, and subsequently forty larger U.S. cities as an unusual, vivid, extremely successful "psychological chronicle of war," which dug deep into the human effects of war but without battle scenes or mangled corpses. Bonney's unposed photos were "one of those things that 'must be seen.' It is something new under the sun—a new and timely application of photography." The exhibitions proved to be a success to Bonney as a photojournalist and war correspondent, with the Carnegie Corporation approving a grant from the

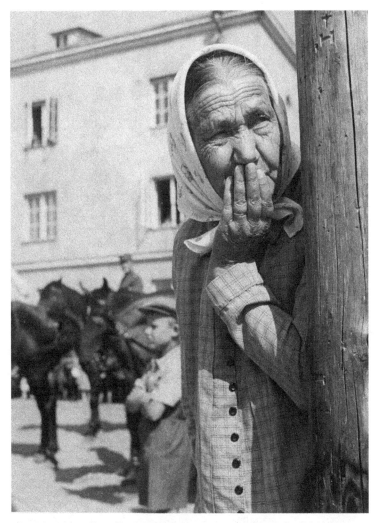

An elderly scarfed woman, who must have experienced the Finnish war of independence against Soviet Russia (1918–1920), covering her mouth in shock while watching the military parade only two decades later in Viipuri, Finnish Karelia, in 1939. Behind her is the worried but determined flat-cap boy. This photograph is deeply linked with the photograph of the flat-cap boy and Marshall. In fact, it is necessary to see both photographs to understand the deep link and the sharp contrast with the picture about the boy and Marshall that Bonney wished to portray. Photo: Thérèse Bonney. Courtesy of the Finnish Heritage Agency. https://www.finna.fi/Record/museovirasto.A83C26765BBF467 641770641888148B7.

A professor in uniform missing his students in a gloomy lecture hall in 1939. Photo: Thérèse Bonney. Courtesy of the Finnish Heritage Agency. https://www.finna.fi/Record/museovirasto.66DF23A5D15D6B1C086 9968CB51B431E.

American Council of Learned Societies to enable Bonney to return to Europe "to record with her camera what war does to the people."[58]

While Bonney returned to photograph in Europe in 1941, she did not go to Finland, though she had wanted to and acquired a visa to do so.[59] Her second trip to Finland became very different.

Unpublished Front-Page News Gathered by the OSS Agent Bonney

When Bonney returned to the United States in 1942, she encountered trouble from U.S. Customs, the Federal Bureau of Investigation (FBI), and an intelligence agency, the Office of the Coordinator of Information (COI). Many photographs, films, papers, and notes were confiscated, and items useful for U.S. anti-Nazi propaganda disappeared. Some material was returned to Bonney, but she protested the loss of material "at her own front door" before fulfilling her editorial commitments. However, after discussions with Commander William H. Vanderbilt, correspondent Bonney was ready to collaborate with the COI in any way possible and became an undercover agent.[60]

While Bonney had been photographing in Europe, Finland had become a co-belligerent of Germany. U.S. officials considered it difficult to communicate with the Finnish leadership, which was careful not to annoy the Germans. The Office of Strategic Services (OSS), which knew of Bonney's connections in the publishing world and State Department, hired her under the cover of a journalistic assignment to Finland.[61] The OSS deputy director of special operations (SO), Colonel Millard Preston Goodfellow,[62] and SO Officer Vanderbilt employed Bonney as a "roving" representative in June 1942 for a secret mission to contact familiar Finnish leadership and determine if Finland could withdraw from the war against the Soviet Union in the Northern Front. Another goal was to dissipate anti-British feeling and propaganda coming from Finland.[63] The Soviet Union had pressured the United Kingdom and the Commonwealth countries to declare war on Finland.[64] The vice president in charge of operations of Columbia Broadcasting System (CBS), Major Lawrence Lowman, organized Bonney a cover as a reporter, arranging a letter of authorization and advanced funds through the CBS director of news broadcasts Paul White, who gave Bonney a letter to be delivered in London to the broadcaster Edward R. Murrow, who led a team of war correspondents.[65] At Vanderbilt's request, Bonney arranged a letter of authorization from a weekly magazine of investigative journalism, *Collier's,* with a circulation of 2.5 million, which knew of her service to the government but not that she was an agent.[66]

Bonney submitted a budget of $7,474, including three months' salary, for the trip to Vanderbilt. She also demanded that compensation for reporting, delays, and possible imprisonment be deposited in Washington, DC, and made removable only by her. In the case of imprisonment, the OSS was to secure release or priority using CBS. Yet according to her official war correspondent identification, Bonney represented Duell, Sloan, and Pearce,

Inc., New York,[67] a company recently founded in 1939 that published general fiction, non-fiction, and photographic essays.[68] It was not likely to be easily linked to the U.S. government operation.

Bonney was convinced that she would be released and obtain her reward if detained in Finland, a friendly Nordic democracy that tried keenly to depict itself as having a separate war with the Soviets, not being a member of the Tripartite or Axis Pact, and not being at war with the United States.[69] However, Germany tried to tighten the link between itself and Finland, which the United States noticed. In June 1942, *Newsweek* ran a story about Adolf Hitler's surprise visit to Mannerheim's seventy-fifth birthday that included Bonney's earlier picture of Mannerheim.[70] Bonney was especially ready to meet him again—but not to take portraits.

The OSS lost contact with Bonney while she was traveling in August 1942. Interestingly, her prepaid three-month employment also ended on August 22.[71] She seems to have been on an undercover mission without being on the active payroll and without official communications channels. By September, she made her way to Sweden, where she received permission to photograph and familiarize herself with local conditions. In fact, she focused primarily on the situation in Finland. She claimed to contact the Finnish consul, probably the influential, anglophile ambassador G. A. Gripenberg in Stockholm, for a visa to photograph war refugee children.[72] Although to the Finnish Mission she was a familiar and perhaps even expected visitor, the Germans warned the Finnish State Police, *Valtiollinen poliisi* (Valpo), about allowing Bonney to enter in the country. Her visa was initially denied, but her Winter War contacts prevailed, and with Mannerheim's special permission, she was granted entrance.[73]

It has been thought that Bonney arrived in Finland on December 12, 1942. In fact, she spent October in Finland, settled in the centrally located and luxurious Hotel Kämp in Helsinki.[74] Kämp had served as the press center during the Winter War[75] and was, for Bonney, a natural place to meet parliamentarians and officials and observe influential foreigners, including high-ranking Germans. The U.S. ambassador to Finland, H. F. Arthur Schoenfeld, sent a wire to Secretary of State Cordell Hull stating that Bonney had inspired the Finns to believe that the United States might apply political pressure but would not wage war.[76] Already this could have been a rich topic for investigative journalism, but there were numerous sensational front-page news stories that Bonney captured. She had long discussions with representatives of parliament (*eduskunta*), such as Väinö Tanner, a leading figure of the Social Democratic Party and the Minister of Finance, who advised Bonney that the British should not propagandize with the U.S.-Finnish

Hotel Kämp in 1939. Photo: Thérèse Bonney. Courtesy of the Finnish Heritage Agency. https://www.finna.fi/Record/museovirasto.E778C99D34AB6AC8E597173A35AEAA2E.

discussions because the goaded Germans would pressure Finland to break off all relations with the United Nations. The Finns stopped their anti-British radio propaganda following the United States' request, for which Bonney took credit.[77]

Bonney analyzed reactions to the propaganda of the U.S. Office of War Information (OWI), which the Finns did not block. She worried because the "widely reading" Finns did "not like it," and these "avid readers" considered it as "very poor," naïve, straightforward, and underestimating. Because it was relayed by a public service broadcaster, the British Broadcasting Corporation (BBC), it was also believed to originate from Britain. Bonney compared the U.S. propaganda with the interesting and subtle propaganda mixed with news for the Finns by the German monthly magazine *Signal*.[78] Now Bonney found an extraordinary chance to create a similar mix.

Bonney met German women journalists heading for the Northern front, but Mannerheim and the headquarters arranged a top-secret five-day tour to the Karelian front for her. She reported, correctly, that German troops were in Northern Finland and Lapland and that the German and Finnish

combined strength was between 200,000 and 250,000 soldiers.[79] She also discussed German nutrition and morale, especially the Germans' vulnerability to Lapland sickness (seasonal affective disorder [SAD]), and pointed out that the Germans respected the Finns as Arctic fighters, but that this attitude was one-sided. Most significantly, she revealed the static situation in Karelia, concluding that the Finns could easily cut the Murmansk railroad line if they wanted to. The officers explained that they had stopped due to U.S. pressure but were furious about the U.S. military materiel used by the Soviets against the Finns.[80]

The Finns requested international and American Red Cross aid to feed numerous malnourished Soviet prisoners. Bonney reported that the Finns were starving, even though the Germans were not really "milking" the country while they took strategic materials and minerals, such as nickel. However, Finland depended on grain, which Germany used to blackmail the country. In an important observation, Bonney understood that after the winter of 1942–43, there would be food shortages and a compelling need for German aid.[81]

The Finns saw the Germans being defeated in Stalingrad when Bonney met Finnish President Risto Ryti for her ultimate mission of a separate peace. She reported that the Soviets were regarded by the Finns as not weak enough to want peace nor the British or Americans close enough to persuade them. The Finns did not seek a "dishonorable peace"; they let Germany know that they would not declare war on the United States, and the Germans demanded that the Finns stop scheming with their enemy.[82] For a war correspondent, the subject was extremely complex and delicate. So as not to endanger her mission, U.S. Ambassador Schoenfeld and the First Secretary Robert M. McClintock instructed Bonney to take distance from them. Also, she and other OSS agents could not route "their stuff," that is, secret information, via U.S. legation without acceptance.[83]

The Finnish Minister of Finance, Tanner, warned Bonney about "a Himmler man in town" and advised her to return temporarily to Sweden. The German *Geheime Staatspolizei* (Gestapo) agent actively monitored Bonney, who reminisced in 1967 about a *Schutzstaffel* (SS) colonel following her constantly.[84]

Bonney followed the advice to maintain her correspondent's cover and pursue harmless topics. She visited day cares and hospitals, and when she left Finland, she accompanied a train transporting refugee children to Sweden, whose overall motive, Bonney concluded, was to preserve Finland as a buffer state against the Soviet Union.[85] This role in following the children set the tone to her stories, which were quite limited at the time.

A lone and exhausted Finnish refugee boy. He was one of the children with whom Miss Bonney shared a train ride to Avesta Krylbo station, Sweden in 1942. Photo: Thérèse Bonney. Järnvägsmuseet. https://digitaltmuseum.se/021018169069/transport-av-barn-fran-finland-i-samband-med-barnevakueringen-under-krige.

Tanner suggested that Bonney make a broadcast to CBS from Helsinki. When she consulted Schoenfeld, he regarded the idea as "alright, but rather delicate." Bonney decided to obtain OSS permission via US Military Attaché Colonel Hugh B. Waddell in Stockholm,[86] allowing Washington, DC, to decide what could be published, but Waddell had left for Washington. On November 9, Bonney contacted the OSS via the State Department channel to state that she could return to Finland, where she had permission for a CBS broadcast and requested a two-month follow-up agreement and further funds. After waiting for a week, she sent a new message through the regular channel of the U.S. legation, which began to send follow-up cables to receive answers and inquire from the State Department about Bonney's real "identity."[87]

In Sweden Bonney provided statements about the Winter War to the daily *Aftonbladet,* which were made to look as if they originated from her

office in New York. She explained her difficulties as a war reporter and the cold on the Finnish front, where even the shutter of her camera had iced. Regarding her motives, she stated that she wanted to make the Finnish heroic fight for independence an example to Americans.[88] What was incorrect was her location because she was not in New York, but in Stockholm.

The Finns asked Bonney to return, and she received validation on her passport to do so. However, a French CBS representative delivered a message ordering her to return home, and the State Department cabled the legation not to validate her passport. However, the legation told Bonney that she could go anyway. As she weighed these contradictory wishes, she received orders via the legation to report to the London OSS, which broke her cover and revealed her identity.[89] She was not going to make a CBS broadcast from Helsinki.

Bonney reported to Goodfellow via Waddell on December 25 and left for London, where she was allowed to talk only with the BBC representatives working for the British intelligence, whom she informed about the situation in Finland,[90] and she left the country quickly. Bonney had neither time nor a chance to publish stories. She was keenly expected in Washington, DC, but not in a newsroom.

Publication of Second Truth Raid Bits

In January 1943, the director of the OSS, William J. Donovan, was alerted by his deputy chief and the chief of special operations, Lieutenant Commander R. Davis Halliwell,[91] when the London office reported the arrival of "dangerous and predatory" Bonney, advised "a security lecture" for her, and demanded that she be sent home immediately due to her anti-Soviet and pro-Finnish utterances. The British recommended keeping Bonney in the United States. Halliwell considered Bonney to be "undoubtedly aggressive and erratic" and was uncertain of Goodfellow's role and how valuable Bonney's information from Finland was. When Bonney entered New York, she was to first meet an OSS secret intelligence branch[92] official, Calvin B. Hoover, responsible for Swedish operations,[93] and Colonel Francis Pickens Miller, who collaborated with the British.[94] Thereafter, OSS Lieutenant Walter R. Mansfield[95] was to take care of Bonney.[96] But others got to Bonney first.

Upon Bonney's arrival, the U.S. Customs, the FBI, Office of Naval Intelligence (ONI), and the Army intelligence (G-2) interrogated her at the airport and found papers mentioning Goodfellow and Vanderbilt. The offices were to begin investigations and surveillance. Furthermore, the OSS did not know how to explain to the OWI or Finnish legation, if they began to ask questions.[97] Mansfield reported to Halliwell that Bonney had been allowed

Miss Bonney Reporting from the Arctic Front | 73

to reveal her identity only to the interim Chief of SO, Colonel Gustave B. Gunther[98] or Captain Richard P. Heppner[99] of the OSS London. However, Gunther had not believed nor aided Bonney, who had been forbidden to reveal her real mission to anyone else.[100] Halliwell reported to Donovan that Bonney was to be handled by the mission's originators. Donovan advised Goodfellow in his one-sentence-long letter: "Please tell Bill Kimbel what you have done about Therese Bonney." In Goodfellow's administrative assistant's reply to OSS Director Kimbel was added in a handwritten line: "The Bonney matter is well on the way to an amicable adjustment." Kimbel also reported to Donovan that the State Department was content with the OSS's explanation.[101] Instructions for handling the matter came from Donovan, and eventually, the clarification discussions were quick. However, Bonney's problems were far from over.

She quarreled with the OSS about the missing salary caused by one month's stay in Stockholm while waiting for an answer to her cable. Discussion about reimbursement continued intensely until July.[102] Bonney had also trouble with income tax to be filed. According to the OSS instructions, seemingly from Douglas M. Dimond, Bonney was advised to declare income as received from the U.S. government but was forbidden to mention the agency or to report any expenses. If she questioned, she could only answer that the expenses were advanced for a government job.[103] Bonney also faced a major problem for a war correspondent: She wanted to publish, but would she be allowed to? The problem of a Finnish-Soviet separate peace increasingly worried Bonney due to the strengthening of the Soviet Union. She laid her hopes on the Finnish opposition group in parliament, which emphasized that Eastern Karelia was reconquered and the war should be abandoned.[104] But could she write about this matter?

For the OSS, the problem was whether Bonney would be allowed to write her stories for *Collier's* and broadcast with CBS or not. The OSS estimated that Bonney had collected massive data on Finland and Sweden. Even though the OSS had paid and covered all expenses, it did not have any exclusive rights to the material gathered while she was under cover as a war correspondent. Nevertheless, the OSS held up publication of any of Bonney's data until they had utilized it.[105]

After the Finnish elections on February 15, 1943, and intensified rumors about a separate peace, Bonney appeared in the *March of Time* broadcast from Washington, DC, on February 25. She was introduced as a leading journalist-photographer and war correspondent who had visited a "traditional friend of America." Bonney reported that "there is a far greater bond between the people of the United States and Finland than most people seem

74 | Henry Oinas-Kukkonen

to realize" in the United States. She defended Finland against the Soviet Union and explained that these cobelligerents of Germany were not pro-Nazi. She presented a three-step proposal. First, the United States, Sweden, or the Vatican was needed as an intermediary for peace negotiations. Second, food aid was necessary. And third, the self-reliant Finns would "pull their chestnuts out of the fire"—that is, oust the German troops.[106] These were the "pro-Finnish utterances" that the OSS London office had feared.

Bonney continued to present the Finns in a positive light. In March, the *Christian Science Monitor* was told that Bonney called her extraordinary "lone wolf war correspondent" trip for *Collier's* her second truth raid and stated that "Finland intends to do everything she can to remain a democracy." She revealed that the Finns had allowed her to visit the front in Karelia, "a bird's flight" from the encircled Leningrad. Nevertheless, she focused on her agreed themes: human aspects, such as the effects of war on children and reconstruction.[107] She did not have much to report about the campaigns of the Arctic War in detail.

In *Collier's,* she finally published her report on May 29, 1943, in which she admitted that Finland was cooperating with the enemy but was a friendly, small democracy and not a national socialist monstrosity in miniature scale. The Finns had accepted German aid as "their sole chance of survival" after the German invasion of Norway. Bonney interpreted the hungry, disillusioned, and bitter Finns as wanting peace but without dishonor and major territorial losses. She repeated her three premises presented in the *March of Time* broadcast. At the time, the Soviet Union demanded unconditional surrender and Germany threatened to seek revenge if Finland signed a separate peace treaty.[108] However, Bonney's description conveyed how the Finns felt and what they aimed for, whether or not Moscow, London, Berlin, or even Washington, DC, wanted to hear it.

Bonney also published her interpretation of the amount, location, equipment, morale, and "Lapland sickness" of 100,000 to 200,000 German troops in Northern Finland.[109] Interestingly, the U.S. knowledge of the correct strength of 200,000 to 250,000 German soldiers was blurred from the German observers.

In *Collier's,* Bonney openly revealed her trip to the Ladoga front and published a picture of the destruction in the retaken city of Viipuri and a Karelian dugout she called "Kuros"[110] (actually *korsu*). These pictures proved that she had been in Finland after the Winter War, which surely irritated the Germans, even though they knew about her visit. Bonney bluntly criticized U.S. propaganda through the OWI in U.S.-friendly Finland and revealed that members of the Finnish-American Club in Helsinki, many

Miss Bonney Reporting from the Arctic Front | 75

parliamentarians and members of the public wanted better U.S. publications and broadcasts.[111] Perhaps, she hoped to become involved in making U.S. propaganda to Finland.

Bonney continued publishing her views in *Collier's* in August, revealing that she had returned to Finland in October 1942. Her nine-photo story told about everyday life in war-ridden Finland, pestered with shortages, rationing, substitute products, the black market, and smuggling. During her second truth raid, she took 247 photograph negatives in Finland, according to her log book.[112] However, it seems that few pictures were published. Perhaps many were confiscated, or publishing was forbidden by the authorities.

Not everyone was happy about Bonney's stories from Finland. In November 1943, the U.S. Communist Party's *Daily Worker* attacked Bonney, her trip, and "pictures of hungry children" as means of drumming up sympathy and money for Hitler's ally.[113] The *Daily Worker* in New York clearly supported the Soviet Union and was against its adversary Finland.[114]

After strenuous effort, Bonney published her best-known book, *Europe's Children, 1939 to 1943*, in 1943, which included shocking photographs of women and children imprisoned in German concentration camps. It also contained many Winter War photographs of Finnish children. Her book was distributed by Duell, Sloan, and Pearce,[115] which had accredited Bonney as a reporter and received her publication. It is often claimed that the book had such a profound impact on the opinions of the time that it supported the establishment of the United Nations International Children's Emergency Fund (UNICEF).

Conclusion

Bonney saw so much, was involved in so much, photographed so much, and published important pictures and news pieces. Her way to becoming a war correspondent was a long process and unconventional. Well educated, Bonney photographed cultural themes and designs and, during her time in Finland, pursued commercial photographing of the Olympic Games, celebrities, and advertising material to promote tourism and goodwill. However, she ended up as a war correspondent on the Arctic front, where she found her photojournalistic style.

The first truth raid in the Winter War trained her to cope with tough conditions and press on in photographing, despite obstacles and setbacks. There, she gained the identity of a war correspondent, as manifested in the White Rose medal. Her pictures spread from the press to exhibitions on both sides of the Atlantic, making clear her focus on depicting the distress

76 | Henry Oinas-Kukkonen

and resilience of civilians, especially children, at war. During the second truth raid, she returned to the Arctic front, but this time, she was a roving OSS agent under cover as a correspondent pursuing harmless topics. While she was unsuccessful in guiding Finland and the Soviet Union toward a separate peace, she collected vast and important intelligence data. However, it took time, effort, and courage to publish bits and pieces of her new stories and pictures from the North.

The Arctic front had a lasting effect on Bonney's vision of humanity and of the abilities of a woman to work on her own. More than an undercover agent sent on an improbable mission, Bonney was, in her essence, a photojournalist and a war correspondent invested in the portrayal of small democracies, people, and, most of all, children in distress.

Notes

1. "Maamme valokuvattavana Yhdysvaltain lehdistöä varten," *Kaleva*, August 6, 1939; Norman C. Lipton, "War Comes to the People," *Good Photography* 1, no. 6 (1941): 6, 9.

2. Henry Oinas-Kukkonen, "US-Finnish Relations Reflected in the 'Photo Fighter' of True Comics," *Faravid* 36 (2012); J. E. Smyth, "Fred Zinnemann's Search (1945–48): Reconstructing the Voices of Europe's Children," *Film History* 23, no. 1 (2011): 76–79, 88; Raoul J. Granqvist, *Photography and American Coloniality: Eliot Elisofon in Africa, 1942–1972*, in *African Humanities and the Arts* (East Lansing: Michigan State University Press, 2017), chap. 1.

3. Rodney Angove, "American Photographer: Therese Bonney Fights On," *Free Lance-Star*, November 28, 1967, 9.

4. Marjorie Bryer, *Finding Aid to the Thérèse Bonney Papers BANC MSS 83/111 z*. The Bancroft Library University of California 2018, 2, http://pdf.oac.cdlib.org /pdf/berkeley/bancroft/m83_111_cubanc.pdf.

5. Catherine Gourley, *War, Women, and the News: How Female Journalists Won the Battle to Cover World War II* (New York: Atheneum Books for Young Readers, 2007), 55–56.

6. Rebecca Tolley-Stokes, "Bonney, Therese (1894–1978)," in *Women and War: A Historical Encyclopedia from Antiquity to the Present*, vol. 1, ed. Bernard A. Cook (Santa Barbara, California: ABC-CLIO, 2006), 70; Timothy Rothang, "The Life of Therese Bonney," *The Therese Bonney Collection at St. Bonaventure University Friedsam Memorial Library*, 2006, http://archives.sbu.edu/Biographies/therese bonney/bonneybio.htm.

7. M. Thérèse Bonney and Louise Bonney, *French Cooking for American Kitchens* (New York: Robert M. McBride, 1929); M. Thérèse Bonney and Louise Bonney, *Buying Antique and Modern Furniture in Paris* (New York Robert M. McBride, 1929).

Miss Bonney Reporting from the Arctic Front | 77

8. "Bonney, Thérèse (1894?–1978)," in *Famous American Women: A Biographical Dictionary from Colonial Times to the Present*, ed. Robert McHenry (Mineola, NY: Dover, 1983), 43.

9. Tolley-Stokes, "Bonney," 70, 71.

10. M. Therese Bonney, *The Vatican* (Boston: Houghton Mifflin, 1939).

11. "Bonney, Thérèse (1894?–1978)," 43.

12. See, e.g., "Maamme valokuvattavana Yhdysvaltain lehdistöä varten," *Kaleva*, August 6, 1939, *Etelä-Savo, Raahen Seutu, Sisä-Suomi, Uudenkaupungin Sanomat, Uusimaa* and *Varkauden Lehti*, August 8, 1939; "Maamme valokuvataan Yhdysvaltain lehdistöä varten," *Forssan Lehti*, August 7, 1939; "Suomi valokuvatta vana," *Lalli*, August 8, 1939.

13. R. Michael Berry, *American Foreign Policy and the Finnish Exception: Ideological Preferences and Wartime Realities* (Helsinki: SHS, 1987), 45, 56–58; Reino Kero, *Suureen länteen: Siirtolaisuus Suomesta Yhdysvaltoihin ja Kanadaan* (Turku: Siirtolaisuusinstituutti, 1996), 54–55, 65.

14. Visa Heinonen and Mika Pantzar, "'Little America': The Modernisation of the Finnish Consumer Society in the 1950s and 1960s," in *Americanisation in 20th Century Europe: Business, Culture, Politics*, vol. 2, ed. Nick Tiratsoo and Mathias Kipping (Lille: Publications de l'Institut de recherches historiques du Septentrion, 2018).

15. Jari Sedergren, "Lehdistösensuuri talvisodassa," in *Talvisodan pikkujättiläinen*, ed. Antti Juutilainen and Jari Leskinen (Helsinki: Werner Söderström Osakeyhtiö, 1999), 270.

16. "Värifimi Suomesta: Amerikkalainen valokuvaajaesitelmöitsijä Suomea kiertämässä," *Helsingin Sanomat*, August 9, 1939; Jaakko Lehtonen, "Finland," in *Public Relations and Communication Management in Europe: A Nation-by-Nation Introduction to Public Relations Theory and Practice*, ed. Betteke van Ruler and Dejan Vercic (Berlin: De Gruyter Mouton, 2004), 110.

17. See, e.g., *Pictorial History of the Twenty-sixth Division, United States Army: With Official Government Pictures Made by United States Signal Corps Unit under Command of Captain Edwin H. Cooper, Text by Albert E. George and Captain Edwin H. Cooper, with Appreciation by Major-General Clarence R. Edwards* (Boston: Ball, 1920).

18. "Yhdysvaltain Suomi-sympatia meille varsinainen kansallisaarre," *Helsingin Sanomat*, June 23, 1939; "Amerikka haluaa valokuvia Suomesta," *Helsingin Sanomat*, August 6, 1939; "Bilderboken är framtides bok," *Hufvudstadsbladet*, August 6, 1939; "Valokuvareportaashi maastamme Yhdysvaltain lehdistöä varten," *Varsinais-Suomi*, August 6, 1939; "Maamme valokuvattavana Yhdysvaltain lehdistöä varten," *Vaasa*, August 6, 1939.

19. Thérèse Bonney's passport issued on February 26, 1938. File Bonney, Mabel Thérèse: Passports 1938–1961. UC Bancroft Library, Manuscript Division, 83/111 z (Cited hereafter as BANC MSS 83/111 z), carton 11; Ilmari Hakala, "Ilmari

78 | Henry Oinas-Kukkonen

Turja ja Finlandia Uutistoimisto," in *Ilmari Turja rauhan ja sodan töissä,* Ilmari Turjan seuran julkaisuja 3 (Helsinki: Yliopistopaino, 2002), 25.

20. Thérèse Bonney, "I Cover Two Wars," *Popular Photography,* March 1941, 23.

21. Bonney, "I Cover Two Wars," 22, 23, 90.

22. "Valtava sotilasparaati eilen Viipurissa, *"Helsingin Sanomat,* August 14, 1939; Bonney, "I Cover Two Wars," 90.

23. Bonney, "I Cover Two Wars," 23.

24. Granqvist, *Photography and American Coloniality,* chap. 1.

25. "Life's Pictures," *Life,* October 30, 1939, 92, to Robert St. John, "Personality of the Day." WEAF & Network, November 8, 1943, 9:45 to 10:00 AM. Therese Bonney Collection, WEAF "Personality of the Day" spot, George C. Marshall Foundation, https://www.marshallfoundation.org/library/digital-archive/weaf -personality-of-the-day-spot/.

26. Jussi Hanhimäki, *Scandinavia and the United States: An Insecure Friendship* (New York: Twayne, 1997), 6–7.

27. "The Liberator of Finland Mobilizes against Russia," *Life,* October 23, 1939; "Life's Pictures," *Life,* October 23, 1939; Henry Oinas-Kukkonen, "Finland's Relations with the Allied War Effort," in *Unknown Conflicts of the Second World War: Forgotten Fronts,* ed. Chris Murray (London: Routledge, 2019), 39.

28. "Finland: Soviet Russia Crowds a Nation of Democrats," *Life,* October 30, 1939; Contents and "Life's Pictures," *Life,* October 30, 1939.

29. Sheila Fitzpatrick and Michael Geyer, *Beyond Totalitarianism: Stalinism and Nazism Compared* (New York: Cambridge University Press, 2009), 1.

30. Granqvist, *Photography and American Coloniality,* chap. 1; "Life's Pictures," *Life,* April 15, 1940.

31. Ilmari Turja, *Ei kukaa oo mikää sanoo Rannanjärvi* (Porvoo: Werner Söderström Osakeyhtiö, 1975), 111; Sedergren, "Lehdistösensuuri," 273.

32. Bonney, "I Cover Two Wars," 91; "Finnish Refugees," *Sunday News,* November 26, 1939.

33. "Viimeinen kuvasarjani Suomesta tulee kuvaamaan voittoanne," *Itä-Häme,* January 15, 1940; Bonney, "I Cover Two Wars," 90; Gourley, *War, Women, and the News,* 56.

34. Comp. Bonney, "I Cover Two Wars," 90 and P3132–33, Prop.Os./PM, Sotapäiväkirja 9.10.39–15.4.40. Talvisodan sotapäiväkirjat. SPK 2789 Päämaja. Propagandaosasto (1940). Sotapäiväkirjat-kokoelma, 63. National Archives of Finland, Helsinki. Hereafter cited as NAF.

35. Bonney, "I Cover Two Wars," 90, 92; Antti Juutilainen, "Väestön ja laitosten suojaaminen pommituksilta," 663, and Jari Leskinen, "Pommikuormia Virosta," 671–672, both in *Talvisodan pikkujättiläinen,* ed. Antti Juutilainen and Jari Leskinen (Helsinki: Werner Söderström Osakeyhtiö, 1999).

36. Martti Julkunen, *Talvisodan kuva: Ulkomaiset sotakirjeenvaihtajat Suomessa v. 1939—1940* (Turku: Turun yliopisto, 1975), 16, 49, 51–53; Gordon F.

Miss Bonney Reporting from the Arctic Front | 79

Sander, *Taistelu Suomesta 1939–1940*, trans. Arto Häilä (Helsinki: Werner Söderström Osakeyhtiö, 2010), 49, 51; Gourley, *War, Women, and the News*, 56–57.

37. Bonney, "I Cover Two Wars," 22, 23, 90.

38. Comp. November 9 and 28. P3132–33, Prop.Os./PM, SOTAPÄIVÄKIRJA 9.10.39–15.4.40, Talvisodan sotapäiväkirjat, SPK 2789 Päämaja, Propagandaosasto (1940), Sotapäiväkirjat-kokoelma, 61, NAF; Antti Juutilainen, "Tiedoitustoiminta," in *Talvisodan pikkujättiläinen*, ed. Antti Juutilainen and Jari Leskinen (Helsinki: Werner Söderström Osakeyhtiö, 1999), 279; Ulkolaisten lehtimiesten sijainti 12.1, Päämaja. Ulkomaanpropagandatoimisto (Prop.2), 54, Yleinen ja salainen kirjeenvaihto 1940–1940, Perus-3132/28, NAF; Turja, *"Ei kukaa,"* 112.

39. "A Pleasant Interlude Just before the Invasion," *New York Sun*, December 1, 1939; *Musical America*, February 10, 1940.

40. *Suomen Kuvalehti*, No. 44, 46 & 47, 1939; *Kuva*, No. 23, 1939; *Hakkapeliitta*, No. 11, 1940; *Dagens Nyheter*, February 15, 1940; *Vecko-Journalen*, No. 43 & 49, 1939 & No. 7, 1940; *Aftenposten*, February 14, 1940; *Politiken*, February 1940; *Le Journal*, February 16, 1940; *New York Herald Tribune*, December 3, 1939; Bonney, "I Cover Two Wars," 90.

41. Bonney, "I Cover Two Wars," 91; Juutilainen 1999, "Tiedoitustoiminta," 280.

42. Bonney, "I Cover Two Wars," 90–92.

43. Juutilainen 1999, "Tiedoitustoiminta," 280; Bonney, "I Cover Two Wars," 92, 93.

44. *Newsweek*, December 25, 1939; *Harper's Bazaar*, 2/40; *105 Taistelun Päivää: Suomen Ja Neuvostoliiton Sota Talvella 1939–40. Itsenäinen Suomi 1940: n:o 5*, ed. Örnulf Tigerstedt (Helsinki: Itsenäisyyden liitto, 1940), *passim*.

45. *Se*, December 13–16, 1939, January 13–17, 1940, and January 20—23, 1940; *Dagens Nyheter*, December 9, 1939; Henrik Berggren, *Landet utanför: Sverige 1939–1945* (Stockholm: Norstedt, 2018).

46. *Dagens Nyheter*, December 6, 1939; *Dagens Nyheter*, December 15, 1939; Bruce Downes, "Thérèse Bonney Photographs Nazi Victims, Europe's Children— and Makes a Dramatic Book of Photographs," *Popular Photography*, December 1943, 49.

47. "Suomen Valkoisen Ruusun ansiomitali," *Helsingin Sanomat*, January 20, 1940; "Amerikansk fotograf får Finlands Vita ros," *Hufvudstadsbladet*, January 21, 1940; Gourley, *War, Women, and the News*, 55–57; "Bonney, Thérèse (1894?–1978)," 43.

48. Tolley-Stokes, "Bonney," 71; Angove, "American Photographer," 9.

49. Bonney, "I Cover Two Wars," 22; Hudson Strode, "SISU: A Word That Explains Finland," *New York Times*, January 14, 1940; Downes, "Thérèse Bonney Photographs Nazi Victims," 38.

50. Lipton, "War Comes to the People," 9; Thérèse Bonney's passport issued on February 26, 1938. File Bonney, Mabel Thérèse: Passports 1938–1961, BANC MSS 83/111 z, c. 11.

80 | Henry Oinas-Kukkonen

51. Excerpts from Stockholm Press, BANC MSS 83/111 z, c. V. 11, Oversize; *Dagens Nyheter,* January 16, 1940.

52. Bonney, "I Cover Two Wars," 93; Oinas-Kukkonen, "US-Finnish Relations," 155, 156.

53. Eino Saari to Therese Bonney, Valtioneuvoston tiedoituskeskus, Helsinki, April 5, 1940. File: Finland, BANC MSS 83/111 z, c. 12, Finland.

54. Admission/ticket, LA FINLANDE de la Paix à la Guerre, Palais des Beaux-Arts, Bruxelles, 3–15.5.1940. File: Finland, BANC MSS 83/111 z, c. 12; Bonney, "I Cover Two Wars," 90–94.

55. *New York Herald Tribune,* July 28, 1940; Lipton, "War Comes to the People," 10.

56. The Exhibition of Photographs by Miss Therese Bonney, An Invitation to Exhibition Opening, November 15, 1940, Library of Congress, Hoover Institution Archives, National Committee on Food for the Small Democracies records, 1939–1946, Box 7, Folder 8.

57. A press release, The Museum of Modern Art, "Museum of Modern Art Opens Exhibition of Thérèse Bonney's War History Written with the Lens," December 11, 1940, https://www.moma.org/momaorg/shared/pdfs/docs/press_archives/654/releases/MOMA_1940_0085_1940-12-10_401210-76.pdf; Downes, "Thérèse Bonney Photographs Nazi Victims," 49; Gourley, *War, Women, and the News,* 59.

58. Lipton, "War Comes to the People," 6, 9; A press release, The Museum of Modern Art, "Thérèse Bonney on Eve of Exhibition at Museum of Modern Art Honored by Carnegie Grant to Continue Recording War History with Camera in Europe," December 5, 1940, https://www.moma.org/momaorg/shared/pdfs/docs/press_archives/653/releases/MOMA_1940_0084_1940-12-04_401204-75.pdf; Tolley-Stokes, "Bonney," 71.

59. Thérèse Bonney's passport issued on December 20, 1940. File Bonney, Mabel Thérèse: Passports 1938–1961, BANC MSS 83/111 z, c. 11; Therese Bonney, "How Peace Came to Finland," Photogravure Section, *Washington Post,* December 8, 194; Bonney, "I Cover Two Wars," 94.

60. William H. Vanderbilt to Mr. James R. Murphy, Coordinator of Information, New York. "Miss Theresa Bonney," March 12, 1942. RG 226 Records of the Office of Strategic Services 1940–1946, entry 190, box 575, file 367, United States National Archives and Record Administration, hereafter cited as NARA. J. Edgar Hoover to Colonel William Donovan, Personal and confidential by special messenger, March 18, 1942, 2; Therese Bonney to Colonel W. Donovan, New York, March 18, 1942. Both in RG 226, e. 190, b. 575, f. 367. NARA.

61. Richard Harris Smith, *OSS: The Secret History of America's First Central Intelligence Agency* (Guilford, CT: Lyons Press, 2019), 181; William B. Breuer, *Deceptions of World War II* (New York John Wiley & Sons, 2001), 162, 163; Oinas-Kukkonen, "Finland's Relations with the Allied War Effort," 42–45; R. Davis

Miss Bonney Reporting from the Arctic Front | 81

Halliwell to Colonel Donovan, Secret, January 23, 1943, RG226, e. A1-210, b. 326, f. WN13208, NARA.

62. W. Thomas Smith, *Encyclopedia of the Central Intelligence Agency* (New York: Facts On File, 2003), 112, 113; Walter R. Roberts, *Tito, Mihailović, and the Allies, 1941–1945* (Durham, NC: Duke University Press, 1987), 98.

63. R. Davis Halliwell to Colonel David Bruce, Mr. Whitney Shepardson, Mr. Francis P. Miller, Mr. Calvin Hoover, Mr. Robert P. Pflieger, Secret, January 25, 1943; W. R. Mansfield, Preliminary Statement of Mabel Therese Bonney, Secret, January 30, 1943; From William A. Kimbel to Colonel Donovan, February 13, 1943, 1, 3–5; R. Davis Halliwell to Colonel William J. Donovan, Confidential, January 30, 1943. All in RG226, e. A1-210, b. 326, f. WN13208, NARA.

64. See Oinas-Kukkonen, "Finland's Relations with the Allied War Effort," 44–45.

65. "Lowman Major in Army," *The Billboard*, July 4, 1942; Mike Conway, *The Origins of Television News in America: The Visualizers of CBS in the 1940s* (New York: Peter Lang, 2009), 7.

66. W. R. Mansfield, Preliminary Statement of Mabel Therese Bonney, Secret, January 30, 1943. From William A. Kimbel to Colonel Donovan, February 13, 1943, 2; R. Davis Halliwell to Colonel William J. Donovan, Confidential, January 30, 1943. Both in RG226, e. A1-210, b. 326, f. WN13208, NARA. Sander, "*Taistelu*," 49.

67. To Commander William H. Vanderbilt, pp. 1–2, Office of Strategic Services, Q Building, 25th and Constitution Avenue, Washington, DC, July 29, 1942. File: Correspondence and papers re her expenditures, BANC MSS 83/111 z, c. 12; Notes, undated, US Office of Strategic Services Notes; Correspondent's identification card, No. 217, Director, Bureau of Public Relations, War Department, Washington, DC, Issued July, 9, 1942, File Bonney, Mabel Thérèse: Identity papers and official passes, 1940–, BANC MSS 83/111 z, c. 11.

68. "Charles H. Duell, Publisher, Is Dead," *New York Times*, July 12, 1970.

69. Oinas-Kukkonen, "Finland's Relations with the Allied War Effort," 43–46.

70. "Presence of Uninvited Guest Puts Finland into a Flutter," *Newsweek*, June 15, 1942, File: Finland, Clippings, Include reproductions of photographs by Bonney, BANC MSS 83/111 z, c. 12.

71. R. Davis Halliwell to Colonel Donovan, Secret, January 23, 1943. RG226, e. A1-210, b. 326, f. WN13208, NARA; To Commander William H. Vanderbilt, pp. 1–2, Office of Strategic Services, Q Building, 25th and Constitution Avenue, Washington, DC, July 29, 1942, File: Correspondence and papers re her expenditures, BANC MSS 83/111 z, c. 12, Notes, undated, US Office of Strategic Services Notes.

72. Krister Wahlbäck, "G. A. Gripenberg (1890–1975)," in *Suomalainen diplomaatti: Muotokuvia muistista ja arkistojen kätköistä*, ed. Arto Mansala and Juhani Suomi (Helsinki: Suomalaisen Kirjallisuuden Seura, 2003), 271–277; W. R.

82 | Henry Oinas-Kukkonen

Mansfield, Preliminary Statement of Mabel Therese Bonney, Secret, January 30, 1943. From William A. Kimbel to Colonel Donovan, February 13, 1943, 6, RG226, e. A1-210, b. 326, f. WN13208, NARA.

73. Oinas-Kukkonen, "US-Finnish Relations," 156, 157; Breuer, *Deceptions*, 162.

74. Breuer, *Deceptions*, 162; W. R. Mansfield, Preliminary Statement of Mabel Therese Bonney, Secret, January 30, 1943. From William A. Kimbel to Colonel Donovan, February 13, 1943, 1, 3–5, 9; R. Davis Halliwell to Colonel William J. Donovan, Confidential, January 30, 1943. Both in RG226, e. A1-210, b. 326, f. WN13208, NARA.

75. Sedergren, "Lehdistösensuuri," 271.

76. Schoenfeld to the Secretary of State, Telegram, October 28, 1942, RG59 Records of the Department of State, Decimal files, 860D.00/972, NARA.

77. W. R. Mansfield, Preliminary Statement of Mabel Therese Bonney, Secret, January 30, 1943. From William A. Kimbel to Colonel Donovan, February 13, 1943, 13, 15, RG226, e. A1-210, b. 326, f. WN13208, NARA.

78. Ibid., 16.

79. Henry Oinas-Kukkonen, "The Problem of the Finnish Separate Peace, US Initiatives, and the Second Front in 1943," *Faravid* 48 (2019): 63.

80. W. R. Mansfield, Preliminary Statement of Mabel Therese Bonney, Secret, January 30, 1943. From William A. Kimbel to Colonel Donovan, February 13, 1943, 10–12, RG226, e. A1-210, b. 326, f. WN13208, NARA.

81. Ibid., 11–12, 16; Oinas-Kukkonen, "Finland's Relations with the Allied War Effort," 47.

82. W. R. Mansfield, Preliminary Statement of Mabel Therese Bonney, Secret, January 30, 1943. From William A. Kimbel to Colonel Donovan, February 13, 1943, 12, RG226, e. A1-210, b. 326, f. WN13208, NARA; Henry Oinas-Kukkonen, *Finalaska: Unelma suomalaisesta osavaltiosta* (Tampere: Vastapaino, 2017), 186, 187; Oinas-Kukkonen, "The Problem of the Finnish Separate Peace," 49.

83. W. R. Mansfield, Preliminary Statement of Mabel Therese Bonney, Secret, January 30, 1943. From William A. Kimbel to Colonel Donovan, February 13, 1943, 13. RG226, e. A1-210, b. 326, f. WN13208, NARA.

84. Ibid., 1; Breuer, *Deceptions*, 162; Angove, "American Photographer," 9.

85. W. R. Mansfield, Preliminary Statement of Mabel Therese Bonney, Secret, January 30, 1943. From William A. Kimbel to Colonel Donovan, February 13, 1943, 7, 9, 14. RG226, e. A1-210, b. 326, f. WN13208, NARA.

86. Ibid., 14, 17.

87. Ibid., 17, 18.

88. *Aftonbladet*, Uppl. 2., November 17, 1942.

89. W. R. Mansfield, Preliminary Statement of Mabel Therese Bonney, Secret, January 30, 1943. From William A. Kimbel to Colonel Donovan, February 13, 1943, 18. RG226, e. A1-210, b. 326, f. WN13208, NARA.

90. Ibid., 19.

Miss Bonney Reporting from the Arctic Front | 83

91. Richard Harris Smith, *OSS*, 234.

92. Lawrence H. McDonald, "The OSS and Its Records," in *The Secret War: The Office of Strategic Services in World War II*, ed. George C. Chalou (Washington, DC.: National Archives and Records Administration, 2002), 87.

93. Smith, *OSS*, 183; Wilhelm Agrell, *Skuggor Runt Wallenberg: Uppdrag I Ungern 1943–45* (Lund: Historiska media, 2006), 34, 41, 82.

94. Smith, *OSS*, 158, 159.

95. Dick Camp, *Shadow Warriors: The Untold Stories of American Special Operations During WWII* (Minneapolis: Zenith Press, 2013) 42; Smith, *OSS*, 128.

96. R. Davis Halliwell to Colonel Donovan, Secret, January 23, 1943, RG226, e. A1-210, b. 326, f. WN13208, NARA.

97. R. Davis Halliwell to Colonel William J. Donovan, Confidential, January 30, 1943, RG226, e. A1-210, b. 326, f. WN13208, NARA.

98. Jay Jakub, *Spies and Saboteurs: Anglo-American Collaboration and Rivalry in Human Intelligence Collection and Special Operations, 1940–45* (New York: St. Martin's Press, 1999), 248.

99. Jennet Conant, *A Covert Affair: Julia Child and Paul Child in the OSS* (New York: Simon & Schuster, 2011), 77. Heppner was also a junior partner in Donovan's law firm.

100. W. R. Mansfield, Preliminary Statement of Mabel Therese Bonney, Secret, January 30, 1943. From William A. Kimbel to Colonel Donovan, February 13, 1943, 1, 3–5; R. R. Davis Halliwell to Colonel William J. Donovan, Confidential, January 30, 1943. Both in RG226, e. A1-210, b. 326, f. WN13208, NARA.

101. R. Davis Halliwell to Colonel William J. Donovan, confidential, January 30, 1943; William A. Kimbel to Colonel Donovan, secret, February 13, 1943; William A. Kimbel to Colonel Goodfellow, secret, February 13, 1943. All in RG226, e. A1-210, b. 326, f. WN13208, NARA; Richard Breitman, *U.S. Intelligence and the Nazis* (Cambridge: Cambridge University Press, 2005), 20.

102. Memo no. 26, RE: Accounts, Salaries due since September 22, 1942, February 21, 1943, 1; To Colonel Preston Goodfellow, Office of the Strategic Services, Washington, DC, June 9, 1943; Ellen A. Docker to Miss Bonney, July 26, 1943. All in file: Correspondence and Papers re her expenditures, BANC MSS 83/111 z, c. 12.

103. An instruction note, Undated and unsigned; Douglas M. Dimond to National City Bank, August 3, 1943. Both in RG 226, e. 169A, b. 4, f. 156, NARA.

104. W. R. Mansfield, Preliminary Statement of Mabel Therese Bonney,. Secret, January 30, 1943. From William A. Kimbel to Colonel Donovan, February 13, 1943, 13, 15. RG226, e. A1-210, b. 326, f. WN13208, NARA.

105. Ibid., 2; R. Davis Halliwell to Colonel William J. Donovan,. Confidential, January 30, 1943. Both in RG226, e. A1-210, b. 326, f. WN13208, NARA.

106. Script of the *March of Time* broadcast by Therese Bonney on February 25, 1943, from Washington, DC, BANC MSS 83/111 z, c. V. 11, Oversize; Oinas-Kukkonen, "The Problem of the Finnish Separate Peace," 44–46.

84 | Henry Oinas-Kukkonen

107. Inez Whiteley Foster, "Thérèse Bonney Has a Look at Finland," *Christian Science Monitor*, March 2, 1943.

108. Thérèse Bonney, "Report From Finland," *Collier's*, May 29, 1943; see also the contents page of the magazine; Oinas-Kukkonen, "The Problem of the Finnish Separate Peace," 44, 46, 49, 63.

109. Bonney, "Report from Finland," 18.

110. Ibid., 18.

111. Ibid., 18–19.

112. Thérèse Bonney, "How the Finns Live," *Collier's*, August 21, 1943, 24–25; Thérèse Bonney, August 1942–January 26, 1943, England, Sweden, Finland. Bancroft Library, Manuscript Division, Thérèse Bonney photograph collection, Banc PIC 1982.111.05-PIC, Container 3: England, Sweden, Finland, 1942–1943 Logbook, series 5, folder 2.

113. A clipping of an article: Eva Lapin, "Father Walsh Helps a Friend of Finland," *Daily Worker*, November 24, 1943. File: Finland. BANC MSS 83/111 z, c. 12.

114. Lisa Phillips. *A Renegade Union: Interracial Organizing and Labor Radicalism: The Working Class in American History* (Urbana: University of Illinois Press, 2013), 28.

115. Thérèse Bonney, *Europe's Children 1939 to 1943* (New York: Rhode, 1943); Tolley-Stokes, "Bonney," 70.

4

Reporting from the Bureaus
The Lesser-Known World War II Correspondents

Kendall Cosley

In his diary, Associated Press (AP) correspondent Don Whitehead noted two types of reporters during World War II (WWII): war correspondents and combat correspondents.[1] Although scholars often use the terms interchangeably, they have two distinct definitions. Combat correspondents received accreditation, approval from the War Department to report from fronts in exchange for following military rules and being subject to military law. They lived at the military camps and followed the soldiers to the fronts. These reporters gained prominence for relaying the gritty details of the worn-down, tired, but determined American soldiers. Combat correspondents became part of the military with many of the reporters feeling akin to the GIs who starred in their dispatches. In contrast, the war correspondent remained outside of the military machine, lived in relatively safe cities, worked from the comfort of an office, and wrote on the broader geopolitical aspects of the war. The war correspondents, referred to in this paper as war, foreign, or bureau correspondents, had experiences that resembled those of diplomats, including privileges of traveling and attending events and dinners.

Combat correspondents, like Don Whitehead, received much of the fame and credit for reporting the war because their voices came to life through their dispatches. Americans at home felt like they knew the reporters personally. War correspondents, in contrast, are often left out of the story because they wrote the meta-narrative of the conflict rather than the heroic accounts. Their fact-based reporting left little room for the reporters' personalities to shine through. These reporters also seemed to be a step removed from the war since they only occasionally went to the front lines and lived in metropolitan cities. However, the bureau journalists played a pivotal role in informing the American people of the geopolitical movements of the war and its impact on foreign civilian societies. The purpose of this chapter is to shed light on the relatively unknown experiences and hardships of the

86 | Kendall Cosley

war correspondents whose fact-based reporting forms the basis of our knowledge of WWII. Their accounts offer a different perspective of the conflict: the civilian view of war-torn Europe.

The AP Berlin and Budapest bureaus, with mention of the Paris, London, and Stockholm AP offices, will be the primary focus of this study. The main sources are pulled from the letters, diaries, published memoirs, and wire copies of AP employees Louis P. Lochner, Edwin A. Shanke, Alvin J. Steinkopf, and Edward P. Kennedy. I selected these few men as a sample of the war correspondent experience. They were some of the leading bureau reporters at the time. They also experienced several transfers, became prisoners of the Nazi regime, lived among the European populations, and greatly aided in the AP's ability to report on the geopolitical events of the Second World War. Each of these reporters has several forms of documentation, such as personal photographs, AP photographs, letters to their families as well as correspondence among their fellow reporters, and copies of their wire stories. Together, these sources help piece together their experiences and demonstrate how they reported the war.

Lochner, a prominent foreign correspondent and vocal pacifist, became the bureau chief of the Berlin office. He spent most of his time as a war correspondent in Berlin for the AP during his tenure overseas. Shanke worked mainly in Berlin at the beginning of the war, transferring to Budapest briefly in 1938 and permanently to Stockholm, Sweden, in 1942. Steinkopf spent the prewar years in Budapest and relocated to Berlin in 1939. His wife Irene, who worked first for the United Press (UP) and later for the AP, spent the early war years in Copenhagen for health reasons. She returned to the United States in 1941 and reconnected with Al in 1942. Steinkopf and Lochner returned to Germany in 1945. Edward Kennedy worked in the Paris bureau for part of the war, transferring several times to Rome, Algiers, Cairo, and back to Paris. Although the experiences of these four war correspondents are not entirely representative of all bureau workers, their sources allow us to catch a glimpse of what it meant to be a foreign correspondent and to see how they documented the Second World War.

As points of contrast, a few combat correspondents, such as Ernie Pyle, Don Whitehead, and Andy Rooney will be mentioned to differentiate the experiences of war and combat reporters during the conflict. These reporters are perhaps some of the most famous reporters from the war. Pyle published popular books on his experiences at war, *Here Is Your War* (1943) and *Brave Men* (1944), and he also died in the war, becoming a national hero. Don Whitehead covered WWII, the Korean War, and wrote several books. Andy Rooney wrote for the *Stars and Stripes* as an enlisted soldier. Postwar he

worked as a CBS News contributor on *60 Minutes.* He published a memoir titled *My War* in 1995. Known for their personal stories of combat in World War II, these men became solidified in American memory for their impact on the public's understanding of the conflict.[2]

The AP, a national nonprofit, cooperative press association, became one of the leading news outlets for informing the American public of the substantial global shifts over the course of the war. Currently, the AP has bureaus all over the world and is responsible for much of the news stories circulated nation-wide. The AP does not publish its own newspaper. Instead, it sends correspondents around the world to experience events firsthand and write up dispatches. The press association then sells the brief facts and photographs to major newspapers throughout the United States. The goal of AP reporters is to be an eyewitness to international news and provide an objective view of the events.[3] Keeping themselves out of the story is the aim of AP reporters.

The AP is a wire service, meaning they traditionally sent stories along the telegraph wire to sell to newspapers and radio broadcasters. During WWII, The AP's stories and photos reached a vast number of readers and listeners. By 1923 the AP had twenty-three foreign bureaus in major international cities, including Berlin, London, Budapest, Paris, and Stockholm.[4] Americans chosen to work as European bureau reporters interacted intimately with foreign officials and the civilians in these cities. The journalists sent their stories home to New York where news broadcasters then transmitted their stories. Americans nationwide read their dispatches and millions more heard their reports on the radio.[5] When it became evident that a war loomed in the near future, the AP increased its hiring of both foreign and combat correspondents to fulfill its needs of covering all aspects of the global conflict: the boots-on-the-ground view and the quick facts of the significant strategical and political progressions. Don Whitehead exemplified the AP combat correspondent cohort, and he is one of the better-known WWII reporters. The story of the AP's bureau journalists, in contrast, still largely remains in the margins of the history of reporting the Second World War, part of which rests on the nature of wire reporting.

The bureau correspondents essentially had three different methods for crafting reports. Reporters constructed short, "breaking news" dispatches, more fleshed-out stories of the events, and personal interest pieces. The nature of reporting breaking news stories via the wire did not allow for bureau journalists to craft rich and descriptive accounts of the events. Their primary job consisted of getting the word out about the events as quickly as possible. To send a story along the wire, correspondents had to break up

88 | Kendall Cosley

their news into short bits, often excluding filler words. Correspondent Edwin Shanke explained the process in a letter home to his parents in 1938. He wrote, "We try to say as much as possible in as few words as possible because of the expense. As a result, all 'the's' and 'a's' and unnecessary words are omitted and we use peculiar combinations of words to express ideas. For instance, if I wanted to say John Jones went to Rome I would cable it thus: 'john jones romeward.'"[6] Their news came over the wire in disjointed pieces. Shanke's wire story on the German army's capture of Paris demonstrates the choppy nature of wire dispatches. He wrote, "SHANKES TEN 1800 NEWS SEIZURE PARIS SPREAD LIKE WILDFIRE THROUGH BERLIN STOP FOR MANY GERMANS WHO DIDNT HAPPEN BE AT RADIO RINGING CHURCH BELLS WAS SIGNAL SOMETHING PRIME IMPORTANCE HAPPENED STOP."[7] The "STOP" signified the end of a sentence. The words after the break would be a separate message. Editors in New York would receive these wires, tidy up the wording by adding back in filler words and send the breaking news clips to other outlets to spread the information to the American public.

After the excitement of rushing out the breaking news stories died down, the journalists would write more descriptive accounts of the events and send those back to the United States to fill in the gaps. For example, Shanke compiled all his notes on the daily and sometimes hourly movements from the invasion of Poland in 1939.[8] These more comprehensive accounts followed the trajectory of changing lines and capitulation of cities, but sometimes they lacked expressive substance. The importance of these compiled news clippings rested on their usability for other news agencies to piece together the narrative of what happened in a particular battle or campaign. Together, these clippings told the overarching story of the invasion of Poland, the fall of France, Germany's air war over Britain, American troop movements, and eventually the fall of Nazi Germany. As the famous expression goes, journalism is the first rough draft of history, and the bureau reporters' writings provided the overview and timeline of these important events.

The third method of crafting reports consisted of descriptive personal interest pieces. Since the bureau reporters lived in the cities among the populations, they had a front-row seat to the impacts of the war on European civilians. Often, these wire stories provided more in-depth descriptions of the consequences of the conflict. One primary focus of the interest pieces centered on the economic hardships in the European cities. Acquiring material goods became a significant concern as Germany focused its resources on supplying the war.[9] The governments required citizens to ration, limiting the number of eggs, butter, and meat civilians could take home to their families. Correspondents captured the shift in consumerism as goods were

The Lesser-Known World War II Correspondents | 89

not as readily available. Another point of concern rested with the Catholic Church and its response to the Nazi government's seizure of power. For example, Shanke wrote a lengthy article on Bishop Clemens August Graf von Galen who spoke out against Hitler:

COUNT CLEMENS VONGALEN FEARLESS BISHOP OF MUENSTER DEFIED GESTAPO AND OVERNIGHT BECAME CHAMPION GERMAN CATHOLICS STOP STALWART SIXTYTHREE YEAR OLD BISHOP PROTESTED OVER HEADS GESTAPO TO HITLER HIMSELF AGAINST CONFISCATION OF CATHOLIC CLOISTERS RELIGIOUS HOUSES IN MUENSTER AND BANISHMENT PRIESTS NUNS FROM PROVINCE OF WESTPHALIA STOP HIS APPEAL WAS FRUITLESS BUT DRAMATIC STORY.[10]

He captured the weight of the bishop's action and the excitement it ignited within the Catholic community. Shanke breathed as much life into the story as he could withing the constraints of a wire story. These interest pieces resembled the detail-oriented writings of the combat correspondents; however, these stories did not always get published. As stated previously, the purpose of the AP rested on the short, fact-based meta-narrative news, not the little details of warfare.

Although scholars typically hail reporters such as Ernie Pyle for writing the gritty, descriptive accounts of combat in a way that allowed readers to step into the shoes of American GIs, bureau reporters also tried to set the scenes for the American public. Kent Cooper, the New York bureau chief, encouraged the bureau correspondents to write descriptive and personal stories to engage readers.[11] But again, this was a tricky balance to strike if they sent the story within the restrictions of wire reporting. Journalists for non-wire services such as *The Stars and Stripes*, *Yank*, and some of the significant domestic dailies could write more detailed and coherent stories for their editors. Andy Rooney, a correspondent for the military newspaper *Stars and Stripes*, mentioned relaying his stories over telephone or radio after typing them up and getting them passed through the censors. Each paper was allotted three minutes to dictate their story, meaning correspondents had to talk fast to get their entire story told in 180 seconds.[12] Combat reporters could flesh out stories more than wire services because they were not limited to short, abbreviated lines. AP bureau reporters tried to emulate the combat correspondents' writing style by using their personal experiences to detail the background setting of the political events when possible. However, the expensive nature of transmitting long dispatches forced AP reporters to cut down their stories. Due to the choppy nature of wire reporting, the correspondents lost their "voice" and ability to write eloquent prose.

90 | Kendall Cosley

This could attribute to why their writings have been overshadowed by the skillful narration of the likes of Pyle and Whitehead. Foreign correspondents' contributions rested mainly on the fact-based breaking news stories rather than the boots-on-the-ground narratives.

These were the three main writing styles the AP correspondents had to work with when they moved overseas to work as foreign reporters. In the mid to late 1930s, the AP started hiring more foreign correspondents as turmoil increased throughout Europe with the formation of new political parties and coalitions. Personal connections and language proficiency proved to be significant factors in the hiring process. In 1937, Lochner, the bureau chief of the Berlin office, traveled home to Madison, Wisconsin, to visit his children. While in the area, he passed through Milwaukee to talk to a recent Marquette graduate, Shanke, about joining the AP. Part of Shanke's qualifications stemmed from his fluency in the German language. Though in letters home he noted to his parents he felt that he did not have a great grasp of speaking the language, he managed to communicate just fine.[13] Another recruit, Edward Kennedy had lived in Paris in the 1920s, becoming fluent in French. He had worked for the *Chicago Tribune* but in 1932 sought employment elsewhere. The AP employed him because of his reputation as a reporter and for his knowledge of the French language.[14] Alvin Steinkopf joined the AP team in 1931 and reported from Vienna, Budapest, and Berlin throughout the 1930s. Steinkopf too became proficient in Hungarian and German. The AP men and women needed to communicate efficiently with their European hosts and to be able to interview prominent foreign leaders. Thus, the war correspondent cohort became a selective group due to the need for knowledge of foreign customs and multiple languages.

Spending several years in Europe prior to the start of the war allowed the bureau reporters to witness and report on the march toward the war that was unfolding right in front of their eyes. Shanke, for example, on his first job in Berlin covered one of the largest Nazi demonstrations in its history. In his wire story of the 1937 event, he detailed the immensity of the crowd, the excitement, and the pomp and circumstance that went into the affair.[15] Shanke also reported on the Austrian Anschluss vote which allowed Germany to annex the nation. Lochner and Shanke both traveled to Godesberg, Germany, to cover the Sudetenland crisis, which ended in the Munich Agreement, according to which the Sudetenland was ceded to the German empire.[16] The culmination of these events led to the German invasion of Poland in September 1939, an event the AP closely covered.

Living among the European populations also allowed the foreign reporters to better grasp how the civilians felt about the political situation and the

The Lesser-Known World War II Correspondents | 91

rumors about a future war. In much the same way that Ernie Pyle lived with the soldiers and felt akin to their plight during the war, foreign correspondents forged ties with the German, Hungarian, and French populations because they experienced the tumultuous events together. While working in the overseas bureaus, the correspondents had to find housing close to their offices in the European cities. Lochner and his wife lived in an apartment in Berlin and created many friendships with the local population. Some correspondents, to save money, immersed themselves in the culture and rented rooms from German families. Shanke, since he was young, single, and had just begun his career, decided to rent a room from the Volmer family. Living with Frau Volmer and her daughters allowed the inexperienced reporter to hone his language skills and become acquainted with German customs.

Shanke fostered a unique relationship with his adopted family, whom he became quite fond of during his stay. Frau Volmer always tried to make him feel at home by learning some of his favorite American recipes like apple pie.[17] This family offered Shanke an intimate glimpse into the German mind about the war, since Frau Volmer's son Norbert served in the German army. In his letters home to Wisconsin, Shanke often mentioned if the family had heard from Norbert and if they knew roughly where he was stationed. With the German invasion of the Soviet Union in the summer of 1941, Norbert went to the Eastern front and wrote home of the miserable conditions under the Bolshevik rule.[18] Not only did Shanke catch quick tidbits about German soldiers' whereabouts and their sentiments on the war, he also experienced the anxiety felt by German families with sons and fathers off fighting in the conflict.

Though the correspondents saw firsthand the hardships that politics and warfare thrust upon Europeans, their privileged status meant they did not suffer the same consequences as the general population. European host nations treated them like diplomats or ambassadors rather than journalists. The AP bureau workers became a bridge between the European nations at war and the United States. For example, during the early stages of the global conflict, German army leaders would escort correspondents to the war zone, providing them with official information to report. The escorts also took the reporters on little excursions during their trips to the front. Shanke in a letter to his parents described his "splendid tour" of the Maginot Line and a delicious dinner afterward at a famous restaurant called Walters in France.[19] Unlike combat correspondents who lived, ate, and experienced the war at the fronts with the troops, war correspondents had the ability to escape the dangerous and exhausting hardships of life in the war zone.

92 | Kendall Cosley

Foreign host countries benefited from treating the war correspondents well because the journalists could influence public opinion back in the United States. As such, the host nations invited the quasi-diplomats to attend banquets, theater shows, and gallery openings to experience some of the more exceptional cultural affairs European cities had to offer. Lochner and his wife enjoyed attending quartets and farewell dinners for diplomats. They also frequented the opera whenever they had the chance. The cultured pair made a name for themselves among German leaders, which aided Lochner's acceptance by the Nazi elite. Because of his high status, Lochner gained the ability to interview Hermann Göring and Adolf Hitler. Though Lochner did not sympathize with the Nazis and fervently abhorred warfare, he acted professionally and objectively while interviewing the most ardent Nazi figures.[20] Though they were viewed as privileged guests in the countries, sometimes the correspondents, in Germany in particular, had to toe a fine line with the leadership in order to gain access to high-profile interviews and meetings.

The AP had to succumb to Nazi demands on matters of race and ethnicity. Since the AP workers in Germany held a quasi-diplomatic status, the "purity of their blood" became a point of concern. German officials mandated that all media employees had to be of "Aryan" German descent. Nazi party employees screened all AP reporters working in Germany and deemed several of them as "undesirables," meaning they were of Jewish origin. These AP employees would be subject to German racial laws. To protect its own, the AP transferred its Jewish reporters to bureaus outside of the Nazi domain in 1935.[21] Lochner, Shanke, and Steinkopf were all of German descent and could speak the language, which is why they managed to maintain their status in Berlin. The AP complied with German officials because it allowed the news agency to receive insider information, and the company wanted to ensure the safety of its reporters. Other European bureaus did not have to worry about these racial and ethnic concerns, but for Berlin, the heart of the Nazi war machine, it was a grave point of contention.

Berlin in the late 1930s and early 1940s was perhaps one of the busiest bureaus, since Germany was at the epicenter of the political and military maneuvers in Europe. News continuously came into the office from wires, phones, and telegrams, and there was immense pressure to get the stories out as fast as possible. Part of acquiring the freshest information rested on forming strong relations with officials from the European host nations in the war-torn countries. In Germany, for example, the connection between correspondents and Nazi officials centered on a relationship of reciprocity. In exchange for access to the fronts and military reports the correspondents

The Lesser-Known World War II Correspondents | 93

had to use the information provided to them by German officials and submit their wires through a German censor. Officials also restricted what correspondents could observe in combat zones. The AP bureau workers could not go to Poland, France, or Russia unless escorted by German military officers who fed the reporters information on the invasions.[22] The journalists relied on the information the German officials provided to them, such as how many British planes the Luftwaffe shot down or how many ships the Germans sunk.[23] Bureau reporters' access to information hinged on fraternizing with officials and succumbing to government control of knowledge.

Although correspondents had to use the official statements provided by Nazi officers, they added their commentary and put their own spin on the stories in their dispatches. Using words and phrases such as the Germans "claimed" or their agency "allegedly reported" allowed the correspondent to use the official information while emphasizing some of their skepticism on the numbers and statements. For example, in Shanke's wire copy on the German invasion of the Soviet Union in the summer of 1941, he wrote,

OFFICIAL GERMAN NEWS AGENCY CLAIMED RUSSIAN PLANE LOSSES WERE QUOTE GROWING STEADILY HOUR BY HOUR UNQUOTE INDICATING FIERCE AERIAL FIGHTING STOP . . . IN SECOND RAID MESSERSCHMITTS WERE SAID HAVE ANNIHILATED STRONG GROUP THIRTYFIVE RUSSIAN PLANES OVER POLISH GENERAL GOVERNMENT STOP ONLY TWO ESCAPED DNB SAID.[24]

Reporters put the accountability for the information on the German state-controlled press agency, *Deutsches Nachrichtenbüro* (DNB). The journalists did not spread Nazi propaganda by merely regurgitating the facts and figures presented by Axis authorities. Correspondents assessed the messages and presented them in ways that demonstrated their doubts about the official information.

On a more day-to-day basis, the reporters dealt with the more mundane aspects of being newspapermen. Reporting routines for bureau reporters consisted of long hours, continuous writing, and readiness to follow a significant story at a moment's notice. The workers of the Berlin bureau primarily wrote from their desks at the foreign office. The office housed their typewriters, paper, telephones, and a telegraph wire to send their stories back to the New York bureau for publishing in American newspapers. Correspondents spent countless hours, usually burning the midnight oil, typing out the stories they observed that day. Shanke worked the night shift for several months, often with much grumbling, as the stories seemed to never stop coming into the office.[25] Since public speaking events and meetings

94 | Kendall Cosley

between politicians occurred frequently, the bureau always needed a correspondent on call to keep the news of the leading European cities reaching New York continuously.

Although correspondents worked hard in the United States, Shanke alluded to the pace and priorities being different abroad. In his view, "In the states you put in your eight hours, go home and forget the office, play golf, go for a swim or something of that sort. Here a newspaperman constantly is on edge. You put in plenty of overtime, get routed out of bed at 4 a.m. . . . [and] you always have an uneasy feeling something important may be happening right under your feet."[26] They worked long and hard hours, sometimes writing all night and catching a train the next morning to cover a speech or a meeting in a nearby country. Reporting routines for these correspondents paralleled their work environments at home: another day at the office with frequent trips to cover stories, but the urgency and primacy had increased significantly. Combat reporters also experienced intense work schedules, but their exhaustion existed on a different level as they would experience combat, march with the troops, sleep in the foxholes, and then type out a story when they had a moment to rest.[27] These combat journalists lived the story and wrote about it shortly afterward, whereas the bureau reporters had to keep up with constant news feeds from all over the world, not just what happened directly in front of them.

A considerable component of bureau reporting centered on traveling to other European countries for rallies, speeches, and international meetings. Reporters frequently traveled because the AP expected the bureau workers to follow the stories as Germany began extending its influence over Europe. In 1938–1939 the Austrian Anschluss, the Munich Agreement, and Nazi Germany's displays of military might signaled to the world that Germany was heading toward war. The bureau reporters in Berlin went to Vienna to witness the vote to allow Germany to annex Austria. They also covered Hitler's meetings with Neville Chamberlain in Berchtesgaden and Godesberg. Lochner attended the September 1938 meeting in Munich where he witnessed the "Munich Agreement" of Germany's annexation of the Sudetenland from Czechoslovakia. Shanke reported daily and sometimes hourly on the German invasion of Poland and even went to Poland a few days after the German military moved through the country. These events occurred quickly, often back-to-back with very little rest in between.[28] With the story always changing and endless opportunities for covering significant events, the correspondents seemed to perpetually be on the move at a relentless pace.

The continuous travel wore down the correspondents, but it also came with perks. One advantage of the constant movement consisted of the AP

The Lesser-Known World War II Correspondents | 95

men and women visiting beautiful and historic cities. They often went on tours around the towns to get a background on the historical significance of the event occurring in a particular location. Hitler's speech in Danzig, for example, provided an opportunity for the reporters to go on a boat tour of the Free City and learn of its tumultuous past and importance of its free status. The Free City of Danzig had been established in 1920 as part of the Treaty of Versailles after World War I. The city was supposed to be autonomous. However, with Germany's invasion of Poland in September 1939, Danzig lost its autonomous status and became part of the Reich.

The reporters could bring their own cameras and take photos of the places they visited for work or go off touring on their own. Shanke bought a car while in Berlin, and he would travel around Germany on his days off. He took several day trips to visit his ancestral home in Papenberg, visited a palace in Potsdam, and even went to the Berlin Zoo.[29] The young reporter brought his Brownie box camera with him, snapping photographs of himself posing in front of historic monuments or goofing off with his colleagues on their days off. One aspect the journalists discussed in-depth in their personal correspondence was the food they ate while touring new cities. Shanke, never one to turn down a hearty meal, wrote to his parents about the delicacies he ate in Budapest, never eating the same thing twice.[30] The reporters always hunted down some of the best restaurants and foods in the cities, especially steaks and foreign delicacies unique to each community. These correspondents were privileged with access to goods and freedom of movement and could act as tourists even while on the job.

Besides traveling to cover stories, the correspondents also frequently transferred to other European bureaus. The AP relocated workers to other offices if vacancies opened or if they needed more reporters in a particular city that seemed to be bustling with news. In a letter to his parents, Shanke expressed, "There are a great many changes being made in the foreign service. New bureaus being formed and men being switched."[31] Shanke and Steinkopf often alternated working in Berlin or Budapest. Kennedy transferred numerous times throughout the war as his bureau would get shut down and had to move because of the shifting lines. The AP office in Paris, which initially shut down when the Germans took the city, reopened toward the end of the war. There the correspondents worked around the clock to keep up with the Allied advance and desperately needed more staff to send stories on the wire.[32] Constant relocation and demanding work hours could take its toll on the correspondents.

A change of pace helped reinvigorate the tired reporters. The AP allowed each reporter up to a month's leave for a European vacation and six weeks

96 | Kendall Cosley

if they planned to travel back to the United States. Traveling in Europe, especially to neutral countries, did not pose a significant threat to the reporters, but crossing the Atlantic Ocean in the 1940s offered a new danger with U-boat attacks. Regardless of the risks, Lochner, Shanke, and Steinkopf all went on trips home and in Europe. Lochner went on a "majestic" trip to Finland in the summer of 1941.[33] Shanke went on an excursion through Southern Europe in the spring of 1939 visiting Rome and Athens.[34] He also explored various parts of Switzerland in 1940.[35] In 1941 Shanke even boarded a ship to cross the Atlantic for a trip to Bermuda and the United States. Despite the threat of a possible U-boat attack, he noted "The sea voyage was uneventful."[36] Vacations allowed the tired and overworked reporters to rest, recuperate, and experience new and beautiful countries.

Even though bureau reporters received these perks, they still experienced the hardships of being a civilian in wartime. Constant transferring made it hard to keep a lot of belongings while living in Europe. Language barriers also became a problem. Shanke knew German well but struggled greatly with learning Hungarian.[37] For Steinkopf, transfers also meant being separated from his wife, Irene. She worked for the UP and spent most of the war away from her husband, either staying in Copenhagen due to medical issues or returning home to the United States as Europe became increasingly dangerous.[38] Always moving also meant loneliness since correspondents did not put down roots for long and usually only saw their acquaintances in passing. Unlike the combat reporters who lived with the troops and created strong bonds with the GIs, bureau reporters had a small group of friends at the bureaus but usually traveled and lived alone. To top it all off, the reporters had to adjust to a new office space and create relationships with different colleagues every time they transferred to a new location. Losing a friend to another bureau could alter the dynamics of an office space. For some, it seemed that as soon as they settled into one office and made friends, they received a notice of transfer.[39] However, making contacts at various offices could aid the foreign correspondents.

During the buildup to the war and throughout the conflict, the AP had established several important bureaus in Europe, but the ones in neutral countries became crucial centers for transmitting uncensored news. Countries such as Great Britain, Italy, Germany, Japan, and the Soviet Union implemented strict censorship guidelines in the late 1930s and throughout the 1940s. Correspondents writing in those zones had to adhere to the nation's censorship rules when sending reports to the United States.[40] However, neutral countries, such as Sweden and Switzerland, provided the AP and other news agencies an avenue for exchanging information and sending stories

The Lesser-Known World War II Correspondents | 97

home sans censorship.[41] Correspondents from Berlin, Moscow, Rome, and London would telephone their dispatches to bureau reporters in Bern, Switzerland, and Stockholm. Reporters in these offices would then transmit the messages on the wire to the United States. This could be a murky business and got some foreign correspondents into hot water with military censors and their news agencies.

Though many foreign correspondents believed in their duty to inform the American people of the war's progress, their professional aspirations sometimes trumped the military's guidelines and rules for reporters. The war provided reporters an opportunity to become household names. One of the ways to gain fame rested on "scooping" stories from the other correspondents and publishing the news first. Scooping stories also involved questionable methods of breaking the story, including passing the news through unapproved channels. Ed Kennedy is a case in point. Kennedy had been working in the Paris bureau in May 1945 when he learned of the German surrender. The Supreme Headquarters Allied Expeditionary Forces (SHAEF) ordered the correspondents to keep the story silent until military officials released the story. Kennedy disagreed with SHAEF leaders, believing the world had a right to know the extraordinary news. Taking matters into his own hands, Kennedy dictated to a staff member the story of Germany's surrender which the staff member then relayed to the London office using a military telephone. This established and secure line allowed him to get the story to London quickly, and the news broke shortly thereafter. Though Kennedy in his memoirs claimed that he did not scoop the story with the intention of advancing his career, he became the man who informed the world that the war in Europe had finally ended.[42] Evading the rules, however, did not go without repercussions. SHAEF leaders suspended the AP. The suspension on the news agency did not last long, but Kennedy's suspension held. The AP fired Kennedy for undermining the military embargo of the news of the surrender.[43]

While correspondents understood they needed to follow the restrictions and guidelines, and generally did so, some like Kennedy pushed the limits too far. Other correspondents, like those working in Berlin, experienced different tensions and relationships to balance. Those in Berlin could be accused of following the rules and toeing the line with the Germans too much, to the point where they could be considered conspirators with or sympathizers of the Nazi government. This too could jeopardize one's career and reporting legacy.

Some news outlets back in the United States alluded to reporters being Nazi sympathizers or promoting German propaganda; however, the correspondents did not support the political party in Germany.[44] Some historians

98 | Kendall Cosley

have echoed these criticisms from domestic news outlets. Recently, a German historian, Harriet Scharnberg, accused the reporters in Berlin of collaborating with the Nazi officials by partaking in a photo exchange with German photographers via the Swedish bureau.[45] Shanke has been accused of being the middleman in Stockholm who facilitated this exchange. In response, the AP in 2017 published a report of the Berlin bureau refuting Scharnberg's claims. The personal diaries and letters written by these AP workers reveal their disgust and distrust of Hitler, his advisers, and the SS officers. These primary documents support the AP's claims that their reporters did not support the Axis war effort. Lochner despised the German's anti-Semitism and took it upon himself to take in Jewish refugees and try to get them to safety.[46]

Foreign correspondents were horrified by the Nazi actions against the European Jews. Bureau reporters had documented the initial violence against the Jewish populations in the ramp-up to war and saw firsthand the racism and hatred aimed at "undesirable" peoples. Lochner and Shanke paid particular attention to the plight of Jews in 1938 with *Kristallnacht* (the Night of Broken Glass), the violent pogrom against Jewish people and their businesses. The correspondents did not turn a blind eye to the SS attacks or the "othering" of the Jewish populations; however, they had to tread lightly. Much of their contempt for the violence came out in their letters to their families. However, because their messages had to pass through German censors, they had to phrase their commentary very carefully. Lochner used phrases such as "being moved to tears" seeing the aftermath of the "Jewish situation" to express his and his wife's shock and sadness without directly criticizing the government.[47] Knowing the censors would read his letters, Lochner sometimes addressed the censors directly in his correspondence acknowledging that his critiques of Germany would not reach a public audience. His children would be the only ones to read his personal views, and they would not publish the information. In a message about the Jewish situation and the official information given by the Germans, he wrote to his kids, "Can you wonder that sometimes we despair of 'official' information? (You who read this letter: of course none of this is for publication—I want to keep my job here!)."[48] American reporters could send some critiques home, but German reporters who criticized the Nazi government, SS actions, or military affairs sometimes "disappeared." Since the Germans viewed American reporters as diplomats, officials would scold American reporters for their careless stories but did not physically harm the reporters.[49]

While in Germany or Axis-held territories the reporters had to toe the line with officials, but they could be more expressive when they returned

The Lesser-Known World War II Correspondents | 99

to the United States. Lochner, an ardent pacifist, after a brief internment in Germany, moved back to United States in June 1942. While back in the safety and privilege of American freedom of speech and limited censorship, Lochner could convey his true sentiments of the German empire. His book *What About Germany?*, published in 1942, detailed the horrors of the Nazi reign in Germany. Though Lochner loved the country and the German people, he detested the Nazi leaders and underlings who carried out atrocious actions against its own people. His boss, Kent Cooper, suggested that Lochner take some time off from reporting and write about his experiences in Germany. While he initially did not want the Americans to join the war effort because of his ardent pacifism and the fact that his son was of draft age, Lochner understood quickly that Hitler's regime could only be met with force. He wanted the American people to fully get behind the war effort to defeat this tyrant. In his book's introduction, Lochner expressed, "I want the reader to feel as burning an anger as I do at the perversion of civilization that Adolf Hitler is trying to foist on an unwilling world, including millions of his own countrymen."[50]

Lochner, the former Berlin bureau chief, wanted Americans to understand the ugly nature of Hitler's rule, and discussing treatment of the Jews was a prominent feature in his account. As stated earlier, Lochner vehemently hated the treatment of the Jews in Europe, but he could not write publicly about it while working for the AP in Berlin. When Lochner returned home to write his book, he could finally discuss his opinions on the subject. In the book, he described how he and his wife took in Jews on the night of *Kristallnacht*. "During that hideous night," he recounted, "when no Jew dared remain in his own home for fear he might be tortured or murdered, there was not an American house in Berlin which did not offer shelter to some Jewish fugitive from Nazi terror."[51] Lochner could not express his sheer disgust with the Nazi treatment of the Jewish population in his reports for the AP because he feared losing his friendly status with German officials, but he could freely express his views and try to sway public opinion with his book back in the United States.

Witnessing the brutality of the Axis powers across the world and seeing the war's effects of combat on the human condition proved to be a harsh reality of war reporting. Bureau correspondents often visited the combat zone after the end of fighting to examine the repercussions of battle. Reporters walked through field hospitals where they saw the destruction of soldiers' bodies and mental well-being. In Poland, the correspondents observed refugees standing in line, holding all their belongings, trying to get on a transport vehicle to leave the country. On a trip to Krakow, Shanke noted, "One of the

most tragic sights was to see the Polish fugitives, thousands and thousands of them, trudging along the roads with their entire worldly possessions in a bundle on their backs and perhaps with a baby in their arms. They were a pitiful sight."[52] Bureau reporters wrote about the people who were displaced by war and lost everything. In France, the reporters walked through the rubble of destroyed cafes, churches, and houses. Correspondents even went to prisoner of war (POW) camps and documented the experiences of French prisoners whom the Germans forced to defuse booby traps at the Maginot Line.[53] Lochner, because of his status as a distinguished foreign correspondent and bureau chief, received an escort to the Eastern front in 1941, where he saw the countryside burning and soldiers and civilians dying in hospitals.[54] Even though these reporters may not have seen combat on the same scale and magnitude as frontline reporters, they saw the war's impact on the environment, on communities, and on the human condition. Seeing these heartbreaking scenes weighed heavily on the correspondents.

Although the AP bureau workers did not exist in the same level of danger that the combat correspondents did in the foxholes, they still faced threats to their well-being. Living in Berlin became increasingly dangerous. The constant threat of air raids and blackouts proved to be terrifying experiences.[55] For the correspondents in London and Paris, working in the bureau did not provide much safety either as they feared attacks by the Luftwaffe. As the war spread throughout Europe in 1941, correspondents questioned if they should stay in the bureaus and continue to report on the war or return home. Steinkopf, fearing for Irene's safety, arranged for his wife to return to the United States to stay with his father.[56] However, most journalists decided to stay for a variety of reasons, including chasing major stories, belief in the mission of documenting history, or to further one's career.

Ultimately, experiences in bureau reporting depended on the city a correspondent worked and lived in at any given moment. Life in Berlin for the correspondents before the United States entered the war consisted of walking a fine line with the Nazi government and abiding by official guidelines, yet they lived a rather privileged life in the city. Budapest in 1938 and 1939 proved to be more relaxed than Berlin with its constant news streams, but Budapest became tense as the German army began making its way into Hungary. The Stockholm office worked continuously as a middleman for bureaus to send the news to the United States without the hindrance of censorship. Correspondents in Paris wrote nonstop, trying to keep up with Allied advances into Germany.

Each country had different atmospheres and levels of danger, mainly depending on when correspondents worked in certain cities. The relative

safety of being in Berlin at the start of the war quickly took a turn for the worse in 1941. Foreign reporters could remain within Germany if officials deemed them as "friendly," meaning their country was not at odds with the Nazi government. The German forces permitted American correspondents to maintain their bureau in Berlin up until 1941 because the United States had not formally declared war. If American AP workers used the information provided by officials, did not go to the fronts without an escort, subjected their personal mail and correspondence to German censorship, and abided by German censorship guidelines for news stories, the workers could stay within the country. However, once the United States declared war on Japan in December 1941, Germany, in support of their Japanese allies, declared war on the United States. With Hitler's declaration, the American reporters became enemies of the Nazi empire. SS officials rounded up the "unfriendly" reporters from their homes in the middle of the night and brought them into a police station for questioning. SS officers then transported the bureau correspondents to a hotel in Bad Nauheim, Germany, where they spent six months in internment.[57]

Due to their status as quasi-diplomats, reporters spent their internment with American ambassadors. Unlike combat correspondents captured by enemies during battles and questioned as spies, the bureau reporters were treated well in contrast to other POWs. The correspondents created their own newspaper, *Bad Nauheim Pudding*, from within internment, hid a contraband radio they would listen to for information about the war, and played games and tricks on the SS officers.[58] Their confinement did not parallel or compare to that of other WWII POWs. However, the correspondents still experienced the emotions of fear, boredom, and homesickness, and they faced the uncertainty of when they would get to leave internment. After six months at Bad Nauheim, German officials released the reporters and ambassadors in a prisoner exchange with the United States. To inform his parents of his safety, Shanke sent a telegram to his parents with the message, "ARRIVED LISBON FREE AT LAST GOOD HEALTH HOPE EVERYONE AT HOME WELL ASSIGNED LONDON CABLE ME ASSOCIATED LISBON WRITE TO ALL MY LOVE = EDDIE SHANKE."[59]

Upon their release, the AP reporters received transfer orders to other European bureaus, and some returned home for a time. Shanke worked in London for a few months until he transferred to the Stockholm bureau in Sweden where he would spend the rest of his career as a foreign correspondent. Lochner returned to the United States in June 1942 where he immediately produced *What About Germany?* Steinkopf, who reunited with his wife, Irene, took a hiatus from the AP and worked as a radio correspondent

for WBBM in Chicago. In 1944, Lochner and Steinkopf both returned to Europe to continue their work for the AP. Because of their expert knowledge of Nazi Germany, the correspondents joined Ed Kennedy and others who followed the Allied troops as they began their invasion of Germany. Lochner and Steinkopf covered the fall of the Nazi empire from within Germany's borders.

This chapter has focused on the experiences of a few select bureau reporters from various points throughout the war. The correspondents mentioned are not representative of the encounters of all bureau reporters; however, their stories allow us to catch a glimpse of life as a foreign/war correspondent. At times the job could be thrilling by chasing the story or furthering one's career. Other times it challenged the reporters to keep going in the face of danger, exhaustion, and witnessing some of the darkest sides of humanity. Traveling remained a constant and could be a pleasant experience or could add to the exhaustion and burnout of reporters. They had to keep learning the new standards and regulations of censors in each of the cities they transferred to and had to keep up with the demands of their editors.

Bureau reporters held a different status than combat correspondents, who became part of the military. Foreign correspondents lived more privileged lives as quasi-diplomats and captured the war from a different perspective. Combat correspondents risked their lives to capture the essence of combat in their dispatches, and they detailed it eloquently. Pyle, famous for his "average GI Joe" accounts, demonstrated how extraordinary an ordinary American acted in the face of battle. He brought their stories to life through his rich detail. Rooney and Whitehead both used humor and descriptive information to portray the nature of combat to the Americans back at home. Their stories are remembered because the correspondents highlighted humanity amid the chaos and destruction of war. They gave battle a human face and told harrowing stories of the tired, worn-down men who kept going. While these stories certainly needed to be told and have constructed our own understandings of WWII combatants, these were not the only stories of the war.

Highlighting the experiences of the bureau correspondents is imperative for grasping the full scope of reporting the Second World War. Many of the facts and narratives we know of the war today derive from the news flashes and breaking stories written by the men and women who worked in the offices. They wrote the first draft of history because they recorded the who, what, where, and whys of events that the combat correspondents embellished and brought to life. They also revealed a different side of the war than

The Lesser-Known World War II Correspondents | 103

combat correspondents: a behind-the-lines view, a view that combat reporters could not relate to because bureau officials saw what GIs couldn't: life within Nazi Germany and those under its reign. Foreign correspondents saw the impact of the war on European peoples as it was happening versus the combat journalists who witnessed the aftermath of the Nazi occupation. Though these foreign correspondents might not have been as eloquent as combat reporters, they offer a different, unique, and equally important perspective of the Second World War. Because of their work, we know the more comprehensive, overarching narrative of the Second World War.

Notes

1. *Combat Reporter: Don Whitehead's World War II Diary and Memoirs*, ed. John B. Romeiser (New York: Fordham University Press, 2006), 2.

2. Ernie Pyle, *Here Is Your War* (New York: H. Holt, 1943); Ernie Pyle, *Brave Men* (New York: H. Holt, 1944); and Andy Rooney, *My War* (New York: Times Books, 1995).

3. Vincent Alabiso, Kelly Smith Tunney, and Chuck Zoeller, *Flash! The Associated Press Covers the World* (New York: Associated Press in association with Harry N. Abrams, 1998), 15.

4. *Breaking News: How the Associated Press Has Covered War, Peace, and Everything Else*, ed. reporters of the Associated Press (New York: Princeton Architectural Press, 2007), 265.

5. Kent Cooper, *Kent Cooper and the Associated Press: An Autobiography* (New York: Random House, 1959), 3.

6. Edwin A. Shanke to parents, January 9, 1938, box 1, folder 1, Edwin A. Shanke Papers, Marquette University Special Collections and University Archives (hereafter MUUA).

7. Edwin A. Shanke, wire copy drafted for the Associated Press about German troops' march into Paris, 1940, box 6, folder 25, Edwin A. Shanke Papers, MUUA.

8. Edwin A. Shanke, wire copy drafted for the Associated Press about Germany's invasion of Poland, 1939, box 6, folder 16, Edwin A. Shanke Papers, MUUA.

9. Edwin A. Shanke, wire copy drafted for the Associated Press about hardships on the German home front, 1941, box 7, folder 12, Edwin A. Shanke Papers, MUUA.

10. Edwin A. Shanke, wire copy drafted for the Associated Press about Bishop von Galen speaking out against Hitler, July 1941, box 7, folder 9, Edwin A. Shanke Papers, MUUA.

11. *Breaking News*, 226.

12. Rooney, *My War*, 230.

13. Edwin A. Shanke to parents, February 6, 1938, box 1, folder 1, Edwin A. Shanke Papers, MUUA.

104 | Kendall Cosley

14. Ed Kennedy and Julia Kennedy Cochran, *Ed Kennedy's War: V-E Day, Censorship, and the Associated Press* (Baton Rouge: Louisiana State University Press, 2012), xxiv–xxv.

15. Edwin A. Shanke, wire copy drafted for the Associated Press about a large Nazi demonstration in Berlin, 1937, box 6, folder 2, Edwin A. Shanke Papers, MUUA.

16. Louis P. Lochner to Betty and Bobby, April 18, 1938, box 6, folder 38, Louis P. Lochner Papers, Wisconsin Historical Society (hereafter WHS).

17. Edwin A. Shanke to parents, July 3, 1939, box 1, folder 1, Edwin A. Shanke Papers, MUUA.

18. Edwin A. Shanke to family, "Mom-Ber-Dad," August 12, 1941, box 1, folder 3, Edwin A. Shanke Papers, MUUA.

19. Edwin A. Shanke to family, "Mom-Ber-Dad," August 4, 1940, box 1, folder 2, Edwin A. Shanke Papers, MUUA.

20. Louis P. Lochner to his beloved children, November 14, 1937, box 6, folder 38, Louis P. Lochner Papers, WHS.

21. Associated Press, Report, "Covering Tyranny: The AP and Nazi Germany: 1933–1945," 3–5, https://www.ap.org/about/history/ap-in-germany-1933-1945/ap-in -germany-report.pdf.

22. Edwin A. Shanke to parents, September 6, 1939, box 1, folder 1, Edwin A. Shanke Papers, MUUA.

23. Edwin A. Shanke, wire copy drafted for the Associated Press about Germans sinking British ships near Namsos, Norway, 1940, box 6, folder 23, Edwin A. Shanke Papers, MUUA; and Edwin A. Shanke, wire copy drafted for the Associated Press about German bombers assaulting London, September 1940, box 7, folder 3, Edwin A. Shanke Papers, MUUA.

24. Edwin A. Shanke, wire copy drafted for the Associated Press about Germany invading the Soviet Union, June 1941, box 7, folder 8, Edwin A. Shanke Papers, MUUA.

25. Edwin A. Shanke to parents, March 3, 1938, box 1, folder 1, Edwin A. Shanke Papers, MUUA.

26. Edwin A. Shanke to parents, June 7, 1938, box 1, folder 1, Edwin A. Shanke Papers, MUUA.

27. Steven Casey, *The War Beat, Europe*: *The American Media at War against Nazi Germany* (New York: Oxford University Press, 2017), 231.

28. Edwin A. Shanke to parents, October 12, 1938, box 1, folder 1, Edwin A. Shanke Papers. MUUA.

29. Photographs of Edwin Shanke and colleagues, Shanke Photo Album, 1937–1941, box 3, Edwin A. Shanke Papers, MUUA. He also mentioned his tour of German cities in his letter Edwin A. Shanke to parents, September 13, 1939, box 1, folder 1, Edwin A. Shanke Papers. MUUA.

30. Edwin A. Shanke to parents, October 12, 1938, box 1, folder 1, Edwin A. Shanke Papers, MUUA.

The Lesser-Known World War II Correspondents | 105

31. Edwin A. Shanke to parents, March 30, 1939, box 1, folder 1, Edwin A. Shanke Papers. MUUA.

32. Kennedy, *Ed Kennedy's War*, 192.

33. Louis P. Lochner to his dear children, August 18, 1941, box 6, folder 41, Louis P. Lochner Papers, WHS.

34. Edwin A. Shanke to parents, June 11, 1939, box 1, folder 1, Edwin A. Shanke Papers, MUUA.

35. Edwin A. Shanke to "Mom-Ber-Dad," October 21, 1940, box 1, folder 2, Edwin A. Shanke Papers, MUUA.

36. Edwin A. Shanke to "Mom-Ber-Dad," April 30,1941, box 1, folder 3, Edwin A. Shanke Papers, MUUA.

37. Edwin A. Shanke to parents, November 7, 1938, box 1, folder 1, Edwin A. Shanke Papers, MUUA.

38. Alvin J. Steinkopf to Irene, August 26, 1941, box 1, folder 14, Alvin J. Steinkopf Papers, WHS.

39. Edwin A. Shanke to parents, March 30, 1939, box 1, folder 1, Edwin A. Shanke Papers, MUUA.

40. *Breaking News*, 22.

41. Robert W. Desmond, *Tides of War: World News Reporting, 1940–1945* (Iowa City: University of Iowa Press, 1984), 271.

42. Kennedy, *Ed Kennedy's War*, 160–166.

43. Kennedy, *Ed Kennedy's War*, 167.

44. Associated Press, Report, "Covering Tyranny," 23.

45. Harriet Scharnberg, "The A and P of Propaganda: Associated Press and the National Socialist Image," *Journalism in Contemporary History*, online edition, 13 (2016). https://zeithistorische-forschungen.de/1-2016/5324.

46. Louis P. Lochner to his darling children, November 28, 1938, box 6, folder 38, Louis P. Lochner Papers, WHS.

47. Edwin A. Shanke to parents, November 24, 1938, box 1, folder 1, Edwin A. Shanke Papers, MUUA.

48. Louis P. Lochner to his beloved children, March 15, 1938, box 6, folder 38, Louis P. Lochner Papers, WHS.

49. *Breaking News*, 222.

50. Louis P. Lochner, *What About Germany?* (New York: Dodd, Mead, 1942), viii.

51. Lochner, *What About Germany?* 239.

52. Edwin A. Shanke to parents, September 23, 1939, box 1, folder 1, Edwin A. Shanke Papers, MUUA.

53. Edwin A. Shanke to Mom-Ber-Dad, August 4, 1940, box 1, folder 2, Edwin A. Shanke Papers, MUUA.

54. Louis P. Lochner to his dear children, August 18, 1941, box 6, folder 41, Louis P. Lochner Papers, WHS.

106 | Kendall Cosley

55. Edwin A. Shanke to Mom-Ber-Dad, July 15, 1940, box 1, folder 2, Edwin A. Shanke Papers, WHS.

56. Alvin J. Steinkopf to Oscar Steinkopf (dad), August 26, 1941, box 1, folder 14, Alvin J. Steinkopf Papers, WHS.

57. Edwin A. Shanke to "Mom-Ber-Dad," June 2, 1942, box 1, folder 3, Edwin A. Shanke Papers, MUUA.

58. Alvin J. Steinkopf, folder on Bad Nauheim, box 5, folder 2, Alvin J. Steinkopf Papers, WHS.

59. Telegram from Edwin A. Shanke to father, May 17, 1942, box 1, folder 13, Edwin A. Shanke Papers, MUUA.

5 Two African American Journalists Confront World War II
Perspectives on Nationalism, Racism, and Identity

Larry A. Greene and Alan Delozier

The Significance of Roi Ottley and Ollie Stewart

Roi Ottley and Ollie Stewart were two of the premier Black journalists out of a group of twenty-seven African American correspondents covering the Second World War. Both were born in the same year (1906) into middle-class households in New York City and Louisiana respectively. Ottley's parents emigrated from the Caribbean to Harlem and achieved economic success. Stewart was the son of a pastor and dean of Coleman College, a historically Black Baptist college. Ottley, a Catholic northerner, attended a Catholic college, St. Bonaventure, located in New York state, and later the University of Michigan, while Stewart graduated from Tennessee Agricultural and Industrial College, a historically Black college in the segregated South. Stewart reported for the *Afro-American* newspaper chain and was the first African American war correspondent to go abroad during World War II, and Ottley was the first African American to report during the war for a mainstream newspaper, *PM*, based in New York City.

Their coverage of the battlefield struggles of Black troops abroad began in 1942 for Stewart and 1943 for Ottley, but their coverage of the Black struggle at home for civil rights began before their overseas assignments. America's racial past influenced not only their perception of the war but also their perception of America's present and future as seen through the prismatic lens of nationalism, race, and the cosmopolitanism of travel during the war and postwar years.

Analysis of the war begins two months after the December 7, 1941, attack on Pearl Harbor at a time when the African American press had inaugurated a "Double V" campaign led by the *Pittsburgh Courier*, calling for victory over fascism abroad and victory over racism at home. Ottley's accounts from the battlefield are few, but his columns focus primarily on the personalities,

108 | Larry A. Greene and Alan Delozier

circumstances, and perceptions that made up the multilayered nature of interracial relations during the conflict. Stewart wrote many dispatches from the European theater of war from England, North Africa, Sicily, Italy, and Germany with emphasis on the outstanding contribution of African American servicemen and servicewomen whether in logistical support (transport), engineering, or in combat regiments, although a smaller number of African Americans was in combat.

Stewart and Ottley asserted, as did the prose and cartoon campaign of the Black press, that the Axis could be defeated only by the creation of a multiracial democracy at home. Ottley added and expanded on the extension of democracy to the colonized non-white world in his diary written between 1944 and 1945. Stewart's columns, while suggesting overwhelmingly harmonious relations between Black and white servicemen unified in the need to defeat the Axis powers, have to be compared with the columns and editorials in the very same issues of his newspaper, the *Afro-American*, depicting interracial tensions, clashes, and significant discrimination against Black servicemen by the U.S. military at home and abroad. War correspondents' reports were censored, and Black newspapers were watched by the FBI. Consequently, the reporting of Stewart and Ottley reflects that reality in their newspaper accounts, unpublished writings, and postwar observations of the war.

Ottley after the war continued to study Black-white relations as he did in his 1943 well-received work, *New World A-Coming*, and in his 1951 book, *No Green Pastures*. He traveled 60,000 miles visiting twenty-two different countries between 1943 and 1945. Stewart returned to America in 1946 and resumed his career with the *Afro-American*, but his disillusionment with the state of American race relations and the persistence of racism witnessed at the 1946 Columbia race trial in Tennessee played a role among other incidents in driving him to return to France in 1949. He observed: "During the war we did have a chance in a foxhole when things got rough—but I'm not so sure about this place."[1]

Roi Ottley: War Reports to Diverse Readership Circles

As a field correspondent for the New York City–based *PM* daily, Ottley wrote dispatches that also appeared in *Liberty* magazine, the African American themed *Pittsburgh Courier*, and *New York Amsterdam News* between 1944 and 1946.[2] His primary reporting during the World War II era focused on the social aspects of the conflict from a racial and socioeconomic standpoint, which encompassed not only military personnel, but civilians, politicians,

and a comparison of different overseas societies at this time of global conflict.

The commercial and critical appeal of his first major work, *New World A-Coming: Inside Black America*, published in 1943, brought Ottley many honors, but the most important one bestowed in terms of future research opportunities came through the Rosenwald Foundation, known primarily for its promotion of social science–based scholarship. A grant prize of $2,500 from this organization covered a major portion of Ottley's travel expenses during an extended fact-finding trip to study racial situations abroad during World War II.[3] Ottley traveled under the protective cover of war correspondent with the rank of captain as he sought out stories while in small towns, urban areas, military bases, and various offbeat places rather than the front line.[4] Altogether, between 1944 and 1946 Ottley's worldwide odyssey covered 60,000 miles with stops in several different countries throughout Europe, Africa, and the Middle East.[5] This journey resulted in numerous interviews with soldiers, civilians, and government officials that further complemented Ottley's detailed and revealing observation notes related to his unique perspectives on the study of race and civilization.

Ottley hoped Black involvement would be rewarded with equality and improved socioeconomic opportunities in the postwar period. Ottley expressed these objectives in various forms especially in many of his dispatches to *PM*. The New York City–based daily known as *PM* premiered in April 1940, and its distinguishing characteristics included an absence of advertising space and a racially liberal editorial policy.[6] Ottley ultimately became the correspondent on African American affairs with *PM* in 1944 and reported on matters such as Black-white interaction at training bases, African American performance in battle, and racial relations among officers and soldiers of all ranks.[7] Ottley simultaneously promoted the same causes in his *Pittsburgh Courier* articles, and like those, most of his pieces during this time featured such provocative titles as "Fascists Used Jim Crow against Allies," "There's No Race Problem in the Foxholes," "White Folks War?," and "Ethiopia Avenged!" His articles were forthright in substance and style in order to make a strong and memorable point.

When he arrived in Europe during the summer of 1944, Ottley noted that there was a unity of purpose in what he did, and he reflected that " being a war correspondent has become a sort of cult—like some swank upper class fraternity."[8] However, Ottley did note that among some of the white correspondents, he was a "crasher" and was regularly scrutinized, but while resented by some journalists, he and his Black press peers were mostly

tolerated because they posed no real commercial or personal threat to them.[9] Additionally, some African American correspondents resented Ottley because of his ties to a specialty periodical, an opportunity not open to a majority of non-white journalists.[10]

Beyond individual perceptions, Ottley went on to follow his own path and reinforced the need for a strong African American press presence and a "crusade" of purpose.[11] He went on to express the following direct stance regarding his fellow newspapermen and newspaperwomen: "Possessed of no talk-softly policy, it is the Negro's most potent weapon of protest and propaganda, which, perhaps, is an aspect of its voracious appetite for sensationalism. It is a vigorous organ, maintaining a policy of 'race-angling' the news which affects Negroes directly. The daily is essential, but the weekly Negro paper is indispensable."[12] These references are prototypical of Ottley as he went right to the heart of what readers were used to, wanted to see, and now expected to see in their news stories. Regardless of the light or serious themes, Ottley wanted to make his writing mission and subsequent output worth the effort.

Ottley on Democracy and the "Double V"

The one important concept that Ottley used to measure the success of racial relations ultimately focused on full inclusion and a direct "crusade for democracy!"[13] All individuals were due justice and fairness in every area of society according to Ottley. Collectively, he found that support of equality, democracy, and the values of a free society for all African Americans was the legacy left by the Black press during the World War II era. He further maintained that the ideal of democracy and patriotism in the American model was a higher cause that had to be protected at home and abroad.

> The Negro stands at the door of a fretful future. What it will be no man can say—there are no blueprints. The Negro may not be able to predict his future, but he knows what he wants—liberty and peace, and an enriched life, free of want, oppression, violence, and proscription. In a word, he wants democracy— cleansed and refreshed. He wants to be able to feel, see, and smell, and get his teeth into it—democracy can be like that![14]

Furthermore, he called for firm guarantees of racial equality and asserted that hollow pledges without practical policies led to a seriously flawed society that included lack of political power and voting rights and respect, in addition to displaying a colonial mentality, segregation, and other factors that made protest necessary.

Although racial discrimination continued in the military, housing, employment, and other areas of life, improved circumstances were possible. Ottley further believed that African Americans should think of themselves not only as Black but also as citizens of the United States who had much to contribute to the nation in terms of both labor and leadership. He wrote emphatically that "the Negro has shaped the character of American life profoundly" and that white countrymen gave only "lip service" to equality.[15] This led to the dual goal of trying harder to attain the objective of what came to be known as "Double V" recognition.

The "Double V" slogan (victory *abroad* in war and victory *at home* with equal rights) promoted by the Black press and adhered to by the African American masses became synonymous with what they were fighting for as citizens of the United States.[16] When it came to achieving the objectives of the "Double V" in tangible form, Ottley optimistically noted: "Tradition must be overturned, and democracy extended to the Negro. These are hardly the times to fumble with abstractions. . . . Negroes, as well as colored peoples elsewhere, must be galvanized into decisive action on the side of democracy."[17] Despite the adversity of racial intolerance and inequality, the idealism won out for many African American combatants who fought for an Allied triumph first, and then expected full integration and rights as citizens afterward. Beyond generalizations and broad objectives, each individual had his own stories and wanted to feel part of a true-to-life fighting experience to justify his time in the service.

Racial Equality in World War II:
African Americans and the United States Military

Between 1940 and early 1941, close to three million African Americans registered for selective service, and one million were drafted, but only about one third of this total number engaged in duty overseas.[18] However, most African American draftees were placed in the important, but less glamorous, "labor battalions" within kitchens, sanitary units, or other service areas instead of the infantry, engineers, or other frontline specializations.[19]

Despite early doubts, eventually various African American combat units were formed later in the war. The group that Ottley focused on the most in his analysis was the 92nd Division stationed in Italy, which became the lone African American infantry division that saw action in the European theater.[20] He criticized the segregated conditions and racial harassment these soldiers experienced from white critics who doubted their ability to fight effectively. Overall, Ottley noted an oft-expressed viewpoint that many white officers believed that African Americans would crack under the pressure of battle

or would contribute to a state of poor morale among white troops encouraged non-participation of African American soldiers. This segregation perpetuated a low sense of self-esteem among Black soldiers and reinforced the evils of racial bias.[21] Ottley further noted that "waste," "inefficiency," and "neglect" reflected the worst aspects of segregated units such as the 92nd Division and perpetuated negative perceptions and lack of needed support.[22]

Ottley came to the main conclusion that white officers were the ones who contributed to a state of bad feeling and lack of support for their African American charges. He also found that opinions among African American soldiers tended to be open and articulated in a formalized way when posed to them directly by way of General Dwight D. Eisenhower. "The declared policy of the American Army in relation to the Negro soldier is absolutely clear: 'He is to receive the same treatment, wages, rations as the white troops. He is to have equal opportunities for recreation.'"[23] However, this edict was routinely ignored by officers, which made the transition toward equality all the more challenging.

Despite the hardships outlined, the war record of outfits of the 92nd Division generally showed that African American soldiers were more than capable and willing to give themselves to the fight for freedom.[24] After seeing African American troops bivouacked and mirroring the conditions faced by their white counterparts, Ottley asserted that in many instances liberal soldiers came to the conclusion that "they seemed to sense that equality of peril deserves equality of treatment and recreation" not only for themselves but also for their Black comrades in arms.[25] In harsher terms, Ottley noted the following in regard to who was most at blame: "To put it bluntly: . . . With a belief almost approaching a passion, the men felt their white officers were often sending them forward to be slaughtered unnecessarily. With this sort of background, it is a wonder that the division did as well as it did do."[26]

Ottley found that nearly every African American soldier responded "No" to the question "Do you believe that all white men are enemies of the Negro?" Although African American GIs said they received the same rations, clothes, equipment, and food as white troops, more than 95 percent said they had been treated unfairly in the army, and had not received equal opportunity for promotion. There was nearly 100 percent agreement among them that white MPs were unfair to Negro soldiers.[27] This assessment showed a consistency in how they were unfairly treated, and after a review of this poll, Ottley surmised that any white individual who opposes the

concept of democracy can be considered an adversary to the African American community.

Analysis and Conclusions Made by Roi Ottley

Near the end of hostilities during February 1945, the *Pittsburgh Courier* printed select comments made by a returning Ottley, who delivered an address to a receptive audience at a neighborhood YMCA in the Steel City where he summarized his findings on relations abroad and how the African American military was treated. Ottley expressed what he discovered and how the ideals of democracy looked on his return compared to what had been tested during the past few years. When Ottley was quizzed about what African American soldiers expected on their return home, he said on behalf of his audience in the crowd and beyond: "He expects a better America. He wants a good job and more opportunities. . . . [Ottley also] recommended a new approach to labor vocations—such as carpenters, mechanics and other trades—and as a result we have suffered . . . we must give dignity to labor so that men will appreciate whatever jobs they hold. If they appreciate them and are respected for whatever they can do, they'll be happier. . . . [Ottley] further notes a sense of American complacency in a war-torn world. . . . Americans still do not recognize the significance of this war."[28] This was an emotion that would take time to realize especially in the postwar period that was not quite reached at the time of this speech.

When it came to revisiting one of his favorite themes, that of democracy, Ottley emphasized to his audience that:

> The Negro stands at the door of a fretful future. What it will be no man can say—there are no blueprints. The Negro may not be able to predict his future, but he knows what he wants—liberty and peace, and an enriched life, free of want, oppression, violence, and proscription. In a word, he wants democracy— cleansed and refreshed. He wants to be able to feel, see and smell, and get his teeth into it—democracy can be like that![29]

Ottley further emphasized this point and went on to write that considering the the sacrifices African Americans made in war, they expected to receive fairness in peace.

> There is nothing mystical about the Negro's aggressive attitude. The noisy espousal of democracy in the last war gave stimulus to the Negro's cause, and set the race implacably in motion. By advancing it in this war, democracy

114 | Larry A. Greene and Alan Delozier

has become an immediate goal to the Negro. His rumblings for equality in every phase of American life will reverberate into a mighty roar in the days to come. For the Negro feels that the day for talking quietly has passed.[30]

Through this pronouncement, Ottley was echoing the frustrations that time and actions were not moving quickly enough and that the goal of recognition had to happen immediately in a new world of peace and promising opportunities.

Ottley summarized finally:

The Negro's cause will rise or fall with America. He knows well that his destiny is intimately bound to that of the nation. America stands as a symbol of freedom! The loss of this symbol will mean the loss of hope for white and black alike. This war undeniably belongs to the Negro as well as to the white man.[31]

This in sum was a final pronouncement that Ottley wanted to see in his lifetime as he went back to civilian reporting in the post–World War II period.

Remarkably, despite the consistent incidents of racial tension that Ottley encountered firsthand and learned of from various African Americans during his wartime travels, he still contended that the United States held the most personal and economic growth potential for African Americans in the long run. He optimistically believed that, despite the positive prospects found in England, France, and other places visited during his world tour of 1944 (and another two years later). He also looked as other African Americans did to expected rewards. He encouraged leaders and citizenry alike to change their attitudes, reception, and means of support to all individuals as part of a nation now at peace. Although he found his relationship with white people mostly positive before his trip abroad, he became first and foremost a staunch advocate of equal rights not only for African Americans but for all Americans who embraced fairness and the promise of a more harmonious society well into the future. This would become a hallmark of his work, like that of his colleague Ollie Stewart as the postwar era merged into a more active civil rights era in the decades ahead.

Ollie Stewart: From War Correspondent to Expatriate

Ollie Stewart and the *Afro-American* faced the dilemma of how vociferously they could cover and oppose racism and discrimination in the military without running afoul of the federal government, since they were the first

Black newspaper after Pearl Harbor that J. Edgar Hoover sought an indict-ment against based on sedition. Although the indictment never appeared, the threat of it clearly affected the newspaper's coverage of the war. The paper extolled the virtue of the Allied nations over the Axis powers, and their war correspondents praised the soldiers and sailors in the field and at sea, but on the home front the paper relentlessly carried stories of racial conflict in the military, war industries, and Southern "boot" camps. There existed a strategic schizophrenic quality to the reporting as reflected in the *Afro-American* editorials and articles condemning racism on the home front and abroad, whereas Stewart's coverage of racial tensions in the war zones was nearly nonexistent until the end of the war.

Stewart's early career pushed an optimistic belief in America's racial improvement despite the reality of persistent racism. As he matured, his writings reflected more of the civil rights advocacy of the Black press, espe-cially in the later years of World War II and his post-WWII career. Unlike Roi Ottley, he never wrote histories pertaining to African American life or biography. However, Stewart had one of the longest journalistic careers of any Black newspaperman, spending nearly forty years with the *Baltimore Afro-American* and writing several hundred columns for the newspaper chain, which published editions in five different East Coast cities (Baltimore, Newark, Philadelphia, Richmond, and Washington, DC). The *Afro-American* along with the *Chicago Defender* and the *Pittsburgh Courier* were the three largest and most influential Black newspapers in America.[32] Stewart's entire journalistic career was spent with the *Afro-American* from the late 1930s through the Second World War and into the post–World War II era. He was one of at least twenty-seven overseas war correspondents for African American newspapers.

World War II Journalistic Career

Stewart embarked on a 1941 tour of army camps in the American South at the behest of *Afro-American* editor and publisher Carl Murphy. Some twenty-three articles were published on the subject. Stewart's tone is far more critical and less optimistic about race relations than in his 1939 *Reader's Digest* article on the South. Two of his 1941 pre–Pearl Harbor articles were especially controversial. "White Faces Making Lee [Fort Lee] Soldiers Sick" depicted racist white officers who did not understand the desire of Black soldiers for fair treatment. "Here's Stewart's Riot Prediction Powder Keg at Two Army Camps" foreshadowed increased racial tensions between Black and white troops. Stewart's premonition contributed to the displeasure of the FBI with the *Afro-American* newspaper chain.[33] Stewart's articles were part of the

newspaper chain's coverage of racism in the armed services and were not limited to the *Baltimore Afro-American* edition or Stewart's articles. An editorial, "More and Better Riots Brewing," which appeared in the *New Jersey Afro-American*, was critical of army leadership and the War Department for a policy of segregation in basic training camps in the South, which followed the "jim crowed" practices of Southern towns. In the same 1941 issue an article appeared by an unnamed staff correspondent with the headline "Blame Officers at Fort Bragg for Riot in Which Two Die." Racial conflicts were not limited to army camps in the South, for some occurred in the North, and the *New Jersey Afro-American* covered one in an article from the wire service of the Associated Negro Press (ANP) titled "Army Keeps Mum about Oswego Riot," which occurred in western New York state.[34]

What is most interesting was that the *Afro-American* chain placed the blame for the rioting primarily on white military and civilian leaders and avoided the reality that many rank-and-file Americans in the military and civilians in army camp towns were deeply prejudiced against African Americans. The editorial asserted: "Between the majority of colored and white men in the ranks there is no ill feeling, and there has never been. It is easily created, however, by the War Department, which does everything by the Jim Crow rule of the South and does not respect the absence of racial segregation that prevails in Northern and Western States."[35] This assertion ignores widespread de facto segregation in non-Southern states and minimizes how deeply ingrained racial prejudice was among the Southern populace after two centuries of Black racial inferiority propaganda and white supremacy indoctrination.

Black war correspondents faced a challenge about how intensely they could cover racial tensions and discrimination in the armed forces and war industries during WWII given the problems presented in WWI. Would they have to temper their language and ignore critical stories? In World War I, Black leftist newspapers, such as the *Messenger*, and even some more moderate ones, felt the pressure of the Justice Department under Attorney General A. Mitchell Palmer during and after World War I and during World War II under FBI director J. Edgar Hoover. Historian Theodore Kornweibel Jr., in his book, *Seeing Red,* asserted that the term was originally coined by Palmer to smear the the Black press claims of widespread racism with the bias of leftist politics and anti-Americanism.[36] To a large extent, this pattern manifested itself during World War II in the *Afro-American* with the exception that the nation had an attorney general, Francis Biddle, who was sympathetic to free speech against an aggressive J. Edgar Hoover.

Two African American Journalists Confront World War II | 117

On December 8 following the attack on Pearl Harbor, close to twenty Black journalists were told by Colonel E. R. Householder of the Adjutant General's office that elimination of Jim Crow policies like segregation were off the table because the U.S. "army was not a sociological laboratory." Ollie Stewart was at the conference and persuaded the publisher of the *Afro-American* to seek permission to send war correspondents to Europe. Some twenty-seven African American correspondents were sent to the European, Pacific, and North African theaters of operations. The *Afro-American* newspaper chain and the *Pittsburgh Courier* led the way with each sending seven correspondents.[37]

Hoover sought the first FBI post–Pearl Harbor indictment of the Black press in charges against the *Afro-American* newspaper chain on January 30, 1942, based on a brief interview in "The Inquiring Reporter" section of the December 20, 1941, *Baltimore Afro-American* in which a Black printer in an answer to a question said that "colored races as a whole would benefit" if Japan won the war. On January 30 Hoover asked Wendell Berge, head of the Criminal Division of the Justice Department, if the newspaper violated the federal sedition law. Berge said no because it was the opinion of an interviewee.[38] Hoover continued his judicial campaign over the next four years to seek an indictment of the Black press, and he targeted the *Afro-American* newspaper chain.

Angered by the February 1942 Double V campaign initiated by the *Pittsburgh Courier*, FBI director Hoover sent Wendell Berge ten issues of the *Baltimore Afro-American* from March through May of 1942, which he claimed were seditious and possibly in violation of the sedition statute.

After reviewing the ten issues, Berge concluded that none were seditious and consequently did not constitute grounds for indictment. In a May 22, 1942, White House cabinet meeting, President Roosevelt wanted Attorney General Biddle and Postmaster General Frank Walker to talk to African American editors "to see what could be done about preventing their subversive language."[39] Both Hoover and FDR may have been agitated by the *Afro-American* newspaper pre-WWII criticism of American and European foreign policies toward Africa. In the 1920s and 1930s the paper criticized Firestone's interference in the internal affairs of the Liberian government as they sought control over lucrative rubber production and editorialized against American occupation of Haiti. The paper denounced the Italian invasion of Ethiopia in 1935 and the tepid response of the European nations in the League of Nations and that of the United States.[40] While the newspaper vehemently denounced the racist Nazi regime in the 1930s, it heaped praise on Japan as a liberating force for Asia, even denouncing China as the "Uncle

of Tom" of Asia selling out Asian interests to European colonizers.[41] The only significant change in the paper's worldview after the war began was a more critical view of Japan as an enemy nation, which they had already maintained regarding Germany and Italy before Pearl Harbor.

John Sengstacke, editor of the influential *Chicago Defender*, sought a meeting with Francis Biddle to respond to federal pressure. The meeting in June 1942 concluded with some degree of rapprochement between the two men. Sengstacke pointed out to Biddle that the charges of sedition were not valid since Black newspapers were patriotic and their press criticism was nothing new since exposing racism and discrimination in civilian life is what the Black press did decades before World War II. Biddle agreed to facilitate meetings with war agencies and the African American press in response to Sengstacke's charge of a history of exclusion. An example of this rapprochement is the "Victory Through Unity" insert in the September 26 issue of the *Chicago Defender* in which Sengstacke and staff were able to secure essays from FDR, Biddle, and other prominent whites and Blacks praising the loyalty of the African American community.[42] The Double V campaign did not go away, but it underwent a transformation, doubling-down on the concept, emphasizing the racist nature of the Jim Crow South by comparing it to the Nazi regime and the need to defeat both while eventually integrating the army and reducing anti-Black-style pogroms and voter suppression. The ideological and tactical roots of the postwar African American civil rights movement were laid down in the turmoil of the World War II era, complete with the first proposed March on Washington by African Americans for civil rights scheduled for July 4, 1941.[43]

Ollie Stewart arrived in England in September 1942 fresh from America where the embryonic seeds were being planted for a future massive civil rights movement. The path, however, was not free of obstacles. Hoover between November 1942 and July of 1943 sent issues of the *Afro-American, Pittsburgh Courier,* and *Chicago Defender* to Berge inquiring if they violated the Espionage Act. Berge replied they were within the law.[44] Hoover's hostility necessitated caution, subtlety, and a division of labor between home-front reporters and editorialists rigorously advocating a Double V campaign and war correspondents working under direct government censorship and the threat of revocation of their war correspondent status. The seemingly schizophrenic press coverage was tactically sound, as evident in a close reading of Stewart and the *Afro-American.*

Ollie Stewart's articles cabled from England beginning in September 1942 covered the contribution of African American soldiers to the war effort and focused on the quartermaster, transportation, and engineering units

where Blacks were concentrated. In most of his articles he cites the names, units, and hometowns of the Black GIs interviewed. Britons received high marks for weathering German bombing raids and maintaining high morale as well as for their positive receptivity to African American troops. Stewart notes that Black soldiers were invited to the homes of Londoners. The titles are a clear indication of the positive tone of the overwhelming majority of Stewart's articles: "Ollie Stewart Finds British Hospitable," "*AFRO* Writer Finds Londoners Can Yet Smile Despite the War," "Stewart Finds U.S. Well Liked by British People," "Our Boys in AEF Making Good Record," "Outfit Sets Record for Construction, Anxious for Combat," "Boys Haul Troops and Move Supplies 8 to 20 Hours Daily."[45] When Stewart mentions the American Red Cross clubs "for our troops," he implies that they are segregated, but he does not note the controversy in the African American home press over the segregated nature of the clubs, Red Cross segregating blood, the absence of Black commissioned officers, and the concentration of Black soldiers and sailors in noncombat units. Yet there is a positive aspect to his articles that created a sense of pride on the Black home front that African Americans were making significant contributions to the war effort.

Ollie Stewart's columns, while never overtly protest-oriented, contained brief references to racial tensions among Black and white soldiers and other racial issues embedded in articles that were clearly exalting the contributions of Black troops and avoiding wartime censorship. In a column titled "Will Give Attention to Men Stationed in the United Kingdom" after praising Black troops, he noted that he saw no Black combat units. In an extremely rare and atypical observation, Stewart commented on the psychological impact of service, "Physically, the troops are in fine shape. Their health is good, but mentally they are under terrific strain. They are well accepted by the English, but segregation, white officers and strange country keep them jumpy."[46] The complexity of war aims are seldom explored and most often limited to the obvious goals of defeating fascism and preserving freedom and democracy, but a column titled "Ollie Stewart Stops Londoners on Street to Ask War Aims" delves into the multiplicity of goals of such a diverse coalition of nations and ethnicities fighting against the Axis powers. Stewart cogently observed the complexity: "Victory has many faces and freedom means many things. We are all fighting for the same thing, but each man has reduced the big objective to his own personal denomination." Stewart asked the question of an Indian chap in the RAF, what are you fighting for, and he replied, "I am fighting for a free India." To the same question a man from Florida replied, "I am fighting to be free from segregation." A young man from Nigeria answered, "I fight with the hope of going back to my

people to help them develop industry and our national resources." A British home guard soldier stated in explicit detail, "I am fighting for a new life, a job, a home in one of the new planned housing projects, and an end of the dole in England."[47] What is noteworthy is that the colonial respondents of color were most concerned about their contributions bringing economic freedom and some form of national independence to their colonized countries, and Afro-Americans were seeking freedom from American segregation. The British soldier was clearly concerned about improving his standard of living and loosening the reins of the class system in Britain.

Stewart rarely addressed the issue of racism in his columns while in England or other countries. Roi Ottley was more forthright writing for a liberal white newspaper, but Stewart's own newspaper was relentless in challenging racism. While Stewart's columns focused on the efficiency of Black logistical units in England, his newspaper in the same time frame vociferously condemned segregation in the military, lack of Black commissioned officers, anti-Black violence in Southern boot camps and in England by white soldiers, and he even criticized General Eisenhower. The *Afro-American* carried two articles in October 1942 pertaining to criticism of American authorities establishing a "color bar" in England among its troops. Independent member of the House of Commons, Thomas Driberg, asked Prime Minister Churchill to "make friendly representations to American military authorities requesting them to instruct their men that the color bar was not a custom in Britain." Churchill was noncommittal, indicating that "the points of view of all concerned will be mutually understood and respected."[48]

An *Afro-American* editorial from October 1942 placed the responsibility upon President Roosevelt and told him to speak out against the War Department and Secretary of War Stimson's implementation of segregation in England, referring to the House of Commons session. In another editorial, the *Afro-American* called upon FDR to issue an emergency order abolishing "all segregation on account of race in the army, navy and air forces."[49]

A more aggressive editorial blamed General Eisenhower, commander of American forces in England, stating that he "should discipline southern troops or War Department should discipline General Eisenhower" for allowing out-of-control white troops pressuring British tavern owners not to serve Black troops or attempting to force Black troops to ride in the back of British buses or from socializing with the British.[50] As Allied military efforts expanded to North Africa, Italy, France, and Germany, so did racial tensions expand as well. The pattern remains similar with Stewart applauding the virtues of African American soldiers, ignoring racism faced by Black troops,

Two African American Journalists Confront World War II | 121

while the *Afro-American* newspaper chain aggressively challenged the American government to defend its commitment to democracy and FDR's "Four Freedoms."

Ollie Stewart by the late fall of 1942 was on his way to North Africa and landed in Oran, Algeria; he sent a cable in December, "Ollie Stewart with Soldiers in Africa." Like his columns from England, his columns from North Africa extolled the commitment of African American logistical support troops to the Allied war effort with added praise for Tuskegee Airmen on their first overseas combat mission against Rommel's "Africa Corps."[51] He eagerly praised the arrival in Tunisia of Black ground combat troops in the form of artillery and medium tank units, which engaged Rommel's forces as an indirect rebuttal to those decrying the effectiveness of Black combat soldiers.[52] Stewart's commentary on race is subtle and often embedded in articles praising the efforts of Black servicemen. His article with the headline "Stewart No Problem Says White Writer" refers to a comment made by well-known white war correspondent Ernie Pyle in a syndicated column appearing in the *Washington Daily News*: "Ollie Stewart is the only colored American correspondent accredited to the European theatre. He is well educated, conducts himself well and has traveled quite a bit in foreign countries before. We all grew to like him very much on the trip."[53] There is more to this innocuous article, for it suggest that Blacks and whites can get on as equals with mutual respect. The realities of racial tensions are explored in Stewart's columns. Pyle may not have known, and Stewart never revealed in any of his North African columns, that during his first night in Oran a white colonel in charge of press quarters forced him to spend the night three blocks away because he objected to integrated living quarters.[54]

Covering the Casablanca Conference, Stewart's article, titled "Arabs' Peacefulness Baffles U.S. Troops," is an exercise in the soft-sell: "Apparently they have never heard of discrimination based upon color. Every group you see has blacks, whites and in-between. One chaplain [African American] has idea of doing missionary work among them, but after living here for a few weeks decided to abandon the idea."[55] Stewart received a lot of notoriety for a CBS radio broadcast from North Africa celebrating National Negro Newspaper Week, in which he described the vital logistical supply role of Black troops in North Africa and how anxious they were for a combat role. Although he was already in North Africa, he was hundreds of miles from the broadcasting point and had to take a plane to get there, reaching his destination on the day of the broadcast, and he "wrote the script with the help of Charles Collingwood, CBS announcer."[56] While the Stewart columns from the front in North Africa appear with great regularity, his newspaper carries with

equal regularity stories and editorials from the home front of racial conflict and strife.[57]

Reading between the lines, we see that Morocco provided an example of what a multiracial country like America could become. In subsequent articles from Casablanca, Stewart detailed with reverence the press lunch with FDR as he sat two tables away from President Roosevelt and saw General Eisenhower.[58]

His columns from Italy took on a new focus regarding civilian suffering during the war in "What War Bombings Do to the Italian People" and "What Happens to a Mayor When His City Is Invaded?" The destruction of civilian homes from Allied and German bombing, hunger in the towns and villages, people fleeing to the mountains to avoid warfare, mayors without resources to address these problems, and the smell of death from bloated bodies on the battlefield were vividly described by Stewart.[59] Everywhere he witnessed the liberation of an area from German rule, he observed an impoverished and oppressed population. While Stewart reported on the heroic efforts of Black soldiers and the racial unity and equality in the foxholes of the battle zones, his newspaper painted a far different picture of racial disunity and discrimination in war industries on the home front. Even in Italy, the *Afro* observed, "Army Jim Crow Signs Go Up Over in Italy"; there were inscriptions in Naples hotels of "No Negroes" signed by Colonel James E. Manley, area commander of police in Naples. On the home front, the *Afro* articles and editorials were no less vigorous in their criticism of the failure of the army to protect Black soldiers from the military police, the civilian police, and mob violence in basic training camps across the South and the North. The paper raised these questions and the failure of the Navy to allow Black women to join the WAVES or nurses or provide for any Black commissioned officers. Questions were raised whether FDR had the courage to oppose Southern proponents of racial discrimination in his own party. Most disturbing, was the failure of the five American newsreel companies to show Black victims of white mob violence in Detroit and a willingness to exclude Black soldiers from many of its newsreels.[60] The *Afro* considered Attorney General Biddle a liberal ally in opposing FBI director Hoover's attempts to silence the Black press, but when Biddle's confidential letter was leaked advising FDR not to give a radio address to the nation on the race problem and to limit African American migrations to cities, which allegedly could not absorb them due to overcrowding or racial prejudice leading to race riots, questions were raised about the administration's commitment to racial equality.[61]

Ollie Stewart left Italy on his way home for a brief furlough from the battle zone, spending the Christmas holidays in London.[62] He returned to

the United States in the new year of 1944 to highly inquisitive African American audiences eager for war news from abroad. He also spoke to college audiences at Howard and Lincoln Universities about the plight of Black troops in Baltimore, Newark, Philadelphia, and Washington, DC. Stewart was a much sought-after speaker who couldn't possibly fulfill all of the requests. African American war correspondents were equivalent to entertainment and athletic stars. He made his first public address at the NAACP January membership meeting in Baltimore. Four war correspondents just returned from the front, including the *Afro*'s Stewart and Art Carter still in Italy, participated in two half-hour radio programs carried by two of the nation's major radio networks for National Negro Newspaper Week. Stewart in his Baltimore engagement at the St. James Protestant Episcopal Church diplomatically expressed Black soldiers' expectations of expanded civil rights upon their return and for their home-front families to back them up. Stewart was asked many questions after his much-awaited lecture in Newark, New Jersey, at the St. James AME church. "Were there colored officers with colored troops in North Africa, Sicily, and Italy?" He was also asked, "Does the Red Cross discriminate abroad?" He stated that he saw Black commissioned and non-commissioned officers, but did not volunteer information that Black troops wanted many more. His answer to the Red Cross question was evasive, yet clear: "Abroad the Red Cross is just as American as the New Jersey Bell Telephone Company." It had been established by various commissions that Bell Telephone companies discriminated against Black women, and the Red Cross segregated blood. To the all-important question of army policy toward "the prejudice displayed by white soldiers from the South," Stewart with diplomatic clarity to the audience indicated, "The Army's policy abroad is simply an extension of its policy at home."[63]

Stewart in an address at the Allen AME Church in Philadelphia told the audience of the soldiers' hopes for a better life upon their return: "He will be looking for a real democracy—one that did not exist before he left." Soldiers and war correspondents like Stewart were limited in what they could do and say or write, for wartime censorship and military discipline did not lend itself to free speech or actions, as he noted in uncharacteristically blunt language: "The pattern for the American Army was set right here in America," he asserted. "Those who went over didn't change it. If this is to be changed, it's up to you." Injustices faced by civilians at home are a product of the same racism abroad: "You should know what's happening to the boys overseas if you know what they are getting over here."[64]

Stewart returned overseas after the June 6, 1944, D-Day cross-channel invasion of France. He witnessed subsequent battles securing the beachheads

124 | Larry A. Greene and Alan Delozier

and penetrating inland. His readers were treated to detailed descriptions of the beautiful Normandy countryside, French gratitude for their liberation, and the heroic efforts of the supply troops of the famed "Red-Ball express."[65] Perhaps Stewart's most vivid description of his French experience was the liberation of Paris. As one of the first African Americans in the newly liberated Paris, he wrote, "Our arrival concluded three days and nights of camping on the outskirts of the city waiting the mopping up of the last pockets of German resistance." On his first day in Paris the "liberated city staged one of the greatest parades of all times," as he and his colleagues "rode behind General de Gaulle up to the Arc de Triomphe as millions of people cheered and and applauded the Allies." Unfortunately, a bit later he found himself "pinned under a jeep for three minutes by machine gun fire" from the last of German resistance in the city firing from rooftops and windows. The snipers were captured, and Stewart went on to witness the reopening of the City of Light and the return of jazz with liberated African American and French jazz men like the legendary guitarist Django Reinhardt once again playing in the reopened clubs.[66]

While traveling through France with the troops, Stewart said that Pvt. William H. Dockins of Baltimore "asked me whether I thought conditions would be any better for colored Americans after what they were going through over here. I had to admit that I didn't know." Another interviewee from Chicago "wanted to know whether Bilbo [U.S. segregationist senator from Mississippi] was still hating against everything Black and hating colored Americans so much that he was happy to defy the Constitution if it meant keeping colored persons from voting. Again, I had to give a vague answer, because I long ago stopped reading Bilbo utterances."[67] Stewart's understated reply is self-evident to his readers concerning the hopes and aspirations of African American servicemen and his lack of assurance about the future.

The war in Europe would soon end, and Stewart was left to reflect on the meaning of a defeated and occupied Germany for African Americans. He noted in a December 22, 1945, issue of the *Afro-American* that racial tensions in Germany were especially high, and Black soldiers would not go out alone at night without carrying nightsticks. Clashes between Black and white soldiers had been reported in England and France. Yet the mixing of Black and white infantry platoons had some success. Lacking the 20/20 vision of hindsight, the verdict was not immediately clear nor without obstacles. Three years later the American armed forces would be desegregated by executive order of President Harry Truman, but twenty years would pass before the nation would eliminate segregation and voter suppression in

civilian life with President Lyndon Johnson's signature on the 1964 Civil Rights Act and the 1965 Voting Rights Act.

Post-WWII and Pre-Paris Ollie Stewart

Stewart returned to the States for three brief years before leaving for a twenty-eight-year stay in Paris as the foreign correspondent for the *Afro-American*. He covered civil rights issues and race relations. He covered the 1946 Columbia, Tennessee, race trial in which an all-white jury ruled on the charges of the twenty-six Black defendants who were accused of rioting and murder. Stewart covered the Heman Sweatt case of a Black student denied admission to the University of Texas Law School because of race. He witnessed, as did many African Americans, that returning Black soldiers were threatened and attacked; one was even blinded in South Carolina. Expectations were high as were frustrations when the sacrifices of so many African American servicemen were so great. Ollie Stewart need a break from the tension and the sense of disillusionment with America. His explanation for his move to Paris in an interview quoted in the *New York Times* was, "I can concentrate here." In Jinx Broussard and Newly Paul's article on Stewart's Paris years he observed, "In America I would spend 75 percent of my time thinking about color—here color is nothing to worry about."[68] Stewart, like some very prominent African American writers including Richard Wright, James Baldwin, Chester Himes, William Gardner Smith, and cartoonist Ollie Harington, found Paris to be sufficiently liberating to allow them to write and reflect. Stewart's columns covered the Paris scene for American travelers, but he also commented on the American civil rights movement, the Vietnam War, and neocolonialism in Africa and Asia. Stewart found peace of mind and his voice to carry on the struggle for human rights nationally and internationally.

Ottley and Stewart Confronted the War and the Future

Ottley and Stewart were more than war correspondents covering the war against the totalitarian Axis powers; they were also confronting the American ideological contradictions of fighting imperialism and racism overseas while tolerating an American system of apartheid and denial of political rights at home. They waged a two-front war with the pen not the sword, not for territory but to convert America to a more democratic mentality and society. Although taking different paths after World War II, they continued the struggle into the next era. As WWII correspondents, they set the stage for the modern civil rights movement to begin a decade later by preparing

126 | Larry A. Greene and Alan Delozier

African Americans for the struggle they would have to wage and the nation for an understanding of the democratic justice of that struggle.

Notes

1. *Afro-American*, June 29, 1946, as quoted in Jinx Coleman Broussard and Newly Paul, "Ollie Stewart: An African American Looking at American Politics, Society and Culture," *Journal of Pan-African Studies* 6 (March 2014): 233.

2. Maxine Block, *Current Biography, Who's Who & Why, 1943* (New York: H. W. Wilson, 1944), 566.

3. Ibid. Luther P. Jackson Jr. and John A. Garraty, eds., *Dictionary of American Biography (Supplement Six), 1956–60* (New York: Charles Scribner's Sons, 1980), 489.

4. Block, *Current Biography*, 566. *Who's Who in America, 1961–68*, vol. 4 (Chicago: Marquis Who's Who, 1968), 726.-

5. "Roi Ottley Buried in Chicago," *New York Amsterdam News*, October 8 1960, 1, 11. Paul Milkman, *PM: A New Deal in Journalism, 1940–1948* (New Brunswick, NJ: Rutgers University Press, 1997), 90, 148.

6. Roi Ottley, *Notes, Observations and Memoranda concerning Travels in Scotland, Ireland, Wales, England, France, Belgium, Italy, and North Africa—June to December 1944* (1945), 183–184.

7. Roi Ottley, "Negro Morale," *New Republic*, November 10, 1941, 613–615. Milkman, *PM*, 51, 148. John Tebbel, *The Marshall Fields: A Study in Wealth* (New York: E. P. Dutton, 1947), 200.

8. Ottley, *Notes, Observations and Memoranda*, 183–184.

9. Ibid., 184–185.

10. Ibid., 190.

11. Roi Ottley, "New World A-Coming: The Negro Press and Democracy: The Negro Press Is Both a Crusade and Supplement of Dailies on the Negro Freedom of the Press," City Edition, *New York Amsterdam News*, June 3, 1944, 7A.

12. Ibid.

13. Roi Ottley, *New World A-Coming, Inside Black America* (Boston: Houghton Mifflin, 1943), 287.

14. Ottley, *New World A-Coming*, 343. Paul Alkebulan, *The African Press in World War II: Toward Victory at Home and Abroad* (Lanham, MD: Lexington Books, 2014), 143–146. Roi Ottley, *Northwestern University on the Air: Of Men and Books,* 5:8, August 7, 1945, 7–8.

15. Roi Ottley, *Black Odyssey: The Story of the Negro in America* (New York: Charles Scribner's Sons, 1950), 2. Alkebulan, *The African Press in World War II*, 146.

16. Philip McGuire, *Taps for a Jim Crow Army: Letters from Black Soldiers in World War II* (Santa Barbara, CA: ABC-Clio, 1983), 70, 79. John Hope Franklin, *From Slavery to Freedom, A History of Negro Americans*, 5th ed. (New York: Alfred A. Knopf, 1980), 442–444. Patrick S. Washburn, *A Question of Sedition: The Federal Government's Investigation of the Black Press during World War II*

Two African American Journalists Confront World War II | 127

(New York: Oxford University Press, 1986), 54–56, 100–101. (The *Pittsburgh Courier* began printing the "VV" symbol within its pages a couple of weeks after Pearl Harbor. Afterward, over 340 column inches, or approximately 8 percent of the total paper space of text or illustrations on average were in some way devoted to the "Double V.")

17. Ottley, *New World A-Coming*, 344–345.

18. Ottley, *Black Odyssey*, 290. Franklin, 428–430. Brenda L. Moore, "African Americans in the Military," in *The Columbia Guide to African American History since 1939*, ed. Robert L. Harris and Rosalyn Terborg-Penn, Columbia Guides to American History and Cultures (New York: Columbia University Press, 2006), 122. (According to Moore, around 909,000 African Americans served in the military during World War II with 500,000 seeing action abroad, but in "racially segregated engineering, quartermaster, combat support, hospital, aviation, artillery, and armored units.")

19. Graham Smith, *When Jim Crow Met John Bull—Black American Soldiers in World War II Britain* (New York: St. Martin's Press, 1987), 21. Harvard Sitkoff, *A New Deal for Blacks: The Emergence of Civil Rights as a National Issue,* vol. 1: *The Depression Decade* (New York: Oxford University Press, 1978), 321–323. Franklin, 426–430.

20. Roi Ottley, "92nd Had No Faith in Its Leadership," *Pittsburgh Courier*, December 21, 1946, 21. Ottley, *Black Odyssey*, 290. Franklin, 428–430. (The 92nd Infantry Division was one of the few African American infantry divisions to see combat in Europe during World War II as part of the U.S. Fifth Army. The 92nd fought in the Italian Campaign from 1944 until the end of the conflict. They were nicknamed the "Buffalo Soldiers" and fought under the motto: "Deeds, Not Words.")

21. Alan Delozier, "An Examination of Racial Relations in Great Britain and the United States, 1942–45, by Black American Journalist Roi Ottley" (thesis, Villanova University, 1998), 52–53.

22. Ottley, *Black Odyssey*, 294. Ottley, "92nd Had No Faith in Its Leadership"; Michael L. Levine, *African-Americans and Civil Rights: From 1619 to the Present* (Phoenix, AZ: Oryz Press, 1996), 169.

23. Ottley, *Notes, Observations, and Memoranda.* Roi Ottley, "There's No Problem in the Foxholes," *PM*, January 1, 1945, 3–7.

24. Ottley, "92nd Had No Faith in Its Leadership," 21. Ottley, "There's No Problem in the Foxholes," 3–7. (The 92nd collectively won approximately 12,000 medals for bravery in action during World War II.)

25. Ottley, "92nd Had No Faith in Its Leadership," 21.

26. Ottley, "92nd Had No Faith in Its Leadership," 21.

27. Roi Ottley, "GIs Choose 10 They 'Hate to Come Home To': Bilbo Far Ahead in Public Enemy Poll," *Pittsburgh Courier*, September 1, 1945, 12. (Theodore Bilbo [1877–1947] was a U.S. Senator from Mississippi and noted racist. The initials "MP" stand for military police.)

128 | Larry A. Greene and Alan Delozier

28. "Author Airs World Problems in Speech: Roi Ottley," *Pittsburgh Courier*, February 24, 1945, 1.

29. Ottley, *New World A-Coming*.

30. Ibid., 343.

31. Roi Ottley, *No Green Pastures* (New York: Charles Scribner's Sons, 1951), 1. Moore, 121. (One way that helped in terms of equality under the law was the Servicemen's Readjustment Act of 1944 that provided educational benefits for all veterans regardless of race or gender after the war; this act helped on vocational, economic, and status fronts.)

32. Frederick G. Detweiler, *The Negro Press in the United States* (Chicago: University of Chicago Press, 1922); Lee Finkle, *Forum for Protest: The Black Press during World War II* (Cranbury, NJ: Associated University Presses, 1975); Armistead S. Pride and Clint C. Wilson, *A History of the Black Press* (Washington, DC: Howard University Press, 1997); Roi Ottley, *The Lonely Warrior: The Life and Times of Robert S. Abbott* (Chicago: Henry Regnery, 1955); Theodore Kornweibel Jr., *Seeing Red: Federal Campaigns against Black Militancy, 1919–1925* (Bloomington: Indiana University Press, 1998); Washburn, *A Question of Sedition: The Federal Government's Investigation of the Black Press during World War II*; Ethan Michaeli, *The Defender: How the Legendary Black Newspaper Changed America* (New York: Houghton Mifflin Harcourt, 2016).

33. Ollie Stewart, "White Faces Making Lee Soldiers Sick," *Baltimore Afro-American*, November 29, 1941; Stewart, "Here's Stewart's Riot Prediction Powder Keg at Two Army Camps," *Baltimore Afro-American*, July 22, 1941. Both articles are cited in Antero Pietila and Stacy Spaulding, "*The Afro-American's* World War II Correspondents: Feuilletonism as Social Action," *Literary Journalism Studies* 105 (2013): 41, 42.

34. Editorial, "More and Better Rioting," and Staff Correspondent, "Blame Officers at Fort Bragg for Rioting in Which Two Die," *New Jersey Afro-American*, August 16, 1941; Associated Negro Press, "Army Keeps Mum about Oswego Riot," September 20, 1941.

35. "More and Better Rioting."

36. Kornweibel Jr., *Seeing Red*, xv.

37. Pietila and Spaulding, "*The Afro-American's* World War II Correspondents," 45; John D. Stevens, *From the Back of the Foxhole: Black Correspondents in World War II*, Journalism Monographs, no. 27 (Austin, TX: Association in Journalism, 1973), 10, 16.

38. "The Inquiring Reporter," *Baltimore Afro-American*, December 20, 1941; Patrick S. Washburn, "J. Edgar Hoover and the Black Press in World War II," paper presented at the Annual Meeting of the Association for Education in Journalism and Mass Communication, Norman, OK, August 3–6, 1986, 5–7.

39. Quoted in Washburn, *A Question of Sedition*, 80, 81.

40. Haywood Farrar, *The Baltimore Afro-American: 1892–1950* (Westport, CT: Greenwood Press, 1998), 157–165.

Two African American Journalists Confront World War II | 129

41. See for information on Asia and African Americans: Gerald Horne, *Facing the Rising Sun: African Americans, Japan, and the Rise of Afro-Asian Solidarity* (New York: New York University Press, 2018); Marc Gallicchio, *The African American Encounter with Japan and China* (Chapel Hill: University of North Carolina Press, 2000); Brenda Gayle Plummer, *Rising Wind: Black Americans and U.S. Foreign Affairs, 1935–1960* (Chapel Hill: University of North Carolina Press, 1996).

42. Michaeli, *The Defender*, 246–250; Rawn James Jr., *The Double V: How Wars, Protest, and Harry Truman Desegregated America's Military* (New York: Bloomsbury Press, 2013), 137–144; William G. Jordan, *Black Newspapers and America's War for Democracy* (Chapel Hill: University of North Carolina Press, 2001), 36–67, 68–98.

43. See Larry A. Greene, "Race in the Reich: The African American Press on Nazi Germany," in *Germans and African Americans: Two Centuries of Exchange*, ed. Larry A. Greene and Anke Ortlepp (Jackson: University Press of Mississippi, 2011), 70–87.

44. Washburn, "J. Edgar Hoover and the Black Press in World War II," 10–12.

45. Editorial, "Ollie Stewart's First Cable from Britain," *New Jersey Afro-American,* September 12, 1942. See the following articles by Ollie Stewart in the *New Jersey Afro-American*: "Afro-Writer Finds Londoners Can Yet Smile, Despite War," September 12, 1942; "Stewart Finds U.S. Troops Well Liked by British People," September 19, 1942; "Our Boys in AEF Making Good Record," September 26, 1942; "Ollie Stewart Finds British Hospitable," October 17, 1942; "Outfit Sets Record for Construction; Anxious for Combat," October 10, 1942; "Boys Haul, Troops and Move Supplies 8 to 20 Hours Daily," October 17, 1942.

46. Ollie Stewart, "Will Give Attention to Men Stationed in the United Kingdom," *New Jersey Afro-American,* October 3, 1942.

47. Ollie Stewart, "Ollie Stewart Stops Londoners on Street to Ask War Aims," *New Jersey Afro-American,* October 31, 1942.

48. Special to the *Afro*, "House of Commons Hears of American Jim Crow in London," *New Jersey Afro-American,* October 3, 1942.

49. Editorials, "Speak Out, Mr. Roosevelt," *New Jersey Afro-American,* October 10, October 17, 1942.

50. Editorial, "Eisenhower to Blame for Race Friction in England," *New Jersey Afro-American,* October 24, 1942.

51. Ollie Stewart articles in the *New Jersey Afro-American:* "Ollie Stewart with Soldiers in Africa," December 5, 1942; "100,000 Refugees from France Swell Algiers Population," December 12, 1942; "Stewart Talks to Our Boys in North Africa" December 19, 1942; "Ollie Stewart Travels with Troops Supplying Front Lines in N. Africa," December 26, 1942; "Stewart Finds Arabs Short of Sugar, Soap," January 9, 1943.

52. Ollie Stewart in the *New Jersey Afro-American*: "Stewart Sees First Colored Fighters in the Advance on Rommel," April 3, 1943; "Guns Shell Rommel," April 10, 1943.

53. Ollie Stewart, "Stewart No Problem Says White Writer," *New Jersey Afro-American,* December 26, 1942.

54. Stevens, "From the Back of Foxholes," 19. Stewart reveals the incident to Stevens many years later in a May 22, 1971, personal communication.

55. Ollie Stewart articles in *New Jersey Afro-American*, "Arabs' Peacefulness Baffles U.S. Troops," January 23, 1943; "Finds No Color Line in Morocco," February 13, 1943.

56. Ollie Stewart, "Plane, Jeep Got Stewart to CBS in N. Africa for Broadcast," *New Jersey Afro-American,* March 13, 1943; Editorial, "Newspaper Week Broadcast," March 13, 1943.

57. Typical *New Jersey Afro-American* examples*:* Michael Carter, "Race Relations in Jersey War Plants," March 13, 1943; "Still Bar Nurses in N. Jersey Hospitals," March 20, 1943. The articles explored racial discrimination in employment of Black workers in New Jersey war industries and Black nurses in New Jersey hospitals. Similar stories appeared in all five city editions of the *Afro-American* newspaper.

58. Ollie Stewart, "One of Our First Writers to See FDR," *New Jersey Afro-American,* January 30, 1943; "Roosevelt, Churchill in Surprise Visit to North Africa," January 30, 1943.

59. Ollie Stewart articles in *New Jersey Afro-American*: "What War Bombings Do to the Italian People," November 27, 1943; "What Happens to a Mayor When His City Is Invaded," December 4, 1943.

60. *New Jersey Afro-American* articles: "Army Jim Crow Signs Go Up Over in Italy," January 15, 1944; Editorial, "Army Responsible for Tensions," July 17, 1943; "Army Can Protect Soldiers from Civilian Violence—Why Doesn't It?" November 27, 1943; Editorial, "Who's Boss—F.D.R. or the Navy?" November 20, 1943; Editorial, "Has Dixie Got to F.D.R.?" November 6, 1943.

61. Editorial, "Mr. Biddle's Confidential Letter to the White House," *New Jersey Afro-American,* August 21, 1943; "Here's Biddle's Letter to FDR Suggesting Curb on Migration," *New Jersey Afro-American*, August 21, 1943.

62. Ollie Stewart, "Stewart Finds London Full of Holiday Spirit despite War, Fog," *New Jersey Afro-American,* December 25, 1943.

63. "Four War Correspondents to Broadcast from Abroad," *New Jersey Afro-American,* February 19, 1944; "Ollie Stewart Speaks at St. James Church," *New Jersey Afro-American,* February 19, 1944; "Stewart Asked Many Questions," March 4, 1944; "It Happened in Newark: Mr. Stewart Was Right," *New Jersey Afro-American,* March 4, 1944.

64. "Stewart Tells of Soldiers' Hopes," *New Jersey Afro-American*, March 4, 1944.

65. Stewart articles from France in *New Jersey Afro-American*: "Stewart in France," July 15, 1944; "Normandy Land of Plenty despite War, Stewart Says," July 22, 1944; "Tan Gun Crew Stuns Germans," July 29, 1944. (Reports also focused on Black artillery units and engineering units, one of which constructed a 1,000-bed hospital.)

Two African American Journalists Confront World War II | 131

66 "Stewart Describes Triumphant Entry," *New Jersey Afro-American*, September 2, 1944; Stewart Dodges Bullets in Paris," *New Jersey Afro-American*, September 2, 1944; "Paris Sees Rebirth of Swing as Yanks Enter," September 9, 1944.

67. The Afro-American Company, ed., *This Is Our War* (Baltimore: Afro-American Company, 1945), 24, 25.

68. Jinx Coleman Broussard and Newly Paul, "Ollie Stewart: An African American Looking at American Politics, Society and Culture," *Journal of Pan African Studies* 5 (March 2014): 232–234; Ollie Stewart, "Trial Scene Like a Battlefront," *Afro-American,* June 29, 1946. All of the defendants were acquitted under the defense of their legal counsel, NAACP lawyer Thurgood Marshall; Ollie Stewart, "Stewart Sees US on Trial in Sweatt Case," *Afro-American*, May 24, 1947.

6

Bylines and Bayonets
How United States Marine Corps Combat Correspondents in World War II Blended Journalism and Public Relations

Douglass K. Daniel

In the seventy-six hours after the first naval barrage struck the South Pacific atoll called Tarawa and American forces landed on its shores, hundreds of United States Marines died on Betio Beach alone. Bodies floated in the waters off the ring-shaped chain of coral islands. Smoke billowed from transport boats and tanks struck by mortar fire from Japanese inland forces. On the fourth day, November 23, 1943, battered but victorious Marines cleared out pillboxes and other defenses from which Japanese soldiers had held off the amphibious assault. Amid the carnage that killed more than 1,000 Americans and three times as many Japanese,[1] Marine Master Technical Sergeant Jim Lucas found a quiet perch in the ruins of a hangar that the medical corps had transformed into a hospital to begin writing an account of the battle on a borrowed typewriter. He had abandoned the one he carried in a pack during a chaotic landing that first day.[2]

"Five minutes ago we wrested this strategic Gilbert Island outpost and its all-important air strip from the Japanese who seized it from missionaries and native people weeks after the enemy had attacked Pearl Harbor," Lucas wrote. "It has been the bitterest, costliest, most sustained fighting on any front. It has cost us the lives of hundreds of United States marines." He would add: "Before we started it was great fun. We grinned and chortled. We said, 'There won't be a Jap alive when we get ashore.'"[3] Despite a guideline to avoid writing in first person, Lucas described what he experienced as he hit the beach and tried to stay alive.

Lucas was a Marine Corps combat correspondent, a new breed of American serviceman. Nearly all had been journalists with newspapers, wire services, magazines, or radio outlets or had other media experience, including in motion pictures, publicity, or public relations. All had been Marine recruits,

typically undergoing boot camp at South Carolina's Parris Island or the service's base in San Diego before they were assigned to Marine divisions. Carrying a rifle as well as a typewriter, the Marines known as CCs had an assignment unique in the American military at the time: promote the Marine Corps by reporting on its troops as they prepared for battle and fought the enemy. More than three hundred CCs, combat photographers, artists, and public relations officers would serve in the Corps' Division of Public Relations; many would be decorated for their work; several would be wounded, and fourteen would die in service of their country.

Lucas's vivid bylined dispatch from Tarawa appeared in American newspapers eager for an eyewitness account of one of the bloodiest battles in Marine Corps history. Among those publishing his story were the *New York Times, Chicago Daily News*, and other major newspapers as well as smaller dailies such as the *Tulsa Tribune*, the newspaper where Lucas had worked as a courthouse reporter before joining the Marines. His original dispatch was even more dramatic, and more personal, than the version that reached millions of readers. Protocol called for Navy and Marine officers overseeing public information to edit the version Lucas had submitted. They were trained to exclude certain facts in all dispatches from the CCs—primarily names of casualties, details of military activity that could inadvertently aid the enemy, battlefield gore and similar issues of taste, and material that could cast a negative light on the Marine Corps. One example of a section deleted from Lucas's dispatch was his description of the death of a close friend, Second Lieutenant Ernest A. Matthews Jr., a public relations officer who had been standing with Lucas and Corporal Raymond Matjasic, a combat photographer, on a dock when a mortar round struck. Lucas detailed his frantic efforts to pull his wounded friend to safety and then find a corpsman to treat him.

> Snipers were covering the dock, and we crawled up to Matty on our stomachs. The corpsman felt Matty's pulse and heartbeat.
>
> "He's dead," he said.
>
> Matjasic began to cry.
>
> "Let's pray over him, Lucas," he begged, but I was already on my knees. I shall remember that prayer as long as I live. While we prayed, a Marine fell with a sniper's bullet through his head only 10 feet away.[4]

Whether that passage and others were cut for length or because they were deemed too wrenching or for other reasons was not recorded. Lucas would not know how his story had been edited until he saw a clipping from

134 | Douglass K. Daniel

a newspaper. Eventually his original typed report would be filed away in the National Archives along with thousands of other stories written by CCs during the war.

This chapter explores the blend of journalism and public relations that resulted in a significant amount of war reporting that appeared in American newspapers, magazines, radio broadcasts, and motion pictures. It draws from original CC dispatches, newsletter-like bulletins from the Division of Public Relations, oral histories, and interviews.[5] The focus is on print rather than broadcast and film because the combat correspondents' original dispatches allow for a comparison of what was written versus what was distributed for publication. The study examines whether the work of the combat correspondents was mainly journalism or mainly public relations and how striving to meet the conflicting aims of the two approaches to mass communications affected the resulting stories. In addition, the study considers whether the CCs and the policies governing their activities met the stated goals of the Marine Corps in creating its band of writers: general Marine duties, promoting the Corps as a fighting force, collecting military information and facts of historical value to the Corps, and preparing articles of interest to the American public.

Institutional histories of Marine combat correspondents in World War II avoided controversial subjects and critical analysis, preferring instead to commemorate the courage and sacrifice of Marines in general and the efforts of the CCs in particular.[6] The handful of memoirs by former combat correspondents and others in the Division of Public Relations offer more detailed and colorful descriptions of their experiences.[7] The relatively few studies of Marine Corps public relations and the CCs provided academic context to the innovation of placing reporters and other professional communicators with combat units after they had joined the service.[8]

Early Marine Corps Publicity Operations

In the early twentieth century the publicity operations of the Marine Corps centered on recruitment, the lifeblood of any military service. In 1907 it opened its first publicity bureau, a single Chicago office, likely a result of increased enlistment quotas stemming from the Spanish-American War (1898) and the insurrection in the Philippines (1899–1902).[9] The Marine Corps began operating a national Recruiting Publicity Bureau in 1911, first in New York and later in Philadelphia, to handle press relations, publicity campaigns, advertising copy writing, and, starting in 1916, film production.[10]

Two events influenced the Marine Corps to expand its organizational approach to managing its public image. First, Marine exploits at France's

Belleau Wood and other engagements during World War I prompted headlines around the country and enhanced its reputation as a fighting force. Second, the practice of public relations gained credence in corporate America about the same time. Public relations practitioners established professional norms while initiating campaigns to defend or improve the public perception of controversial entities including the oil and tobacco industries. In government, the Wilson administration turned to public relations to develop support for its programs.[11] The close of the first quarter-century of Marine Corps public relations saw a dedicated public relations section opened at service headquarters in 1933.[12]

After Germany invaded Poland in 1939, the United States increased preparations for what many believed was the nation's inevitable role in a worldwide conflict. Competing more than ever with the Army and Navy for recruits, the Marine Corps established in 1941 a Division of Public Relations at its headquarters in Arlington, Virginia, across the Potomac River from Washington, DC. To lead the division, the commandant of the Marine Corps, Major General Thomas Holcomb, chose a thirty-six-year veteran, Colonel Robert L. Denig, with whom he had served in France during World War I. Initially Denig seemed a strange choice because he had no experience in communications. Moreover, he was on the verge of retiring as commander of the Marine barracks in Bremerton, Washington. In recalling his new assignment some twenty years later, Denig described his conversation with Holcomb at headquarters.

> I went in there and he said, "Well, Denig," he said, "what do you know about public relations?" I said, "1 don't know anything about it. I never heard of it before. What is it?" Well, he said, "You'd better learn because that's what you're gonna be." That's my introduction to public relations.[13]

Officially, Denig retired June 30, 1941, but was reactivated the next day, with a promotion to brigadier general and assigned to command the Division of Public Relations, then relegated to a tiny office with a sergeant and two civilian clerks.[14]

The division oversaw all news, information, and other material produced for public dissemination, but recruitment remained its top priority.[15] In August Denig brought to the division George Van der Hoef, a thirty-year-old University of Chicago graduate who had been working for several years as a publicity official with the Federal Housing Administration. Denig had Van der Hoef commissioned as a major and assigned to be his executive officer and the division's assistant director.[16] Denig would recall of Van der Hoef,

"He put me wise to a lot of things that go on that I didn't know anything about."[17] Despite his ignorance—or perhaps because of it—Denig was open to new ideas for promoting the Marine Corps. That fall Denig and Van der Hoef began considering placing journalists with Marine divisions to report on their activities for hometown newspapers and other print media.[18] First and foremost, they wanted stories about the average Marine whether he was a combat hero or one of the innumerable cooks, mechanics, drivers, and other personnel who kept the war machine operating.

Not one but two events on December 7, 1941, gave urgency to their idea. Japanese forces attacked Pearl Harbor, of course, but nearly 2,500 miles to the west, they also struck the American naval and air base on Wake Island. While the Pearl Harbor attack was a one-day event, the battle for Wake Island turned into a two-week siege as more than four hundred Marines, about seventy Navy and Army personnel, and more than twelve hundred civilians endured the assault.[19] No civilian or military journalists reported from Wake Island, which left the dissemination of information to American and Japanese officials. While Navy communiqués announcing continued resistance and other developments garnered headlines, they lacked the detail and color of on-the-scene news reporting.[20] When the Japanese overwhelmed Wake Island just before Christmas Day, the *Chicago Tribune* described the resulting Navy communiqué as "a laconic statement, barren of details of a combat that when all facts are known promises to become a classic episode in American arms."[21] Intense public interest in Wake Island was an argument for the Marine Corps to take charge of reporting the activities of its own men now that America was at war.

Amid the immediate demands of publicity and recruitment, Commandant Holcomb appeared skeptical of the proposal but eventually authorized Denig to try to recruit ten men for what amounted to a preliminary test of the idea's feasibility.[22] In early spring 1942 Denig dispatched his lone sergeant to newsrooms around Washington to announce that the Marine Corps was signing up reporters as correspondents who would accompany combat troops and write about them. The first class of CCs numbered more than a dozen men from the ranks of the *Times-Herald*, the *Post*, the *Star*, the *News*, and the International News Service. Impressed by Denig's success, Holcomb allowed him to expand the informal recruiting effort to other cities.[23] In addition, some journalists who had already joined the Marines learned of the combat correspondents' formation and sought transfers. Some Marine veterans working as journalists would return to the service with the goal of becoming a CC.

Denig and Van der Hoef were eager to assign division reporters to accompany combat-bound Marines as the United States planned its Pacific offensive. In April, Van der Hoef persuaded his friend Herbert C. Merillat, a twenty-six-year-old Rhodes Scholar and Yale Law School alumnus working for the Treasury Department, to accept a commission as a public relations officer. Like Van der Hoef, Merillat had neither journalism credentials nor Marine Corps experience—not even boot camp training. Before a week had passed Merillat, now a second lieutenant, was on his way to North Carolina to join the First Marine Division. With him was thirty-one-year-old James W. Hurlbut, who had served in the Corps for five years before working for the *Chicago Tribune*, the *Chicago News*, and Washington radio station WJSV.[24] Hurlbut would teach the newly commissioned officer about journalism and the Marines.[25] Such was the hurried nature of wartime activities.

The Marine Corps took the combat correspondent proposal public in early June when Holcomb announced that newspaper reporters with at least five years' experience were being accepted for enlistment as combat correspondents. After six weeks training as fighting troops, Holcomb said, they would be given the rank of sergeant and sent overseas with combat units.[26] The announcement reported by the Associated Press noted that none of the service's high standards and physical requirements would be sacrificed. In practice, the physical requirements and the level of experience were flexible. Denig was open to seeking waivers for those whose eyesight or other physical traits fell short of standards, though in training the potential CCs still had to prove their stamina and their accuracy with a rifle.[27] The demand for journalism experience tended to push the age of the average CC several years beyond the typical recruit, who was between eighteen and twenty-one. Most in the initial class of combat correspondents were in their mid-twenties; the oldest was thirty-two.[28]

Two enticements proved to be critical to recruiting journalists and supporting their mission to cover the average Marine: seeing action and achieving rank. By promising them a combat assignment Denig assured those willing to put their professional careers on hold that they would join fighting men and not be assigned to a desk job. Also, the promise of a sergeant's rank after boot camp was a valuable perquisite; a Marine might serve for a decade or more before gaining that rank. Both factors were important in terms of reporting; it would be easier for a noncommissioned officer facing the same risks to relate to and gain the cooperation of the very people the CCs were created to cover. In other words, he would be one of them. "If

138 | Douglass K. Daniel

you were in there as a major or captain you wouldn't have the same cama-
raderie with the enlisted," former combat correspondent Cyril J. O'Brien
observed in an interview in 2005.[29] Some journalists became commissioned
officers who would report and write as well as oversee their sergeants; and
some sergeants would be promoted after outstanding performance and even
become public relations officers themselves.

Recruits enduring the physical and mental pressures of boot camp
needed reassurances that they were not forgotten at the Division of Public
Relations. Beginning in June 1942 and continuing throughout the war, the
division distributed once or twice a month a mimeographed bulletin that
served as a newsletter. At first the bulletin took a breezy air, sharing news
of weddings and births as well as tidbits of information about writing as-
signments and promotional projects. In time it became division headquar-
ters' primary method of communicating policy, criticism, requests for specific
material, and other information to personnel stationed around the world.
A cozy tone eventually gave way to a more official voice, one that could be
congratulatory and encouraging or scolding and sarcastic, often in the same
edition. The bulletin and a log also kept track of stories, serving the dual
purpose of assuring individual CCs that their copy had been received and
published while subtly shaming less productive writers.

By mid-July 1942 the first eleven recruits had returned to Washington
as Marine privates to undergo orientation at the Division of Public Relations,
perform writing and editing tasks, and await their promotions to sergeant
and an overseas assignment. They lived either in the barracks at the Navy
Yard or civilian quarters in the city. Reporting to headquarters by eight each
morning but Sunday, they might receive a lecture from Denig about their
future work as well as lectures from other high-ranking Marine officers
about censorship and security regulations. When writing news releases or
other material, they worked with the kind of typewriter they would take
with them overseas, typically a small Hermes portable. By four-thirty in the
afternoon they were off-duty. The respite was short-lived for most; the av-
erage CC spent just a few weeks at headquarters before being transferred
to a Marine division.[30] Their ranks continued to grow; more than thirty CCs
were undergoing orientation at headquarters later that summer.

Denig and Van der Hoef often traveled around the country, speaking to
civic and business groups to seek cooperation in promoting the Marine
Corps, and appearing at professional gatherings of journalists. After Van
der Hoef returned from a convention of the National Editorial Association,
the bulletin reported in July1942 that he found many editors "woefully ig-
norant" about the Marine Corps but enthusiastic about the possibilities the

combat correspondent program presented. "Especially do they want to get information about the boys from their home towns serving abroad."[31] Throughout the war the bulletin would maintain a drumbeat on the point.

In their interaction with editors and publishers and in news stories, Denig and Van der Hoef assured the press that the combat correspondents would assist civilian reporters and not compete with them. Some in the press remained wary that "government competition" was afoot, but CCs were reminded that their job was not aimed at "scoring beats over accredited civilian reporters."[32] Such concerns appeared to diminish over time as the CCs wrote the locally oriented stories that most civilian correspondents with major publications passed over. CCs provided information to civilian correspondents and were quoted in their stories, often by name. Civilian correspondents could use such material without attribution in stories that reached American news media long before the CCs' stories, limiting interest in the CCs' own work.[33] Losing space was accepted to adhere to division policy of not competing with the civilian press.

By the end of the summer of 1942 combat correspondents were being sent to Marine operations in Alaska, British Guinea, Trinidad, Cuba, Iceland, England, Ireland, and Hawaii's Pearl Harbor, the most likely stopover for a CC destined to accompany a Marine division heading to the Pacific theater. With their early assignment to the First Marine Division, public relations officer Merillat and combat correspondent Hurlbut were the first division personnel in combat. Their stories, particularly Hurlbut's from a transport ship to the Solomon Islands and Merillat's report on the Marine landings at Tulagi and Guadalcanal, were prominent in newspapers. In a September dispatch from Guadalcanal, Hurlbut described a patrol operation against the Japanese.

> Enemy forces were well dug in. They had trenches and machine gun nests and many snipers in trees. Here again their uncanny ability at concealment was demonstrated. Lieut. John E. Flaherty of Wilmington, Del., reports that while leading a platoon he was fired upon at least 50 times during the day by snipers without out actually seeing one.
>
> One of our lieutenants and his runner, a private, were active in reconnaissance work, going well ahead to scout enemy positions. While they were moving in the open, our observers saw the private shot and killed by a sniper. The lieutenant bent over the private to give aid and was also hit.
>
> Marine Gunner Edward S. Rust, of Detroit, Mich., said he saw the lieutenant, although mortally wounded, fire on the Jap sniper with his pistol. The Jap was found dead a few feet away with two slugs in his body.[34]

Compared to the communiqués about Wake Island, such stories offered readers energetic writing and descriptions of Marine activity, often in narrative form. "All in all, the press has given the combat correspondents a fine reception," the bulletin reported, "and now that we're 'in' it's up to the whole gang to follow through."[35] Not lost on those yet to be deployed was the prospect of national headlines.

The Division of Public Relations grew into a thriving operation. One year after the public appeal for journalists to enlist, more than 100 were reporting from various Marine Corps operations. The number of stories received at headquarters topped 1,000 a month in May 1943, rose through the year to a high of 2,523 in September and would continue to number more than 1,500 a month throughout the war. Photographers had sent in an estimated 900 photographs in March 1943 and by May the number reached 1,500.[36] Footage shot by the division's motion picture cameramen became a documentary, *With the Marines at Tarawa* (1944), which won an Academy Award. By the time the division entered its fourth year of training combat correspondents, in July 1945, its ranks included 275 officers, enlisted personnel, and clerks.[37] Another sign of success: In spring 1944 the Army had begun operating a new unit, the Information and Historical Service, which sought to recruit experienced journalists. The War Department described the unit's GI reporters as "foxhole writers" and outlined their mission with goals similar to those of the CCs.[38]

Just as the civilian press took time to see the merits of the combat correspondents, those in the Marine Corps itself were initially unsure of the CCs' purpose and could be dismissive about their operation and mission. Numerous CCs reported quizzical looks and even hostility from officers. Some of the writers who became Marines were put to work digging ditches and performing other routine tasks. Such attitudes quickly changed once stories about the officers and their men began to appear in print. Denig would later recall how officers' attitudes changed: "They realized that the public relations section took an appreciable load off their shoulders, that it was compiling a valuable history of their unit's part in the show, that it was a consistent booster of the morale of their men, and that it was doing an irreplaceable service back home."[39] Officers would naturally be suspicious, not knowing the difference between a journalistic operation in a traditional watchdog role and a public relations effort designed to present a positive image.

A Journalistic Operation

Journalists turned into Marine writers were not left to their judgment alone when deciding what to report and how to report it. Through pre-deployment

Bylines and Bayonets | 141

orientation at division headquarters and through the bulletin, the Division of Public Relations provided guidance on subjects, style, content, and presentation. To process the stories and other material that came from those in the field, the division developed a structure similar to that of a newspaper city room in which reporters wrote stories and editors reviewed and changed them before determining their placement in pages. Establishing the "city room" at headquarters fell to Captain David E. Nopper, who had worked for the *Washington Post, Baltimore Sun,* and the Maryland statehouse bureau of the Associated Press before joining the Marine Corps in 1942.[40] The structure Nopper devised was not only familiar to the combat correspondents who came from the news media, it provided the operation more journalistic character.

The copy chain began when a CC completed a story and turned it over to his public relations officer, who conducted an initial edit. A Navy security officer, working in Pearl Harbor, Washington, or another behind-the-lines location, then checked the story for any information that could benefit the enemy. Forwarded to division headquarters, the story was edited in its so-called city room for style and other content matters as well as any censorship deemed necessary. It was then revised or even rewritten before being typed, mimeographed, and branded an official Marine Corps press release. Division personnel determined which news outlets would receive the story, ranging from regional and national wire services to major newspapers, small dailies, and weeklies. Public relations personnel at districts around the country ensured that local media received copies of stories, among them a subject's high school newspaper and former employer.[41] In the summer of 1944 the division began producing what it called a clipsheet, a nine-column page designed to showcase the week's best stories. It was mailed each Monday to 4,900 daily and weekly publications.[42]

As part of the effort to promote the Marine Corps in any venue, the division developed stories for news and consumer magazines, special interest publications, professional journals, and industry and other nondaily publications. The division established a New York office to deal specifically with magazines, though its focus would be those with a national circulation.[43] The division bulletin warned CCs that bylines in *The Saturday Evening Post* and *Colliers* were nearly impossible, but they were told that such publications would gladly accept exclusive material with the understanding that the magazines could do with it as they chose.[44] The United States government paid the CCs, of course, and division headquarters reminded them that they were not allowed to solicit or accept paid assignments as freelancers.[45]

142 | Douglass K. Daniel

Weeks would pass as a story traveled through the copy chain and reached the civilian press. The initial stories from Guadalcanal took two to four weeks to reach newspaper readers.[46] Airmail was the mode of delivery for stories from the field to division headquarters, just one factor contributing to the time lag. Radio, telegraph, or telephone may not have been employed because of expense and the priority of more important transmissions. Security clearances as well as editing by the division's city room staff of two or three people were other factors. The division did seek to shorten the delay for extraordinary events. For example, when Marines landed at the western Pacific island of Saipan in June 1944, the division's city room worked around the clock to process stories and approved 315 for distribution in two days. Large numbers of stories, photographs, motion picture films, and radio recordings from Saipan continued to arrive at headquarters for weeks thereafter.[47]

For much of what the combat correspondents covered, the number of days that passed before their stories reached readers did not matter. CCs were assigned to write about the average Marine before, during, and after a battle or the Marine serving in a noncombat zone. The focus on the common Marine was summed up by the CCs' nickname for such stories, "Joe Blows." Not unlike the nickname "GI" in the United States Army meant "General Issue," Joe Blow was a Marine Corps term for the recruit or the ordinary man in uniform. Outside of battle, the story could be anything from a profile to a humorous piece that allowed its subject a moment of public recognition for doing his part in the war effort. The division stylebook reiterated the reason and need for such stories.

> While the daily activities of the men in your unit, and their environment, are ordinary stuff to you, they are matters of great personal concern to people in the States whose sons, husbands and neighbors are, as we say, somewhere in the South Pacific. Don't let routine and daily contact with your news sources dull your appreciation of their news values back home.
>
> When you are not in combat write the individual stories of men who are standing by awaiting their turn; when you go into combat write the stories of the men behind the stories—and you will be giving the American people one paramount part of the war coverage we ask you to be determined they shall have.[48]

Division headquarters demanded that each Marine referred to by name in a story be identified by his hometown as well as his military serial number, the latter a way of helping headquarters check that the name and other

information were correct. Of particular concern were photographs, a never-ending source of headaches at headquarters as editors tried to ensure captions were correct, photos and stories were available simultaneously, and film was not damaged in transit.

The bulletin at times carried some of the most basic rules of news and feature writing: focus on a key point, write tightly, and avoid repetition; show instead of tell; check for style, spelling, and accuracy. Stories came in at 800 words on average when press associations informed the division that 300 to 400 words or less were enough for stories that were not major news. "We don't want, we can't use, flowery writing. We want direct writing. Say what you have to say with punch, with the fewest words possible," the bulletin advised. Another admonition: "Don't pad. The illusion seems to persist with some that a story is judged on the basis of quantity rather than quality."[49] Nonetheless, complaints from division headquarters lingered and grew sharper.

One rule dealt with racial references to African Americans. In general the bulletin reflected attitudes in the civilian press that later generations would recognize as racist. The bulletin and CC stories routinely referred to the enemy as "Japs," an accepted racial pejorative of the time. The first edition of the bulletin jokingly called a Spanish-language magazine "a slick in spic," a rare reference to anything Hispanic.[50] African American Marines were a recent development in the Corps, which only had begun enlisting Black men in summer 1942 after having rejected them solely on the basis of race. A bulletin entry in October 1943 advised the CCs to identify any African American Marine as "a Negro" in their copy, especially for stories bound for the Southern Procurement Division (SPD), which distributed copy locally. "Southern newspapers for whites do not publish Negro news or carry it on a separate page. Consequently, stories concerning Negro service personnel are sent by the SPD to the Negro press. The SPD reports receiving some stories about Negroes that have not made their identification clear."[51] Nonwhite racial identification was not unusual in the American press at the time, and the Division of Public Relations honored the practice of segregated news reporting.

Subjects for stories were a regular topic in the bulletin. The division frequently listed those not worth the CCs' attention or those whose interest with civilian editors had waned. They included pets, general accounts of trips, appeals for mail from home, general morale pieces, books the troops were reading, and worship services.[52] The personal approach had limitations: The bulletin advised CCs not to refer to a Marine's girlfriend as the woman he intends to marry because sometimes it turned out not to be the woman's

144 | Douglass K. Daniel

plan and she was embarrassed when such statements appeared in the local newspaper.[53] Headquarters complained that some CCs were still having trouble finding something to write about and pointed to a story arriving in May 1943 relating to the attack on Pearl Harbor. The bulletin commented, "At that rate we'll soon be trying to tell the folks about the Revolutionary War."[54]

Newswriting veterans, college graduates among them, may have chafed at what could be taken as the bulletin's patronizing attitude. Cyril J. O'Brien, who had been a reporter for the Camden, New Jersey, *Courier-Post* when he joined the Marines as a CC at twenty-three in 1942, recalled how the CCs were a professional cadre.

> The only training we had to have was training as Marines. We were just as much Marines as any rifleman who fired an M-1. We didn't have to have newspaper training because we were all reporters already. The Marine Corps sure as hell couldn't teach us anything about journalism.[55]

However, the public relations officers who published the division bulletin clearly did not share O'Brien's sentiment. They routinely praised their far-flung staff but also scolded them, at times by name, for failing to write succinctly, follow style, and provide correctly spelled names and other accurate information. "We don't appreciate having to do elementary copy-editing on your material. Make your stories easy to get out once they arrive here, if you care about your reputation at headquarters."[56] It may be that the news experience of many CCs was limited and in their ranks were many average writers, a reflection of the range in quality within the civilian media. For their part, combat correspondents complained that following the stylebook required a great deal of concentration for men often under fire. In response, headquarters lifted most style rules in October 1944, advising CCs to "write as you please."[57]

The Marine landings at Iwo Jima in February 1945 showed the progress the Division of Public Relations had achieved. The six-week battle for the Japanese island brought another all-hands response at division headquarters. Stories, photographs, and motion picture film from Iwo Jima were picked up in Guam and flown to Chicago and then New York, where the film was processed and the stories sent on by train to Washington. Along the way a story by combat correspondent Keyes Beech was dropped off in Philadelphia, processed, and transmitted by national wire services. His story carried the hometown elements that gave the CCs' work their special distinction.

Out of countless tales of heroism there came today the story of a Marine lieutenant and two enlisted men who fought their way through pillboxes, bunkers, blockhouses and machine-gun nests to cross to the western shore of this island only 90 minutes after they landed on the east.

When he hit the beach at H-Hour, Feb. 19, 2nd Lt. Frank J. Wright, 25, of Pittsburgh, Pa., had a platoon of 60 men.

By the time he had crossed the island an hour and a half later two of the 60 remained with him and instead of being a platoon leader Lt. Wright was a company commander.

Four of his company's officers, including the company commander, were killed or wounded as they attempted to follow him across.[58]

Beech not only provided a stirring account of the three men as they "blazed a death strewn trail" for 800 yards, he included their names and hometowns. In Pittsburgh, the story was headlined, "Pittsburgher and 60 Men Start Across Iwo, 3 Make It." Newspapers across the country carried the story even without a local angle. The passage of ten days from the landings at Iwo Jima to publication March 1 had not lessened its news value.

The division's city room worked into the night to process sixty more stories within a few hours. Subsequent batches of copy from Iwo Jima arrived within seven days of being airmailed from the field, which division officials regarded as "excellent time." The copy from the initial fighting arrived far ahead of the "en route" stories that had been written aboard transports as troops moved into the area, rendering them out of date and unusable.[59] The Marine Corps' own record of how its troops fought their most famous battle of the war benefited from a journalistic organization that by then had three years of experience in reporting and placing stories in American media.

A Public Relations Operation

Journalism experience and working within a journalistic structure did not change the fact that Marine combat correspondents were assigned to the Division of Public Relations and were expected to adhere to the mission of promoting the service. Officially, their stories were referred to as "press releases," not news stories.[60] More significant in terms of story content were admonitions such as one that appeared in a bulletin in August 1943: "Remember, you are always writing as a representative of the Marine Corps; you are a spokesman; your dispatches are semi-official; what you write either brings credit to, or reflects upon, the Corps."[61] Their public relations function no secret, the news media veterans who joined the Marine Corps to report

146 | Douglass K. Daniel

and write were called on to put aside the independence and impartiality that were expected in news writing at the time.

Two primary areas of censorship in wartime reporting—security and taste—applied to civilian correspondents as well as the CCs, but in different respects. For civilians, censorship for security was imposed by the government and could be specifically defined; taste was a form of self-imposed censorship and more subjective. The United States government had rapidly increased its censorship of defense information after Pearl Harbor and established the Office of Censorship to monitor domestic and international news. Media agreed to adhere to a voluntary censorship code and were notified when the office found violations, although it seldom took any action.[62] Journalism historian Michael S. Sweeney noted that Army and Navy censorship of the civilian press in combat zones was mandatory while domestic press censorship was voluntary, calling it "one of the shared sacrifices of war for American journalists."[63]

The Marine writers were advised at headquarters about matters of taste before deployment, and the division security guide included a brief section on "certain matters of policy" not directly related to security. The security guide advocated avoiding "boastfulness," exercising "good taste," and keeping in mind civilian readers. In a separate category was a caution about reporting "bloodshed," the security guide advising that death or suffering should not be described in "gory detail" because it would be painful to friends and relatives and "would do little to heighten morale."[64] This guidance may have been abundantly clear if not obvious; unlike the frequent admonitions about security and writing, directives about bloodshed did not appear in the regular bulletin.

"Good taste" fell into the murky realm of what was considered fit for public consumption. Former combat correspondent Cyril J. O'Brien recalled the impact of taste and security concerns on his reporting.

> The censorship was mostly for taste. I didn't know enough about strategy and all that to say anything that would be in any way classified. I didn't know enough to say anything classified. . . . There was no need to write about blood and guts all over anybody or something like that. You didn't talk about a lot of blood streaming out and things like that. You could say someone was hit, but you didn't talk about a lot of gory things.[65]

Newspapers and general-interest magazines did not, as a rule, publish foul language and other material they considered offensive to their readers. Those who had worked in news media would have developed a sense of

what was not allowed, and the division's city room likely followed common journalistic practice. Still, division headquarters chided the CCs for lapses. "Stories in obvious bad taste, having no value whatsoever for Marine Corps public relations, have been showing up too frequently of late," the bulletin advised in August 1943.[66] Cited were a story about the "love life" of dogs and another about a town's red-light district. Some prohibitions, such as photographs of graves of dogs and other animals marked by crosses, appeared to arise on an ad hoc basis.[67] Casual profanity such as "damn" and "hell" was all but prohibited.[68] Scatological humor was turned away. One rejected story described a straddle trench latrine that used dirt instead of water; a sign hanging from a shovel read, "Please Flush."[69] Similarly rejected was a story in which Marines taught island natives the "Bronx cheer."[70] What was considered too coarse for civilian publications reflected the social mores of the times.

Unlike lapses in taste that could offend readers, security matters carried life-and-death consequences. Avoiding the unintended disclosure of information that could aid the enemy was an ongoing concern at division headquarters and with security officers who censored the CCs' stories. The Marine writers attended lectures about security before their deployment and had access to the division security guide outlining prohibited subjects. The division stylebook also contained a security section on prohibited subjects and information. As another reminder, a bulletin in June 1943 carried a list from the Pacific Fleet detailing subjects prohibited for civilian correspondents to report.[71]

The bulletin and security officers' editing of CC dispatches refuted the views of combat correspondents like O'Brien who believed their lack of knowledge of classified information meant their stories presented no security issues. The bulletin frequently cited subjects that should not be reported for security reasons, indicating that stories were mentioning them. Prohibited subjects included radar, armor and special weapons, aviation-related activities aboard carriers, code names for areas and places, and any words in a coded message lest they help the enemy break the code.[72] To be treated with care were such subjects as successful escapes from enemy incarceration, troop movements, special vehicles or weapons, and other information that could aid the enemy if too many details were provided.[73] Malaria, perhaps the most pernicious of the tropical diseases affecting troops in the Pacific, rated a separate military security memorandum that was cited in the decision to kill a CC's story about the disease.[74] Security officers may have been concerned that reporting on the debilitating impact of malaria would reflect troop readiness.

148 | Douglass K. Daniel

When violations of security appeared in a combat correspondent's story, a Navy security officer would strike the offending word, phrase, or section. Entire stories were rejected with the words "kill" or "do not use" scrawled in red pencil or in dark lead pencil. Not written on a story was the reason, but in many instances it appeared that too much information was being imparted. For example, security officers rejected a detailed story about Navajo Indians and how their language was an unbreakable code.[75] A month later the bulletin noted succinctly, "Never mention Navajo Indians," not risking in print the explanation.[76] Also rejected was a story about Marines learning common Japanese military terms.[77] A lengthy feature about sniper school was approved for distribution only after numerous deletions of specific training and tactics, such as moving in triangular formation and darkening faces.[78] Regular warnings about security issues from division headquarters, frequent deletions, and outright rejection of stories indicated that many CCs did not fully comprehend their access to sensitive information.

Public relations officers in the field or working in division headquarters not only edited copy for style, effective writing, and taste, they were tasked with censoring material they believed would damage the image of the Marine Corps. Security officers may have done so as well if they considered the service's image a security concern. The editing marks on the original dispatches of combat correspondents and public relations officers did not indicate the identity of the editor. However, they suggested a widely shared skepticism for stories in which Marines were anything other than hardcharging, self-effacing, tough, and heroic—qualities that would attract young men to their ranks.

Instances in which Marines might have looked reckless, frivolous or silly could draw rejection. One such story described a Marine on the island of Bougainville staying awake on duty by clutching a live hand grenade, the fear of detonation keeping him from falling asleep.[79] A story from Guadalcanal reported that native men were no longer helping build houses or jungle roads so they could make grass skirts bought by Marines.[80] Division headquarters sought to quell stories that played up traditional rivalries between the Marine Corps and the Navy or the Army. A story in which Marines taught clumsy sailors how to drill was dropped altogether while a Marine platoon sergeant's declaration that an unchallenged beachhead at Okinawa was a "MacArthur landing" was cut from a different story.[81] A tale of courage under fire could be rejected if its heroes had disobeyed orders. At Tarawa two Marines seeking combat but held back on ship for support duties later climbed into a shore-bound supply boat and randomly joined an infantry

unit.[82] Praise from the unit's commander did not persuade the censor that such an incident should be publicized.

Some stories problematic for the Marine image as a humane if tough warfighter were edited or denied distribution. A dispatch from an unnamed hospital base listed popular souvenirs taken from Japanese soldiers, including flags, handguns, and sabers. Stricken from the list were dog tags, "gold teeth, a favorite Jap mouth ornament," and pocketbooks containing money and "pictures of the Jap's family."[83] Reporting from Guadalcanal in October 1943, Staff Sergeant Francis H. Barr described by name a Marine who kept in his tent a Japanese skull wearing a helmet "just as a daily reminder that many more skulls must be collected before the war is won." The item added: "He decided to keep this particular skull because he says 'the guy looks like as if he is about to say, "so sorry, please."'"[84] During the battle for Bougainville in November 1943, Staff Sergeant Solomon Blechman reported on the sinking of a convoy ship and the downing of the Japanese plane that had fired the torpedo. A Marine lieutenant aboard a craft rescuing the ship's survivors pulled in the Japanese pilot, apparently not knowing whom he was aiding. Blechman reported, "A moment later a sailor recognized the pilot as a Jap, pulled his automatic and shot him."[85] Stories about Marines' encounters with Japanese soldiers were routinely distributed, but not if their behavior could be regarded as immoral.

A reporter's news judgment did not vanish because he was a Marine, but official censorship and the public relations aspects of their work almost certainly contributed to self-censorship. In his 1999 memoir *Combat Correspondent*, Samuel E. Stavisky asserted that CCs were not permitted to send "bad news" back to the States and that he came to regard the censors as much an adversary as the Japanese.[86] In one example, Stavisky wrote that several Marines had given him their account of a highly publicized action that was contrary to the heroic tale that civilian reporters had already published. "I didn't give the censors a chance to kill this incredible story. I killed the story myself. Why get another reprimand?"[87] Combat correspondent Dan Levin, in his 1995 memoir *From the Battlefield*, described a truck on Iwo Jima piled high with the bodies of Marines and why he decided not to attempt to include the scene in a story.

> Our dispatches avoided such raw and close-up scenes. This was not due merely to censorship. We accepted the war as a just war. So our restraint came from within. We had to report truth, but total battlefield truth could injure morale. That was understood by civilians as well, and we had to understand it even better.[88]

150 | Douglass K. Daniel

Self-censorship may also have been a reaction to a system that did not allow for discussion and argument over content. It would have been impracticable to seek or receive an explanation for censorship or any other changes, or to argue about them given the distances, time constraints, and multiple people in the copy chain, not to mention that the changes were being made by an officer of higher rank.

Even the most experienced combat correspondents at times crossed the imprecise line of what was suitable to report about Marines. Jim Lucas, whose Tarawa story had brought him headlines and journalism awards, was one of the most prolific writers in the division. Out of bounds but written nonetheless was a story describing the Marines whom Lucas encountered at a battalion aid station on Saipan.

> There was one kid there—he had to be led in—with eyes so glazed that you thought at first he was blind. It didn't take much guessing to decide what was wrong with him; he'd spent five days up on the front lines with Jap mortars bursting around him, and he'd reached the breaking point.
>
> There were seven Marines almost like him in the same ambulance jeep. They didn't walk in; you couldn't even call it a shuffle. One husky fellow stepped on a limb no bigger around than the handle of a garden rake, and it threw him. He just laid there and sobbed until someone picked him up.

Lucas went on to describe other Marines suffering from shell shock or wounds from gunfire or shrapnel. It ended with a plea:

> I wished that the men who make wars could have gone to that aid station and seen the things we saw there. But I knew immediately it wouldn't have done any good. The men who make wars have seen these things, and they call it the supreme goal of human endeavor.[89]

In red pencil in the upper right corner were the words "No—Cmdr. McCarthy." Another marking in dark pencil read, "Killed—Navy." In a similar vein, an eighty-word Lucas story from Iwo Jima reported a Marine casualty and was marked "not used":

> This is one of the saddest stories to come out of the bitter battle for Iwo Jima.
>
> A young Marine was taken from his regular place in a tank crew and left behind to assist in repairing a disabled vehicle. While he was safe on the beach, his tank hit a mine and four of the five crewmen lost their lives.

Bylines and Bayonets | 151

When he heard what had happened, the boy lost his mind and had to be evacuated from the island.[90]

Lucas's front-page story from Tarawa had led to a promotion to second lieutenant and the designation of public information officer. Undoubtedly mindful of the Marine image, he still believed there were stories about the war that readers should know.

Reflecting on censorship sixty years after he had served as a public relations officer, Millard Kaufman in 2005 recalled trying to retain the writer's voice and to "let the guy write" as he edited stories. Kaufman was a young but experienced journalist, having worked in New York for the *Mount Vernon Daily Argus* and the *New York Daily News* before joining the Marines in his mid-twenties and later accompanying landing forces at Guam and Okinawa. He recalled leaving censorship decisions to those in higher command. However, Kaufman noted that reporting such incidents as shell shock and friendly fire would not have been in keeping with the public relations mission.

> All this stuff was done to recruit Marines. They didn't want any situation where a guy was going to go off his rocker. That didn't encourage enlistment. . . . Marines were perfect, immortal human beings. They didn't shoot at each other. Nobody was reporting grisly deaths, and they certainly weren't being reported as shooting at each other. I think all that was done from higher up.[91]

Whether in the form of civilian journalism or Marine Corps public relations, stories from the battlefield were subject to many of the same limitations in pursuit of the shared goal of an American victory over its enemies. For the Marine combat correspondents, the goal of advocating for the Marine Corps provided an additional rationale not to acknowledge all the uncomfortable truths of war.

Conclusions

The endeavors of Marines who worked in the field for the Division of Public Relations came at a human cost. While the division bulletin often carried reports of its men firing on Japanese soldiers and occasionally killing them, it also noted the toll among its own.[92] The Marine Corps Combat Correspondents Association counted fourteen correspondents, photographers, and cameramen as killed during World War II; five died on Iwo Jima alone.[93] Declared missing in action in Saipan and presumed dead was Staff Sergeant

Richard J. Murphy Jr., who had left the *Washington Evening Star* to become a combat correspondent even though he was blind in one eye. In 2018 remains recovered after the June 1944 landings at Saipan were identified as Murphy's after a DNA analysis.[94] During the war numerous division personnel were wounded, some seriously.[95] While the CCs drew criticism at times from division headquarters, their courage was never questioned.

When General Robert Denig and Major George Van der Hoef conceived the idea of a fighting and writing Marine recruited from the newsroom to promote the Corps, they may not have appreciated the professional tension inherent in such a hybrid. The bulletin, which was full of advice for what to cover and how to write, did not address the ethical dilemma that may have faced the journalist who had become a public relations practitioner. Would the combat correspondent who witnessed or was told of an event that could undercut Marine discipline or public morale still report it? Most likely Denig and Van der Hoef assumed, with good reason, any American would understand that achieving the aim of the war effort—victory—was the final consideration whenever the practice of public relations compromised the practice of journalism. The bulletin never advised combat correspondents and others to be dishonest or to publish a falsehood, and no memoir or oral history suggested dishonesty was part of their training. However, the demand that they not damage the reputation of the Marine Corps turned the CCs away from journalism and toward public relations even if their work was truthful and accurate.

Truth and accuracy had been central to the discussions of ethical conduct for journalism and public relations that emerged during the two decades before World War II. As part of newspapers' transition from a party-aligned press in the eighteenth century to objective reporting, the American Society of Newspaper Editors in 1923 adopted an influential "canons of journalism" that included truthfulness, accuracy, independence, impartiality, and decency.[96] While not as specific, pioneering public relations practitioner Ivy Lee's groundbreaking "Declaration of Principles" in 1905 had included accuracy but focused on the practice of providing guidance to reporters seeking information about a client on subjects of value and interest to the public. In later years Lee would add advocacy to the practitioner's craft.[97] Missing from Lee's declaration, understandably, were the ASNE standards of independence and impartiality, two points that separated journalism and public relations even if truth and accuracy did not.

The professional divide was evident in the headquarters guidance for the combat correspondents and public relations officers and in the editing of their stories. Public relations demanded that they not report that Marines

fired upon each other by accident or that Marines suffered from what could later be called post-traumatic stress. Stories that did acknowledge such occurrences were not distributed for publication. The failure to tell the truth to the American public during wartime was arguably a lie of omission justified by the need for a strong defense. The journalists who joined the Division of Public Relations could hardly be faulted for accepting the "shared sacrifice," as Sweeney called it, that the civilian press willingly undertook while the United States fought for its survival. Civilian editors who published the CCs' stories apparently did not disapprove of the blending of journalism and public relations, especially given readers' appreciation of the hometown focus of such stories.

While the Division of Public Relations achieved its goal of promoting the Marine Corps as a fighting force, the division fell short of its further objective of collecting military information and facts of significant historical value to the Corps. By discouraging its writers from recording everything they witnessed or were told, the division sanctioned an incomplete Marine chronicle. Just as any authorized institutional history would run the risk of omitting the less exemplary events, the CC stories from the battlefield and elsewhere avoided recording flaws and failings or even the colorful if sometimes cringe-worthy facts of Marine life in the field. Furthermore, in bowing to the segregationist attitudes of some segments of the national news media, the division diminished the collection and dissemination of the contributions of African American Marines to the war effort and to their inclusion in Corps history. When only approved versions of their stories reached the news media, the combat correspondents placed into the public record a sanitized version of reality.

The CCs' success in placing news about Marines in local and national media inspired greater efforts by the United States military to create its own journalism in the form of public information and public relations. Within a few years after the end of the war, the Army, Navy, and Air Force were sending military personnel to their own separate schools for journalism or public information or both. Consolidating the services' goals in training personnel for communications duties led to the creation, in 1964, of the Defense Information School, which operates today at Fort Meade, Maryland, with the motto "Strength Through Truth."[98]

A year after the creation of the Marine Corps combat correspondent, the internal bulletin of April 7, 1943, carried a demand that would prove impossible for those within the Division of Public Relations to achieve: "Absolute accuracy and absolute truth must never fail to govern the preparation of all photographic and news material issued by this Division." Covering the brutal

154 | Douglass K. Daniel

realities of war that lay ahead for the Marines in the Pacific would challenge that directive. At headquarters and elsewhere, officers weighing the potential impact of combat correspondents' stories on discipline, morale, and recruiting undercut the pursuit of absolute accuracy and absolute truth long before the Marine landings at Tarawa and beyond.

Notes

1. Statement, Defense POW/MIA Accounting Agency, July 17, 2019, https://www.dpaa.mil/Resources/Fact-Sheets/Article-View/Article/569615/tarawa/ (accessed February 17, 2020).

2. Jim Lucas, *Combat Correspondent* (New York: Reynal & Hitchcock, 1944), 189.

3. Master Technical Sergeant Jim Lucas, "How U.S. Won Tarawa! Story by a Marine," *Chicago Daily Tribune*, December 4, 1943.

4. Lucas, dateline Tarawa, November 23, 1943. Lucas files, boxes 6–7, 370/23/18/04, Record Group 127, Records of the United States Marine Corps, National Archives and Record Administration, College Park, Maryland. Hereafter, referred to as USMC, NARA.

5. CC dispatches and some copies of the bulletin and other CC material are housed at NARA as cited in notes below. A more comprehensive collection of the bulletins as well as related oral histories, also cited in notes below, are housed at the Marine Corps Archives, Marine Corps History Division, Marine Corps Base Quantico, Virginia.

6. Institutional histories included Benis M. Frank, *Denig's Demons and How They Grew: The Story of Marine Combat Correspondents, Photographers and Artists* (Washington, DC: Moore & Moore, 1967); and Garry M. Cameron, *Last to Know, First to Go: The United States Marine Corps' Combat Correspondents* (Capistrano Beach, CA: Charger Books, 1988). The latter was updated as *First to Go: The History of the USMC Combat Correspondents Association* (Haworth, NJ: St. Johann Press, 2018).

7. Memoirs included Herbert Christian Merillat, *Guadalcanal Remembered* (Tuscaloosa: University of Alabama Press, 2003); Dan Levin, *From the Battlefield: Dispatches of a World War II Marine* (Annapolis, MD: Naval Institute Press, 1995); Samuel E. Stavisky, *Marine Combat Correspondent: World War II in the Pacific* (New York: Ivy Books, 1999); and Alvin M. Josephy Jr., *A Walk toward Oregon: A Memoir* (New York: Knopf, 2000). Also published were Charles Jones, *War Shots: Norm Hatch and the U.S. Marine Corps Combat Cameramen of World War II* (Mechanicsburg, PA: Stackpole, 2011), and a collection of dispatches, Claude R. Canup, *War Is Not Just for Heroes: World War II Dispatches and Letters of U.S. Marine Corps Combat Correspondent Claude R. "Red" Canup*, ed. Linda M. Canup Keaton-Lima (Columbia: University of South Carolina Press, 2012). A collection of combat correspondent stories appeared after the war: Captain

Patrick O'Sheel, ed., *Semper Fidelis: The U.S. Marines in the Pacific, 1942–1945* (New York: William Sloane, 1947).

8. Academic studies include Robert G. Lindsay, *This High Name: Public Relations and the U.S. Marine Corps* (Madison: University of Wisconsin Press, 1956); Aaron B. O'Connell, *Underdogs: The Making of the Modern Marine Corps* (Cambridge, MA: Harvard University Press, 2012); and Colin Colbourn, "Esprit De Marine Corps: The Making of the Modern Marine Corps through Public Relations, 1898–1945" (diss., University of Southern Mississippi, 2018).

9. Lindsay, *This High Name*, 9.

10. Ibid., 10–11.

11. See Scott M. Cutlip, *The Unseen Power: Public Relations: A History* (Hillsdale, NJ: Lawrence Erlbaum Associates, 1994).

12. Lindsay, *This High Name*, 4.

13. Robert L. Denig, oral history conducted May 24, 1967, U.S. Marine Corps Oral History Program, Marine Corps Archives, Marine Corps History Division, 3–4.

14. Frank, *Denig's Demons*, 3.

15. John W. Thomason III, "Public Relations Division Makes Rapid Progress," *Marine Recruiter*, December 1941, 1.

16. See Van der Hoef obituary, *Washington Post*, February 26, 1962; and Frank, *Denig's Demons*, 3.

17. Denig oral history, 13.

18. Ibid., 26–27.

19. See Guy Nasuti, "The Forsaken Defenders of Wake Island," Naval History and Heritage Command, https://www.history.navy.mil/content/history/nhhc /browse-by-topic/wars-conflicts-and-operations/world-war-ii/1941/philippines /defenders-of-wake.html (accessed January 15, 2020).

20. See "Wake and Guam Reported Taken," *New York Times*, December 9, 1941; "Marines Still Hold Wake and Midway," *Los Angeles Times*, December 13, 1941; and "John Fisher, "Japs Again Raid Wake Island," *Chicago Tribune*, December 15, 1941; "U.S. Marines Beat Off 2 More Jap Attacks on Wake," *Chicago Tribune*, December 20, 1941.

21. Hal Foust, "Japs on Wake Island," *Chicago Tribune*, December 24, 1941.

22. See memo, "News Coverage throughout the Marine Corps," March 22, 1942, Combat Correspondents file 1, MCA, MCHD; and Frank, *Denig's Demons*, 6.

23. Frank, *Denig's Demons*, 6–7.

24. "Names of Many D.C. Men Go on Promotion Lists," *Washington Post*, November 23, 1942.

25. Merillat, *Guadalcanal Remembered*, 7–11.

26. Lucas, *Combat Correspondent*, 1.

27. See Stavisky, *Marine Combat Correspondent*, 7–8; and Merillat, *Guadalcanal Remembered*, 9.

28. "4 of Post Staff to Be Combat Writers," *Washington Post*, August 15, 1942.

156 | Douglass K. Daniel

29. O'Brien interview with author, August 26, 2005.

30. Bulletin, August 8, 1942, Combat Correspondent file 1, MCA, MCHD. Hereafter CC file 1–3, MCA.

31. Bulletin, second July edition, 1942, CC file 1, MCA.

32. Bulletin, December 8, 1942, CC file 1, MCA.

33. Bulletin, February 17, 1944, CC file 2, MCA

34. James W. Hurlbut, "Systematic Marine Patrols Wipe Out Jap Stronghold," *Tucson Citizen*, September 14, 1942.

35. See bulletins, August 8, September 17, and October 10, 1942, CC file 1, MCA.

36. Bulletins of June 2, 1943, CC file 1, MCA; and October 19, 1943, CC Bulletin file, vol. 2, box 3, A1 1007 370/23/20/03, USMC, NARA.

37. Bulletin, July 7, 1945, CC Bulletin file, vol. 4, NARA.

38. "Army Now Using 'Foxhole' Writers," *New York Times*, May 7, 1944.

39. Bulletin, April 3, 1944, CC file 2, MCA.

40. "AP Editors Join Military Forces," *Hagerstown (MD) Daily Mail*, July 1, 1942.

41. See bulletins of January 6 and May 4, 1943; special bulletin of May 18, 1943, CC file 1, MCA.

42. Bulletin, August 3, 1944, CC file 3, MCA.

43. Bulletin, April 17, 1944, CC file 2, MCA.

44. Bulletin, June 2, 1943, CC file 1, MCA.

45. Bulletin, September 1, 1944, CC file 3, MCA.

46. Bulletin, December 8, 1942, CC file 1, MCA.

47. Bulletin, July 17 and August 3, 1944, CC file 3, MCA.

48. "Official Style Book for Marine Corps Public Relations Officers and Combat Correspondents," box 3, A1 1006 1007 1008, USMC, NARA. The guide is not dated; a bulletin noted it had been distributed in mid-June 1943.

49. Bulletin, April 7, 1943, CC file 1, MCA.

50. Bulletin, June 1942, CC file 1, MCA.

51. Bulletin, October 30, 1943, CC file 2, MCA.

52. See bulletins of January 6, 1943, CC file 1; August 12 and August 25, 1943, CC Bulletin file, vol. 2, NARA; and March 20, 1945, CC Bulletin file, vol. 4, NARA.

53. Bulletin, August 12, 1943, CC Bulletin file, vol. 2, NARA.

54. Bulletin, May 4, 1943, CC file 1, MCA.

55. O'Brien to Daniel, 2005.

56. Bulletin December 8, 1942, CC file 1, MCA.

57. Bulletin, October 9, 1944, CC file 3, MCA.

58. Sergeant Keyes Beech, "Pittsburgher and 60 Men Start across Iwo, 3 Make It," *Pittsburgh Press*, March 1, 1945.

59. Bulletin, March 20, 1945, CC Bulletin file, vol. 4, NARA.

60. Bulletin, February 24, 1943, CC file 1, MCA.

61. Bulletin, August 12, 1943, CC Bulletin file, vol. 2, NARA.

Bylines and Bayonets | 157

62. See Jean Folkerts and Dwight L. Teeter Jr., *Voices of a Nation: A History of Mass Media in the United States*, 3rd ed. (Boston: Allyn and Bacon, 1998), 422–423.

63. See Michael S. Sweeney, *Secrets of Victory: The Office of Censorship and the American Press and Radio in World War II* (Chapel Hill: University of North Carolina Press, 2001), 3.

64. See security guide file, box 3, A1 1008 370/23/20/03, NARA.

65. O'Brien interview.

66. Bulletin, August 12, 1943, CC Bulletin file, vol. 2, NARA.

67. Bulletin December 1, 1944, CC Bulletin file, vol. 3, NARA.

68. Bulletin, March 1, 1944, CC file 2, MCA.

69. Staff Sergeant Joseph L. Alli, untitled, January 16 [1944], Alli file, box 1, 370/23/18/06, USMC, NARA. Bracketed years were estimated by the author.

70. Sergeant Bob Stinson, "Bad Medicine," November 7 [1943], Stinson file, box 62, 370/23/20/01, USMC, NARA.

71. Bulletin, June 2, 1943, CC file 1, MCA.

72. See bulletins of July 26, 1943, CC file 2, MCA; and October 9, 1944, CC file 3, MCA.

73. See bulletins of January 20, February 17, and March 20, 1944, CC file 2, MCA.

74. Bulletin, October 9, 1944, CC file 3, MCA.

75. Alli, "Navajo Indians," August 27 [1943], Alli file.

76. Bulletin, September 28, 1943, CC Bulletin, vol. 2, NARA.

77. Alli, untitled, August 27 [1943], Alli file.

78. Alli, "Scout-Sniper School" [1943], Alli file.

79. Sergeant Solomon Blechman, untitled, December 6, 1943, Blechman file, boxes 5–6, 370/23/18/07, USMC, NARA.

80. Blechman, "War Effort Hurt," September 25 [1943], Blechman file.

81. See Sergeant Richard J. Murphy Jr., "Marines Instill Military Snap in Drilling Sailors," December 14, 1942, Murphy file, boxes 49–50, 370/23/19/06, USMC, NARA; and First Lieutenant Millard Kaufman, "Motobu," June 18, 1945, Kaufman file, box 5, 370/23/18/04, USMC, NARA. The bulletin of August 25, 1943, expressly waved off criticizing the Army and the Navy.

82. Sergeant Pete Zurlinden, "Jumping Heroes," November 24, 1943, Zurlinden file, box 14, 370/23/18/06, USMC, NARA.

83. Blechman, untitled, May 29 [1943], Blechman file.

84. Sergeant Francis H. Barr, October 27, 1943, Barr file, box 3, 370/23/18/06, USMC, NARA.

85. Blechman, untitled, November 19 [1943], Blechman file.

86. Stavisky, *Combat Correspondent*, 33.

87. Ibid, 37.

88. Levin, *From the Battlefield*, 97.

89. Lucas, "Battalion Aid Station," June 20 [1944], Lucas file.

158 | Douglass K. Daniel

90. Lucas, "Survivor," undated, Lucas file.

91. Millard Kaufman to Daniel, undated interview, 2005.

92. For examples of CCs killing Japanese, see bulletins of November 20, 1943, CC Bulletin, vol. 2, NARA; March 20, 1944, CC file 2, MCA.

93. Cameron, *First to Go*, dedication page.

94. See Jessica Contrera, "74 Years after His Death in WWII, a Marine Is Returned Home," *Washington Post*, December 1, 2018.

95. For examples of wounded CCs, see bulletins of November 20, 1943, CC Bulletin, vol. 2, NARA; and November 6, 1944, CC Bulletin file, vol. 3, NARA.

96. See "A Newspaper Code," *New York Times*, April 29, 1923.

97. The text of the declaration and Lee's other views are included in Karen Miller Russell and Carl O. Bishop's study "Understanding Ivy Lee's Declaration of Principles: U.S. Newspaper and Magazine Coverage of Publicity and Press Agentry, 1865–1904," *Public Relations Review* 35 (2009): 91–92.

98. See history page, Defense Information School website, https://www.dinfos .dma.mil/ (accessed December 25, 2021).

7 Reporting Reconnaissance to the Public
A Comparative Analysis of Canadian and American Strategies

Victoria Sotvedt

During the Second World War, millions of Canadian and American troops took part in operations in Europe. Civilians at home relied on letters, radio reports, and newspaper articles to follow family members and friends through the chaos. Newspaper articles were a way for audiences in a specific locale to find out about the activities of regiments from their area, and thus extrapolate about soldiers they knew personally. However, these reports had to balance carefully between informing civilians in North America and informing the enemy of their immediate actions and plans. This is particularly evident when reviewing articles about units that operated with relative secrecy, both in the Canadian and American armies. Reconnaissance regiments were at the very forefront of the war in Europe, often scouting and skirmishing miles ahead of the main army, and particularly in areas where operations were imminent. Keeping their movements secret was critical to the success of future operations involving their respective divisions.

Despite the numerous differences between the Canadian and American armies and newspaper structures, reporters in both countries handled the reporting of sensitive reconnaissance information in a remarkably similar way. First and foremost, reports were delayed from appearing in newspapers for days or weeks, until any danger of informing German troops of Allied plans had passed. Second, reports were stripped of much personal detail, to obfuscate particular roles and their importance in the scope of their attached divisions. Third, newspapers strove to redirect their readers' attention to the successes of local troops instead of "big picture" accounts, frequently adopting a light-hearted and familiar tone. This included using informal language and slang terms, such as shortening "reconnaissance" to "recce" in many of the reports. Media in both countries followed these principles when reporting on reconnaissance activities, despite the numerous differences between

160 | Victoria Sotvedt

their activities. Canadian reports on the 7th Canadian Reconnaissance Regiment, which was attached to the 3rd Canadian Infantry Division and had approximately 700 members, were in many ways virtually identical to American reports on the 82nd Reconnaissance Battalion, a much bigger unit attached to Patton's famous 2nd Armored Division, despite the differences in size, scope, and readership. Virtually the only difference was that American papers prioritized reports about reconnaissance before they saw action, with very limited mentions after deployment. Canadian papers, however, had very little interest in reconnaissance units until after their deployment. American civilians understood more about how reconnaissance units were structured, but Canadian civilians had a better sense of their actual actions in Europe.

One thing linked almost all newspaper reports of activity on the front, regardless of the nationality of the soldiers or the target of their advance. This was of course the delay between the writing of the report and its appearance in local (or international) papers. Though certain broad details might be released immediately after a significant event, specifics were often kept quiet. For example, the front page of the *New York Times* on June 6, 1944, read in large capital letters "Allied Armies Land in France in the Havre-Cherbourg Area; Great Invasion is Under Way."[1] D-Day, arguably the most significant single attack of the war, had begun during the night. However, even the actions of D-Day received little more elaboration than that headline. A rough map of the English Channel and coastal France was captioned with a note that read "While the landing points were not specified, the Germans said that troops had gone ashore near Havre and that fighting raged at Caen."[2] In point of fact, troops did not reach Caen for more than a month. Troops from the 3rd Canadian Infantry Division penetrated the farthest inland on D-Day, but were stopped four miles from the city. The most that could be confirmed was that fighting in the area seemed to suggest that at least one of the five planned beachheads had been seized. SHAEF's (Supreme Headquarters of the Allied Expeditionary Force) official statement was even vaguer: "Under the command of General Eisenhower, Allied naval forces, supported by strong air forces, began landing Allied armies this morning on the northern coast of France."[3] The full article summarized the state of Allied war reporting nicely when it stated that "[SHAEF's] first communiqué was terse and calculated to give little information to the enemy."[4] The deliberate restricting of information was one thing that linked both Canadian and American reporting. Nowhere is this more evident than if we turn our attention to how they handled newspaper reports from reconnaissance regiments.

Reporters in both Canadian and American units had to balance on the fine line between informing the population and informing the enemy. Family members at home eagerly awaited any glimpse of what their sons, brothers, and fathers might be doing in the war. Unfortunately, German intelligence did also, looking for any hint of upcoming attacks. This usually resulted in one of the following two types of articles: detailed articles that might refer to individuals and specific places that had been delayed for up to a month before publication, or vague outlines of offensives that were currently underway. This applied to all articles, even those outside of the immediate front. An article that appeared in the *Toronto Star* on March 26, 1944, had as its byline location "A Canadian airfield in Scotland" rather than a specific locale—even though Allies were not yet on the continent, nor would they be for another two and a half months, and any serious threat of a German invasion of the British Isles had passed.[5] The article followed Arthur W. Woodhouse, of 7th Recce, in his role as an ALO (Air Liaison Officer). The role of an ALO was "highly secret," and "comparatively little" was known about them, save that they played a key role in limiting friendly bombing and strafing of units at the front, and in particular recce units, which were often much farther out ahead than infantry or other armoured units.[6] The article demonstrates a common work-around of reconnaissance reporting. The qualifications of an ALO are discussed in detail:

> Before an ALO is selected by the Air Branch of Army Headquarters he must have had a year's experience in the field with his unit. He must also be fully trained in Commando tactics, must be something of a psychologist, and a good salesman. If he meets these qualifications he is given a course of specialized training and the title of "G.3 (Air)"-junior staff officer. He is then ready to sell the army to the air force and vice versa.

We must presume Captain Woodhouse had these qualifications, because there is very little *personal* detail about him, his background, or his previous work with the 7th. In his interview, he discusses only the importance of cooperation between the air force and ground forces and his role in helping keep morale up by ensuring that the infantry was supported with air power when appropriate. What he did with his unit or what he had done so far as an ALO are completely omitted from the article, yet there is enough information that readers could *feel* as if they understood what he had done. This was the key to good war reporting.

Newspaper analysis of the roles armored reconnaissance was to play began early in the American press. The *Town Talk*, a local paper from Alexandria,

Louisiana, ran an article titled "Panzer Unit 'Little Army' Is Complete" on July 25, 1941. Though the term "panzer" was typically reserved for German tanks, the article was discussing the completion of the 2nd Armored Division. The division was able to "wage [a] small war alone" according to the article's sub-heading.[7] "Uncle Sam's newest tactics to outblitz foreign brands of blitz business," the article began, were to be "tested in unprecedented panzer operations" the following month.[8] The 2nd Armored Division would make its name as "Hell on Wheels" as the war went on, but at the time of the article's publication, divisional armor at such a scale was largely untested by the Allies. The article therefore described the "usual function" of such a division: first, it would "send out its reconnaissance elements, [to] feel carefully along the enemy front for soft spots."[9] Once these spots were identified, it was the work of the division to punch through "like a spear" and "rais[e] the dickens."[10] It is here interesting to note the specific reference to the importance of the reconnaissance battalion within the division as a whole. Canadian newspapers did not make this connection apparent to their readers until after the D-Day landings almost three years later, and even then, the 7th Canadian Reconnaissance Regiment was typically referred to as a largely independent force, rather than an integral part of a division. The article in the *Town Talk* continued one step further when it devoted an entire paragraph to what it called the "reconnaissance echelon." The echelon, which was in reality the 82nd Reconnaissance Battalion, was designed to move "in front of the division, gathering information," which it then sent "to the command echelon."[11] Though heavily armed, the 82nd "[did] not fight except when necessary" and operated in a combination of "tanks, scout cars and motorcycles."[12] Herein lay another difference between Canadian and American recce units: Canadian units operated solely with armored cars or tanks and the occasional motorcycle—not with a mix of cars and tanks. Despite the lack of tanks, both Canadian and American regiments conducted a blend of reconnaissance and combat operations. Overall, as the war progressed, Americans were better informed about the actual role of reconnaissance in the battle order, as it was talked about to a much greater extent than in Canadian newspapers, at least before combat.

Both Canadian and American newspapers often adopted an informal tone, even regarding these highly secretive units. Shortly after the 82nd Battalion's introduction to the American public, another article ran in the United Press and the *Pittsburgh Press*. The title read "Captured!" in bold letters, complete with exclamation mark.[13] Those who read only the first line might panic when they saw "First Army Commander Reported a War Captive," especially considering that American forces were not yet in the theater of war.[14] There was no need for alarm however, as the article was really about

war games taking place in Chester, North Carolina (the Carolina Maneuvers). The capture of Lt. Gen. Hugh A. Drum, commander of the U.S. First Army at the time, occurred in "the first day" of the war games.[15] Even more impressively, though not specified in the article, Drum's capture actually came within the first 90 minutes of the game's commencement.[16] The article reported that "credit for the capture was given to elements of Company D, 82nd Reconnaissance Battalion of the Second Armored Division" under the command of 2nd Armored Division's then Maj. Gen. Patton.[17] The 82nd was not so remarkable as to have made it all the way to "enemy" headquarters, but it made it much further than Drum had anticipated and found him inspecting his forward troops. Drum was not held long and soon returned to his command, but it is unclear if he talked his captors into freeing him or if the umpires ordered him to be released to facilitate the continuation of the game.[18]

Incidentally, this started a series of events that led to Drum's not being chosen for a field command role,[19] despite his army's success later in the exercise, as it provided grounds for concern about his decision making in the field.[20] Nor was this the first instance of such remarkable reconnaissance success. Toward the end of the earlier Louisiana Maneuvers, B Company captured the airfield operations office of the opposing team, causing the air base to be "out of action" for at least a day.[21] This action, though an indication of how well reconnaissance training was developing, was not quite as dramatic as the capture of Drum two months later and did not receive newspaper attention. However, the fact remains that almost a year before their deployment against the enemy, the 82nd had been able to distinguish themselves enough to be mentioned in newspapers well outside of their Fort Benning, Georgia, origins. In contrast, 7th Recce was rarely mentioned in papers outside of Montreal (and, to a lesser extent, Toronto, which had supplied a not insignificant number of troops to the regiment) until well after their deployment.

What is especially interesting to note here is that almost exactly six months later, in May 1942, 7th Recce distinguished themselves in an almost identical fashion during Exercise Tiger.[22] During the exercise, which was organized and overseen by the recently promoted Lt.-Gen. Bernard Montgomery, A Squadron, one of the 7th's three combat squadrons, "arrived at the 'enemy's' main headquarters" unexpectedly.[23] The exercise was planned to last for ten days, but A Squadron found the "enemy" headquarters sometime during the afternoon of the second day. After some brief consternation, A Squadron was recalled, in order to prevent cancellation of the remainder of the exercise. Montgomery was so impressed by the regiment's

164 | Victoria Sotvedt

abilities, despite their utter lack of combat experience, that he personally inspected them shortly after the conclusion of Exercise Tiger.[24] They were also designated an official portion of the Royal Canadian Armoured Corps and given their black berets, which was "a great honour to the Regiment," although it is unclear if this was directly related to their performance in Exercise Tiger or was more on the strength of their overall development up to that point.[25] After Montgomery arrived in Libya, he wrote to then-Colonel (later Lt. Col. and commander of the 7th between early 1942 and early 1944) V. W. Hugman regarding the regiment's performance during the May exercise. In it, he told Hugman that the regiment was developing "along the right lines for the type of action they would eventually get into."[26] Despite this level of professional success, the exploits of the 7th during Exercise Tiger do not appear to have made it into the news in Canada, unlike their American counterparts during the earlier war games. Canadian newspapers gave only extremely limited space to training exercises and usually only when such exercises resulted in fatalities (such as Exercise Tiger in 1944), regardless of how local regiments performed, preferring to focus on ongoing actions in Europe and North Africa, and to a lesser extent in the Pacific. On the whole, the Canadian public was far less informed about the development of reconnaissance units, and had much less information about them than the American public. After D-Day, there was a reversal of the situation; Canadians could expect more detailed and more frequent reports on local reconnaissance units than Americans.

The work of reconnaissance regiments was so specialized that confirmation of their arrival on the continent was delayed by almost a month in Canadian newspapers. The report had been written sometime between June 6 and June 7, but did not appear in the press until June 30. A detachment of 7th Recce landed with the 3rd Canadian Infantry Division on Juno Beach on June 6, in order to "see that the Divisional commander was kept informed at all times" of positions and progress in the beachhead.[27] While operating as Maj.-Gen. Keller's "front-line leg men,"[28] the detachment suffered four casualties, one of which was fatal.[29] However, their presence in France was not confirmed until an article appeared in the *Globe and Mail* on June 30. Even then, the article confined itself to those first few critical hours on the beach—none of their other exploits were listed. They conducted reconnaissance to identify exits from the beach as they became available (particularly in armored areas to prevent traffic jams), and also directed units through those exits when possible.[30] All the while, they "report[ed] to divisional headquarters and Maj.-Gen. Keller on the situation during the vital first few hours."[31] By the time that newspaper report appeared in Canada, Allied forces

had been on the continent for more than three weeks, and Canadian troops were pushing toward Caen, an event that would be covered by newspapers toward the end of July. As discussed above, newspapers broadly limited reports on D-Day, and little information was released at all. What is interesting here is the length of time that passed before even relatively short but detailed reports were published, especially considering the scope of the detailed reports. Much like the report on ALOs, the June 30 article was careful in how it handled detail. The task (traffic management) was described, along with the regiment's success. Maj.-Gen. Keller was identified, as it was well known that he was the commanding officer of the 3rd Canadian Infantry Division, but none of the reconnaissance men were. The impact of the successful traffic management was reported, but not how it was actually done. Readers of the article would come away with a sense of understanding what was happening, but even this delayed report carefully avoided identifying strategic information for the enemy.

The first truly detailed report about Canadian reconnaissance in Europe was published July 22, 1944, more than a month and a half after operations in Normandy began, and about two weeks after the events it described, in the *Standard*, a paper from Montreal. The article was titled "Hussars Probe German Lines; Montreal Recce Regiment Plays Big Role at Caen."[32] Caen, which was being used as a German command center in Normandy, had been one of the initial operational targets of D-Day, but due to stiff German resistance, it was not captured until July 9. The article was written by Gerald Clark, the *Standard*'s primary war correspondent, after he was invited on the mission to reconnoiter Caen before the Canadian and British assault on the city. From its first lines, the tone of the article was far more jovial than the actual recce operation had ever been. "When you are amongst the first soldiers to reach a town and the liberated people cheer and climb over your vehicle," Clark began, "the danger of becoming drunk is just as great as being hit by enemy bullets. Of course, no one is disputing which is more pleasant."[33] Recall that newspapers at this time had two major goals in their reporting: to inform the public but also to reassure them. Those at home in Montreal wanted to hear how well their hometown soldiers were doing in France, and to feel that their sons and brothers were not *really* at risk of dying at any moment. The four men in the armored car that Clark rode in were listed by name and address, and their pictures were also published alongside the text.[34] Clark was creating real, tangible links to the war for those in Montreal, and perhaps some of the first specific links since the start of the war. Identifying information had been carefully left out of other articles, though the scope of action they covered tended to be far greater than a single patrol.

166 | Victoria Sotvedt

Information was more available at a micro-level; identifying four individuals out of a whole division was not as problematic as identifying the actions and officers of an entire regiment.

In addition to reassuring Montrealers, the article also served as one of the first accurate descriptions of the tasks and role of armored recce in either country, as Clark had ridden with the crew of an armored car and was reporting on his firsthand experience. Though the recce boys claimed that "making first contact with the enemy is much the safest job on the front," the infantry Clark interviewed apparently disagreed: "Give the credit to the boys of recce. . . . We don't envy their job."[35] The report continued in a lighthearted tone, up to and including a combat situation: "There was no sign of the enemy. No firing. No landmines. Then suddenly three machine guns opened up."[36] Rather than dwelling on the seriousness of a lone car coming under fire from three gun-nests without easy backup, Clark did everything possible to present this as quite normal and unexciting. While it was, in a way, the norm for the boys in the cars, the real art of war reporting was in making readers on the other side of the ocean feel that coming under fire was an opportunity for a job well done, rather than a threat that their loved ones came under most days. Clark described Lieutenant Douglas Johnson returning fire with the rather disliked Sten gun. Afterwards, he is quoted as saying, "It was a bit risky. But what else was a fellow to do?"[37] Here again was the reassurance that this was quite normal and entirely within the realm of situations that reconnaissance troops faced and overcame every day, coupled with the chance to prove the devotion to duty of the Canadian troops. The article also included a reference to the German troops: Lieutenant Johnson was "not feeling any emotion about the Germans when they fell from his bullets. 'You fire on them automatically. You don't think of the personal history you're making. It's just a question of who comes out alive—you or them.'"[38] Today, serious questions might be raised about troops—and reporters—who chose to so completely remove the human element from their enemy. Questions of racism and latent white supremacy in modern armies have been addressed time and time again based on comments not dissimilar to these. In 1944 however, these concerns simply did not exist. Germany—and therefore German troops—were the conquerors and murderers of innocent millions in Allied propaganda and newspapers. Short of actual war crimes (for example, the Canadian tank crew that tied a captured German to the front of their tank in retaliation for the massacre of twenty Canadian POWs at Ardenne Abbey), German troops received little sympathy in either Canadian or American newspapers.

Like Canadian papers, local American newspapers also reported on individuals of interest when possible. Unfortunately, unlike the Canadian papers, most of these personal-touch articles were written to announce the death of well-known and/or well-liked American soldiers. One example of this was an article published sometime in early August titled "Lt. O'Connor, Palermo Hero, Slain in France." "Lt. James J. O'Connor, of 4126 Wilcox St was killed in action in France on July 29" the article reported.[39] Lt. O'Connor's engagements prior to his death were listed, including his winning of a Silver Star (the third highest award for valor in action against an enemy) at the Italian town of Palermo. His father received a letter "telling how the troops had passed Cherbourg and Caen and were in the open on the way to Paris" on July 28, and "a telegram announcing his death" on the 29.[40] Lt. O'Connor left behind a widow, Ms. Jeanne O'Connor, and two children, aged four and two.[41] The article also listed his three sisters (including where they now lived) and his two brothers (including their ranks).[42] The intimate detail in the article suggests it could have originated in any small town, one of the sort of places where everyone knows everyone. In point of fact, however, it was published in Chicago, a city of approximately 3.4 million at the time.[43]

Death announcements were comparable in Canadian papers, though somewhat less detailed and slightly shorter. Lieutenant Nelson "Nels" Riff Johnston was killed in action on August 9 while relieving an advance contact patrol. His death was reported in the *Montreal Star*, and is largely similar to the report on Lt. O'Connor's death. Unlike the report about Lt. O'Connor, the article on Lt. Johnston does not mention his communication with his parents or their reaction. However, virtually everything else appears in almost exactly the same way. Johnston's parents are listed, as is their address. His education is covered, and his siblings, their ranks, and their postings are also listed (a brother in France and a sister, a Wren, stationed at St. Hyacinthe).[44] Like Chicago, Montreal was a large city, with 1.3 million citizens. The *Montreal Star* was not a small paper either; at the time Lt. Johnston's death announcement appeared, it was considered Canada's biggest newspaper.[45] The size of the city and circulation of the newspaper, whether American or Canadian, was no obstacle to the easy, intimate tone that articles about soldiers preferred to adopt.

The free flow of pre-combat information in American newspapers dried up when the 82nd got to Europe. Glimpses in the national paper of the battalion became buried in articles on the larger workings of the 2nd Armored Division and the First U.S. Army. One of the few post D-Day mentions

168 | Victoria Sotvedt

of the work of reconnaissance was in an article published September 6, 1944, some three months after the landings and several weeks after the conclusion of the Battle of Normandy. The article was published on a Wednesday, but was reluctant even to confirm events that had happened on the Sunday before. In a clipped tone, the *Lewiston Evening Journal* informed its readers that reconnaissance elements had managed "penetrations of the Reich frontier as actions perhaps 25 or 30 miles ahead of the main front."[46] Patrols "crossed the boundary Sunday, ranged about in German territory, and then withdrew to the main American position . . . their reconnaissance mission accomplished."[47] In terms of information, the most significant thing identified in the article is how far ahead the 82nd operated. Though it may seem an exaggeration, this figure approximately lines up with repeated instances in war diaries and map records of the 82nd and the 7th, indicating that reconnaissance units operated so far ahead on at least a semi-regular basis. Beyond the vague "reconnaissance mission," no objective was ever identified, and no report on the nature of what was being done was forthcoming. Rather than balancing intimate detail with broad context, American combat reports on reconnaissance missions were extremely limited, offering little or no insight about specific actions or individuals still in the field.

The lack of information went both ways. Consider the case of Sgt. John McGowan, a member of the 7th Canadian Recce Regiment. McGowan and his three brothers were all a part of active service, but all served with different branches. While operating in France, McGowan received a letter from his mother with a newspaper clipping enclosed. The clipping was from the *Montreal Star,* and reported that "Corporal [Peter] McGowan . . . [of] the Hastings and Prince Edward Regiment . . . is reported missing, but according to some of his colleagues in the battalion, was captured" while serving in Italy.[48] McGowan's mother had found out this bit of distressing news from the article, and her son found out about his brother's capture several weeks later from the clipping she forwarded. Peter's capture (as opposed to his death) was not officially confirmed for several months after the publication of that article. The nature of limited information about soldiers on the front, combined with the wide-ranging and secretive nature of reconnaissance regiments severely limited the flow of information to individuals serving at the front. Their information was often limited to what their group was doing, and rarely extended past their own division. The newspapers that kept the public in North America semi-informed were not available to soldiers, unless relatives sent clippings, as McGowan's mother did. Incidentally, the McGowan boys were reunited six weeks before the end of the war, when they ended up in the same hospital ward in Britain—Peter as a recently

liberated POW weighing only 97 pounds, and John with a broken ankle from a two-story jump into a ditch.[49] Until this rather remarkable coincidence, neither had any information regarding the other—or the other two brothers in different branches of the service, both of whom also survived.

Many of the most harrowing stories of the Second World War will never be told. During the war, an effort was made to tell these stories in a way that reassured the public at home. Despite the differences between the 7th Canadian Reconnaissance Regiment and the 82nd Reconnaissance Battalion, including their size, scope, attached division, nationality, and the culture from which they were drawn, reporters handled many stories about both groups in a similar fashion. Canadian and American newspapers adopted a cheerful and often informal tone in an attempt to reassure their readership. Reports were delayed as much as possible without losing their relevance. Details that might give German leadership insight into the daily operations of the units were cut, yet newspapers managed to still have enough detail that made readers feel properly informed. These similarities are remarkable. Perhaps the biggest difference is when these detailed reports were disseminated. In American papers, specific actions tended to be reported before reconnaissance units saw action in Europe. Many of these reports were dedicated to explaining reconnaissance and its potential to the American public. In contrast, Canadian papers were reluctant to report on reconnaissance or its development until after these units saw action, meaning Canadians understood less about how reconnaissance operated but more about specific actions undertaken in Europe. Ultimately, papers in both countries attempted to keep the public abreast of the war while managing strategic concerns about information dissemination. Aside from the timing of these reports, this balance was maintained in a remarkably similar fashion in both countries.

Notes

1. "Allied Armies Land in France in the Havre-Cherbourg Area; Great Invasion Is Under Way," *New York Times*, June 6, 1944, in *The New York Times Front Pages: 1851–2013* (New York: Black Dog & Leventhal, 2013), 187.

2. Ibid.

3. Ibid.

4. Ibid.

5. "Toronto Man Holds Job of Major War Import," *Toronto Star*, March 26, 1944.

6. Ibid.

7. "Panzer Unit 'Little Army' Is Complete: 2nd Armored Division Can Wage Small War Alone," *Town Talk*, July 25, 1941.

170 | Victoria Sotvedt

8. Ibid.

9. Ibid.

10. Ibid.

11. Ibid.

12. Ibid.

13. United Press, "Captured!" *Pittsburgh Press*, November 17, 1941.

14. Ibid.

15. Ibid.

16. Christopher R. Gabel, *The U.S. Army GHQ Maneuvers of 1941* (Washington, DC: Center of Military History United States Army, 1991), 136–137.

17. "Captured!"

18. Gabel, *U.S. Army GHQ Maneuvers*, 136.

19. It should be noted that other elements played a role beyond Drum's capture, including several infractions committed during the setup for the Carolina Maneuvers. The reconnaissance position that Drum ordered as part of his setup was outside of legal bounds for the games, and he preemptively laid telephone wire that connected to a civilian grid. Later, it was discovered he was also illegally using ration trucks (which were immune to capture rules) to conduct reconnaissance. The official US 50th anniversary study of the war games went so far as to call Drum's violations flagrant, something which certainly would not have helped him maintain his command.

20. Michael Keene, *Patton: Blood, Guts, and Prayer* (Washington, DC: Regnery History, 2012), 111.

21. Gable, *U.S. Army GHQ Maneuvers*, 110.

22. Not to be confused with Exercise Tiger in 1944, in which troops trained for D-Day. The 1942 Exercise Tiger was, at the time, the largest army exercise ever performed in the United Kingdom, and involved over 100,000 troops in a simulated broad front scenario.

23. Capt. Walter G. Pavey, *An Historical Account of the 7th Canadian Reconnaissance Regiment (Duke of York's Royal Canadian Hussars) in World War II, 1939–1945* (Gardenvale, Quebec: Harpell's Press Co-operative, 1948), 29.

24. Ibid.

25. Ibid.

26. Ibid.

27. C. P. Stacey, *The Victory Campaign* (Ottawa: Queen's Printer and Controller of Stationery, 1960), 82.

28. William Stewart, "Invasion Line Leg-Men Wired Recce Report," *Globe and Mail*, June 30, 1944.

29. Lieutenant-Colonel T. C. Lewis, "June 6, 1944," *War Diary of 7 Canadian Reconnaissance Regiment (17 D.Y.R.C.H.), June–September 1944,* Textual Records, RG 24-C-3, vol. 14217, microfilm reel T-12660, The Department of National Defence Fonds, LAC: 3.

30. Pavey, *7th Canadian Reconnaissance Regiment in World War II*, 39.

Reporting Reconnaissance to the Public | 171

31. "Invasion Line Leg-Men Wired Recce Report."
32. Gerald Clark, "Hussars Probe German Lines," *Standard*, July 22, 1944.
33. Ibid.
34. Ibid.
35. Ibid.
36. Ibid.
37. Ibid.
38. Ibid.
39. "Lt. O'Connor, Palermo Hero, Slain in France," August 1944.
40. Ibid.
41. Ibid.
42. Ibid.
43. "1950 Census of Population, Volume I: Number of Inhabitants: Illinois," *US Census*, US Census Bureau, 1950, https://www2.census.gov/library/publications/decennial/1950/population-volume-1/vol-01-16.pdf (accessed January 13, 2020).
44. "Killed: Lieut. Nelson Riff Johnston," *Montreal Star*, n.d.
45. W. H. Kesterton, *A History of Journalism in Canada* (Montreal: McGill-Queen's University Press, 1967), 90.
46. "France, Cont. from Pg. 1," *Lewiston Evening Journal*, September 6, 1944.
47. Ibid.
48. "Corporal Reported Missing," *Montreal Star*, n.d.
49. John McGowan, in discussion with the author, 2012.

8

Outstanding and Conspicuous Service
Iris Carpenter, Lee Carson, and Ann Stringer in the European Theater

Carolyn M. Edy

Sitting in a New York hotel sipping orange juice, not long after arriving with thirteen other well-worn war correspondents on troopship SS *Monticello*, Iris Carpenter declared herself ready for a vacation.[1] It was June 1945. She hadn't touched a typewriter in three weeks, and it had been nearly twice that long since she'd seen enemy fire. But in the eleven months up to V-E Day, Carpenter had traveled thousands of miles while writing hundreds of stories about the war in Europe for the *Daily Boston Globe* and *London Daily Herald*.[2] She would take a breathing spell, Carpenter told the reporter interviewing her, and then she hoped to cover war in the Pacific—so long as she could continue doing so with the full privileges of accreditation she enjoyed while attached to the "Fighting First" Division of the United States Army in the European Theater of Operations. Anything less and she might have to think twice.

Carpenter was eager to return to covering the war, but she did not want to revisit the "unmitigated hell" she said she faced when she started.[3] In spring 1944, Carpenter had gained military accreditation as a war correspondent in the ETO only to discover she lacked access to the jeeps, press facilities, and military intelligence available to her male colleagues—a hindrance that made it "damn dangerous" to cover the early French invasion, Carpenter explained, "because they didn't tell women where the fighting was."[4] Even when women found war and wrote about it, without access to teletype or radio transmission their stories became stale on arrival. "You either played by the rules," Carpenter said, "in which case you were no good to your paper. Or you used what means you could," such as begging for a ride or cajoling a pilot to carry off your dispatch.[5]

Iris Carpenter, Lee Carson, and Ann Stringer, along with many women accredited as war correspondents, were undaunted by rules and knew how

to make the most of their surroundings. In the summer of 1944, after the War Department officially tied women's accreditation to a willingness to cover the woman's angle, Carpenter wrote about wounded soldiers, wartime fashion, and civilian morale in England and France—even as she found ways to write about military operations, battle lines, and weaponry. Carson all but avoided woman's angle topics during this time, at first by satisfying a hunger for publicity "of which all air forces were equally guilty," as one military official reported, with elaborate articles about air bases and airmen.[6] Although their tactics varied, by December 1944, Carpenter and Carson counted themselves among an elite group of war correspondents attached to the First United States Army, with the same access to press facilities, transportation, and battle lines as their male colleagues. Ann Stringer started later. She had delayed her trip from New York to France after enemy fire struck her husband's jeep in Normandy, killing him instantly, on August 17, 1944.[7] When Stringer finally did reach the ETO, she faced opposition from male colleagues and military officials alike, and yet she, too, soon found her way to the front.

All three women—Carpenter for the *Boston Globe*, Carson for International News Service, and Stringer for United Press—used their reporting skills, and the military connections these skills earned them, to find and break news so often that by March 1945 their bylines appeared regularly beneath front-page headlines, often internationally syndicated. A *Newsweek* article in March 1945 touted Carpenter, Carson, and Stringer as the "Rhine Maidens," describing the challenges they posed, daily, for military officials, even as they modeled new objectives for other women who sought similar opportunities.[8] Despite military policies preventing female war correspondents from covering the front and limiting them to the use of mail couriers, datelines on Carpenter's, Carson's, and Stringer's articles in the final months of the war in Europe place them at the front and reveal their reports most often traveled by wireless, appearing in print within twenty-four hours. In 1946, Carpenter, Carson, and Stringer received theater medals from the United States War Department for "outstanding and conspicuous service with the armed forces under difficult and hazardous combat conditions."[9]

The War Department had been accrediting women to cover World War II since American troops landed in England in January 1942. As shown in an earlier study, United States military regulations did not include gender-based categories or exceptions for war correspondents until June 1944.[10] Before then, War Department regulations stipulated equal rights and status for all accredited war correspondents. An ambiguous caveat, however, permitted military officials to impose restrictions or bestow privileges however they

174 | Carolyn M. Edy

saw fit.[11] This allowance for individual interpretation caused conflict and confusion, which in turn led the War Department to refine its accreditation policies in preparation for Operation Overlord, revising its press regulations to add "woman war correspondent" as a new category of accreditation, one that not only limited women's privileges and restricted their movement but stipulated what they could write about.[12] This chapter looks specifically at Carpenter, Carson, and Stringer to explore the ways in which the military's gender-based limitations alternately hindered and facilitated their work.

All three women were white, raised in affluent families, and began their careers as reporters. Iris Carpenter, born in England in 1904, took college classes in English and economics at the University of London before working for a short time as a reporter for the *London Sunday Express*, marrying, and having two children.[13] By 1941, Carpenter's marriage was beginning to fall apart and three parachute mines had destroyed any sense of peace in her neighborhood.[14] She sent her children to live with family while she remained in London, working for the British Ministry of Information and the *London Daily Herald*, writing about women in war services. Lee Carson, born in Chicago in 1916, attended the Ogontz School for Young Ladies in Pennsylvania, studied in France, and graduated from Smith College before working as a style editor and feature writer for the *Chicago Daily News*. International News Service hired Carson in 1941 to cover Washington as an accredited member of the press corps.[15] The youngest of the three women, Ann Stringer, was born in 1918 and raised in Texas. She graduated from the University of Texas at Austin with degrees in English and journalism, and worked as a Texas state house reporter for less than a year before marrying her classmate, Bill Stringer, in 1941.[16] By the time the United States entered the war, the couple had worked for United Press news bureaus in Ohio, Argentina, and New York.[17]

England and France, June–September 1944

It might have been the War Department connections Lee Carson gained as a member of the Washington press corps or her success writing about foreign relations and the military, but by March 1944 she was stationed in England.

Although Supreme Headquarters Allied Expeditionary Force (SHAEF) reported that Carson was attached to the First United States Army from March 1944 to May 1945,[18] datelines show that she moved around continually in her first several months of accreditation. Her stories also show that she developed close ties to pilots, such as Captain Don Gentile, whom she

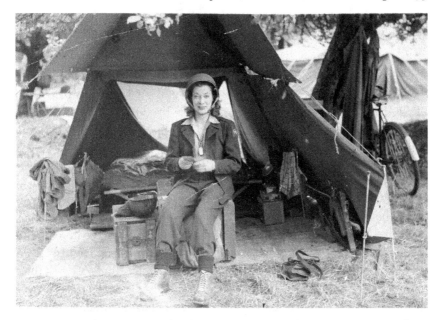

Lee Carson, war correspondent for International News Service. Courtesy of the George Peck Collection, San Diego Air & Space Museum.

interviewed for a four-part profile series. At the Halesworth officers' club in early 1944, Carson posed for photographs with several of the airmen she covered for INS. Colonel Hubert Zemke wrote on the back of one, "You know the flies love honey," and on the back of another Zemke's handwritten caption is more revealing: "An individual woman on base caused all sorts of problems. First, we had no billet to keep them. An officer had to move from his bed to provide lodge, and then again they were forever wanting to follow the CO and force their way into briefings. In this case Miss Carson was assigned to [Commanding Officer Major Walker] Mahurin and told to talk to the troops who did the fighting. Mahurin kept her out of my hair."[19]

Military correspondence regarding SHAEF preparations for Operation Overlord lists Carson as among war correspondents accredited to the Allied Expeditionary Air Force.[20] Along with credentials, Carson had also earned a reputation in London for staying ahead of Supreme Headquarters Allied Expeditionary Force officials, if not sidestepping SHAEF entirely—which, she told one reporter, "was sorta fun in fact."[21] Recalling how she hitched a ride on a fighter plane, she told another reporter: "I was in Normandy about two weeks when Allied Headquarters called me back to England and bellowed, 'Don't you know an article of war states women are not allowed with

176 | Carolyn M. Edy

combat troops?' Sure, I knew it, but it was my job to get the news. That came ahead of any articles of war or maidenly modesty."[22]

Carson said the fact SHAEF made her return to the air base allowed her to file stories June 6, breaking news of the dramatic accounts of fighter pilots who described landings under "red glare and black smoke" and "troops piling up on the beaches as thick as seaweed," as battleships and destroyers systematically poured in.[23] A front page story June 7 stated that Carson was assigned to headquarters of the U.S. Ninth Air Force tactical command, where she had disclosed that "Allied holdings in northern France now stretch from five to six miles inshore from Valognes on the Cherbourg peninsula to Trouville on the Seine estuary."[24] Knowing whether, when, and how to break the rules also meant knowing what information to share, as well as when and how to share it. Firsthand accounts that revealed too much information, without censor-approval, could get any war correspondent stripped of credentials. But women often needed a vague dateline that obscured their whereabouts to appease SHAEF officials as well. After Lee Carson's ride over the D-Day landings June 6, her stories ran on front pages with datelines such as "An Advanced Fighter Base in England," "With a tactical fighter reconnaissance group," and "With American forces in France."[25]

Although Carson avoided the woman's angle in her reporting, she likely still benefited from the War Department's public relations objectives. A story's angle often determined a reporter's access to information, not to mention transportation.[26] As Colonel Barney Oldfield noted, "If the story had an Air Force angle, a jeep was available; if not, no jeep."[27] Oldfield, who was the public relations officer for the Ninth Army and whose memoir reads like a dime novel whenever he describes interactions between men and women, dismissed Carson's journalistic expertise and credited feminine wiles instead: "Lee Carson, a charmer of the first order, wangled herself into a flight by batting her eyelashes at the group commander and got one of the good D-Day aerial stories."[28]

Wangling or not, Carson found her way to the action continually throughout June, July, and August 1944, earning front page bylines along the way. She wrote about bombing attacks and the advancing battle line as vividly as censors would allow, revealing her familiarity with the minute-by-minute horrors of war as well as her understanding of military strategy and her access to inside information.[29] Her courage and coverage made her the focus of headlines, as well, including a lead story about the danger she and Ernest Hemingway faced when Germans unexpectedly returned to Rambouillet in the middle of the night.[30] A feature with the headline "No 'Sob Sister': Lee Carson" crowed that Carson was "believed to be the first and only woman

to come perilously close to actual invasion combat" and that she had "covered the all-out allied bombardment of Cherbourg from one of our bombers."[31]

While Carson was finding inroads to action through connections to air bases, Iris Carpenter capitalized on her attachment to the Women's Army Corps and her relationship with the Ministry of Information. In June 1944, she was assigned to cover the Fifth General Hospital in Carentan.[32] "Women were farmed out, as it were, for short spells at a time to hospitals which were much nearer enemy lines than were the press camps—lines which moved fast, as did everything else about modern war, without giving any indication of where they had moved to," Carpenter wrote in her memoir. "Headquarters were miles back, yet, no matter how fluid the fighting became, the women dared not officially put as much as a nose inside the press camp to find out where the line of our own fire was, to say nothing of the enemy's."[33]

In addition to the hospital-related stories Carpenter had agreed to cover in June and July, she wrote about K-rations, military supplies, and other topics related to the general care and feeding of troops.[34] Notably, she also found ways to cover other aspects of military operations, such as foxholes and weaponry, by interviewing servicemen with ties to the Boston area or by reporting on news she uncovered, regardless of its relation to the woman's angle the military had prescribed.[35] "Why none of us ever got killed, hurt, or taken prisoner no one will ever know," she later wrote of her time in Normandy, where she found herself "under our own air strafe on one occasion and heading fast for the still German-held village of Canisy on another."[36] By August, however, consequences had begun to catch up with Carpenter. While she reported on fighting in St. Lô, a shell struck nearby and shattered her eardrum.[37] A SHAEF memo struck a second blow a few days later, noting that Carpenter had visited forward areas without permission. The memo concluded: "No objection here if CARPENTER stays in COMZONE. She must not visit battle areas, briefing conferences or troops of 21 Army Group other than women."[38]

Well chastened, Carpenter joined the other women correspondents who, "thanks to SHAEF," she said, "were denied the tremendous experience of participating in the liberation of the city," and instead were rounded up and kept in a small hotel in Rennes, under the custody of a public relations official who required them to sign in and out and report on their destinations every day.[39] In mid-September, Carpenter seized another chance to skirt SHAEF restrictions after she was hospitalized with her badly infected, shattered eardrum. A nurse told her the 91st Evacuation Hospital would soon be among the first to enter Germany. Carpenter secured permission to switch hospitals and enter Germany as a patient as well as a war correspondent.[40]

178 | Carolyn M. Edy

Lee Carson enjoyed far greater access and freedom as she circumvented SHAEF rules to cover the French invasion, right up through Liberation Day. *Stars & Stripes* correspondent Andy Rooney said Carson was likely the first war correspondent, as well as the first American, to enter Paris the morning of August 25, 1944, given her position in a jeep she shared with two other war correspondents: "By the distance from a jeep's front to back seat Lee was the first correspondent into Paris and no one ever accused her of having had it happen by accident."[41] It was a few days after she and Ernest Hemingway had their close call with German forces in Rambouillet, and she witnessed General Charles De Gaulle's historic arrival amid a hail of gunfire. Someone shoved Carson "roughly and efficiently to the floor," where she and others lay and watched, "unable to get up without exposing ourselves to the sniper on the roof on the other side of the street," she wrote in a story that ran the next day. "Bullets flew thicker and crazier than leaves in a Kansas cyclone. Suddenly the entire mob rose and flooded down the street, screaming angrily."[42]

In his memoir, Colonel Oldfield recalled that SHAEF wanted Carson apprehended and sent back to England but did not manage to catch up with her until Liberation Day, when Major Frank Mayborn checked into the Hotel Scribe in Paris and "swiftly went from the Angel of Wrath to the Southern gentleman at the sight of the attractive and elusive reporter. 'How nice to see you. It's good to see that you got here safely.' And that ended that summary punishment for infraction of rules!"[43] Carson remembered it differently, noting that after she was disciplined in Paris she traveled "under a black cloud" for a few weeks.[44] Perhaps related to her punishment, Carson followed up on her Liberation Day story with an overtly woman's angle story, on fashion in Paris, which ran internationally.[45] And yet by mid-September Carson was back to covering military operations, breaking the news of 20,000 Germans surrendering in Beaugency.[46]

Belgium and Germany, October–December 1944

Iris Carpenter's hospital ploy paid off, and soon she was reporting on Aachen. "In this closest hospital to the breach, the American Army has smashed through the German Westwall," she wrote, before describing an abundance of land mines and a steady stream of wounded infantrymen.[47] Carpenter's articles in October, November, and early December continued to balance coverage of hospital care with angles localized for Boston readers, such as an interview with a former mayor from Massachusetts who was a major in the First Army.[48] A letter to the editor described Carpenter's writing as having the "Ernie Pyle touch" and commended her for her accurate portrayal of the

81st Combat Battalion.[49] Even as she reported her hospital-based, localized stories, though, Carpenter continued to add official accounts of military activities and battle reports, as well as, increasingly, her own observations of fighting and devastation.[50] By the end of December, Carpenter was publishing front-page, hard news accounts; sometimes two in one day.[51]

WITH UNITED STATES 1ST ARMY IN BELGIUM. Dec. 28—Manhay, between LaRoche and Stavelot is *now* in our hands after some of the fiercest fighting I have seen yet along the northern shoulder of the line before which the enemy is foiled for the time being in his effort to drive up towards Liege. But the enemy is now consolidating.

The fighting around Grand Menil continues, with our troops on the fringe of the town. The last report was "encountering plenty of small arms fire and artillery but going very nicely." At the village of Havreen, eight kilometers from our line of march there was a sharp encounter today in which their infantry backed up by six tanks were repulsed.[52]

In a telegram to the *London Daily Herald,* Carpenter explained that the situation was fluid and likely to get worse. "So if stories coming through late and seemingly thrown together please bear in mind censorship extremely rigorous. Will do best possible," she wrote before asking whether she should request a transfer to the Third Army. That could take some time, she noted, and it might be wiser not to draw attention to the "feminine gender question again at this point" since things seemed to be working out at last.[53]

Meanwhile, Lee Carson seemed to have gained SHAEF's unofficial blessing, or at least its blind eye. As early as mid-October, Carson was back at the battle lines, describing the action at Aachen:

Dead Germans are sprawled and huddled everywhere, piled against sand-bagged basements or windows, where once machine guns chattered, or curled stiffly in shattered doorways. . . . American soldiers are visible occasionally, running hunched over across an avenue commanded by a German 88-mm gun, or roaring swiftly along in jeeps toward the cathedral, with the machine-gun in the back of the vehicles ready and the seats piled high with ammunition.[54]

Carson gained more leeway after stepping up to cover for INS correspondent Richard Tregaskis, who left the U.S. First Army October 22 for health reasons.[55] She covered several battles in the Siegfried Line campaign, including the Metz onslaught and the brutal fighting in Hurtgen Forest, where

180 | Carolyn M. Edy

frigid weather had blocked the delivery of food and supplies, and where troops had to carve dugouts out of frozen ground.[56] On November 19, Carson wrote about becoming transfixed by the fighting.

> From the rooftop of a battalion command post I watched our artillery lay down preparatory fire on the hill early in the sunny afternoon. Twenty minutes later the artillerymen turned their attention to a slope on high ground between the ridge and a forest and soon the doughboys came running from the forest. The first tank soon trundled forward with a rifle platoon clinging to its sides. Three more then bounced majestically out into the open.
>
> "If they don't make it in 20 minutes they won't make it at all," said the battalion commander, looking at his watch.
>
> Big puffs of smoke screening the infantry's advance still hung protectively in the air. Our artillery opened up on three enemy tanks on the ridge. A few seconds later a big gun thundered sharply from west of the battlefield and then a house two doors away disappeared in a big blob of sticks, stones and smoke, and an ear-splitting noise.
>
> A house on the side of the little hill in back of the one we were using as an observation post was plowed up and one end of the tiled roof came rattling down.
>
> "This is exactly the time to leave," suggested Capt. Robert Irvine of Framingham, Mass., but the well-lighted, miniature hell on earth, kept me there.[57]

Shortly before celebrating Thanksgiving with the troops in Aachen,[58] Carson rode with Associated Press correspondent Don Whitehead into Eschweiler, where they faced what she would later recall as her closest brush with death. A mortar shell hit their jeep, throwing Carson from the vehicle at "60 miles an hour," she said. Whitehead was not injured, but the fall opened Carson's old appendectomy incision and hurled them both into greater danger.[59]

> We had been told a third of the city was cleared and a battalion of American troops was there. So we went rootie-tootie into the town and promptly got mortared. There were only four doughboys and two correspondents in the city. We ducked into a building and the Germans started systematically to shelling us. For two hours we lay there with the walls coming down around our ears. Then we decided to get out. Just as I got to the doorway, a "120" mortar shell went through the wall where I had been.[60]

Carson earned herself several front page stories during this time, along with a reputation for gallantry and, as AP war correspondent Hal Boyle later reminisced, "enough physical bravery to fill an army's quota."[61] Ernest Hemingway recalled a moment when he knew he was in danger because Carson said it was time to leave, and, he wrote in a letter to a fellow war correspondent, "as we all know, Lee was not repeat not a spooky girl."[62] AP war correspondent Bill Boni shared a jeep assignment with Carson in November and December, and later recalled: "Army press officers were always telling her when she turned up unexpectedly, 'You can't be here.' Lee's simple rebuttal: 'But here I am.' During the frantic days when Nazis tried a do-or-die breakthrough in Belgium in the waning weeks of 1944, Lee ranged hundreds of miles across icy roads from one beleaguered post to another." It was Carson's idea, Boni said, to cover the front line firsthand with the troops on Christmas Eve, which led to Boni and Carson sitting in a blackened living room that shook from the blasts, while a Tiger tank roamed nearby, firing rounds. "There were no tree decorations, but there was the crunching of shattered window glass underfoot as we ducked and dodged from doorway to doorway back to our jeeps," Boni wrote. "But we had to ride back up the hill in just one jeep—the bursting mortar shells had disabled the other one completely.[63]

As Carson and Carpenter were pushing past SHAEF to cover troops advancing through Belgium and France, Ann Stringer was finally gaining ground on her quest to cover the war in Europe. After arriving in England November 9, she took up her assigned post as head of the news desk for the United Press's London Bureau.[64]

Germany and Russia, January–May 1945

Iris Carpenter had front page, above-the-fold articles in the *Boston Globe* nearly every day from January 5 to January 15 and then again from January 23 to January 31 in 1945, as well as throughout much of February and March. In January, Carpenter covered the Battle of the Bulge alongside the Third Armored Division, in breathless articles describing tank battles, fighter bombers, and shell fire.[65] In February and March, her firsthand accounts of combat and advancing battle lines continued as the First U.S. Army crossed the Rhine, with no mention of a nurse, a medical ward, or anything resembling SHAEF's prescribed woman's angle.[66]

Although Lee Carson also had an impressive number of scoops and front page articles, syndicated internationally, in early January and late February, she appears to have spent some of that time back in Paris for surgery.[67] Jack

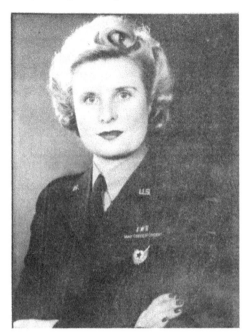

Iris Carpenter, war correspondent for the Boston Globe. Courtesy of Patricia Perry and Brian Scruby.

Oestreicher, head of foreign news for International News Service, recalled that Carson, "certainly the top-notch of all women correspondents in the war game," had returned to Paris "with an injury suffered aboard a jeep that would necessitate a quick operation and at least two weeks someplace on the Riviera in the sunshine."[68] INS had just begun to make arrangements for someone to replace Carson, Oestreicher recalled, "but before anything whatever could be done, there landed on my desk a flash datelined out of U.S. First Army headquarters" stamped "URGENT" and breaking news that the First Army had seized the Remagen and established a bridgehead over the Rhine.[69] "This indomitable young lady, back in Paris for an operation, had heard by one means or another that she had left the front at exactly the wrong time," Oestreicher said. "Operation or no operation, she had found some means of getting back before it was too late."[70] Carson's Remagen articles began by March 9, 1945, with reporting on the "the hottest shooting gallery since D-Day," where she said she felt like a target herself and had to dive into a foxhole and remain there for safety.[71]

By January, Ann Stringer had found her way from heading United Press's news desk in London to writing bylined stories about the war, accompanied by datelines such as "A Fighter Base Somewhere in England."[72] Soon after, she joined the war correspondents billeted at the Hotel Scribe in Paris. Her

Iris Carpenter, Lee Carson, and Ann Stringer | 183

first story near the battle lines, in late February, was a front-page scoop that dug up trouble for her with the Ninth Army.[73] Stringer and *New York Times* correspondent Clifton Daniel followed a tip that Americans were about to cross the river into Germany. They drove to the west bank of the Roer, and then hid behind a tree to wait out the fighter planes.[74] The bridges were down, and so they found a small boat and rowed across the river to the Jülich Citadel, where they found it surprisingly easy to enter, as Stringer recalled:

> Three German guards were standing there. They let us in. I don't know why they did so. It didn't make any sense to us. They apparently could see that we were correspondents. We weren't causing them any problems, and weren't armed. Maybe they felt that it was simply a matter of time before the GIs took the Citadel. We told them we just wanted to come in and look around. I didn't have any problems with the Germans. I had more problems with the Americans after I came out and filed the story.[75]

Clifton Daniel's story ran on the front page of the *New York Times* the next day, spanning more than forty column inches as he broke the news of American forces capturing half of Düren, overrunning two dozen towns, and netting four thousand prisoners.[76] Stringer's story was comparatively short and staid, under headlines such as "Spring Comes Early to Germany in Midst of War," or "Woman Writer Watches End of Stubborn Fight," that some United States newspapers placed more than ten pages deep.[77] After a few paragraphs in which Stringer described exhaust trails of fighter planes embroidering the sky, warm winter sunshine, smoke clouds, and rubble-filled streets, Stringer dropped the reader onto the damp ground with her, where she lay listening to the hollow sound of a Nazi sniper's rifle.

> Then came the sharp report of a big gun, a shrill whoosh and a deafening explosion. Two doughboys jumped up, ran crouched across the roadway and disappeared behind a side wall. In a few minutes, there was a series of shots, but this time they had a different ring. The hollow-sounding Nazi rifle had stopped.
>
> Far off the big gun started up again. The sound of bombardment trebled into a road. But a new sound—different from the others—joined in. It was a searing swish, like the blast from the open door of a giant furnace.
>
> Several hundred yards to our right, hell-colored flames shot toward the same stubborn objective. Flames rushed orange and savage in a long clinging stream through the already blackened trees.

184 | Carolyn M. Edy

For a few minutes, the flamethrowers hurled their fiery blasts and then stopped. It meant the stubborn point had given up.

It was a good day for war—for some.[78]

The day did not turn out to be a good one for Stringer, however, after SHAEF officials got a glimpse at her dateline: "Inside the Juelich Citadel, Germany, Feb. 24, 6:30 PM." But her subsequent fame "made it a little difficult" for SHAEF to discipline her, she said, and after a few weeks, Stringer switched from the Ninth Army to the First, where Carson and Carpenter had already pushed the boundaries for women so far forward they no longer seemed to exist.[79] The First Army had gotten used to women going with the men to cover the front, INS photographer Allan Jackson explained.[80] Stringer connected with the First Army when she interviewed General Terry Allen and wrote about the 104th Division of the First Army's drive into Cologne March 5. Her Ninth Army datelines continued until mid-March, but by April Stringer was writing consistently about the First Army divisions.

The final month of their attachment to the First U.S. Army offered additional scoops for all three women. Despite the headlines that Carson and Stringer gained for "firsts" they achieved in reaching the Elbe, they had fewer bylines and shorter articles in April and May. Ann Stringer's April 1945 articles included spot news and short feature articles about Black American troops, Russian celebrations, and the gruesome sights of concentration camps.[81] Although Stringer and others would later claim that she had been the lone correspondent to break news of the linkup at Torgau, at the time many newspapers ran her story on inside pages, under headlines such as "News-woman Tells Celebration," or featured photographs of her rejoicing with Russian soldiers. Stringer was accompanying the 69th Division when a young boy, dripping wet from a swim across the river, saw them and began yelling "Bravo Amerikanski!" and "Bravo, Comrades!"[82]

I had just flown in a Piper Cub plane into this historic town where the official juncture of the Americans and Russians took place. We landed in a clover field, climbed over two road blocks and then saw the young Russian running up the street. A little earlier an American patrol had penetrated into Torgau.

The Germans blew all the bridges across the Elbe, but there is a small fleet of shaky boats and canoes and I decided to cross the river in one of them.

As the Russians on the eastern bank saw us coming in our canoe they rushed down to the river bank and began yelling greetings.[83]

Ann Stringer, war correspondent for the United Press, celebrates with Russians and Americans after the link up at Torgau. Courtesy of the West Virginia and Regional History Center, West Virginia University Libraries.

Lee Carson, in addition to reporting on the movements and successes of the First U.S. Army in April, covered spot news stories about the accidental shooting death of a field commander, how American tanks seized the first intact V-2 rockets, the establishment by Russian and Polish officers of the first Communist settlement in Germany, and the presentation of a historic Stalingrad flag to a U.S. general.[84] The *Boston Globe* ran more than three dozen articles with Iris Carpenter's byline between April and V-E Day, placing her work on the front page more than half the time. Her articles also described the advance to the Elbe, Nazi suicides, and the horrors of concentration camps before reporting on the linkup under datelines such as "In Russian Blackout Area, April 24" and "With the 1st American and the Ukrainian Armies, Torgau, Germany, April 26."[85]

When they landed in New York in June 1945, Iris Carpenter and Lee Carson humored reporters with thrilling anecdotes and described their plans to continue reporting from the Pacific. Instead, the war ended and both women traded full-time reporting roles for part-time work as feature

186 | Carolyn M. Edy

columnists. Ann Stringer, after toasting Russian soldiers at the Elbe, traveled to Italy and continued breaking news regularly as a successful foreign correspondent, writing about the aftermath, postwar foreign relations, and the Nuremberg trials. Sadly, the glory and defeat all three women had witnessed in the final year of the war seemed to continually play out in their personal lives, as well. Friends and former colleagues who reminisced about Carpenter, Carson, or Stringer described the destruction the war wrought on the lives of all three women, alluding to tragedies and struggles that haunted them in their final decades.[86] By 1946, the War Department had removed the questionable "woman war correspondent" category from its regulations and SHAEF officials recognized the sacrifice and contributions of female war correspondents alongside their male colleagues with medals for "outstanding and conspicuous service."[87] And yet the very same obstacles and arguments would resurface each time women sought to report on military operations up through the Vietnam War and beyond.[88]

Notes

1. *Monticello*, June 3, 1945 (New York, U.S., Arriving Passenger and Crew Lists, 1945), 130–132; John Barry, "Iris Carpenter Arrives—Still with Her 1st Army," *Daily Boston Globe*, June 4, 1945; and Helen M. Staunton "'Unmitigated Hell—' Iris Carpenter Would Have Echoed Sherman," *Editor & Publisher*, June 23, 1945, 74.

2. Iris Carpenter, "Iris Carpenter's Last Battle Dispatch from the Western Front," *Daily Boston Globe*, May 9, 1945, 18.

3. Staunton, "'Unmitigated Hell.' "

4. Ibid.

5. Ibid.

6. Ernest Dupuy, "Elephants" (unpublished manuscript), 118, R. Ernest Dupuy Papers, 1943–1945, unprocessed collection, Wisconsin State Historical Society, Madison, WI.

7. Ann Stringer and Mark Scott, *"Bravo, Amerikanski!" and Other Stories from World War II: As Told to Mark Scott* (Bloomington, IN: First Books Library, 2000), 16; and "Reuter Reporter Killed in France: William Stringer, Texas Native, Was with American Army from First Landing," *New York Times*, August 23, 1944, 5.

8. "The Rhine Maidens," *Newsweek*, March 14, 1945.

9. "European-African-Middle Eastern Campaign Ribbon," Headquarters U.S. Forces, European Theater, November 26, 1945, R. Ernest Dupuy Papers, 1943–1945, unprocessed collection, Wisconsin State Historical Society, Madison, WI; and War Department, "War Correspondents—Decorations and Awards," 1–14, M.C. 417, folder 117, Ruth Cowan Nash Papers, Schlesinger Library.

10. Carolyn M. Edy, *The Woman War Correspondent, the U.S. Military, and the Press: 1846–1947* (Lanham, MD: Lexington Press, 2017), 49–51, 95–100.

11. Ibid., 52; and U.S. War Department, Regulations for War Correspondents Accompanying United States Army Forces in the Field. Field Manual 30–26 (Washington, DC: Government Printing Office, January 21, 1942).

12. Carolyn Edy, "War Correspondents, Women's Interests, and World War II," in *Journalism's Ethical Progression: A Twentieth-Century Journey*, ed. Gwyneth Mellinger and John P. Ferré (Lanham, MD: Lexington Books, 2019), 124–128; and SHAEF Public Relations Division Policy File, "Women Correspondents: SHAEF PRD Memo," June 11, 1944, Record Group 331, Records of Allied Operational and Occupation Headquarters, World War II, 1907–1966, National Archives at College Park, College Park, MD.

13. Iris Carpenter, personal papers (private collection), courtesy of the Perry-Scruby family; and Iris Carpenter, *No Woman's World* (Boston: Houghton Mifflin, 1946).

14. Ibid.

15. "Nine Added to INS Staff, According to Connolly Broadcasting," *Broadcast Advertising*, March 17, 1941, 49; and "Members of the Press Entitled to Admission," Official Congressional Directory, 77th Congress 1st Session, 1941, 704.

16. "East Texas Students on the 40 Acres," *Tyler (TX) Courier-Times*, November 24, 1940, 3; "Elizabeth Ann Harrell, "William J. Stringer to Wed This Morning," *Tyler Courier-Times*, March 2, 1941, 3; and Stringer, *Bravo Amerikanski*, 9.

17. Stringer, *Bravo Amerikanski*, 14.

18. "Correspondents Departed from European Theater," 1945, R. Ernest Dupuy Papers, 1943–1945, unprocessed collection, Wisconsin State Historical Society, Madison, Wisconsin.

19. FRE 9903, Photographs United States Army Air Forces in Britain, 1944, Roger Freeman Collection, Imperial War Museums; FRE 9904, Photographs United States Army Air Forces in Britain, 1944, Roger Freeman Collection, Imperial War Museums.

20. Memorandum for Chief of Staff From: T. J. Davis, Brigadier General, G.S.C., Chief, Public Relations Division Subject: War Correspondents 00074-5, 1-1169, and 1-1170 (April 24, 1944). Records of Allied Operational and Occupation Headquarters, World War II, 1907–1966, National Archives at College Park, College Park, MD.

21. Helen M. Staunton, "1st Army Back Home with Its Reporters," *Editor & Publisher*, June 9, 1945, 12, 60.

22. Dwight Bentel, "Carson Looks Good as War Correspondent," *Editor & Publisher*, June 16, 1945, 6.

23. Ibid.; and Lee Carson, "Beaches 'Alive' with Troops, Returning Fighter Pilots Say," *Honolulu Advertiser*, June 6, 1944, 1.

24. International News Service, "Allies Establish Bridgehead Six Miles Deep: Counter-Attack by German Tanks Is Beaten Off," *Tipton (IN) Daily Tribune*, June 7, 1944, 1.

188 | Carolyn M. Edy

25. Carson, "Beaches 'Alive'," 1; Lee Carson, "Pilot Scores Six Invasion Firsts," *Morning News* (Wilmington, DE), June 7, 1944, 2; Lee Carson, "Beachhead Forces Regain Terrain Lost to Germans," *San Francisco Examiner*, June 9, 1944, 2; and Lee Carson, "Front-Line Troops Relax and Play at Normandy Rest Areas," August 27, 1944, *Waterloo (IA) Sunday Courier*, 3.

26. Steven Casey, *The War Beat Europe* (New York: Oxford University Press, 2017), 347–350.

27. Barney Oldfield, *Never a Shot in Anger* (New York: Duell, Sloan and Pearce, 1956), 105.

28. Ibid., 104.

29. Lee Carson, "Caen Badly Battered: Fliers Report French City Is in Ruins," *Lowell (MA) Sun*, July 8, 1944, 26; Lee Carson, "Panzer Units Flee Madly as Allied Armor Advances," August 17, 1944, *Cedar Rapids Gazette.*

30. Lee Carson, "Hemingway Captures French Town—Gal Reporter Has Close Call in France," *Moline Daily Dispatch*, August 25, 1944, 8; Lee Carson, "Girl Goes to War: Lee Carson Tells of Narrow Escape From Capture," *Daily Journal Gazette*, August 25, 1955, 1; Lee Carson, "Girl Writer Escapes Nazis," *Miami News*, August 25, 1944, 4.

31. "No 'Sob Sister': Lee Carson," *South Bend (IN) Tribune*, August 22, 1944, 18.

32. PRO signed Lee to AD SEC COM Zone to Public Relations, June 21, 1944, File 1 1217, Declassified, 000.74–5 ARC Identifier 615368, Series: Decimal Files, Record Group 331, National Archives at College Park, College Park, MD.

33. Carpenter, *No Woman's World*, 47.

34. Iris Carpenter, "Bill Thompson Works Miracles in Normandy," *Daily Boston Globe*, July 26, 1944, 5.

35. Iris Carpenter, "Beachhead in Normandy Transformed in Two Weeks," *Daily Boston Globe*, July 13, 1944, 13; Iris Carpenter, "Boston Nurse Doing Heroic Work," *Daily Boston Globe*, July 18, 1944, 1; Iris Carpenter, "'Jerries Cracking Like Glass,' Says Haverhill Litter Bearer," *Daily Boston Globe*, August 7, 1944, 11; Iris Carpenter, "Globe Woman behind Nazi Lines: 10,000 Maquis in Brittany Are Taking No Prisoners," *Daily Boston Globe*, August 17, 1944, 11; and Iris Carpenter, "Brittany Town Liberated 10 Days before Allies Came," *Daily Boston Globe*, August 21, 1944.

36. Carpenter, *No Woman's World*, 47.

37. Carpenter, *No Woman's World*, 64–65; and Iris Carpenter, "Northboro Teacher Aids French Children," *Daily Boston Globe*, August 20, 1944.

38. EXFOR MAIN P AND PW to PRD SHAEF for DUPUY, August 22, 1944, 00074-1, Record Group 331, Records of Allied Operational and Occupation Headquarters, World War II, 1907–1966, National Archives at College Park, College Park, MD.

39. Carpenter, *No Woman's World*, 109–110.

40. Ibid., 130–131.

41. Andy Rooney, *Off Record: The Best Stories of Foreign Correspondents* (Garden City, NY: Doubleday, 1953), 31–32.

42. Lee Carson, "Children Shot," *Lincoln Star*, August 28, 1944, 2.

43. Oldfield, *Never a Shot in Anger*, 111–112.

44. Staunton, "1st Army Back Home with Its Reporters," 60.

45. Lee Carson, "Paris Still Style Center Despite Throes of War," *Atlanta Constitution*, August 29, 1944.

46. Lee Carson, "20,000 Germans Surrender to Air Force," *Daily Journal Gazette*, September 18, 1944.

47. Iris Carpenter, "Cost of Break-Through Streams by on Litters," *Daily Boston Globe*, October 8, 1944, D29; Iris Carpenter, "Globe Woman in Germany: Nazis Won't Let Germans Quit Says Surrendered Newsman," *Daily Boston Globe*, October 11, 1944, 10.

48. Iris Carpenter, "Iris Carpenter Tells How Chicopee Mayor Foiled Plan to Dam Roads with Civilians," *Daily Boston Globe*, October 12, 1944, 1; Iris Carpenter, "Old German Castle Now a Red Cross Station," *Daily Boston Globe*, October 20, 1944; Iris Carpenter, "Globe Writer in Germany: Brookline Doughnut Girl, Gretchen Yoffa, Has Hair-Do," *Daily Boston Globe*, November 23, 1944, 11; and Iris Carpenter, "Boston Writer in Metz: Winchester Main Praises His Co. D 'Plaster Boys,'" *Daily Boston Globe*, November 26, 1944, D40.

49. Christopher Costello, "Iris Carpenter," *Daily Boston Globe*, January 23, 1945, 8.

50. Iris Carpenter, "Globe Writer in Germany: Cited Sergeant Blushes as He Highlights Bergstein Battle," *Daily Boston Globe*, December 7, 1944, 1; Iris Carpenter, "Boston Doctor, Winthrop Priest Get Citations for Their Heroism," *Daily Boston Globe*, December 8, 1944, 18; Iris Carpenter, "Globe Writer in Bergstein: German Children Get Christmas Party as Shells Fly Overhead," *Daily Boston Globe*, December 8, 1944, 1; Iris Carpenter, "In Another Grandstand Seat: Iris Carpenter Describes U.S. Tank Charge before Duren," *Daily Boston Globe*, December 11, 1944, 1; Iris Carpenter, "Globe Writer with 1st Army," *Daily Boston Globe*, December 14, 1944, 1; Iris Carpenter, "Globe Writer in Germany: Wounded Nazis in Our Hospitals Fear Plan to Kill Them with Drugs," *Daily Boston Globe*, December 18, 1944, 10.

51. Iris Carpenter, "Germans Gamble All: New Nazi Horde Joins 200,000 in Drive Against 1st Army," *Daily Boston Globe*, December 21, 1944, 1; Iris Carpenter, "Yanks Launch Own Attack at Stavelot; Iris Carpenter Describes Battle," *Daily Boston Globe*, December 22, 1944, 1; Iris Carpenter, "Nazis Kill Every Civilian in Village," *Daily Boston Globe*, December 23, 1944, 1; Iris Carpenter, "Patton Checks Nazis: Globe Writer at the Front: Germans Forced to Give Ground on North Flank," *Daily Boston Globe*, December 23, 1944, 1; and Iris Carpenter, "Nazis Thrust 11 Miles," *Daily Boston Globe*, December 27, 1944, 1.

52. Iris Carpenter, "Globe Writer with 1st Army: Nazis Digging In, Fighting for Time to Consolidate," *Daily Boston Globe*, December 29, 1944, 1.

190 | Carolyn M. Edy

53. Iris Carpenter to William Towler, *Daily Herald*, December 22, 1944 (private collection), courtesy Scruby-Perry Family.

54. Lee Carson, "U.S. Officer Starts Tidal Wave of 'Kamerads' with Curt Talk," *Atlanta Constitution*, October 18, 1944, 1.

55. "Correspondents Departed from European Theater," September 1945, R. Ernest Dupuy Papers, 1943–1945, unprocessed collection, Wisconsin State Historical Society, Madison, WI; "A Man-Sized Job," *Independent Record*, May 12, 1945; and Carpenter, *No Woman's World*, 189–190.

56. Lee Carson, "Patton in Battle of 1,000 Tanks: Metz Onslaught," *Daily Mail* (London), November 11, 1944, 1; and Lee Carson, "2 Lost U.S. Companies Saved in Fight in Snow," *Cedar Rapids Gazette*, November 14, 1944, 14.

57. Lee Carson, "Nazis Reported Falling Back in Ruhr-Rhine Area," *Cedar Rapids Gazette*, November 19, 1944, 6.

58. Nelson D. Lankford, ed., *OSS against the Reich: The World War II Diaries of Colonel David K. E. Bruce* (Kent, OH: Kent State University Press, 1991), 198.

59. Dwight Bentel, "Carson Looks Good as War Correspondent," *Editor & Publisher*, June 16, 1945, 6, 68.

60. "Lee Carson (a) Got the News (b) Wowed the Boys in Europe," *Cedar Rapids Gazette*, June 24, 1945, 13.

61. Hal Boyle, "In Memoriam: Lee Carson Reeves," *Logan (OH) Daily News*, April 16, 1973. See, for example, Carson, "Patton in Battle of 1,000 Tanks"; Lee Carson, "1st Retreat Since the Invasion: But Allies Are Fighting Back," *Daily Mail*, December 19, 1944, 1.

62. Ernest Hemingway to Helen Kirkpatrick, November 12, 1948, in *Ernest Hemingway Selected Letters, 1917–1961*, ed. Carlos Baker (Ernest Hemingway Foundation, 1981), 652.

63. Bill Boni, "Writing Out Loud," *Spokesman Review*, December 24, 1954.

64. *Desirade,* November 9, 1944, Incoming Passenger List, National Archives of the United Kingdom, Surrey, England; and Stringer, *Bravo Amerikanski.*

65. See, for example, Iris Carpenter, "American Armor Battles Over Snow-Clogged Hills," *Daily Boston Globe*, January 6, 1945, 1; Iris Carpenter, "Nazis Get 3 Setbacks: Foe Flees, Bulge Reduced to 10 Miles," *Daily Boston Globe*, January 9, 1945, 1; and Iris Carpenter, "Nazi Industries Seized: Soviets 16 Miles Nearer Berlin; 1st Army Gains 2 Miles in Blizzard-Borne Drive," *Daily Boston Globe*, January 29, 1945, 1.

66. See, for example, Iris Carpenter, "Floodwaters Released: Climax of River Line Battle Seen at Hand," *Daily Boston Globe*, February 10, 1945, 1; Iris Carpenter, "Iris Carpenter's Dispatch: Artillery Gunners Achieve Ambition to Shell Cologne," *Daily Boston Globe*, February, 28 1945, 1; and Iris Carpenter, "Rhineland Capital 3d Largest Rubble Pile in Reich," *Daily Boston Globe*, March 6, 1945, 1; "Rhine Spanned in 10 Minutes," *Daily Boston Globe*, March 10, 1945, 1; and Iris Carpenter, "Situation Too Big for Reporting Full Story," *Daily Boston Globe*, March 31, 1945, 1.

67. See, for example, Lee Carson, "1st Army Drive in Nazi Flank Exacts High Price in Blood," *Fort Worth Star-Telegram,* January 7, 1945, 1; and Lee Carson, "Germans Surrender by Thousands East of Roer River," *Rock Island (IL) Argus,* February 27, 1945, 1.

68. J. C. Oestreicher, *The World Is Their Beat* (New York: Duell, Sloan and Pearce, 1945), 114.

69. Ibid.

70. Ibid.

71. Lee Carson, "Surprise Crossing," *Marysville Journal Tribune,* March 9, 1945, 1; and Lee Carson, "Bridgehead Becomes Hot Shooting Gallery," *New York Journal-American,* March 11, 1945. Also see, for example, Lee Carson, "Writer Describes Epochal Feat of Daring Yanks in Race with TNT across 1,300-foot Rhine Bridge," *Democrat and Chronicle,* March 10, 1945, 1; "Remagen. Bridgehead Turned into Hottest Shooting Gallery since D-Day, Lee Writes," *Clarion-Ledger* (Jackson, MS), March 11, 1945, 1; and Lee Carson, "Under Deadly Fire Yank Engineers Place Pontoon," *Doylestown (PA) Daily Intelligencer,* March 14, 1945, 1.

72. Ann Stringer, "American Ace Gets 23 Planes," *Billings (MT) Gazette,* January 29, 1945, 6.

73. Ann Stringer, "Doughboys Capture Fortress at Juelich; Not a Shot Fired," *Kilgore News Herald,* February 25, 1945, 1; and Oldfield, *Never a Shot in Anger,* 190–191.

74. Stringer, *Bravo Amerikanski,* 25.

75. Ibid., 26.

76. Clifton Daniel, "21 Towns Entered: 1st Army Captures Half of Dueren as 9th Drives on East of Juelich," *New York Times,* February 25, 1945, 1.

77. Ann Stringer, "Spring Comes Early to Germany in Midst of War," *Lowell Sun,* February 26, 1945, 17; and Ann Stringer, "Woman Writer Watches End of Stubborn Fight," *Kenosha Evening News,* February 26, 1945, 14.

78. Ann Stringer, "Spring Comes Early to Germany in Midst of War," *Lowell Sun,* February 26, 1945, 17.

79. Stringer, *Bravo Amerikanski,* 28–29, 39, 90.

80. Ibid., 183.

81. Ann Stringer, "Nazis Used Poison Injections to Kill 8,000 in 'Hospital,'" *Boston Evening Globe,* April 9, 1945, 1; Ann Stringer, "Platoon Licks Adolf's Supers," *Chicago Defender,* April 14, 1945; Ann Stringer, "Dead and Dying Litter Floor of Nazi Prison Barracks," *Los Angeles Times,* April 15, 1945, 4; and Ann Stringer, "Newswoman Tells of Celebration," *Los Angeles Times,* April 28, 1945, 4.

82. Stringer, *Bravo Amerikanski,* 65.

83. Stringer, "Newswoman Tells of Celebration," *Los Angeles Times,* April 28, 1945, 4.

84. Lee Carson, "Racing Yank Forces Ordered to Skip Taking Nazi Prisoners," *Democrat and Chronicle,* April 1, 1945, 3; and Lee Carson, "Jumpy Trigger Finger Fatal: Gen. Rose, Able Commander, Victim of Teen-Age Nazi," *Atlanta*

192 | Carolyn M. Edy

Constitution, April 4, 1945, 4; and Lee Carson, "21 U.S., British War Prisoners Taken to Nazi Alps as Hostages," *Pasadena Star News*, April 17, 1945, 1.

85. Iris Carpenter, "4 Allied Armies Dash for Elbe," *Daily Boston Globe*, April 10, 1945, 1; Iris Carpenter, "Horror of Nordhausen Robot Plant: Yanks Made Germans Bury Bodies of 2,107 Slaves," *Daily Boston Globe*, April 17, 1945, 1; Iris Carpenter, "Leipzig, Halle Seized: Top Nazis Commit Suicide as Yanks Capture Leipzig," *Daily Boston Globe*, April 20, 1945, 1; Iris Carpenter, "Reds Cut Off Berlin: Soviet Armies Join; Hold Half of Capital," *Daily Boston Globe*, April 25, 1945, 1; and Iris Carpenter, "Iris Carpenter at the Link-Up," *Boston Daily Globe,* April 28, 1945, 1

86. Out of respect for the memories of Carpenter, Carson, and Stringer, as well as their surviving family members, this article does not include specifics of these struggles, which are outside the scope of this chapter and, in many cases, based upon hearsay, tabloid articles, or personal documents in private collections.

87. Edy, *Woman War Correspondent*, 124–127.

88. Ibid.

9

A "Butcher and Bolt" Force
Commandos, Rangers, and Newspaper Dramatics in World War II

James Austin Sandy

"The Ranger gets recognition when he crawls black-faced into the enemy's lines—he earns it." So starts a short and author-less article in the back pages of a March 1944 issue of the *New York Times*. The piece, titled "Remembering the Infantry," goes on to say that "the daring specialist, doing things that strike the lay civilian dumb with wonder, is a product of modern war." In an article pleading its readers to not forget the "poor bloody infantry," the marvelous specialists of modern war stand out. Among the airmen, paratroopers, submarine chasers, and Marines the Army Ranger was something different—something special on newspaper pages during the war.[1]

Newspaper reporting during World War II exaggerated the image of the U.S. Army Rangers and British Commandos, inflating their capabilities, training standards, and overall status within the Allied militaries. As the British and American militaries looked for early success against Hitler's Fortress Europe, the specialized training and raiding missions of the Commandos and Rangers offered feel-good stories, momentum-building victories, and ready-made heroes for their publics in uncertain times.[2] The reality of their war reflects a mixed bag: These units were experimental in design and objectives and thus frequently misunderstood and misused in the field. As the war progressed and the Allied prospects of overwhelming victory improved, both the military usefulness and public perception for these units deteriorated and ultimately disappeared.

In a November 1948 issue of *The Listener,* a weekly BBC magazine, newly minted Brigadier General Dudley Clarke told his version of the "The Birth of the Commandos." In the summer of 1940, as the British people licked their wounds from the battle of Dunkirk and braced themselves for the escalating Battle of Britain, the nation saw little evidence of hope. Looking to help "the army to exercise its offensive spirit once again," Clarke and General John

Dill, chief of the Imperial General Staff, put together a proposal for a raiding program against the German held coastlines of Europe. Following presentations to the British cabinet, Prime Minister Winston Churchill declared: "Enterprises must be prepared, with specially-trained troops of the hunter class, who can develop a reign of terror down these coasts, first of all on the 'Butcher and Bolt' policy." Clarke praised the Boer Commandos, a group that fought off the British in South Africa with unconventional raids and devastating ambushes, as his inspiration. Clarke and Dill agreed that their new unit should "hit sharp and quick—then run to fight another day."[3]

Less than three weeks after Churchill's call for a raiding program and only days after his famous "Finest Hour" speech, the first raid took place. On the night of June 24, 115 British soldiers of the 11th Independent Company raided the German-held coast of France near Pas-de-Calais. Operation Collar aimed to gather reconnaissance and capture several German prisoners for interrogation. Neither were accomplished as the men found most of their targets abandoned. The only real action occurred when two British bayonets met a pair of German sentries. The thrill was short-lived as the two men had to abandon their weapons and awkwardly swim to the escape craft. The only British casualty occurred as they withdrew under fire. Lt. Col. Dudley Clarke, along as an observer, suffered a bullet wound behind his ear. The operation yielded no prisoners or actionable intelligence and was made public only through a discreetly published official memo mentioning "naval & military raiders." A similar raid, Operation Ambassador, was conducted three weeks later with similar lackluster results.[4]

Despite the failure to achieve any of their stated objectives, these initial raids provided a foundation to build on. The raids were conducted without any serious casualties, and the soldiers taking part had zero specialized training and weren't even Commandos yet. Most important was the public reaction. The news of Operation Collar went public before the British cabinet even knew it happened. Ernest Chappell, one of the first raiders, understood the effect:

> The Raid didn't achieve much. . . . But it was quite a boost to morale, both to ourselves and, I suppose, to the civilian populace to read . . . that our forces had landed on the Continent less than three weeks after the evacuation. . . . The possibility was there of us doing it again. . . . That, in my view, was what it was all about.[5]

In March 1941, the Commandos executed one of their most successful raids; it was against the German-held Lofoten Islands, off the coast of

A "Butcher and Bolt" Force | 195

northern Norway. Operation Claymore aimed to destroy industrial capabilities and large oil reserves. The "daring raid took the Germans completely by surprise" as the British Navy unloaded members of the No. 3 & 4 Commandos in freezing temperatures. Eyewitness accounts boasted that "our ships were on Hitler's back doorstep for hours!" Commandos and their Norwegian guides destroyed glycerin-producing fish oil factories, petroleum dumps, and several German ships; they took more than two hundred prisoners. Both British and American newspapers boasted about the efficiency of the strike and its overwhelming success. Discussing how surprised the Nazis were, how detailed the preparation was, and the impacts on the Norwegian population suffering under Nazi rule, these stories impressed on their readers the power of these raids.[6]

In a November 1941 address to the House of Commons, Sir Roger Keyes, the original director of the Combined Operations office and the Commandos, enumerated the many benefits of the program and his role. Joking that his appointment the previous summer was kept a secret to not completely alarm and dismay Britain's enemies, Keyes made quite the spectacle as several American congressmen sat in attendance. In a heated debate with members of the House of Commons, Keyes lambasted the slow pace toward Britain's "ultimate victory," saying that he and the Commandos were "eager and ready to act a year ago" and that if unleashed could "have altered the whole course of the war." Boasting about the success of the Lofoten raid and hinting that most of the details were still unknown to the public, Keyes's public claim and its reporting added to the growing aura of the Commandos and their program. Reported on both sides of the Atlantic, news of Keyes's criticism of the pace of the war and his opinions on the Commandos' ability to impact the war was loudly received. Keyes argued that "secret and swift decision, surprise and speedy action are essential" to achieve lasting victory in this war, and the American people and their government watched intently just days before Pearl Harbor and American entry.[7]

As the calendar turned to 1942, larger-scale raids raised the profile of the Commandos on both sides of the Atlantic. Three weeks after the attacks on Pearl Harbor, the British launched the largest raid to date in Operation Archery. More than five hundred Commandos invaded the Norwegian Vaagso Islands to disrupt supplies, dislodge the German occupiers, and cause general havoc. For five hours they fought house to house against entrenched German forces and scored a resounding victory. The peripheral attack forced the German high command to relocate thirty thousand more soldiers to the defense of the Norwegian coastlines. Special war correspondents, including Gordon Holman, Ralph Walling, and Jack Ramsden, accompanied the

196 | James Austin Sandy

Commandos into the fray and reported back eyewitness accounts. A few days after the successful operation, newspaper readers were treated to play-by-play accounts of the raid and examples of heroism and triumph. The first story of the raid, printed in both *The Guardian* and the *New York Times*, contains a bagpipe serenade, young British soldiers waving and daring a German sniper, rescued Norwegian civilians rushing into British ships, and a thorough endorsement of the Commandos and their "guerrilla fighting qualities." Matching the words of Admiral Keyes and demanding more offensive action, Ralph Walling's article ended with an image of the Commandos singing their newly embraced refrain: "Why are we waiting?"[8]

Several days later, American newspapers highlighted the growing importance of these raids as they tested the German defenses, provided vital information, raised morale for the British people, and forecasted the impending invasion of Europe itself. A short *New York Times* article on January 2 highlights the fact plainly, arguing that the Commandos are sure to be the "shock troops in the attack that is coming." The same day that American readers were contemplating the invasion of Europe, British citizens looked behind the veil of Hitler's Fortress Europe with an interview of rescued Norwegian civilians. They spoke of reduced German morale, scarcity of food, and the dangers women faced from their occupiers. Saved by the Commandos, these people put faces and voices to the millions still under Nazi rule. *War Illustrated*, a popular British magazine, published Reuters correspondent Ralph Walling's personal account of the raid: "I Was There!—We Went to Vaagso with the Commando Men." The Commandos and their exploits provided much needed good news for victory-hungry American and British audiences, and newspaper treatments did nothing but fan the flames of the importance of the Commandos and their raids.[9]

As interest in the Commandos soared, so did the audacity of their missions. Operation Chariot targeted the German-held French port of St. Nazaire on the Atlantic coast. Working with the Royal Navy, the Commandos aimed to destroy the dry dock and force any large German vessels through British-controlled seas into the Mediterranean or the Baltic for repairs. As the Commandos disembarked to destroy key equipment and dock defenses, an outdated destroyer loaded with timed explosives, HMS *Campbeltown,* would ram the dry dock and explode a few hours later. The raid commenced just after midnight amid total German confusion. Gordon Holman, *The Guardian*'s special correspondent, accompanied the Commandos and published his eyewitness account just two days later. Appearing in newspapers from London to San Francisco, the dramatic two-page article was long on praise for the operation and the brave men who undertook it, despite an alarming

number of casualties. In "one of the finest aggressive operations we have engaged in since the war started" the dry dock was destroyed and general mayhem and chaos brought upon the German defenders. Most of the smaller British vessels were destroyed in the chaotic battle, resulting in more than one hundred Commandos left behind. Colonel Augustus Charles Newman, commander of the No. 2 Commando, did not hesitate to disembark from one of the few remaining ships to cover the escape. Holman watched from the last ship to leave the harbor and remarked that the Commandos were "the least worried of all about their own withdrawal."[10]

Newspaper stories lauded the "impossible" raid for its bold nature and "sheer daring," largely disregarding the heavy cost of its success. American stories focused exclusively on the Commandos' role and their assured ability to "lift the fighting spirit of the whole British people." Most stories downplayed the role of the Navy, Air Force, and those left behind in favor of highlighting the Commandos and the "shambles" they made of the harbor works. Holman's eyewitness account provided an intimate view of the outlandish feat. Operation Chariot, above all the previous raids, cemented the "daring and gallant" image of the Commandos to the British and American publics as a uniquely capable group undeterred by the steep slope to victory.[11]

Two months after St. Nazaire General George C. Marshall, Chief of Staff of the Army, delivered a graduation speech at the U.S. Military Academy. Speaking to the group of young men about to commission and head to war, Marshall was honest: "No one could tell what the future might hold for us." The army he presided over that day had more officers than the one he inherited in 1939 had soldiers in total. In the months preceding that speech Marshall had spent every waking moment preparing for the inevitable moment when American soldiers entered the war. Ever mindful of manpower limitations, leadership deficiencies, and the complete lack of combat experience within the Army, Marshall looked to all possible avenues of inspiration. The high-profile British Commandos were an easy place to start.[12]

During an April visit to England, Marshall and American commanders were briefed on the Commando program, its training protocols, and operation history. Marshall disliked the idea of specialized units but left the meeting interested in the Commando training program as a chance to improve American readiness. Suggesting that a small American force undergo Commando training and take part in future raids, Marshall hoped to increase the "battle efficiency" of the American military by dispersing Commando-trained individuals throughout conventional American units.[13] General Marshall tasked Colonel Lucian Truscott with the formation of an American

198 | James Austin Sandy

"Commando" unit in the British image. In addition to the small unit, "Commando" training techniques were to be implemented across the army as quickly as possible. Col. Truscott looked to the 34th Infantry Division stationed in Ireland for volunteers to train with the Commandos. Colonel William O. Darby, a member of the 34th and a graduate of West Point with amphibious experience, would lead the new unit. Many of the more than fifteen hundred volunteers did so due to the popularity of the Commandos; Gino Mercuriali and Thomas Holt were two volunteers who joined to see the kind of action reported in the papers.[14] The all-volunteer unit was dubbed the 1st Ranger Battalion to honor Rogers' Rangers from the Seven Years' War and to inject a distinctly "American" feel. Truscott and Darby focused on physical ability, initiative, and sharp intellect as they selected almost six hundred men for the unit. Training took place at the Commando Depot at Achnacarry Castle in Scotland, where the brash Americans were met with an immense physical challenge and the most realistic drills possible. Every element of the program used live ammunition, and multiple men were killed or wounded along the way. During amphibious training, live grenades were regularly thrown into boats full of Rangers. Officers frequently pressed their noncommissioned subordinates into leadership roles to better the reaction ability of their men and the unit. The press took no notice of the American arrivals in Scotland or much of what went on at the training depot.[15]

The inclusion of Americans in the raiding program became public knowledge in the most explosive manner: the Allied raid on German-held Dieppe in August 1942. Operation Jubilee was a test case for the eventual invasion of Europe and dominated newspapers. More than seven thousand Canadian and British soldiers and Commandos stormed the beaches and port facilities at Dieppe while fifty U.S. Army Rangers became the first Americans of the war to see "a baptism of fire in Europe." News of the raid and the Rangers' participation was the first official use of the term by the U.S. Army. Accompanying Lt. Col. Lord Lovat and the No. 4 Commando on the western flank of the operation, the Rangers' first test aimed at disabling a battery of gun emplacements threatening the main landing force. Historians agree that the operation was a failure but provided valuable experience and intelligence for the eventual landings at Normandy.[16] Lord Lovat's Commandos and the U.S. Rangers on the western flank provided the one bright spot of the day, knocking out the guns within an hour and withdrawing largely without incident.[17]

"Wiping out a Nazi Battery" read a subheading in the *Manchester Guardian* the next morning. Newspaper coverage of the raid was extensive in Britain, and through A. B. Austin's eyewitness account readers experienced

the Commandos' success with dramatic flair. Nearing the beach, Lord Lovat was overheard telling his men: "This is the toughest job we've had" and that the Commandos were "the flower of the British Army." Austin was reassured by one of the young Brits before they landed that "the other bastards is twice as scared as you." Twenty-two members of the press accompanied the raiders to Dieppe, and several of them made it ashore alongside Austin. Correspondents such as Holman and Austin brought these moments to the public in an immediate fashion and placed the Commandos and their "Silent Surprise" in the front. The American presence was barely mentioned in the British papers and sometimes left out altogether.[18]

Although only fifty Rangers took part in the raid, their involvement created great excitement at home. Stories ripped through American newspapers about the selection, training, and combat experiences of these volunteers alongside the well-known Commandos. "U.S. Rangers in Dieppe Raid were Pupils of Commandos," "Rangers in Attack with Commandos," "Rangers and Commandos Join Hands in Attack," "American Rangers Meet Germans Hand to Hand" represent the headlines on American front pages the next day. Superlatives abound about the men and their new unit, praising the Rangers as the "toughest of the United States forces" and writing that each man was "brawn as well as brain and common sense along with daring." Stories focused on the creation of the unit and their "rough-and-tumble slaughter training" from the British and contained elaborate descriptions of the ways in which these men were now trained to kill. The American press was also highlighted, especially Larry Meier, who received a shrapnel wound to the face while watching the raid offshore and enjoyed his own brief moment in the spotlight upon his return to London. Both luckier and less fortunate than Meier was *The Sun*'s Alexander MacGowan, who missed the entire raid because he ended up on a ship at the back of the convoy full of reserve tanks. Since he couldn't watch the excitement up close, he drank brandy with the ship's surgeon. As the reality of the American role became better known, the "outrageous exaggerations" of American headlines caused "Americans in Great Britain [to blush] with embarrassment."[19]

American newspapers were fascinated by the Rangers because they were the first Americans in combat in Europe. The Rangers represented exciting and positive news from the war effort, and it was hoped that they would bring the same morale boost that British Commandos brought to England. The news stories sought to elevate the image of the American soldier. Tales of the Dieppe raid offered a great deal of flattery and praise for a unit that, outside these fifty selected observers, had not actually experienced combat. Stories beginning with the harsh requirements of the British training

program and the outlandish character of the drill instructors predictably ended with American trainees either matching their counterparts or outright besting them in toughness and ability. One article claimed that Major Darby, the Rangers' commanding officer, was a match for any Commando leader before their first phase of training was even complete. Darby and his men made a name for themselves in both civilian and military newspapers. Corporal Bill Brady, whose birthday coincided with the raid, told the *Stars and Stripes*, "You just have to do the things you know you have to do, and you don't have time to think about why or how you're doing it." Dieppe and the Ranger arrival allowed American newspapers to paint these men as the heroic soldiers the country was so desperately in search of in the first months of the war. The narrative of the Rangers, their origins, and their training took on a life of its own. While inspiration for the Rangers obviously came from the British Commandos, the press sought to Americanize their origins after Dieppe with overblown links to historical figures such as Robert Rogers, "who introduced to the amazed military minds of his time the idea of a fighting force accustomed to marching at incredible speeds for a smashing blow to the enemy."[20]

The September 13, 1942, edition of *The Observer* highlighted several newly opening films in English cinemas, including *Secret Mission*. Starring Hugh Williams and Carla Lehmann, this forgettable picture tracks the antics of two British and two Free French soldiers as they tramp across the German-held French coastline in preparation for an upcoming raid. Packed with action, suspense, and a forced love story, the movie is pitched as preparations for a "Commando Raid" into occupied France. Unbeknown to those readers, possible filmgoers, and even the press, two of the most unfortunate Commando raids of the war unfolded in those same days. Operations Aquatint and Musketoon took place in the early days of September with small raids into France and Norway. Following the fanfare and excitement of Dieppe, these smaller parties of ten men sought to gain intelligence on German defenses on the French coast and knock the Glomfjord power plant out of enemy hands. Despite the destruction of the power plant, both raids ended with all participants either killed or taken prisoner. Neither raid appeared in the newspapers in the days after, and news of the raids became public only as the fates of those involved came to light. Raids like these highlighted the risk and uncertainty of the program, seldom making it to the press and public.[21]

After two years of exciting raids into enemy territory, Gordon Holman released a crowning achievement of the Commando image and its relationship to the newspaper: his book *Commando Attack*. Holman accompanied

the Commandos on an undetermined number of raids starting in 1940, and in addition to the numerous eyewitness accounts in British and American newspapers he had been working on his book-length tale. Centering on the training program and the character of the Commandos, the book recalls his personal experience surviving the St. Nazaire raid. Holman culminated his work unexpectedly by commenting on the image and battlefield effectiveness of the Commando program. No single person contributed more to the rise of the Commando image than he, but he spent the final pages of his opus telling the reader that the Commandos were not as special as everyone thought. Citing the "Commando Consciousness" created by newspaper stories, Holman argued that these men were just like your average soldier and want to be looked at in that manner. He joined prominent British military voices, including Commando leaders and Lord Louis Mountbatten, on the limitations of what raiding could accomplish in the larger objectives of the war.[22] *Commando Attack* is the most reflective source available in determining the relationship between the Commandos, their warfare, and the press during the war. From 1940 to 1944, the Commandos executed fifty-seven raids ranging from ten thousand men to two, with two distinct results: one of middling military impact and another of dominating public success. Newspapers provided the lifeblood of British morale during the war, and Commando raids factored early and often to contribute to morale. The Commando program faded in both visibility and viability as larger Allied operations took place in 1942, and the American Rangers stepped further into the spotlight.

General Marshall's initial justifications for the Rangers program always had the broader war goals in mind, viewing them as a tool to better the overall combat ability of his army in preparation for the inevitable second front in Europe. Both Marshall and the British command believed that the raids themselves brought little in the way of tangible results toward that larger goal. Small raids were great for publicity and morale and kept the German military on its toes, but ultimately these missions utilized tremendous resources and time while carrying enormous risk for an ultimately limited reward.[23] Public image could not have been further from these assumptions, and newspaper stories sat center stage in the buildup of these programs and the men who undertook them. As that second front grew close in the fall of 1942, the image and usefulness of specialized units were put to the test as the Allied nations executed the invasion of North Africa in Operation TORCH.

"Rangers Participate in Operations That Win Vital Airfields" was one of many stories plastered across American newspapers on November 9, 1942,

announcing the invasions of Morocco and Algeria. "Ranger units are participating in the operation" was the third sentence in the official U.S. War Department communiqué accompanying the news blitz. One hundred thousand soldiers took part in the TORCH landings, and yet the thousand men of the U.S. Army 1st Ranger Battalion were front and center in American newspapers. Colonel Darby's men factored prominently in the seizure of Oran, the principal target of the Central Invasion Task Force, securing two prominent gun emplacements on the city's flanks. In dramatic pre-dawn action, the Rangers split in two and overcame the defenders of each emplacement within half an hour. LTC Darby forced the surrender of a third position by compelling the French commander at gunpoint to phone a detachment of French Legionnaires and convince them to capitulate without fighting. Before any real details of the landings were known, the Rangers' opening dramatics were already prominently covered on newspaper pages.[24]

In the following days, the Rangers' actions were broadcast in popular headlines. Phil Ault, a United Press correspondent, partook in the landings at Oran with a conventional infantry unit and told the tale of the "3-day battle." Ault's unit followed the "force of Rangers" and heard the tale of their midnight raid and silencing of the big guns on the flanks. Even the accompanying photo highlights the soldiers en route to the TORCH landings as Rangers although there was little evidence to support it. Reports cited the "striking power of the rangers" as the "crack combat troops" spearheading the large invasion force. The small role played by the Rangers at Oran received an inordinate amount of attention in comparison with the vast operation ongoing along the northern African coast. The *New York Times* published an article on Eisenhower's army, "a cross section of Young America, engaged in a crusade of liberation" just days after the successful landings. Mentioned more than any other unit are the "veterans of Dieppe," the Rangers. These men who "trained with the commandos and took part in a few raids" have a "proclivity for rough-and-tumble fighting of the gouge-and-bite school." The Rangers offered a vibrant and powerful symbol of American military might, especially in these early days of the fight. Ranger veterans such as Cpl. Robert Skarie of St. Cloud, Minnesota, got a write-up in his hometown paper, boasting of his action at Dieppe where he was wounded and awarded a citation for valor.[25]

The Rangers were small and underpowered compared with a standard infantry battalion. Built for speed and precision, the Ranger structure was designed for raiding missions, but army commanders began using Darby and his men in conventional infantry roles more frequently as the campaign moved forward, but the results were frustrating. High casualties and

A "Butcher and Bolt" Force | 203

lackluster results forced the Rangers briefly out of the headlines and onto the sidelines in early 1943. While waiting for a new assignment, the Ranger image was reinforced with help from one of the most famous American war correspondents: Ernie Pyle. After meeting and talking with the "Restive Rangers" Pyle published several articles about the Rangers' specialty: "landing on enemy beaches and storming gun positions." Trained like "racehorses" was Pyle's description; he hoped for a "new shore to storm" before the Rangers "bust a hamstring." Launching surprise raids on enemy positions was one thing, but spearheading invasions was completely differ-ent. A complicated gulf was growing between the public perception of the Rangers and their actual abilities, and Ernie Pyle and the press were the primary culprits.[26]

After sitting idle for two months the Rangers returned to action in one of their most famous accomplishments: the Raid on Sened Station. On February 11, 1943, Darby's Rangers marched more than twelve miles by moonlight to surprise an Italian garrison. Killing almost one hundred enemy soldiers in less than fifteen minutes, they returned at dawn with ten pris-oners in tow. The Rangers fell in with the 1st Infantry Division's eastern advance, serving on the line as rear guards and conducting raids. Their March 20 raid at Djebel Ank helped spring loose the Allied advance, securing a pivotal choke point and more than two hundred Italian prisoners.[27]

Pyle, Ault, and other correspondents highlighted the Rangers' campaign across Africa with frequent stories from within their ranks. During the vital days of late February and March, Ault spent some time in the Ranger camp and shared his experience with readers. Covering the entire emotional spectrum, the story highlighted the Rangers' nighttime raids into enemy lines, their carefree attitude under fire, the adoption of a lost puppy, and a tear-jerking moment when a young rifleman elected not to execute a sur-rendering prisoner. Sgt. Sandage stopped his fellow Rangers from firing on a young, injured German, ending the article: "They are really human beings after they are captured. Why, that guy had tears in his eyes!"

Even commercial entities singled out the Rangers, in a widely run Camel cigarette ad: "In the Rangers they say: Camel for the Army man's favorite cigarette."[28] The Ranger experiment enjoyed a great deal of public attention and praise in its first year, and newspaper coverage built an image truly larger than life. American military leadership remained wary of the raiding concept, but such successes as Sened and Djebel Ank kept the idea alive. In preparation for the invasion of Italy and the eventual cross-channel attack into France, army command looked to Darby's actions in Africa and envi-sioned Rangers "spearheading" future landing operations. The Rangers were

204 | James Austin Sandy

designed for quick raids, not for leading large-scale landing operations, and that reality would result in death and failure soon enough. Regardless of that gap in understanding, the army created more Rangers. The 1st, 3rd, and 4th Ranger Battalions were formed under the tutelage and command of Darby while the 2nd and 5th Battalions were constituted at Tennessee's Camp Forrest.[29]

The 2nd U.S. Army Ranger School at Camp Forrest offered a new fascination for the American press and public. During the school's opening ceremony, the commandant tried to dispel any notion of elitism, stressing that his students were infantrymen and nothing more. Needing no "songs of glory, glamour, or special insignia," the students were reminded that they represented the regular infantrymen. The commandant's speech signified the arrival of the army's new "Rangerism" doctrine. To better the combat abilities of conventional units, the school stressed that its graduates would return to their units to spread "an ingenious American fight, that was personal, motivated through brain and brawn, and ultimately a carefully thought-out dirtier fight." In their eyes "Rangerism" created the best and most capable conventional soldiers in the world. Although the army argued that Rangers were just regular soldiers and demanded no special attention, the school's first class and graduation demonstration presented the opposite.[30] Army leadership, local leaders, and members of the press witnessed live ammunition and explosives in the spectacular "art of killing" display that culminated in a raid on a mock village dubbed "Nazi-ville." Reports from the weekend described anything but a standard training program with "murder, mayhem, and maiming" all required elements of the "dirty fighting" curriculum. Soldiers in the course were taught all number of tricks, including "gouging out eyes, tearing noses from the face, crushing facial bones so the splinters will pierce the brain." Lt. General Leslie McNair, commander of Army Ground Forces, was present for the display and argued, "The dirtier the better!" Using real dynamite, the "Booby Trap" exercise sought to steel the nerves of the young men chasing a retreating enemy because "the Rangers aren't counting on doing much retreating." Both the curriculum and the students at the new school were placed on a pedestal by the news media, citing that only "The Toughest Men" in the army graduated from a program best described as a mix of a "football camp, a house of horrors, and a homicidal maniac's dream."[31]

As the African campaign came to a victorious end, the Allied planners and press looked to the next hostile shore. Matching the shift in the war, the Rangers completed fewer raids and started preparing to spearhead the next landings. Earning "PhD degrees in death," the newest batch of Americans

A "Butcher and Bolt" Force | 205

training with the Commandos in Scotland generated a fresh surge of headlines. A March report from Tom Wolf focused on the demands facing the new "hard-hitting assault troops" at the Commando Depot; the report harped on the physical rigor demanded in the program, the unique equipment utilized, and the ever-present use of live ammunition. Like Wolf's, articles for American readers display a clear air of distinction and supremacy with a generous application of hyperbole. To Wolf the Americans are huskier than their slighter cousins but excel at imagination and field craft. Although the Brits may have been better disciplined, all the speed march records were proudly held by Americans. Wolf asked the reader: "Who are these supermen?"[32]

As the army argued that no infantryman was special, the press regularly presented the opposite. Even a lighthearted article about the Rangers winning a war game stressed the communication, cooperation, and small-unit leadership of the victorious "bad guys." Just days later two more articles appeared on the subject; one was another puff piece about Ranger training in Scotland and the other an examination of the 76th Infantry Division and its adoption of the army's model: "All Infantrymen Shock Troopers." Maj. General William Schmidt presented the "future of all infantry divisions in the army" as every infantryman was now due to receive Ranger training. Overheard on the training grounds was a young lieutenant barking, "There are no rules of clean fighting that apply here. . . . We must be more silent, cruel and vicious than these little sons of b———." A proud Schmidt claimed that same lieutenant had been a Wall Street clerk just two months prior. Were the Rangers specialized units with superior capabilities or was their training simply a pathway to an overall improved army? If story placement says anything, the "puff piece" was on page 3 while the general was all the way back on page 10.[33]

As the U.S. Army prepared for the Italian campaign and eventual invasion of mainland Europe, their training and related press coverage involved more frequent comparisons to "ranger-type" training. Lt. General Mark Clark's 5th Army experienced an intense two-week "inoculation" to live combat in the weeks prior to the invasion of mainland Italy. The use of live ammunition in training exercises "closely approximated the Ranger type of training" observed in Scotland by one reporter. The North African Assault Training center sought to provide an "emotional armor" so that in the din of battle these soldiers would not flinch. Evoking a connection to the Rangers became commonplace in the news and by army personnel. The prestige of the Ranger and Commando names lent an extra layer of rigor and credibility to training courses with little actual relation. The army's assault training

206 | James Austin Sandy

center and its courses, which prepped soldiers for the Normandy landings, were "as tough as those at the Commando and Ranger training centers."[34]

When the Allies invaded Sicily in July of 1943, Darby's Rangers spearheaded the landings onto the southern coast and secured the town of Gela after "severe street fighting." Newspapers credited the "rugged ranger's" actions in securing a path off the beaches and disabling the gun batteries on the flanks. Taking on the final pocket of German resistance, the Rangers secured the high ground only after calling in naval fire support and suffering heavy casualties. Don Whitehead of the Associated Press landed with the Rangers and had a front-row seat in the battle for Gela. His story on the battle was bombastic and flattering to Darby, the "broad-shouldered, two-fisted commander," as he recounted the Rangers' duel with a German Panzer counterattack. Only when Darby secured an enemy anti-tank gun himself was the battle won. The Rangers' work in Sicily garnered a great deal of attention, but none of their struggles to secure proper firepower made it into the reports. Darby earned the Distinguished Service Cross and for the third time turned down a promotion to colonel and the command of a larger infantry unit: "I feel I can do more good with my Ranger boys than I could with a combat team."[35]

When the Allies invaded the Italian mainland at Salerno, Darby's Ranger Battalions spearheaded the landings and took up positions on the leading edge of the advance. During the Anzio campaign, an operation called for the 1st and 3rd Battalions to infiltrate the German lines under the cover of nightfall. Attempting to replicate the success of the Djbel Ank raid in Africa, the plan met with disaster as the Germans easily surrounded the raiding battalions. Only eight men from the encircled battalions escaped to American lines, while the 4th Battalion suffered over 50 percent casualties in the ultimately vain rescue effort. Cisterna was the end of Darby's Rangers as a fighting force, but even in their ultimate defeat they received hefty praise: "Lost Battalion Fights to End." The Rangers at Cisterna were outgunned, outmaneuvered, and soundly defeated by a superior German force. Nevertheless, superlatives abounded in the press, claiming that if only a few more minutes had allowed the Rangers to entrench, everything would have been different. The reporter spoke of the "Ranger Fashion" in which they dispatched a few German guards along the way, and the survivors' promise of a vengeful "sequel." The Ranger units of the Italian campaign were misused, underpowered, and overextended by their command and the rigors of the campaign and barely resembled the legends from the newspaper pages.[36]

A few months later the two "new" Ranger Battalions took part in Operation Overlord in two drastically different roles. When Lieutenant Sidney

A "Butcher and Bolt" Force | 207

Salomon of the 2nd Ranger Battalion led his men into the "baptism of fire" of Omaha beach, men he had trained with had already been fighting their way up the cliffs at Pointe du Hoc for close to an hour. A selection of men from each battalion scaled the 90-foot cliffs overlooking the landing beaches to disable a German artillery emplacement. While most of the Rangers spearheaded the largest amphibious operation in human history, a few hundred of their comrades fought vertically to the top of a heavily defended cliff. Both groups suffered heavy casualties but were successful. In the newspaper stories covering the invasions, the dueling Ranger feats figured prominently. Naturally, the cliff assault dominated the press attention with such headlines as "Rangers Scale Nazi Cliff, Save Invasion Squadron" and "Rangers Climb Rope Up Cliff and Knock Out German Guns." Heroic tales of hometown boys such as Lt. Col. James Rudder filled local papers of the pre-dawn landing and the vertical struggle to victory. None of these dramatic stories mentioned that on reaching the top and fighting past the garrison, the Rangers found all the artillery had either been moved or destroyed.[37] For one last time the newspapers presented a rosy and incomplete picture of the Rangers and their war.

Both remaining Ranger Battalions served in the campaigns through France, Belgium, and into Germany. As the Allied war machine moved closer to victory and the conclusion of the war, newspaper focus shifted to the bigger picture. There were no specialized moments like Pointe du Hoc after D-Day, and no more articles on Ranger training, their commanders, or missions. As the war progressed and the Allies found their footing, the need for such heroics on the ground and in print collapsed. *Yank,* a weekly magazine published by and for the army, offered a fitting epitaph for the Rangers and their once formidable media focus. The August 4, 1944, issue's cover story, "The Old Rangers Come Home from the War," caught up with the survivors of Darby's Rangers back home. Assigned to long-term R&R, the Ranger vets lounged around reminiscing about "their kind of fighting," and one young man claimed "we hit more'n we run." The article covered the Ranger story start to finish: first the Commando depot and Dieppe to the disaster at Cisterna, and while it mentions the "new" Rangers fighting in France, it is obvious to the author and reader that the "Old Rangers are out of action."[38]

Newspaper coverage of the Rangers and Commandos surged in the early years of the war as these flashy units provided hope in dark and uncertain times while journalists such as Ernie Pyle, Gordon Holman, and Don Whitehead leveraged their coverage of daring nighttime raids and beach assaults into fame of their own. In reality, these specialized units and their

208 | James Austin Sandy

soldiers accomplished a great deal during the war: the Commandos' early raids boosted morale and kept the Third Reich's peripherals on high alert while the Rangers successfully spearheaded the allied landings in Africa, Italy, and France. In the typeset reality of American and British newspapers the images and stories were always a little more dramatic, too positive, and regularly incomplete when compared to the Rangers and Commandos themselves. This mismatch of imagery versus reality has long outlived the war, in part propelling both groups to the legendary and often hyperbolic status Churchill envisioned in his "butcher and bolt" force and the subsequent American "supermen" from the "gouge-and-bite school."

Notes

1. "Remember the Infantry," *New York Times*, March 15, 1944.

2. David Hogan, *Raiders or Elite Infantry? The Changing Role of the U.S. Army Rangers from Dieppe to Grenada* (Westport, CT: Greenwood Press, 1992), 20–23.

3. Dudley Clarke, "The Birth of the Commandos," *The Listener*, November 1948; Winston Churchill, *The Second World War,* vol. 2: *Their Finest Hour* (London: Cassell, 1949), 217.

4. "Report on Operation Collar by OC No. 11 Company. June 26th, War Office Records," n.d., PRO WO 106/1740, The National Archives of the United Kingdom; "British Raids a cross the Channel: Landings on Enemy Coast," *The Guardian,* June 27, 1940.

5. Charles Messenger, *Commandos: The Definitive History of Commando Operations in the Second World War* (London: William Collins, 1985), 33–37; Nicholas Rankin, *A Genius for Deception: How Cunning Helped the British Win Two World Wars* (London: Faber & Faber, 2008), 250–252. ; John Parker, *Commandos: The Inside Story of Britain's Most Elite Fighting Force* (London: Headline Publishing, 2013).

6. "Eyewitness Story of the Lofoten Raid," *The Guardian*, March 7, 1941; A Naval Correspondent, "Nazis Surprised at Lofoten," *The Observer*, March 9, 1941; Messenger, *Commandos*, 46–48.

7. "House of Commons: Sir R. Keyes and Commandos," *The Guardian,* November 26, 1941; Associated Press, "Admiral Criticizes British War Conduct as Negative," *St. Louis Dispatch*, November 25, 1941; Messenger, *Commandos*, 61–63.

8. Messenger, *Commandos*, 64–67; Gordon Holman, *Commando Attack* (New York: G. P. Putnam's Sons, 1942), 164; Ralph Walling, "The Three-Services Exploit at Vaagso Island," *The Guardian*, December 30, 1941; Ralph Walling, "Norse Base Razed in Commando Raid," *New York Times*, December 30, 1941.

9. "The Commandos," *New York Times*, January 2, 1942; "Norwegians' Life under Nazi Rule," *The Guardian*, January 2, 1942; Ralph Walling, "I Was There!—We Went to Vaagso with the Commando Men," *War Illustrated*, January 20, 1942.

A "Butcher and Bolt" Force | 209

10. Gordon Holman, "How the Navy and Commandos Raided St. Nazaire: A Gallant Joint Exploit," *The Guardian*, March 30, 1942. For the comprehensive history of the raid, see James Dorrian, *Storming St. Nazaire: The Gripping Story of the Dock-Busting Raid, March, 1942* (Annapolis, MD: Naval Institute Press, 1998).

11. "Commandos at St. Nazaire," *New York Times*, March 30, 1942; Craig Thompson, "Big Nazi Sea Base Is Closed by Raid," *New York Times*, March 30, 1942; "British Hail Commandos' Daring Raid on St. Nazaire," *Tampa Morning Tribune*, March 30, 1942; Gordon Holman, "Attack on St. Nazaire Described by Newsman," *Honolulu Advertiser*, March 30, 1942.

12. "Gen. Marshall's West Point Address," *New York Times*, May 30, 1942.

13. "'Documents Relating to Subjects Considered by U.S.—British Representatives in London Conferences, April 6–18, 1942.' Tab A: 'Memorandum: American Proposal for Operations in Western Europe.'" (George C. Marshall Papers, n.d.), box 61, folder 49, 1–2., George C. Marshall Library, Lexington, VA.; Hogan, *Raiders or Elite Infantry? The Changing Role of the U.S. Army Rangers from Dieppe to Grenada*, 11–15.

14. "'Gino Mercuriali, 1st Lt.' and 'Thomas Holt, LTC.'" (World War II Veterans Surveys—Rangers, n.d.), 1st Battalion, box 1, United States Army Heritage and Education Center, Carlisle Barracks, PA.

15. "Subject: Commando Organization. To: Commanding General, United States Army Northern Ireland Forces. 1 June 1942. Headquarters 1st Ranger Battalion. History of Darby's Rangers—1st, 3rd, 4th Battalions. 1942–1944—Pt. I.," n.d., INBN-1-0, box 16911., RG: 407, National Archives at College Park, MD; James Altieri, *Spearheaders* (Indianapolis: Bobbs-Merrill, 1960), 22–28, 38–44; William O. Darby and William Baumer, *We Led the Way: Darby's Rangers* (San Rafael, CA: Presidio Press, 1980), 27–38.

16. Charles Schreiner, "The Dieppe Raid: Its Origins, Aims, and Results," *Naval War College Review* 25, no. 5 (1973): 83–97.

17. Rice Yahner, "U.S. Rangers in Dieppe Raid Were Pupils of Commandos," *New York Times*, August 20, 1942, 1; Raymond Daniel, "Hit-And-Run Fight: New U.S. Rangers Join Chiefly Canadian Force in Storming Coast," *New York Times*, August 20, 1942; "Report of Dieppe Operations to Commanding Officer, 1st Ranger B. Headquarters, 1st Ranger Battalion 31 August 1942. History of Darby's Rangers—1st, 3rd, 4th Battalions. 1942–1944.—Pt. II.," n.d., INBN-1-0, box 16911, RG: 407, National Archives at College Park, MD; Hogan, *Raiders or Elite Infantry? The Changing Role of the U.S. Army Rangers from Dieppe to Grenada*, 19–20, 29; Jim DeFelice, *Rangers at Dieppe: The First Combat Action of U.S. Army Rangers in World War II* (New York: Dutton Caliber, 2009).

18. A. B. Austin, "I Saw Lovat's Men Mop Up the Big Nazi Battery," *Daily Herald*, August 21, 1942; A. B. Austin, "Our London Correspondence: The Dieppe Raid," *The Guardian*, August 21, 1942; Associated Press, "News Party of 22 Saw Raid on Dieppe," *New York Times*, August 21, 1942; A. B. Austin, "We Win Wars by Silent Surprise," *Daily Herald*, August 29, 1942.

210 | James Austin Sandy

19. Yahner, "U.S. Rangers in Dieppe Raid Were Pupils of Commandos"; "Rangers in Attack with Commandos," *The Sentinel*, August 20, 1942; Larry Meier, "American Rangers Meet Germans Hand to Hand," *Baltimore Sun*, August 21, 1942; "Taught by Commandos," *New York Times*, August 20, 1942; INS, "Meier Applauded in London Press," *San Francisco Examiner*, August 24, 1942; "Few Rangers in Raid," *New York Times*, August 21, 1942; "The Press: Assignment at Dieppe," *Time*, August 31, 1942.

20. "Taught by Commandos"; "Ranger Fights on French Soil for His 23rd Birthday," *London Stars and Stripes*, August 29, 1942; Ralph Goll, "A Name We Know: First Rangers Saved Detroit in 1762," *Detroit Free Press*, August 20, 1942; UP, "Hard Training Made Fighting Rangers," *Pasadena Post*, August 20, 1942.

21. C. A. Lejeune, "The Films," *The Observer*, September 13, 1942; AP, "Commandos Raid Norway," *Salt Lake Telegram*, November 26, 1942.

22. Holman, *Commando Attack*. 236–240; "Commando Leader's Attack on Lord Strabolgi," *The Guardian*, October 2, 1942; "Commando Chief Hails War Spirit," *New York Times*, June 6, 1942.

23. Hogan, *Raiders or Elite Infantry? The Changing Role of the U.S. Army Rangers from Dieppe to Grenada*, 11, 13.

24. "Rangers Participate in Operations That Win Vital Airfields, United States War Department Communique," *New York Times*, November 9, 1942; "Captain Jacob's Report on the Action at Fort De La Pointe, Arzew, 1st Platoon, A Company, 1st Ranger Battalion, November 15, 1942; History of Darby's Rangers—1st, 3rd, 4th Battalions. 1942–1944," n.d., INBN-1-0, box 16911, RG: 407, National Archives at College Park, MD; "Algiers Surrenders to Yankees: French Navy Contesting Landing of U.S. Rangers," *Cumberland News*, November 9, 1942, 1.

25. Phil Ault, "The Capture of Oran: Report with U.S. Unit Tells of 3-Day Battle," *Philadelphia Inquirer*, November 15, 1942; Wes Gallagher, "Lighting Assault Ended French Hold on Algiers," *Appleton Post-Crescent*, November 9, 1942, sec. 1, 11; Raymond Daniell, "Hell, I Can't—I've Got a Date in Berlin," *New York Times*, November 15, 1942; "Two Jabs at Hitler: City Youth Fights in France, Africa," *St. Cloud Daily Times*, December 30, 1942.

26. "Reports of Action at Arzew, Colonel Darby, January 1, 1943. History of Darby's Rangers—1st, 3rd, 4th Battalions. 1942–1944—Pt. I.," n.d., INBN-1-0, box 16911, RG: 407, National Archives at College Park, MD. Ernie Pyle, "Rangers Restive with No Landings to Make," *Sioux City Journal*, January 19, 1943; Ernie Pyle, *Here Is Your War* (New York: H. Holt, 1943), 34–36.

27. Frank Kluckhohn, "Rangers Who Hit Gafsa Want More," *New York Times*, February 12, 1943; "Report of Action at Djbel Ank, Colonel W. O. Darby, April 9, 1943. History of Darby's Rangers—1st, 3rd, 4th Battalions. 1942–1944.—Pt. I.," n.d., INBN-1-0, box 16911, RG: 407, National Archives at College Park, MD.

A "Butcher and Bolt" Force | 211

28. Phil Ault, "U.S. Rangers 'Have Fun' Chasing Germans Form Vital Tunis Highway," *Miami Daily News*, March 1, 1943; "Camel: Costlier Tobaccos Ad," *Minnesota Star*, March 22, 1943.

29. "ETOUSA Memorandum: Major Richard Fisk, Assistant Adjutant General, ETO, to Adjutant General, December 2, 1942.," n.d., Perlmutter Collection, Collection No. 63–8, Roll 8, John F. Kennedy Special Warfare Center, Ft. Bragg, NC; Hogan, *Raiders or Elite Infantry?* 36–37; David Hogan, *U.S. Army Special Operations in World War II*, CMH Publication 70–42 (Washington, DC: Department of the Army, 1992), 15–20.

30. "'Special Text # 1—Orientation and Commemoration,' Office of the Commandant, Headquarters 2nd Army Ranger School, Camp Forrest, Tennessee, Records of the Second United States Army HQ, Maneuver Director, Records of United States Army Commands, 1942," n.d., box 1, RG:338, National Archives at College Park, MD.

31. "Second Army Ranger School Has Been Instituted," *Independent Record*, January 13, 1943; "Lieut. Carlton Graduates from Ranger School," *Daily-News Journal*, January 24, 1943; "Group Graduates under Fire in Ranger Dirty Fighting Class," *Miami News*, January 24, 1943. ; "Toughest Men in Army Graduate from Camp Forrest 'Dirty School,'" *Chattanooga Daily Times*, January 24, 1943; George Hull, "Ranger School in Army's Answer to the Problems Learned So Far in War," *Chattanooga Daily Times*, January 31, 1943; Bradley Norman, "The Booby Trap," *Evening Review*, March 1, 1943.

32. Tom Wolf, "U.S. Rangers Train in Scotland for Invasion," *Miami Daily News*, March 14, 1943.

33. Milton Bracker, "Americans Prove Skill in Invasion: Ranger Battalion Raises Havoc," *New York Times*, June 1, 1943; "At a Ranger Training," *New York Times*, June 16, 1943; "All Infantrymen Shock Troopers," *New York Times*, June 16, 1943.

34. "Clark's Fifth Army Got Training under Lifelike Battle Conditions," *New York Times*, September 10, 1943; "U.S. Troops in Britain Drilling for Invasion," *New York Times*, October 4, 1943.

35. "U.S. Troops Break Near Fatal-Attack," *New York Times*, July 16, 1943; "Report of Action—1st Ranger Battalion—July 10–14, 1943," n.d., INBN-1-0.3, box 16911, RG: 407, National Archives at College Park, MD; Don Whitehead, "How Rangers Take a Town," *Star Tribune*, July 18, 1943; Don Whitehead, *Combat Reporter: Don Whitehead's World War II Diary and Memoir*, ed. John Romeiser (New York: Fordham University Press, 2006), 161–175; "Hottest Assignment Went to 1st Division," *New York Times*, July 19, 1943; "Darby Refuses Command," *New York Times*, July 17, 1943.

36. Paul Jeffers, *Onward We Charge: The Heroic Story of Darby's Rangers in World War II* (New York: NAL Hardcover, 2007), 196. ; "Report of Action for Period 22 Jan 1944–5 Feb 1944, Ranger Force Headquarters," n.d., INBN-1-0.3, box

16911, RG: 407, National Archives at College Park, MD; *FM 7–85 Ranger Unit Operations* (Washington, DC: Department of the Army, 1991), F-3; "Lost Battalion Fights to End," *Beatrice Daily Sun*, March 8, 1944.

37. "Sidney Saloman, CPT," n.d., World War II Veteran Surveys—2nd Ranger Battalion, United States Army Heritage and Education Center, Carlisle Barracks, PA; "Rangers Scale Nazi Cliff, Save Invasion Squadron," *Daily News*, June 10, 1944; "Rangers Climb Rope Up Cliff and Knock Out German Guns," *Baltimore Sun*, June 10, 1944; "Brady Lt. Col. Leads Rangers of U.S.S. Texas to Objective against Elements and Germans," *Fort Worth Star-Telegram*, June 22, 1943; "Narrative—2nd Ranger Battalion, 'D-Day Assault,' 3–8. After-Action Report—2nd Ranger Battalion, June 1944," n.d., INBN-2-0.3, box 16914, RG: 407, National Archives at College Park, MD.

38. Mack Morriss, "The Old Rangers Come Home from the War," *Yank*, August 4, 1944.

10 "A Major Readjustment"
Omar Bradley's War against the *Stars and Stripes*

Alexander G. Lovelace

Omar Bradley was called the "GI General" by war correspondent Ernie Pyle. The moniker stuck, not least because Bradley actively promoted an image of himself as a general sympathetic to ordinary soldiers. Unlike the egotistical and showy George Patton, Douglas MacArthur, or Mark Clark, so the story goes, the homely Bradley had no interest in glory but only the welfare of his men. Nevertheless, this legend has long concealed Bradley's attack on the U.S. Army's "soldier's newspaper"—the *Stars and Stripes*.

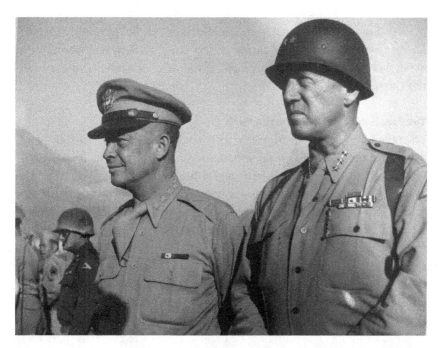

Dwight D. Eisenhower and George S. Patton Jr. in Palermo, Sicily. September 17, 1943. Signal Corps. George S. Patton Jr. Collection, box 1, folder 27, USAHEC.

Why did the "GI General" campaign so strongly against a paper that earnestly tried to be the voice of the ordinary soldier? The answer is not easily found. Bradley was at pains after the war to conceal his actions, and only one of the general's few biographers briefly mentions the incidents.[1] Yet evidence of the story remains, buried deep in the papers of Bradley and his aides. Patton, who was enticed into the dispute, and Eisenhower, who ended it, also left clues.[2]

The evidence suggests that Bradley's campaign against the *Stars and Stripes* was far from a stereotypical encounter between a free press and an autocratic general. Rather, it was a clash of ideas of how best to employ the media in modern war. The paper operated under the assumption that citizen soldiers needed a place to gripe. The *Stars and Stripes'* irreverent humor and editorials—so the thinking went—helped GIs blow off steam and improved morale, making them better soldiers. Bradley took a different view. Like other Allied generals, he believed the press played a vital role in modern warfare by keeping soldiers and civilians informed with accurate news that could boost morale more effectively than propaganda. It was permissible if soldiers wanted to vent a little on the editorial pages of an army newspaper. But when the editorials began to criticize military leadership, threaten security, or hamper morale, Bradley's tolerance vanished. Indeed, Bradley's hostility to the *Stars and Stripes* affected other generals, and was partly responsible for Patton's more famous efforts to ban Bill Mauldin's Willie & Joe cartoons. Together, these incidents reveal a previously unknown side of Omar Bradley and an underexplored dynamic of the media-military relationship during World War II.

The Creation of the "GI Newspaper"

The popular image of the *Stars and Stripes* was that it represented the voice of the ordinary soldier. Indeed, wartime surveys of GIs show that the paper was genuinely popular, with nine out of ten soldiers surveyed rating it as either "excellent" or "good."[3] Yet, as with any news source, the paper was hardly the collective voice of its readership. Rather it reflected the views of its staff, composed mostly of enlisted men with prewar journalism experience.

Military leadership also exercised influence over the paper. Throughout the war, Eisenhower believed the *Stars and Stripes* should be run by and for enlisted soldiers with no censorship except for military security. Indeed, the editors and staff repeatedly praised the Supreme Commander for his support of press freedom.[4] The only time Eisenhower interfered with the paper was when it published news that could damage the Anglo-American Alliance.[5]

This led Major General Everett Hughes, Eisenhower's deputy theater commander in North Africa, to ordered tightened supervision over the paper and directed that while the *Stars and Stripes* was reflecting the "soldier point of view [it] should embrace basic morale concepts such as giving the soldier confidence in his own weapons. While there should not be an attempt to play up commanders, lest soldiers lose confidence in the paper, there should be no attempt to play down their relationship to military events."[6]

Despite Eisenhower's limited control, it is somewhat surprising that the history of the newspaper was not more contentious, given that much of the *Stars and Stripes* staff were much further to the political Left than the conservative army officer corps. This included the chief editor in Algiers Robert Neville, who had been an editor for the far-Left newspaper *PM* before the war.[7] Andy Rooney, who wrote for the *Stars and Stripes*, and Bill Mauldin, who illustrated it, flirted with communism before ultimately finding less controversial ways of being progressive.[8] "Nearly all the staffers were on the same wavelength, and we assumed that all the American men and women in uniform for whom we wrote thought as we did," remembered the former *Stars and Stripes* correspondent Herbert Mitgang. "I believed in the presidency of Franklin D. Roosevelt . . . and the New Deal social legislation that helped so many families weather the Depression. And, of course, we believed in the Allied cause the people of the Soviet Union were fighting on their

Bill Mauldin at work, c. 1945. Library of Congress.

216 | Alexander G. Lovelace

own territory against the twentieth century's warlike Huns in Nazi guise."[9] The staff did not hesitate to push their views in other ways. A lieutenant's suggestion that a chaplain's column be added, was dismissed with a "grimaced" expression and an order not to make "any suggestions," followed by his quick transfer.[10] Hollywood pinups were, however, welcome.[11] The GIs did not appear to mind.

These facts demonstrate that labeling the paper the voice of the ordinary GI is much too simple. Generals and the news staff either directly or indirectly influenced the paper. Nevertheless, the newspaper was extraordinarily popular with most GIs, with a wartime survey finding a "clear majority" both read and agreed with the *Stars and Stripes'* editorial page.[12]

The Creation of the "GI General" and His First Clash with the *Stars and Stripes*

Eisenhower may have been reluctant to directly interfere with *Stars and Stripes*, but he was highly skilled in utilizing the media. Indeed, one of his closest aides was a former CBS executive named Harry Butcher, who spent much of the war as an unofficial public relations officer. Eisenhower believed "public opinion wins wars" and understood that if Bradley was to rise to higher command, he needed a media image. But the unassuming homely Bradley failed to gather much press attention.[13] Perhaps in response, Butcher cornered Ernie Pyle—already an accomplished war correspondent—and urged him to "go and discover Bradley."[14]

Pyle caught up with Bradley in an olive grove northeast of Nicosia, Sicily. Both the reporter and the general were wary. Bradley disliked the idea of such an obvious publicity visit, and Pyle was concerned about losing his reputation for writing on ordinary GIs by publishing a major article on a general.[15] To remain consistent, Pyle cast Bradley as the "GI General," soft-spoken and dedicated to the lives of his soldiers, whom he closely resembled. Several scholars have contested this image. "If truth is the first casualty of war," writes historian Carlo D'Este dismissively, "so was the pretense that Omar Bradley was a general of the masses."[16] Nevertheless, the image stuck. By D-Day, *Life* and *Newsweek* had done major stories on Bradley, while *Time* placed his picture on the cover and, mimicking Pyle, labeled him "The Doughboy's General."[17]

By this point, Bradley had his own ideas of the role of the press in war. Like Eisenhower, he believed the media was essential for communicating with his soldiers and the American people. Later, he explained, "The first object is to win the battle at the least cost of lives. But a close second, or third . . . was to let the people back home know what their kids were doing, and

Bradley's War against the *Stars and Stripes* | 217

so that's why I think you owe a duty to the press, through them to the people back home, to keep them informed."[18] During the North African campaign, Bradley began the practice of holding off-the-record briefings to groups of reporters explaining coming attacks in detail so the correspondents could write better stories.[19]

Indeed, an argument can be made that Bradley was one of the most adroit handlers of the press in World War II. As veteran-turned-scholar Paul Fussell observes, "Bradley . . . seemed entirely homespun and guileless, but he equipped himself with a public-relations staff as able as any."[20] The most important of these officers was Chester B. Hansen, a former reporter, whose wife worked at *Time* magazine.[21] After the war, Bradley admitted that Hansen was useful as a "public relations officer, and he soon became acquainted with all the correspondents that were with our headquarters. He found out what they were thinking, [and] what they wanted to know."[22] Hansen was able to enhance Bradley's image with the press, going so far as to ensure that no reporter took Bradley's picture on D-Day to conceal an untimely nose boil.[23] Though he insisted for the remainder of his days that he was not interested in publicity, Bradley clearly understood how to handle journalists.[24]

If the reminiscences of reporters are any guide, Bradley's press relations were a terrific success.[25] The cynical Joe Liebling of the staid *New Yorker* allegedly claimed that "Bradley was the greatest man after Christ to hit this world."[26] "The outstanding figure on this western front is Lt. Gen. Omar Nelson Bradley," Ernie Pyle wrote in September 1944. "He is so modest and sincere that he probably will not get his proper credit, except in military textbooks."[27] Indeed, fear that Bradley's apparent disinterest in publicity would damage his place in posterity was as much a part of the Bradley legend as being the "GI General."

Practicing his ideas of informing and connecting with his soldiers, Bradley made a point of visiting all the units that would take part on D-Day. This caused his first problem with the *Stars and Stripes* when in April 1944, he addressed the 29th Infantry Division. Though no reporters were present, notes were taken and a few days later a *Stars and Stripes* correspondent saw them and wrote a story.[28] To Bradley's annoyance his remarks were not only published in the *Stars and Stripes* but also in other American papers across the United States complete with his characterization of OVERLORD as the "greatest show on earth," his description of the idea of "tremendous losses" as "tommyrot," and reassurance that "some of you won't come back, but it'll be very few." He ended by telling the soldiers that "I think you are lucky to have this opportunity and I am happy to be with you."[29]

218 | Alexander G. Lovelace

The incident did not turn Bradley against the *Stars and Stripes*. SHAEF policy dictated that "all speeches given to troops by Senior Officers are off the record, unless specifically stated to the contrary."[30] Bradley viewed the incident as an issue of failed censorship and not a deliberate breach of security by a reporter.[31] He angrily informed the SHAEF Public Relations Division, "I have had to take particular pains to bar all correspondents from being present when I made my inspections and, of course, this puts me in the wrong light with our correspondents."[32] He had no words of criticism for the *Stars and Stripes*.

The Second Incident

The first sign of Bradley's irritation with the *Stars and Stripes* came after the Allies had liberated France and were battling their way into Germany. Despite the successes of the summer, the Allies had been slowed at the German border by supply shortages, a failed drive into Holland, and renewed German resistance. Squabbling between the Americans and the British coupled with worsening weather also strained the nerves of Bradley and his fellow generals. It was under these conditions that the Battle for the German city of Aachen began.

As Aachen was destroyed block by block, American soldiers began escorting German civilians out of the dying city. This, however, drew an angry response from the *Stars and Stripes*. In an article titled "Don't Get Chummy with Jerry" the paper warned that

> We may lose this war. Because here's what's going on around Aachen:
> 1. German civilians are given the Yanks the V sign, the glad hand, free beer, big smiles, plenty of talk about not being Nazis at heart, and hurray for Democracy.
> 2. Some GIs and plenty of officers are returning the smiles, flirting with the frauleins, drinking the beer and starting to think what nice folks the Germans really are.
> 3. German civilians are being removed from Aachen and driven two miles in U.S. Army trucks to Lutzon barracks in Brand—a suburb of Aachen.

"To move them out of the city is a matter of strict military necessity," the article continued. "But these Nazis are being quartered in the best buildings outside Aachen." The article then alleged that unlike the GIs, German civilians were moved in covered army trucks, feasted on twenty tons of hot food, and retired to warm beds. "They are being cared for by American and British

Bradley's War against the *Stars and Stripes* | 219

authorities, as solicitous about these poor German civilians as a mother hen over her chicks," the article added. Much of the rest of the piece centered on the travails of GI life and how it was harder than that of the civilians of Aachen. "We're for cuddling Nazis less," the article finished. "We're for cuddling GI Joe more."[33] Winning the hearts and minds of the enemy, the *Stars and Stripes* warned, was dangerous when it worked both ways.

The *Stars and Stripes* article was not written in a vacuum. As the Allied armies approached the Reich, Eisenhower had issued a no fraternization order between German civilians and Allied soldiers. As American troops encountered German civilians for the first time, Bradley's headquarters asked Major Arthur Goodfriend, the editor of the *Stars and Stripes,* to interview GIs about their views of the enemy. Disguised as an enlisted soldier, Goodfriend headed to a replacement depot and emerged with the disturbing news that American soldiers believe that the "Germans aren't bad people" and "don't have any of this Nazi feeling toward us" along with being "cleaner and damned sight friendlier than the frogs. They're our kind of people."[34] Goodfriend's conclusion was that impressionable American youths would soon be fraternizing with hardened Nazis. According to the U.S. Army's Official History on the occupation of Germany, his report likely led to the *Stars and Stripes* article.[35] Therefore, the author of the article almost certainly believed he was helping to win the war by reinforcing GI hatred of the enemy.

Whatever the purpose, the article could not be ignored by American commanders. Any claim that Allied leadership was giving German civilians better food and shelter was highly detrimental to the morale of GIs living in mudholes and eating cold rations. What was more, as an investigation quickly showed, the claim was not true. Only Germans unable to make the two-mile walk out of town were driven, and all were fed with captured food.[36] This point was stressed in a letter to the First Army commander by Major General Clarence R. Huebner, who commanded the 1st Division in Aachen. Huebner was unused to being accused of excessive kindness toward Germans, and his letter complained that the "article in question states that the policy and practice of the command in the Aachen area is to treat civilians better than soldiers. It further states that we may lose the war as a result. It implies that many deaths may result from this policy." The general ended his letter by summarizing the common view of the army high command for a military newspaper. "It is believed that editorials of this type are not only detrimental to morale, but may also have a positive subversive effect. The *Stars and Stripes* should assist both the soldier and his commander in maintaining a high moral and mutual confidence and under no circumstances should it

attempt to establish a barrier between them."[37] He requested that future articles of this type be blocked. Huebner's corps commander, J. Lawton Collins, endorsed the letter, as did First Army commander Lieutenant General Courtney Hodges. He passed the letter on to Bradley adding that "[e]ditorials of this nature not only undermine such mutual trust but actually breed distrust of constituted authority."[38]

Bradley forwarded Huebner's letter to Eisenhower along with Collins's and Hodges's endorsements, accompanied by his own. "This article is a direct criticism of our commanders," Bradley wrote. "It will tend to destroy confidence in our leadership, which is one of our greatest assets in this war." Bradley then turned to the *Stars and Stripes*. "This is not the first article that has appeared in a Stars and Stripes issue which I consider detrimental to the military effort," he wrote without listing the offending articles. "Any deserved criticism of the action of subordinate commanders is a function of command and not of a paper. Since this is a military publication, I suggest that some steps be taken to prevent occurrence of such articles."[39] The staff at the *Stars and Stripes* hoped to help speed victory by using their influence to warn GIs of German perfidy. But for Bradley and his lieutenants the *Stars and Stripes* was damaging the war effort by undermining morale and destroying confidence in military leadership.

What was Eisenhower's reaction to the complaints of his generals? Probably nothing. On Huebner's letter, he scrawled "Handled verbally DE" and indicated that it be filed.[40] Perhaps he warned the *Stars and Stripes* to be more careful. A few weeks later, he was heard to complain that the *Stars and Stripes* should check the editorials by soldiers known as the B-Bag before publishing them.[41] In any case, the damage was done, and there was little that he could do to repair it. But for Bradley, who remembered slights, the incident was now lodged in his memory. A few months later his aide Chester Hansen recorded that the *Stars and Stripes'* editor, Major Arthur Goodfriend, "was particularly delighted with the reasonableness and fairness of" Bradley. But Hansen also revealed growing tension in Bradley's view of the paper. "The B-Bag is now regarded as the most controversial of all S&S features," he added. "G-1 condemns it. Brad admits its usefulness as a safety valve for soldier expression but insists on the reponsibility [*sic*] of its statements."[42] In this griping lay the seeds of a new confrontation.

The Third Incident

A final encounter between Bradley and the *Stars and Stripes* occurred during the Battle of the Bulge between December 1944 and January 1945. The massive German counterattack in the Ardennes Forest was hardly Bradley's

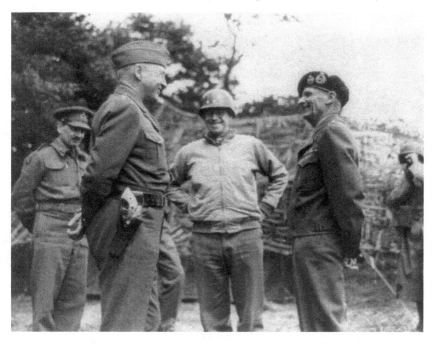

Lt. Gen. George S. Patton, Lt. Gen. Omar N. Bradley, and General Sir Bernard Montgomery meet to discuss the progress of the French campaign, somewhere in France. USASC 192464, Library of Congress.

finest hour. His Twelfth Army Group was split by the Nazi offensive, and Eisenhower quickly decided that it made more sense for the U.S. First and Ninth armies operating on the northern side of the bulge to be put under British Field Marshal Bernard Law Montgomery's control. Bradley was left with only Patton's Third Army.[43] Tactically, the move made sense, since Montgomery could communicate better with all the forces on the north side of the pocket. Bradley understood this, but worried it could be interpreted as an acknowledgment of his failure.[44] Indeed, rumors would persist for years that Bradley had been temporarily relieved of command.[45]

The way that the news of the transfer of two American armies to Montgomery was handled also infuriated Bradley and his staff. Because of the Allied media blackout during the early stages of the Ardennes offensive, the news had not been reported. When *Time* magazine threatened to publish the account of the command shake-up, however, Eisenhower decided it was time to release the story.[46] "When the Germans broke through in the first week-end of their offensive," Chester Wilmot intoned on the BBC, "Field-Marshal Montgomery at once brought British divisions south in case the

222 | Alexander G. Lovelace

Americans needed them and, as the German threat developed, the roads leading back into Belgium were packed with British convoys day and night."[47] Bradley informed his staff that he was getting "goddam sick and tired of this business. I don't listen to the BBC any more; it makes me madd [*sic*]." His staff agreed. Eisenhower's announcement "has precipitated a crisis in our allied relationship," claimed Hansen in a six-page commentary on press relations. After a detailed recounting of Montgomery's sins and Bradley's long-suffering, he concluded the gist of the stories was to have Montgomery named ground commander to "greatly increase the British position in this campaign," and it was undoubtedly "officially inspired."[48]

The *Stars and Stripes* also attracted Bradley's wrath. Hansen recorded

> Everyone was alarmed by the attitude of the Stars and Stripes which headlined the Monty story in a streamer and has fallen [*sic*] into the British press habit of following the action by describing the troops as Monty's troops.
>
> Furthermore in their story they committed the grievous sin of speculating on Bradley's command and sais [*sic*] it said "it is presumed that Bradley continues to command the Twelfth Army Group which now consists ofn [*sic*] only the Third Army."
>
> This infuraiated [*sic*] everyone.[49]

Bradley swore that he would make serious changes at the *Stars and Stripes* if he were in command.[50]

Deciding not to wait for a promotion, Bradley attempted to do something about the editorial policy of the *Stars and Stripes*. During a visit from Eisenhower a few weeks later, Bradley lobbied for a change to how the soldiers' paper was organized. "Bradley retains a traditional distrust of newspapers [*sic*] crusades," Hansen recorded, "while Ike insists on the necessity for a newspaper valve to permit GIs to air their ills." He added that "Ike believes that the paper must remain a soldiers newspaper rather than an agency of command. While Bradley agrees with him, he also suggests that there be greater responsibility attached to the officers for the editorial policy of the publication."[51] There is also evidence that Bradley complained directly to the officers overseeing the *Stars and Stripes*. Though his letter has not been found, Hansen wrote in his diary at the end of March that he "[q]ueried Red O'Hare today on the possibility that there is resentment in S&S towards the General as a result of the letters he has forward [*sic*] inviting criticism to Stars and Stripes articles or editorial policy."[52] It is unfortunate that Hansen did not record O'Hare's response.

Bradley took one additional step—he complained to Patton. It is not difficult to imagine a general famous for discipline and soldierly neatness not caring for the *Stars and Stripes* with its B-Bag complaint section for soldiers, its preachy editorials, and irreverent cartoons. Hansen records the two generals complaining about the editorial comment in the paper and recorded Patton saying, "He believes the Stars and Stripes has lengthened the war six months in its editorial policy and release of information on our units." Bradley replied that he would not go that far, "but you can be sure that if I become the Theater Commander, te [*sic*] Stars and Stripes will undergo a major readjustment in its policy."[53]

A few days later, Patton noted in his diary, "Wrote the Editor of the Stars and Stripes protesting against his paper as subversive of discipline." He sent a copy to General John C. H. Lee along with a warning "that unless there is an improvement, I will not permit the paper to be issued in this Army, nor permit his reporters or photographers in the Army area. It is a scurrilous sheet."[54] There is no evidence that Bradley put Patton up to complaining about the *Stars and Stripes*. It is likely, however, that Bradley's views encouraged Patton to try to curb the paper's editorials. It led to one of the most famous confrontations of Patton's confrontational career.

In his letter, Patton singled out Bill Mauldin's cartoons as a major problem with the *Stars and Stripes*.[55] Mauldin had served in the Seventh Army in Sicily and had become a sergeant and a cartoonist drawing for the *Stars and Stripes* in Italy. His cartoons showed the common GI in the form of Willie & Joe as unshaven, unkempt men who were cynical about the military. Mauldin also enjoyed taking shots at officers by highlighting disparities in privileges. Lee needed little encouragement since, as a stickler for discipline, he hated Mauldin's cartoons almost as much as Patton did. In fact, he had already tried to remove them from the *Stars and Stripes* a few weeks earlier.[56] Likewise, Mauldin's cartoons and their depiction of French drivers had also enraged the French. The result was that General Oscar N. Solbert, head of the Information and Education Division, was dispatched to warn Mauldin.[57]

After word of Patton's fury reached Mauldin, Will Lang of *Time* magazine and Bill Estoff of the *Stars and Stripes* introduced him to Harry Butcher who suggested that the cartoonist meet the general. Talking over their differences, Butcher said, might clear up the problem. Mauldin was terrified. "He's not half as bad as he sounds," Butcher explained. "Pretty nice guy in some ways when you get to know him." As he reached for the telephone, Butcher added, "Don't think Patton won't see the logic and humor in this, too." If that was

224 | Alexander G. Lovelace

the case, Patton hid it well. "If that little son of a bitch sets foot in the Third Army I'll throw his ass in jail," he bellowed over the telephone. After some cajoling and the tacit implication that Eisenhower was behind the idea, Patton agreed to meet the cartoonist.[58]

Mauldin arrived at Patton's palace headquarters and was suitably impressed. Ushered into Patton's office, which Mauldin assumed had once been a throne room, the cartoonist was awestruck by the Third Army Commander. "There he sat, big as life. . . . His hair was silver, his face was pink, his collar and shoulders glittered with more stars than I could count, his fingers sparkled with rings, and an incredible mass of ribbons started around desktop level and spread upward in a flood over his chest to the very top of his shoulder." Patton began to speak. For a time, Mauldin was mesmerized. "Patton was a real master of his subject as I sat there listening to the general talk war, I felt truly privileged, as if I were hearing Michelangelo on painting I felt whatever martial spirit was left in me being lifted out and fanned into flame." After a time Patton concluded, "I don't know what *you* think you're trying to do but the krauts ought to pin a medal on you for helping them mess up discipline for us."[59] He then produced some of the offending cartoons, including one depicting soldiers lobbing fruit at officers.[60] Mauldin answered that his work helped the ordinary soldier blow off steam. After forty-five minutes the meeting came to a frosty end. Will Lang was waiting outside, and Mauldin told him that "Patton had received me courteously, had expressed his feelings about my work, and had given me the opportunity to say a few words myself." He did not believe that he had changed the general's mind.[61] That was correct, and the arrest threats from Third army continued.[62]

Nor had Mauldin seen the error of his ways. He returned to Italy to continue the adventures of Willie & Joe, and they were as disheveled as ever. He also had a new subject. John C. H. Lee sent Patton a sample of Mauldin's latest creation. "Did he not tell you that he draws what he sees?" Lee inquired facetiously. "I just wonder what three starred commander he had in mind."[63] Patton chose not to respond. The meeting was not secret, and word spread around the European Theater of Operations (ETO) that Mauldin had run afoul of Patton. Many GIs who loved his cartoons seem to have taken Mauldin's side. In a survey of soldiers, 58 percent stated that they liked Mauldin's cartoons the best out of those published in the *Stars and Stripes*.[64]

To view the Mauldin-Patton episode—as some writers have done—as a clash of wills or the struggle of military authority versus a free press misses the point of the encounter.[65] Both the general and the cartoonist instinctively understood that news, in general, and Mauldin's cartoons, in particular, could

Bradley's War against the *Stars and Stripes* | 225

help or hurt morale and, by extension, the war. As Butcher knew, both Patton and Mauldin "were trying to win the war and, with this common denominator, they ought to be able to settle their differences."[66] This was impossible, of course, since both men had fundamentally different ideas on what improved morale. Indeed, the incident speaks to the generation gap that veteran-turned-historian William Manchester observed when explaining the difference between Douglas MacArthur's decline in popularity among his troops between the two world wars. "Egalitarianism did not become the triumphant passion of Western society until about the middle of this century," explained Manchester. "Veterans of World War I and World War II saw MacArthur very differently. Doughboys were proud to have fought under the General. GIs weren't; by the 1940s antiauthoritarianism had become dominant."[67] Patton, of the same generation as MacArthur, had similar Victorian ideas about what inspired soldiers. Mauldin argued instead that his cartoons helped the GIs deal with the inequalities of military life. "I always admired Patton," Mauldin wrote later. "Oh sure, the stupid bastard was crazy. He was insane. He thought he was living in the Dark Ages. Soldiers were peasants to him. I don't like that attitude, but I certainly respected his theories and the techniques he used to get his men out of their foxholes."[68]

Despite being several years younger than Patton, Bradley still instinctively sided with older concepts of morale and soldierly discipline. He and his staff believed that the *Stars and Stripes* should be "incorporated as a media of command and used honestly and judiciously not only to report the news, but to establish morale and confidence in our troops."[69] In the end, the "GI General" was unable to fully sympathize with the egalitarianism of a younger generation of American soldiers.

Confrontation and Cover-Up

In the end, neither Bradley nor Patton could achieve a major readjustment with the *Stars and Stripes*. Eisenhower quickly came to the aid of the paper. He almost certainly learned of the Patton-Mauldin confrontation. But it is possible Bradley's criticism also provoked the Supreme Commander's response. "Rumors have come to me to the effect that the staff of 'The Stars and Stripes' feels that it has been subjected to unwarranted pressure by various individuals and officers who apparently seek to dictate the newspaper's policy," Eisenhower wrote Oscar Solbert on March 11, 1945. "The paper is, of course, run for morale purposes among the American forces," he added. But it was up to the editorial staff to make sure it was completing its mission. Eisenhower ordered that his letter be shown to the editor "and instruct him that if he receives communications from officers in high ranking position

where there appears to be an attempt to put pressure on him, he will refer all such messages to you for action."[70] That same day, Eisenhower also reminded Goodfriend: "My original purpose in establishing 'The Stars and Stripes' was to create a facility that would be beneficial to the war effort." This was done by giving soldiers accurate news. "The paper must not, under any circumstances, become a propaganda sheet for exposition of any person's particular views and convictions," he added.[71]

Eisenhower continued to defend the paper until the end of the war. A few weeks later, for reasons unrelated to the attacks on the *Stars and Stripes*, the Special Services section was divided and the information section—including the *Stars and Stripes*—were taken away from Solbert. Eisenhower took the opportunity to remind Lieutenant General Ben Lear, deputy commander of the European Theater of Operations, to pass along his March 11 letters to Solbert and Goodfriend. Eisenhower ordered Lear to inform the news officer overseeing the military publications that he "will not under any circumstances tolerate anyone, including myself, giving orders to the paper as to what it may or may not print, so long as the question of security is not involved." He added, "A great deal of pressure has been brought on me in the past to abolish such things as Mauldin's cartoons, the 'B' Bag, etc.," but he would allow no interference with the paper.[72] He ended a congratulatory message to the *Stars and Stripes* two days later, by stating that "so long as it lives the paper must remain completely free, published by Americans soldiers for their comrades in this Theater."[73] Correspondent Virgil Pinkley later claimed Eisenhower ordered Patton in person to leave the *Stars and Stripes* and Mauldin alone.[74] If this is so, there is no other record of it.

The *Stars and Stripes* had won, and it was only left for Bradley to hide from history his involvement in trying to reform the paper. In this endeavor, he was helped by historians who were distracted by the colorful showdown between Patton and Mauldin, wonderfully retold in the cartoonist's memoirs. Bradley was thus able to hide this piece of his past with considerable skill and success.

The major reason Bradley's attack on the *Stars and Stripes* disappeared from the historical record was that he remained mostly silent on the topic. But it is also clear that his low opinion of the soldiers' paper changed little. On November 11, 1946, the general addressed the Reunion Dinner of the *Stars and Stripes* and chose to speak to the "young veterans"—as opposed to the staff of a newspaper—on issues of war and peace in the atomic era. In the twenty-nine-page speech he did not once mention the *Stars and Stripes*.[75] In his first autobiography published in 1951, Bradley made only

three references to the paper. Two were in passing and the third briefly related Bradley's leaked remarks before D-Day. "I was irritated at having been quoted on an off-the-record speech to my troops and I was chagrined to discover that my predictions had been played with raised eyebrows opposite the dolorous warnings of Churchill, Roosevelt, and General Marshall," Bradley concluded.[76] Nine years later, Bradley agreed to write the foreword to *The Stars and Stripes Story of World War II*. He began by quoting Marshall and Eisenhower's lofty goals of press freedom before stating that the "staffs of various editions of *The Stars and Stripes* were faithful to the noble aims and intentions of their leaders." After noting that the paper's "correspondents often were in the thick of battle," Bradley ended by stating that "[a]mple evidence of how well *The Stars and Stripes* reported the amusing and memorable aspects of the global conflict is presented" in the book.[77] Only a careful reading reveals the foreword's artfully camouflaged faint praise.

By the time he wrote the foreword to *The Stars and Stripes Story of World War II*, Bradley had reasons to further conceal is distaste of the paper. In 1950, the general met Kitty Buhler who was working as a reporter for *The Stars and Stripes*. Sometime later they began an affair and after the death of Bradley's wife, he and Kitty were married.[78] Bradley now had both historical and personal reasons to avoid bringing up his differences with Kitty's former employer. When his ghostwriter Clay Blair published a second autobiography after Bradley's death, *The Stars and Stripes* was hardly mentioned, and its support of Montgomery in the Battle of the Bulge was related without comment.[79]

The general's biographers echoed Bradley's and Blair's silence about Bradley's confrontation with the *Stars and Stripes*. Alan Axelrod's and Steven L. Ossad's biographies of Bradley do not mention the *Stars and Stripes,* while Jeffrey D. Lavoie's book on the general only mentions the paper in relation with Kitty.[80] The main exception, Jim DeFelice's *Omar Bradley: General at War,* gives both Bradley's anger at the publication of his remarks by *Stars and Stripes* before D-Day and his displeasure with the paper during the Ardennes Offensive. But DeFelice adds that Bradley never saw news as a "potential asset" and "never accepted that effective public relations translated into power and leverage behind the scenes."[81] Yet as his struggle with the *Stars and Stripes* shows, Bradley clearly understood the power of the media. None of these omissions implies shielding Bradley or historical skullduggery. The general had a long life, and every biographer must pick and choose. Instead, it demonstrates the GI General's success at concealing his attack on the soldier's paper from history.

228 | Alexander G. Lovelace

Conclusion

Why did the "GI General" react so strongly against the "Soldiers' Paper"? There were several contributing factors. First is a matter of historical perception and labels. The *Stars and Stripes* was not necessarily the "GI newspaper" any more than Bradley was the "GI General." Indeed, the paper was influenced by the Allied high command as well as by its editors and writers who could hardly represent the sixteen million men and women who served during World War II. Bradley's moniker was itself a creation of the media. Nevertheless, it would be dangerous to dismiss both titles as historical myths. Most GIs liked the *Stars and Stripes,* and Bradley tried hard to live up to Ernie Pyle's sobriquet. If nothing else, reasonable historians can disagree over whether Bradley and the army's newspaper deserved their respective titles.

A more helpful answer is that both Bradley and the editors of the *Stars and Stripes* had different philosophies of war. Eisenhower along with the editors and writers of the *Stars and Stripes* shared a desire to provide a platform for American enlisted men to find intellectual relaxation and a place to express themselves. This, so the argument went, helped the war effort by improving morale. To a certain extent, Bradley shared this view. But when he believed the paper was subverting military discipline, he advocated tighter editorial control. Nor was Bradley alone. "Mauldin with his bewhiskered and unkempt characters did more to keep soldiers improperly dressed then all the generals combined can do to keep them soldiery," wrote Hughes.

> Why all this? Because no commander from Ike down will take the responsibility for telling men what to do. Mauldin, 24 years old, draws what he pleases. All generals steer away from any thing demanding a clear cut decision on problems of welfare, VD, fraternization, discipline etc. I'll take that back there are some . . . but they are not popular—they are not candidates for President.[82]

In the end, Bradley sided with an older generation of officers, such as Patton, which was mistrustful of the increased egalitarianism entering the army through the citizen soldiers of World War II.

Finally, the *Stars and Stripes* flirted with content that any military hierarchy might find detrimental. There was no clear line between what was helpful for soldiers blowing off steam and what was detrimental to morale. It was asking a lot of the U.S. Military's signature publication to publish stories that falsely claimed Germans were being treated better than American

Bradley's War against the *Stars and Stripes* | 229

soldiers or cartoons of enlisted men throwing fruit at officers as one of Mauldin's pictures depicted.[83] Likewise, it is hard to claim such stories or cartoons improved morale since the first badly damaged it and the second depicted, and perhaps encouraged, a serious military crime. Bradley, Patton, and other generals were angered by such content. In the delicate balance between freedom of the press and restrictions of news content for military discipline, Eisenhower chose to side with the former.

Notes

1. Jim DeFelice, *Omar Bradley: General at War* (Washington, DC: Regnery, 2011), 172, 315–316.

2. This chapter uses Omar Bradley's papers located at the U.S. Army Heritage and Education Center (USAHEC) and the library and archives at the United States Military Academy at West Point (USMA). I also make use of George Patton's diary, located at the Library of Congress (LOC), and Dwight D. Eisenhower's published and unpublished papers.

3. "Soldier Opinion of 'The Stars and Stripes,'" March 1945, box 111, folder Stars and Stripes, Dwight D. Eisenhower Papers, Pre-Presidential, 1916–52, principal file (hereafter PPPF), Eisenhower Presidential Library, Kansas (hereafter DDEL).

4. Omar N. Bradley, foreword to *The Stars and Stripes Story of World War II* (New York: David McKay, 1960), v; Herbert Mitgang, *Newsmen in Khaki: Tales of a World War II Soldier Correspondent* (New York: Taylor Trade, 2004), 36.

5. Butcher Diary, May 25, 1943, box 166, folder (May 8, 1943–July 6, 1943) (2), PPPF, DDEL.

6. Leon T. David, "Memorandum for the Record," May 24, 1943, box 166, Diary Butcher folder (May 8, 1943–July 6, 1943) (2), ibid.

7. Mitgang, *Newsmen in Khaki*, 14.

8. Andy Rooney, *My War* (New York: Public Affairs, 2000), 244; Todd DePastino, *Bill Mauldin: A Life Up Front* (New York: W. W. Norton, 2008), 233.

9. Mitgang, *Newsmen in Khaki*, 54.

10. Ibid., 60–61.

11. Ibid., 69.

12. "Soldier Opinion of 'The Stars and Stripes,'" March 1945, box 111, Stars and Stripes folder, PPPF, DDEL.

13. Michael S. Sweeney, *Secrets of Victory: The Office of Censorship and the American Press and Radio in World War II* (Chapel Hill: University of North Carolina Press, 2001), 218; Marshall to Eisenhower, May 8, 1943, Radio No. 7586, *The Papers of George Catlett Marshall*, vol. 3, *"The Right Man for the Job," December 7, 1941–May 31, 1943*, ed. Larry I. Bland (Baltimore: Johns Hopkins University Press, 1991), 685.

230 | Alexander G. Lovelace

14. Harry Butcher, *My Three Years with Eisenhower* (New York: Simon and Schuster, 1946), 298. There is no diary entry for May 8, 1943, in Butcher's original diary. It is therefore certain that he added this entry after the war and the date should not be relied on. This is supported by the fact that Pyle did not visit Bradley till months later. Omar N. Bradley, *A Soldier's Story*, Modern Library ed. (New York: Henry Holt, 1951), 147.

15. Bradley, *A Soldier's Story*, 147–148.

16. Carlo D'Este, *Patton: A Genius for War* (New York: HarperCollins, 1996), 467; Douglas Porch, *The Path to Victory: The Mediterranean Theater in World War II* (New York: Farrar, Straus and Giroux, 2004), 409; Jerry D. Morelock, *Generals of the Bulge: Leadership in the U.S. Army's Greatest Battle* (Mechanicsburg, PA: Stackpole Books, 2015), 80. For a defense of Bradley's nickname see Alan Axelrod, *Bradley* (New York: Palgrave Macmillan, 2008), 187; Steven L. Ossad, *Omar Nelson Bradley: America's GI General, 1893–1981* (Columbia: University of Missouri Press, 2017), 8–9.

17. Omar N. Bradley and Clay Blair, *A General's Life* (New York: Simon and Schuster, 1983), 241.

18. Interview with Bradley by Mrs. Bradley and Hansen, circa 1969, box 1, folder 11, Omar N. Bradley Collection (hereafter ONBC), USAHEC.

19. Ibid.

20. Paul Fussell, *Wartime: Understanding and Behavior in the Second World War* (Oxford: Oxford University Press, 1989), 161.

21. Interview with Bradley by Bradley and Hansen, circa 1969, box 1, folder 11, ONBC, USAHEC.

22. Ibid.

23. Bradley and Blair, *A General's Life*, 224.

24. Bradley, *A Soldier's Story*, 147; Interview with Bradley by Mrs. Bradley and Hansen, Circa 1969, box 1, folder 11, ONBC, USAHEC; Bradley and Blair, *A General's Life*, 241.

25. Drew Middleton, *Our Share of Night* (New York: Viking Press, 1946), 301; "Introduction to Bradley by Lee Hills of Miami Herald for the Associated Press Editors Convention," box 25, ONBC, USMA; Ossad, *Omar Nelson Bradley*, 8.

26. Hansen Diary, October 23, 1944, box 6, folder 9, Chester Hansen Papers (hereafter CHP), USAHEC.

27. *Ernie's War: The Best of Ernie Pyle's World War II Dispatches,* ed. David Nichols (New York: Random House, 1986), 358. After he returned to the United States Pyle admitted that Bradley was much better known than he had originally feared. Hansen Diary, November 28, 1944, box 6, folder 10, CHP, USAHEC.

28. C. H. Gerhardt to Bradley, May 4, 1944, letter, box 1, untitled folder, ONBC, USMA.

29. Document titled "The Following story was published in Stars & Stripes, 8 April 1944," box 1, untitled folder, ONBC, USMA.

30. Robert A. McClure to Bradley, April 25, 1944, letter, ibid.

31. Bradley to John C. H. Lee, undated, letter, ibid.

32. Bradley to Robert A. McClure, April 14, 1944, letter, ibid.

33. "Don't Get Chummy with Jerry," *Stars and Stripes,* October 20, 1944, found in box 58, folder Huebner, Clarence R., PPPF, DDEL.

34. Earl F. Ziemke, *The U.S. Army In The Occupation of Germany: 1944–1946* (Washington, DC: Center of Military History United States Army, 1975), 142.

35. Ibid.

36. Ibid., 143–144.

37. Huebner to Commanding General, First US Army, October 21, 1944, box 58, folder Huebner, Clarence R., PPPF, DDEL.

38. J. Lawton Collins to Hodges, October 22, 1944, letter and Hodges to Bradley, October 22, 1944, letter, ibid.

39. Bradley to Eisenhower, October 24, 1944, letter and Hodges to Bradley, October 22, 1944, letter, ibid.

40. Huebner to Commanding General, First US Army, October 21, 1944, ibid.

41. Hughes Diary, November 4, 1944, box I 2, Everett Strait Hughes Papers (hereafter ESHP), LOC.

42. Hansen Diary, November 28, 1944, box 6, folder 10, CHP, USAHEC.

43. Williamson Murray and Allan R. Millett, *A War to Be Won: Fighting the Second World War* (Cambridge, MA: Belknap Press of Harvard University Press, 2000), 469; Robert S. Allen, *Forward with Patton: The World War II Diary of Colonel Robert S. Allen,* ed. John Nelson Rickard (Lexington: University Press of Kentucky, 2017), 127.

44. "General Bradley Personal & Confidential," box 38, folder "General Bradley Personal & Confidential," ONBC, USMA.

45. Wesley K. Clark, foreword to *Bradley* (New York: Palgrave Macmillan, 2008), by Axelrod, ix; Axelrod, *Bradley,* 161; Allen, *Forward with Patton,* 138. Patton's posthumously published memoirs somewhat insensitively stated that Bradley had received "practically a demotion." George S. Patton, Jr., *War as I Knew It,* Bantam ed. (New York: Bantam Books, 1947), 186.

46. Eisenhower to Surles, January 5, 1945, cable, box 1, folder 000.73, SHAEF, Special Staff, Public Relations Division, Executive Branch, Decimal File 1943–45, Record Group 331; National Archives Annex, College Park.

47. Chester Wilmot, "5 January 1954," in *War Report: A Record of Dispatches Broadcast by the BBC's War Correspondents with the Allied Expeditionary Force 6 June 1944–5 May 1945,* ed. the BBC (London: Oxford University Press, 1946), 309–311.

48. Hansen Diary, January 6, 1945, box 7, folder 1, CHP, USAHEC.

49. Ibid.

50. Ibid.

232 | Alexander G. Lovelace

51. Hansen Diary, February 4, 1945, box 7, folder 2, ibid.

52. Hansen Diary, March 27, 1945, box 7, folder 3, ibid.

53. Hansen Diary, January 6, 1945, box 7, folder 1, ibid.

54. Patton Diary, January 13, 1945, George S. Patton Papers (hereafter GSPP), LOC.

55. Butcher, *My Three Years with Eisenhower*, 774.

56. Hughes Diary, January 7, 1945, box I 2, Diary Notes folder, ESHP.

57. DePastino, *Bill Mauldin*, 184–185.

58. Bill Mauldin, *The Brass Ring: A Sort if a Memoir* (New York: W. W. Norton, 1971), 254–255.

59. Mauldin, *The Brass Ring*, 259, 261.

60. DePastino, *Bill Mauldin*, 193.

61. Mauldin, *The Brass Ring*, 264.

62. Butcher, *My Three Years with Eisenhower*, 796.

63. John C. H. Lee to Patton, March 25, 1945, letter, box 35, folder 9, GSPP.

64. "Soldier Opinion of 'The Stars and Stripes,'" March 1945, box 111, Stars and Stripes folder, PPPF, DDEL.

65. See for example DePastino, *Bill Mauldin*, 302; Rooney, *My War*, 196; Virgil Pinkley with James F. Scheer, *Eisenhower Declassified* (Old Tappan, NJ: Fleming H. Revell, 1979), 208.

66. Butcher, *My Three Years with Eisenhower*, 774.

67. William Manchester, *American Caesar: Douglas MacArthur, 1880–1964*, New Laurel ed. (New York: Dell, 1978), 20.

68. Mauldin quoted in D'Este, *Patton*, 694.

69. Hansen Diary, January 10, 1945, box 7, folder 1, CHP, USAHEC.

70. Eisenhower to Oscar Nathaniel Solbert, March 11, 1945, letter, *The Papers of Dwight David Eisenhower,* vol. 4, *The War Years*, ed. Alfred D. Chandler, Jr. (Baltimore, Johns Hopkins University Press, 1970), 2519.

71. Eisenhower to Arthur Goodfriend, March 11, 1945, letter, ibid., 2518.

72. Eisenhower to Ben Lear, April 2, 1945, letter, ibid., 2578.

73. Message signed Dwight D. Eisenhower, April 4, 1945, box 111, Stars and Stripes folder, PPPF, DDEL.

74. Pinkley with Scheer, *Eisenhower Declassified*, 208.

75. Address Before the *Stars and Stripes* Reunion Dinner in New York, November 8, 1946, box 48, folder 14, CHP, USAHEC.

76. Bradley, *A Soldier's Story*, 238.

77. Bradley, foreword to *The Stars and Stripes Story of World War II*, v–vi.

78. Jeffrey D. Lavoie, *The Private Life of General Omar N. Bradley* (Jefferson, NC: McFarland, 2015), 129; Ossad, *Omar Nelson Bradley*, 386–387.

79. Bradley and Blair, *A General's Life*, 381. It is unclear how much help Blair had from Bradley, who apparently saw only the prewar section of the book. Bradley and Blair, *A General's Life*, 10–11.

Bradley's War against the *Stars and Stripes* | 233

80. Axelrod, *Bradley;* Ossad, *Omar Nelson Bradley*; Lavoie, *The Private Life of General Omar N. Bradley*, 129, 135, 195.

81. DeFelice, *Omar Bradley*, 172, 315.

82. Everett Hughes to Kate Hughes, June 12, 1945, letter, box II 4, folder 5, ESHP.

83. DePastino, *Bill Mauldin*, 193.

11

After the Shooting Stopped
Justice and Journalism at Nuremberg

Nathaniel L. Moir

On Tuesday, August 14, 1945, the rural farming community of Grant County, Minnesota, in the west central part of the state, gathered to celebrate the end of World War II. After the destruction of Hiroshima and Nagasaki on August 6 and August 9, Japan's formal surrender would soon occur onboard the USS *Missouri* in Tokyo Bay on September 2. Amid the sobering power of atomic weapons, a mix of resolve, relief, and mourning settled like the grain dust produced from the local wheat harvest ongoing in the surrounding fields. Among this farming community, where most of its inhabitants possessed Scandinavian and German heritage, the local paper, the *Grant County Herald,* summarized the local mood about the resolution of World War II, proclaiming: "End of War Announced: Community Receives News in a Calm and Sane Manner."[1]

The article's author explained:

> There was unbounded joy in the hearts of everyone but, with few exceptions, it was not permitted to become exuberant as people solemnly reflected on the fact that there is still much work to be done, that there are still many months and years of occupation and reconstruction of the conquered nations, still many months and years before our boys and girls can return to the comforts of their homes and the peace which they fought for and for which many of them gave their lives.[2]

Americans across the United States likely shared such conflicting perspectives. Such feelings were undoubtedly far more pronounced in Europe and Japan where, instead of grain dust, atomic fallout continued to settle. Amid such destruction, and with simultaneous efforts to rebuild Europe physically and economically, reestablishing justice through the prosecution of war crimes in Germany and Japan began.

After the Shooting Stopped | 235

Grant County Herald (Elbow Lake, Minnesota), August 16, 1945, vol. 67, no. 25.

The Nuremberg Tribunals, like the Tokyo Trials, were landmarks in International Justice regarding war and in documenting genocide and countless atrocities against millions of humans worldwide.[3] Reflecting on the opening statements of the Nuremberg Trial in 2021, seventy-five years after they were given, it is easy to forget the challenges reporters and reading audiences had in assessing changes to international law. Journalists covering the tribunals and describing its goals had not only the challenges of legal debates to navigate. Critically, the tribunals were momentous because of the evidence documenting the Holocaust that the tribunals made public. The legal proceedings revealed the extent of suffering and atrocity inflicted during the war and this, to be sure, further complicated how to cover the Tribunals. In writing about Treblinka, for example, Soviet journalist Vasily Grossman reflected in the Soviet Paper, Красная звездá, Krasnaya Zvezda (*The Red Star*):

> It is infinitely hard even to read this. The reader must believe me, it is as hard to write it. Someone might ask: "Why write about this, why remember all that?" It is the writer's duty to tell this terrible truth, and it is the civilian duty of the reader to learn it. Everyone who would turn away, who would

236 | Nathaniel L. Moir

shut his eyes and walk past would insult the memory of the dead. Everyone who does not know the truth about this would never be able to understand with what sort of enemy, with what sort of monster, our Red Army started on its own mortal combat.[4]

As Antony Beevor noted, Grossman's report "The Hell of Treblinka" was published in November 1944 after Soviet troops from the 1st Belorussian Front reached Majdanek and then Treblinka in late July 1944. Published initially in Знамя, Znamya (*Banner*) the report was used during the Nuremberg Trials to document how over 800,000 victims died in Treblinka.[5] Developing and conducting the trials and reporting on them was one way to answer Grossman's many questions about the war and to understand its consequences. Journalists reporting from Nuremberg, then, had two challenges: describing the complex legal proceedings themselves and learning about and describing unknown details to reading audiences that made the trials necessary.

This chapter focuses on justice and journalism in Nuremberg. The first part describes the tribunals' origins, the prosecution of war crimes, and legal arguments used against Nazi defendants. Although debates and reporting on the prosecution of war crimes in Tokyo overlapped with those prosecuted during the Nuremberg Tribunals, this chapter focuses on the Nuremberg Tribunals and reporting primarily by Western journalists.[6] The latter part of the chapter focuses on the day-to-day effort involved in reporting on the Nuremberg Tribunals. It describes how reporters, translators, and members of the prosecution staff interacted and how reporters lived and worked while covering the proceedings. To understand their task, however, it is critical to describe the substance of the tribunals because the evidence presented was complicated and voluminous, and much of it was read aloud before entering the court record.

The English transcript of the proceedings, for example, exceeded 17,000 pages, and the prosecution examined over 100,000 captured German documents. According to U.S. Chief Prosecutor Robert H. Jackson, "10,000 were selected for intensive examination as having probable evidentiary value," and this meant that much of this evidence was brought up on a daily basis before the court, journalists, and other attendees.[7] In addition to the challenges of translation and the intense competition for an elusive scoop, prosecutors and journalists faced long tedious days working to find a cohesive thread for short articles that might appeal to editors and readers in their home countries. Making sense of the trials and assessing their significance

After the Shooting Stopped | 237

while the trials were in progress was, therefore, a formidable challenge. Maintaining readers' interest, whether in Grant County, Minnesota, the Soviet Union, or elsewhere, was another difficulty as life moved on.

The tribunals were established while fighting in Europe and Asia began to recede. Between April and June 1945, the San Francisco Conference set the postwar order in motion, and over 2,500 radio broadcasters and press journalists reported on the formation of the United Nations Charter.[8] A cascade of prior diplomacy in Europe and Asia provided a basis for the conference and the UN Charter. Proposals for the UN Charter began with the 1941 Declaration of St. James Palace, the Atlantic Charter, the 1943 Moscow and Tehran Conferences, and especially with the 1944–1945 meetings at Dumbarton Oaks and Yalta.[9] Together, these numerous meetings led to the signing of the United Nations (UN) Charter on June 26, 1945, and the formation of the UN on October 24, 1945.[10] During the formation of the UN Charter, one of four separate commissions drafted the International Court of Justice statute as the principal judicial organization for the United Nations.

In the numerous meetings leading to the UN Charter, the Moscow Conference of 1943 was particularly important to the formation of the later Nuremberg Trials. At this conference in the Soviet capital, a European Advisory Commission authorized by the "Moscow Declaration's Statement on Atrocities" began work on another charter used to prosecute crimes perpetrated by the European Axis Powers during World War II. Henry Stimson, the U.S. Secretary of War, and Murray Bernays, a lawyer who worked for the War Department's Special Projects branch, led efforts to create a trial proposal that President Roosevelt would eventually support for prosecuting war crimes in Europe. All of these initiatives contributed elements that proved critical to the development of the Nuremberg Charter, framed the tribunals' proceedings, and, subsequently, involved great effort in retrieving Nazi-produced documentation of atrocities across Europe and western Asia.[11]

The Nuremberg Charter was drafted by former U.S. Attorney General Robert H. Jackson, then serving as an associate justice on the U.S. Supreme Court, French judge Robert Falco, and Soviet Advocate General Iona T. Nikitchenko.[12] After the Moscow Conference, Jackson, Falco, and Nikitchenko convened in London to issue the charter as a decree on August 8, 1945, under the authority of the European Advisory Commission.[13] For a time it was referred to as the "London Charter" but soon officially became known as the Nuremberg Charter because Nuremberg, regarded as the birthplace of National Socialism in Germany, was chosen for the tribunals' location. It is

238 | Nathaniel L. Moir

notable that the Nuremberg/London Charter also served as a model for the Tokyo Charter that was used in prosecuting war crimes committed by those in the Imperial Japanese military.[14] The Nuremberg Charter described the trial proceeding and was formally titled "The Charter of the International Military Tribunal—Annex to the Agreement for the prosecution and punishment of the major war criminals of the European Axis."[15] It was an intricate but short twelve-page document with thirty legal articles signed by the United States, the Soviet Union, France, and the United Kingdom.

These four countries were responsible for each providing two judges to the tribunal, one of whom was a primary judge while the alternate assisted and served as the primary judge, as necessary. By late December 1945, nineteen other countries signed and adhered to the charter's framework, but they did not provide judges.[16] During the International Military Tribunal (IMT), Robert H. Jackson served as the chief prosecutor, Falco served as the alternate for the French judge Donnedieu de Vabres, and Nikitchenko served as the primary Russian judge. In addition, British judge Geoffrey Lawrence was chosen as the chief judge presiding over the IMT while the U.S. Army managed all accommodations, transportation, communications, and security during the tribunals because they were held within the U.S. assigned zone of control in Germany. To provide perspective on the overwhelming U.S. presence at the court, compared to other countries, the U.S. legal delegation alone included over 2,000 employees, and this staff was ten times larger than the British delegation.[17]

The International Military Tribunal, commonly known simply as the Nuremberg Tribunal, began on November 20, 1945, and lasted until October 1, 1946. The distinction is important because journalists focused on the first trial, technically the International Military Tribunal (IMT), which prosecuted twenty-four major war criminals and seven Nazi organizations.[18] Individual defendants included Hermann Göring, Rudolf Hess, Alfred Jodl, Ernst Kaltenbrunner, and other key Nazi leaders. The Sicherheitsdienst des Reichsführer (SD), Schutzstaffel (SS), Sturmabteilung (SA), Reich Cabinet, and other organizations were also prosecuted. The IMT adjourned on September 1, 1945; guilty defendants were sentenced on September 30 and October 1; and ten individuals were executed by hanging on October 16, 1946.[19] After this more well known trial, a second series of trials began which were called the Nuremberg Military Tribunal (NMT). A U.S. military court, with U.S. Army Brigadier General Telford Taylor serving as chief prosecutor, led the NMT. During these proceedings, beginning in December 1946 and adjourning in October 1948, the NMT prosecuted collective groups that supported

After the Shooting Stopped | 239

the Third Reich through twelve separate sub-tribunals. These different proceedings were then categorized into sectors, such as the "Doctors' Trial," the "Judges' Trial," and the "Industrialists," which included I. G. Farben and the Krupp Corporation.

The Nuremberg Tribunals—In History and Reporting

Despite the destruction of Nuremberg, during which over 20,000 Germans were killed through Allied aerial bombardment, the Nuremberg Palace survived. For this practical reason, along with the symbolism associated with holding the tribunals in the city previously known for the Nuremberg Rallies and the home of National Socialism, the palace was a logical location for lengthy legal proceedings. By the autumn of 1945, the palace's courtrooms and other facilities were renovated to make room for journalists, the prosecution's research staff, prison guards, and numerous other staff and personnel needed to conduct the trials.[20]

A prison complex attached to the palace was another critical factor in selecting Nuremberg, as was its location within the American-controlled zone of occupied Germany. While Nuremberg bars and restaurants benefited from the economic infusion associated with the tribunals, the area was also dangerous. The ruined section of Nuremberg's old city soon became off-limits to Americans at night after numerous robberies and other violent attacks occurred.[21] Even though the war was over, the war's remnants were everywhere, and groups of German POWs, whose wartime status was still under examination, worked in and around the Nuremberg Palace. Journalists, because they did not reside where the proceedings were held, navigated this environment daily.

In the Nuremberg Palace in late 1945, according to Joseph Persico, "POWs were still sweeping up shavings and sawdust and the hallways gave off a bracing smell of fresh paint as the correspondents filed into the press gallery." He added that the journalists

> had a choice position, just behind the prosecutors' tables, with the dock to their left and the judges to their right. Among them were Janet Flanner and Rebecca West, covering for *The New Yorker*, the novelist John Dos Passos for *Life* Magazine, Marguerite Higgins for the New York *Herald Tribune*, and (Howard K.) Smith and (William) Shirer for CBS. Correspondents from twenty-three nations crowded into 250 plush maroon tip-up seats that Dan Kiley had confiscated from a German theater. In a balcony above them, visitors filed into 150 similar seats.[22]

240 | Nathaniel L. Moir

Ernest Hemingway, Martha Gellhorn, and John Steinbeck also reported from Nuremberg.[23] Louis Lochner, a graduate of the University of Wisconsin and an American journalist who was the son of German immigrants, covered the trials. Lochner had a significant vantage on the rise and fall of Nazi Germany because he directly reported from the Third Reich before the December 1941 declaration of war between the United States and Germany. With that declaration, the Nazis imprisoned Lochner. In early 1942, and after five months in prison in Bad Nauheim, he was released in a prisoner exchange and returned to the United States where he became a vocal critic of Nazi Germany.[24] Many other lesser-known figures also had a role in presenting the Nuremberg Palace as a focal point for the tribunals. Dan Kiley, a U.S. Army captain, was responsible for restoring the Palace of Justice for the war-crimes trial and, apparently, was skilled in managing the army's public affairs. The young officer—Persico described him as "elfin-like"—also possessed extensive knowledge of psychological operations. He accumulated these skills through his work for the Office of Strategic Services (OSS) Presentations Branch, for which he assisted in building "mockups of clandestine targets," among other tasks.[25]

In addition to journalists already noted, Walter Cronkite, Ed Murrow, and Hanson Baldwin also reported on the event. However, other young journalists, such as a host of *Stars and Stripes* reporters, Norbert Ehrenfreund and Arthur Noyes, also reported from Nuremberg. Among individuals working for the War Crimes Commission, an important journalist of the Vietnam War—Bernard Fall—would emerge from war-torn Europe as, first, a French resistance fighter and, second, as an employee for the War Crimes Commission. Shortly after the establishment of the War Crimes Commission, Fall served as translator and later as a research analyst for the prosecution staff. This cumulative experience significantly influenced his later scholarship when he became well known as an expert on Indochina during France's war in Indochina and during the early stages of American involvement in Vietnam.

Collectively, journalists reporting on the Nuremberg Tribunals sought to explain to readers around the globe the complicated legal workings of the trials and their potential consequences related to the rule of law in war. Weeks after Robert H. Jackson's dramatic opening statement, interest in the proceedings among reporters diminished in proportion with that of their readers in their respective countries. Persico noted, "The Press bar was crowded, noisy, and smoke-filled. Still, the crush of reporters had thinned considerably since the trial's opening. The papers back home were no longer giving heavy daily play to a trial that, no matter how sensational the

evidence, had already gone on for six weeks."[26] There were simple reasons for why some readers began to lose interest, despite the consequential proceedings.

The tribunals raised numerous substantive and complex legal questions for general readers, and the prosecution's charges against Nazi defendants were controversial. During the IMT, indictments against the defendants included four preliminary charges: conspiracy to wage war, waging aggressive war, war crimes, and crimes against humanity.[27] The legal precedents for the tribunals were many and difficult to follow, Even today, the large body of legal history associated with the tribunals persists as a vast area for legal as well as historical research. Among critical legal topics related to international law of war after World War II, the Lieber Code of 1863, also known as General Orders Number 100, was created to protect prisoners and govern conduct by combatants toward civilians.[28] The Geneva Conventions of 1864 and 1897, the Hague Conventions of 1899 and 1907, and the Kellogg-Briand Pact in 1928 also contributed to the tribunal's precedents.[29]

According to Telford Taylor, the 1899 Hague Convention was considered a breakthrough in international law because it clearly described war crimes. Taylor noted, "The convention leaned heavily on the Lieber Code and dealt chiefly with prisoners of war and the relations between occupation soldiers and noncombatant civilian inhabitants."[30] There were, therefore, many legal problems the defendants and their lawyers raised concerning the indictments against them. These included the legality of "Victor's Justice," the creation of *ex post facto* law (establishing laws judging crimes after the commission of alleged crimes), the questionable determination of individual liability for "acts of State," and the problem of lack of appeal after sentencing. These mattered for reporters because the information formed a basis for their articles. Aside from those readers interested in legal aspects of international law, it is not surprising that reporters' attention focused on the rare dramatic moments in which more notorious Nazi leaders, especially Hermann Göring, spoke or argued with the Allied judges or the prosecution.

Another fundamental problem also included the defendants' charges of *Tu quoque* (a Latin legal term meaning "You also"). Using it, the defendants argued that all parties in war committed similar acts. The Allied firebombing of Dresden, Hamburg, and elsewhere, along with the Katyn Massacre perpetrated by the Russians, complicated the tribunals' legal standing. These arguments led many defendants to claim that they were the victims of victor's justice. Despite the atrocities they committed, relying on such legal arguments was a wedge defendants pushed as far as possible. Pointing out legal challenges, such as *Tu quoque* and *ex post facto* to the prosecution's

arguments, were controversial for Nazi leaders to claim. Other issues with the trials included immense financial costs and, finally, the anticipated lengthy period required to collect evidence and conduct the trials.[31] *Ex post facto* justice and lack of appeal—cited in the Nuremberg Charter's Article 26 which specified: "Judgment of the Trial as to guilt or innocence shall be final and not subject to review"—were especially problematic.[32] To be sure, these were not the kind of problems newspaper readers in the United States were likely eager to contemplate with their morning coffee or breakfast.

Journalists reporting on these developments, therefore, had the task of describing international law developed through the Nuremberg Charter as it was implemented. Despite the serious and legitimate legal controversies associated with the indictments, the basis for the charges was beyond doubt as document after document revealing the Holocaust and countless atrocities were read and entered into the courts' records. According to Walter Cronkite, the tribunal's legacy was critical and clear to reporters at the time: "Although Justice Jackson put it somewhat more obliquely in many of his eloquent statements, I always believed the trial was justified by the necessity of establishing judicial precedent even before the establishment of the international law that it was meant to support."[33] Cronkite was astute in his observation, but these were also seriously complex matters to convey to readers through short newspaper articles. Even for the best of reporters and writers, long-form essays still could not provide enough room to dilute the complexity and consequential nature of the tribunals.[34]

Ex post facto law was a major problem and especially complex to argue in prosecuting Nazi leaders. As a concept, it was a law that retroactively changed the legal consequences of actions committed before the enactment of the law. As used in Nuremberg, it was controversial because the U.S. Constitution stated in Article I, Section 9, Clause 3 that "No Bill of Attainder or ex post facto Law shall be passed," and U.S. federal and state governments were—and remain—prohibited from enacting such laws.[35] Undoubtedly, many newspaper readers possibly lost patience with reporters who were forced to point out legal conventions and virtues, such as defendant's rights, that extended to Nazis they perceived as guilty. General Iona Nikitchenko, who developed the Nuremberg Charter in London with Jackson and then served as the Soviet Union's judge during the IMT, advocated that the tribunal's task was "only to determine the measure of guilt for each particular person and to mete out the necessary punishments—the sentences."[36]

Many Americans, especially those related to the Nazis' victims or whose family members had died in fighting the German army across Europe and Africa, likely shared Nikitchenko's view. Nikitchenko, along with Andrei

After the Shooting Stopped | 243

Vyshinsky, the state prosecutor during Stalin's "show trials" between 1936 and 1938, certainly possessed different understandings of legal nuances between the common law of the British and U.S. systems and civil law used by the Soviets and the French.[37] American and Soviet differences existed across a range of legal concepts that likely accentuated political divisions; for example, even the idea of indictment for crimes differed. According to contemporary historian Francine Hirsch, for Jackson, an indictment was an accusation that did not include the evidence with it. In contrast, in Soviet law, the "indictment included all the evidence supporting the charges and could run thousands of pages long."[38] Perhaps understandably, the Soviets were far more interested in punishing Nazis and avenging the deaths of millions of their citizens than they were in advancing a supranational moral order codified through the Nuremberg Principles and Charter. According to journalist Norbert Ehrenfreund, it was only because of Jackson's demands for a fair trial, one that would uphold the principles of international justice based on natural law, that a legitimate court process even went forward.[39]

In reporting on the legal, ethical, and complex bureaucratic challenges the tribunals presented, how did journalists cover the Nuremberg Tribunals on a day-to-day basis? The prosecution and its research staff sought to make reporters' tasks more manageable, so numerous guides were created, printed, and distributed to journalists. These guides included information on legal concepts, such as *ex post facto* and charges of *tu quoque*. In addition, guides also provided practical information with courtroom charts identifying defendants and their assigned seating, charts with German military and gauleiter rank insignia, the prosecution teams, presiding judges, simple biographical information about participants, and copies of indictments against defendants.[40] Staff, journalists, and visitors all relied on an IBM translation system that provided testimony in German, French, Russian, and English via headphones. Using switch boxes installed on tables and chairs throughout the courtroom, journalists could toggle preferred languages as they worked.[41] Translated transcripts were also developed for staff, and journalists could request these to clarify details when time permitted as they submitted their articles.

In addition to translation services, journalists received other kinds of technical support. Gordon Dean, Robert Jackson's press relations coordinator, was responsible for showing reporters a system that the prosecution devised in which a series of buzzers would signal that consequential information or evidence was soon to be announced. According to Joseph Persico, "One buzz," Dean noted, "signaled something useful coming up in the courtroom. Two buzzes meant something important. Three buzzes meant something

Trial Headquarters. Bernard B. Fall Papers, John F. Kennedy Presidential Library, Boston, Massachusetts, Nuremburg Photo Album, Series 2.03, Box W-01.

sensational. They would be able to hear the buzzer virtually anywhere in the building. Loudspeakers had also been positioned around the courthouse so that they could hear the proceedings even if they were not in the courtroom."[42] Dean was also responsible for providing journalists with controlled access to the prison where they could briefly observe defendants' living conditions.

While journalists spent most of their time in either the Nuremberg Palace's Courtroom 600 or in press offices organized for them, they lived near the Nuremberg Palace for months, so an assortment of living arrangements existed. The primary "Press Camp" was located outside Nuremberg in nearby Stein Castle, but many reporters opted for lodging in Nuremberg, near the palace. The facilities at Stein Castle, owned by the pencil manufacturer Faber-Castell, were a source of complaint among journalists. However, accommodations at Stein Castle were certainly far more hospitable than the living conditions in bombed-out former homes which most Germans managed in the city.[43]

Newspaper photos gave Americans an idea of the difficult circumstances in which children and others lived. Later depictions, such as those provided

After the Shooting Stopped | 245

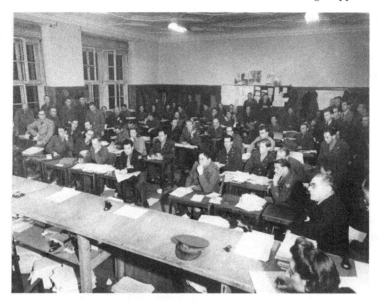

The Press Room at the Nuremberg War Crimes Trial. Alexander, Charles Office of the United States Chief of Counsel, Harry S. Truman Library & Museum. Accession Number: 72-862.

in the film *Judgment at Nuremberg*, reinforced the overwhelming destruction of the city.[44] Despite complaints from some privileged few, life at the relatively posh Faber-Castell "Press Camp" revealed a stark discrepancy between those who were surviving in cold cellars without adequate food and water throughout Nuremberg and those who were busy playing ping-pong after work and had plenty to eat and drink. At Stein Castle, numerous facilities and abundant food and alcohol were accessible for Americans to the point that the wife of American prosecutor, General Telford Taylor, remarked that Stein Castle reminded her of the "colonial lifestyle of the foreign residents of Shanghai."[45]

In the city itself, the Grand Hotel offered journalists a much different world from the somber trials held in the nearby Palace of Justice. The "Marble Room," a restaurant in the Grand Hotel, was particularly popular and catered to senior officials and VIPs.[46] Other dance halls, snack bars, laundry facilities, and a library provided diversions and other resources in the hotel and nearby. At the hotel and in the palace, postal services, printing facilities, and well-equipped and managed communication facilities for transmitting stories via radio and telegram assisted reporters.[47] These and other daily requirements, such as dining facilities, mirrored those at peace-time military

installations that served armed forces personnel. Unsurprisingly, bars were popular for solitary drinkers and for hosting social events where journalists and others deliberated reporting, personal news, and developments affecting the changing international political context. For some, such social interaction undoubtedly provided a reprieve, whether alcohol was consumed or not, from the day-to-day cascade of information journalists consumed. Within the confines of the palace itself, a Court House PX provided yet another place to access Western-supplied food and beverages in a city where chocolate and other goods were difficult to find.

On the one hand, a bombardment of evidence—inflicted daily during the tribunal proceedings—was often gruesome and pervasively depressing. On the other hand, arguments concerning the legal aspects of the trials were often mind-numbing but also consequential. According to Walter Cronkite, "There were many nights at the press camp bar in Nuremberg and later when I argued for the legitimacy of the Nuremberg Trial, defending it against those who contended that it was built on the sand of *ex post facto* justice, on the basis of law that did not exist when the crimes were committed."[48] He added, "There were international treaties that Nazi Germany clearly violated: the Kellogg-Briand Pact of 1928, which outlawed aggressive war, and

Court House PX/Canteen. Bernard B. Fall Papers, John F. Kennedy Presidential Library, Boston, Massachusetts, Nuremburg Photo Album, Series 2.03, Box W-01.

After the Shooting Stopped | 247

the Geneva Convention of 1897 and the Hague Convention of 1899, which defined the treatment of civilians and prisoners of war."[49] These were, to be sure, serious deliberations to engage in over a stein of beer. Throughout the court proceedings, discussions and debates certainly existed—if Cronkite's observations serve as a social barometer—as well-known journalists and writers, such as Cronkite, Steinbeck, and others, learned more about the extent of the Holocaust and other atrocities.

In reporting on the trials, numerous less-known journalists worked for a range of newspapers, and notable among those papers was *Stars and Stripes*. Alan Dreyfus, a reporter who worked in Boston and Chicago before the war, was the paper's lead reporter, but a large and often-changing team of younger reporters also contributed to reporting. For example, *Stars and Stripes* reporter Arthur Noyes worked for the *Chicago Tribune* before joining the army in 1942, which later ordered his transfer to the *Stars and Stripes* staff facilities in Altdorf, Germany. Noyes reported on the IMT and worked at numerous bureaus across Europe before returning to the United States and joining the *New York Daily News* and the *Saturday Evening Post* in early 1952.[50] Another junior journalist, Norbert Ehrenfreund, epitomized the quality of individuals working for the paper. During the war, Ehrenfreund served as a forward observer with the 607th Field Artillery Battalion attached to the U.S. Third Army, led by General George Patton.[51]

Before the war, Ehrenfreund studied at the University of Missouri's School of Journalism, and after the shooting stopped in 1945, he joined *Stars and Stripes* to work as a staff reporter. An American Jew of Czech ancestry, Ehrenfreund's grandfather had been murdered at Treblinka. In his memoir on Nuremberg, Ehrenfreund did not refer to Vasily Grossman's report on Treblinka. However, the young journalist undoubtedly wrestled with an effort to balance professional objectivity in his reporting while also managing personal feelings about the horrors his grandfather suffered. Ehrenfreund, deeply influenced by his experiences at Nuremberg as indicated in his analysis of the IMT, later became a judge in California's Superior Court, where he served for thirty years.

The *Stars and Stripes* was a critical newspaper in postwar Europe and was established in Paris during World War I. Its World War II version began as a weekly publication on April 28, 1942, and was initially based in Northern Ireland.[52] In 1945, the first edition of *Stars and Stripes* printed in occupied Germany was a four-page paper printed in Pfungstadt, a small village south of Frankfurt where the *Frankfurter Zeitung* was previously printed during the war.[53] By May 8, 1945, the *Stars and Stripes*' circulation was already over 245,000 four-page copies. Later that summer, *Stars and Stripes*' operations

248 | Nathaniel L. Moir

expanded, and the paper's staff commandeered a printing facility in Altdorf, a small town near Nuremberg.

The Altdorf facility formerly produced the radical anti-Semitic publication *Der Stürmer*. Created and led by Julius Streicher, *Der Stürmer* published such egregious propaganda—including the 1938 book *Der Giftpilz* for children—that Streicher was considered an embarrassment and even removed as a Gauleiter of Franconia for slandering Hermann Göring.[54] When *Stars and Stripes* took over *Der Stürmer*'s facility, Streicher was a defendant at the First Tribunal in Nuremberg. He was later convicted in early October, and hanged in the Nuremberg Palace Gymnasium on October 26, 1946.[55]

Notably, Western journalists and authorities were ironically both supported and challenged by Soviet journalists and leaders. In *Soviet Judgment at Nuremberg*, perhaps the most comprehensive account of the Soviet Union's inclusion as a nation prosecuting Nazis for war crimes, Francine Hirsch provides ample evidence regarding the Soviet's complex role during the tribunal. In the case of reporting on Göring, for example, Hirsch notes:

> In general, the Western and Soviet journalists took markedly different approaches to Göring's defense. One *New York Times* correspondent noted that many Western journalists, having extensively covered the prosecution's case, now felt obliged to "publish Göring's eulogies of Hitler and his defense of Nazism." The Soviet press was careful not to give the Nazi leader a platform. On one of the most dramatic "Göring days," *Pravda* succinctly noted that Göring had offered the usual "fascist propaganda."[56]

Andrei Vyshinsky, the state prosecutor of Joseph Stalin's Moscow Trials, was the lead Soviet prosecutor at Nuremberg. Vyshinsky wrote extensively for *Pravda*, and, according to Hirsch, "Vyshinsky was doing all he could, in his own way, to bring down the former Nazi leaders . . . as part of an overall effort to fully educate the Soviet people about the depravity of the 'fascist beasts.'"[57] The Katyn Massacre, the Molotov-Ribbentrop Pact, and numerous other factors powerfully complicated the Soviets' role at Nuremberg and the ways in which Soviet reporters covered the trials.

In general terms, two themes consistently surface in reporting on the Nuremberg Tribunals. The first is a palatable sense of shock at the extent and depravity of the Holocaust and Nazi-inflicted war crimes. Even experienced and often jaded journalists registered an incredulity over how the Nazis and German army conducted unimaginable atrocities through the Holocaust and throughout so much of Europe in a perfunctory and entirely bureaucratic manner. The second theme that surfaces concerns how

After the Shooting Stopped | 249

journalists engaged with the amount of evidence they encountered, of which they saw and heard only a small percentage. On a daily basis, the proceedings consisted of a seemingly endless river of evidence and then debate over that documentary evidence.[58]

Regarding the first theme, William Shirer and Cronkite reflected on what they perceived as an entire lack of remorse among the Nazi defendants. Cronkite recounted how Rudolf Höss, the Auschwitz camp commandant, "unemotionally described in excruciating detail the operation of his gas chambers," while Shirer recalled in 1961, "I remember one of the judges at the Nuremberg Trials interrupting Otto Ohlendorf, who led one of the special S.S. groups in Russia. Ohlendorf, like so many S.S. thugs, was a university-trained intellectual. Before the war, he had been a professor in a German university."[59] Shirer concluded that an "anti-Semitic madness" was a disease that Hitler "had imparted to—or shared with—many of his German follow-ers." In his account, Shirer did not so much reflect on the Nuremberg Tribu-nals as register profound shock at the immensity of Hitler's plans. The sheer scale of atrocity—which Shirer, Cronkite, and the rest of the world learned through their reporting at the Nuremberg Tribunals—is among the many key legacies from the tribunals.

The massive documentary evidence scholars continue to examine is another legacy. To be sure, the existing secondary literature investigating the court records and the tribunals is voluminous and continues to grow.[60] However, the amount of material journalists, such as William Shirer and others, researched for their assessments of the rise and fall of the Third Reich are staggering to consider, mainly because the Nazis destroyed so much evidence before retreating and before Allied forces could recover surviving documents. In the trials against Alfried Krupp and the Krupp Corporation, for example, no less than six train cars full of documents were processed to document the abuse of slave labor at over 138 camps the Krupp Corporation operated. The documentation collected for the Krupp Trial provided unde-niable proof that the Krupp family and corporation colluded with and de-pended on the Nazi S.S. to obtain laborers from Auschwitz and from across Eastern Europe—including primarily women—as German forces advanced east during Operation Barbarossa.[61]

The Krupp foundation, currently positioned as a philanthropic organi-zation based in Germany, provides no information about the Krupp family's critical support personally provided to Adolf Hitler.[62] Harold James's history of the Krupp Corporation—funded by the Krupp Foundation, which also owns the copyright for James's book on the subject—fails to note that the only Krupp defendant that James does not write about is Friedrich von

250 | Nathaniel L. Moir

Bülow. In James's work, Von Bülow remains entirely unaccounted for despite evidence presented at Nuremberg that Von Bülow was a critical link between Krupp and Nazi leadership because of his role as head of the Krupp's plant police (*Werkschutz*).[63] Similarly, prewar agreements between the Nazi Party and the Krupp armaments industry, as embodied in the under-analyzed agreement *Lex Krupp*, further demonstrated connections between the Krupp family and Nazi leadership well before 1939. As a member of the Nazi *Spende* and through the *Lex Krupp*—the formal agreement Hitler provided to the Krupp family to monopolize the armaments industry in the service of National Socialism—the Krupp trials during the Nuremberg Military Tribunals proved Alfried Krupp's guilt as a war criminal.[64]

The downside to the tribunals' reliance on documentary evidence, instead of the more limited witness testimony, was the aforementioned tedious nature of the trials. Except for dramatic events, such as the testimony and cross-examination of Hermann Göring by Robert Jackson between March 13 and March 20, 1946, reporters understandably found little to parallel the dramatic action from previous years reporting on combat. In the months after Robert H. Jackson's opening and riveting statement, many prominent journalists moved on to other stories in postwar Europe. When highlights were anticipated, such as the Göring-Jackson exchange, journalists would return to file stories and then travel to other locations. Understandably, many reporters returned for the closing arguments, the sentencing of defendants in October 1946, and the subsequent execution of ten guilty leaders.[65]

These executions were tightly controlled, and Kingsbury Smith, a correspondent for the International News Service, was one of eight journalists chosen to witness them. No reporters were allowed to photograph any part of the executions and a Signal Corps soldier from the Third Army served as the event's official photographer.[66] Smith recounted that his instructions were to be present at the prison visitors' room at 8 pm. His and other reporters' primary role was to confirm the Nazis' deaths to the palace pressroom, at which point journalists would then distribute news of the executions to readers worldwide. As Joseph Persico recounted, "When word raced through the pressroom that *Dana*, the Germany agency, had broken a story that all the war criminals had been executed, the pressure became unbearable. . . . The piece by the New York *Herald Tribune's* correspondent produced an early-edition headline: 11 Nazi Chiefs Hanged in Nuremberg Prison: Goering and Henchmen Pay for War Crimes."[67] However, this headline was inaccurate because reporters had not yet learned that Göring committed suicide taking cyanide the night before his execution.

As to reporting covering the second series of trials, the NMT, articles and reports diminished quickly with every passing day. In one case, Norbert Ehrenfreund recounted a day when he was the only journalist in attendance during the cross-examination of former Reich Chancellor Fritz von Papen. As a result, the young reporter explained: "Stories coming out of the Nuremberg Courtroom began to retreat to the back pages of all the newspapers."[68] Among those journalists still in Nuremberg as the trials concluded, operations and reporting shifted to the ongoing postwar occupation of a divided Germany. News organizations, especially *Stars and Stripes,* continued production, but they assumed a schedule of routine day-to-day coverage that would only regain urgency with the outbreak of the Korean War. However, young researchers and budding journalists associated with *Stars and Stripes* would soon emerge to mark future war reporting and scholarship.

The aforementioned former translator and War Crimes Commission researcher Bernard Fall, for example, worked with *Stars and Stripes* in the newspaper's Munich office as an assistant district manager in 1950.[69] Fall, arguably the most important journalist reporting on developments in Indochina from 1953 until his death at the age of forty in 1967, had gained his position at *Stars and Stripes* after several months working as a tracing officer in the Munich region for the United Nations Tracing Service between 1949 and 1950 before working for *Stars and Stripes* from 1950 to 1951.[70] During the tribunals, Fall worked as a translator and then as a research analyst investigating the Krupp Corporation, which exploited primarily women for slave labor.

Notably, the earliest scholarship Fall produced had nothing to do with Southeast Asia but, instead, centered on developments in Germany leading to World War II and on his work researching the Krupp Corporation during the Nuremberg Trials. After emigrating to the United States as a Fulbright Scholar in 1952, his first significant personal scholarship was his master's thesis "The Keystone of the Arch: A Study of German Illegal Rearmament, 1919–1936," which examined the dismantling of the Treaty of Versailles and the simultaneous undermining of the Weimar Republic.[71] Like Ehrenfreund and others, Fall's transition to journalism and scholarship was directly influenced by his wartime and post-wartime experiences gained at Nuremberg.

Conclusion

The large number of reporters initially covering the Nuremberg Tribunals reflected a sincere and widespread burst of international interest. Critical

events, such as Hermann Göring's testimony and Robert Jackson's examination of Göring on March 13, 1946, were anticipated to such a degree that journalists referred to this confrontation as a "prize fight."[72] In many respects, interest and analysis of Göring indicated great curiosity in the motivations that drove the highest living Nazi leader. In one case, *New Yorker* reporter Janet Flanner remarked of Göring that she had observed "one of the best brains of the period of history when good brains are rare," but that Göring possessed "a brain without a conscience."[73] However, dramatic and exciting days of testimony were also increasingly rare. The decreasing numbers of journalists reporting on the tribunals reflected dwindling public interest as years and the many stages of the Nuremberg Tribunals unfolded.

In recent years, however, there has been renewed interest in the trials and how international justice and the rule of law are used and misused in conflicts. The issue of international justice related to wars in Iraq and Afghanistan, as found in Samuel Moyn's scholarship, but also reflected in articles posted by *New York Times* reporters C. J. Chivers, Lauren Katzenberg, and others, are an essential legacy of the Nuremberg Tribunals. Much as Chivers, Katzenberg, and scholars such as Moyn reflect an understanding of rule of law related to war today, journalists reporting on events in Nuremberg reflected their views and even broader public perspectives on international law. A key difference between then and now, however, was the critical introduction of international justice in prosecuting war crimes that made reporting on events after World War II an arduous but important—even critical—task that is better understood with the many benefits of hindsight.

In 2021–2022, with the 75th anniversary of the International Military Tribunals in Germany and the International Military Tribunal for the Far East in Japan, new archival research continues to illuminate international justice concerning war crimes committed during World War II. Reporters' articles, which detailed the tribunals' proceedings, continue to enrich and humanize historical accounts and legal analyses of complex proceedings related to the deadliest war in human history. The documentary evidence collected across Europe and western Asia and presented in Nuremberg continues to matter to contemporary researchers. At the time, reporters covering the trials helped international audiences understand the proceedings in the late 1940s. However, their articles continue to provide contemporary historians and readers with an extensive range of insights into how perceptions of international justice have changed.

Reporters' articles, like other records, allow contemporary readers to assess changes through time and anticipate changes or challenges to international law meant to regulate, or ideally at least mitigate, future wars. In addition to recent scholarship on international justice, especially on the "Tokyo Trials" and the Soviet Union's role in the Nuremberg Tribunals, ongoing scholarship certainly indicates a vibrant and growing field of study.[74] What reporters wrote in covering those trials form a vital complement to the trials' proceedings and deepen our understanding of World War II. Much may be said of how the Nuremberg Trials—and the ways reporters covered them—inform our understanding of other conflicts and the potential prosecution of war crimes when they occur.

Through what became known as the "Nuremberg Legacy," the tribunals remain therefore relevant in contemporary international justice and in debates concerning human rights. Legal and moral questions concerning war raised at Nuremberg reappeared, especially during the Vietnam War, but the Nuremberg legacy still influences debates today. While war continues with little enforceable and legally grounded punishment of the type Robert H. Jackson called for in the Palace of Justice, reporters' efforts during the Nuremberg Tribunals helped bring a broader consciousness to the possibility that war criminals could, and were, held to account and could be punished. Reporters in the late 1940s likely recognized limitations regarding how far justice could be carried and how it was circumscribed by popular interest that waned as proceedings continued.

While the Nuremberg Tribunals did emerge as a cornerstone of international justice for subsequent conflict, it is unlikely that global power will yield sovereignty to internationally sanctioned punishment that is enforceable by a supranational organization, such as the UN or other international governing organizations. The United States has yet to ratify international agreements, such as the United Nations Convention on the Law of the Sea, let alone fully support the International Court of Justice.[75] However, Robert H. Jackson and Telford Taylor believed that all countries, including the United States, should be held accountable according to principles established at Nuremberg. For reporters simply reporting on events related to World War II, these were challenging subjects to cram into scoops that might appeal to newspaper readers.

Along with the legacy of the tribunals' records, journalists often added a human context to how events at Nuremberg proceeded, how justice was pursued, and how punishments were inflicted for war crimes. While the tribunals provided authority for the legal protection of human rights

254 | Nathaniel L. Moir

established in the United Nations Declaration of Universal Human Rights in 1948—a critical document in human history—journalists described these changes in prosecuting war crimes in ways American readers might better understand. After the shooting stopped with the end of World War II, this was worth reporting then much as it is worth remembering today.

Notes

1. *Grant County Herald* (Elbow Lake, Minnesota) 67, no. 25 (August 16, 1945), Grant County Historical Society, Elbow Lake, Minnesota. Except for figure 11.1 and where otherwise referenced, all other photographs in this chapter are from the Bernard B. Fall Papers, Series 2.3, Box W-01, John F. Kennedy Library, Boston, Massachusetts.

2. Ibid.

3. The International Military Tribunal for the Far East, commonly regarded as the Tokyo trial, began on April 29, 1946, and adjourned on November 12, 1948. For a detailed study see Yuma Totani, *The Tokyo War Crimes Trial: The Pursuit of Justice in the Wake of World War II*, Harvard East Asian Monographs, Book 299 (Cambridge, MA: Harvard University Press, 2008).

4. Vasily Grossman, *A Writer at War: Vasily Grossman with the Red Army*, ed. and trans. Antony Beevor and Luba Vinogradova (New York: Pantheon Books, 2005), 301.

5. Ibid. Beevor's comprehensive analysis of this report, with Grossman's entire report, is located in Chapter 24, "Treblinka," 280–306.

6. For analysis on the International Military Tribunal of the Far East (IMTFE), see Totani, *Tokyo War Crimes Trial*.

7. "Justice Jackson's Final Report to the President concerning the Nurnberg [*sic*] War Crimes Trial," 20 Temp. L.Q. 338 (1946) (Final Report to the President, Oct. 7, 1946). Available at https://www.roberthjackson.org/speech-and-writing /justice-jacksons-final-report/ (accessed April 14, 2021).

8. History of the United Nations, *1945: The San Francisco Conference* https:// www.un.org/en/about-us/un-charter (accessed 19 October 2022).

9. The Declaration of the United Nations is not to be confused with the formation of the United Nations as an organization. For more on the Declaration of the United Nations, see The Avalon Project, Yale Law School, at https://avalon .law.yale.edu/20th_century/decade03.asp (accessed May 4, 2021).

10. Ibid.

11. See Norbert Ehrenfreund, *The Nuremberg Legacy: How the Nazi War Crimes Trials Changed the Course of History* (New York: Palgrave Macmillan, 2007), 7–9.

12. Jackson, from Jamestown, New York, was the only Supreme Court Justice to not earn a JD degree. Although he attended classes at Albany Law

School, he passed the New York state bar exam after further independent study but did not complete the JD degree. For more on Jackson's appointments, see Peter Irons, *A People's History of the Supreme Court: The Men and Women Whose Cases and Decisions Have Shaped Our Constitution* (New York: Penguin, 1999), 343.

13. For a detailed accounting of these developments, see Telford Taylor, *The Anatomy of the Nuremberg Trials: A Personal Memoir* (New York: Alfred A. Knopf, 1992), 78–83.

14. For Telford Taylor's account of the London conference leading to this charter, see ibid., 95–104.

15. Charter of the International Military Tribunal: Agreement for the Prosecution and Punishment of the Major War Criminals of the European Access, Document Number 251. United Nations- Treaty Series, 1951. Available in Appendix A of Taylor, *Anatomy of the Nuremberg Trials.*

16. Ibid., 280.

17. See Markus Urban, *The Nuremberg Trials*, trans. John Jenkins (Nürnberg: Geschichte für Alle e.V.—Institut für Regionalgeschichte, 2012), 33–35.

18. For information on Jackson and Nuremberg, see William R. Castro, *Advising the President: Attorney General Robert H. Jackson and Franklin D. Roosevelt* (Lawrence: University Press of Kansas, 2018). The Robert H. Jackson Center in Jamestown, New York, provides a wealth of information on Jackson and the Nuremberg Tribunals. See https://www.roberthjackson.org (accessed April 12, 2021).

19. For details on individual sentencing and executions, see Urban, *Nuremberg Trials*, 43–44, 70. The last death by hanging occurred on October 17, 1946.

20. Ehrenfreund, *Nuremberg Legacy*, 111.

21. Urban, *Nuremberg Trials*, 48.

22. Joseph E. Persico, *Nuremberg: Infamy on Trial* (New York: Penguin, 1994), 132.

23. Urban, *Nuremberg Trials*, 51.

24. For an overview on Lochner, see Meg Jones, "Our Man in Berlin," *On Wisconsin* 118, no. 2 (2017): 28–33. See also Louis P. Lochner, *Always the Unexpected* (New York: Macmillan, 1956).

25. Persico, *Nuremberg*, 132.

26. Ibid., 203.

27. For detailed descriptions of the four categories of charged crimes, see Eugene Davidson, *The Trial of the Germans: An Account of the Twenty-Two Defendants before the International Military Tribunal at Nuremberg* (New York: Macmillan, 1966), 19.

28. For a discussion of the development of international law of war and its failures, see John Fabian Witt, "The Dismal History of the Laws of War," *UC Irvine Law Review* 1, no. 3 (2012): 895–911.

29. For a landmark study on the Kellogg-Briand Pact, see Oona A. Hathaway and Scott J. Shapiro, *The Internationalists: How a Radical Plan to Outlaw War Remade the World* (New York: Simon & Schuster, 2018).

30. See Taylor, *Anatomy of the Nuremberg Trials*, 9–11.

31. Sheldon Glueck, *War Criminals: Their Prosecution and Punishment* (New York: Alfred A. Knopf, 1944), 10, 12–17.

32. Discussion of *Ex Post Facto* justice is available in Taylor, *Anatomy of the Nuremberg Trials,* For article 26, see Taylor, page 652.

33. Walter Cronkite, *A Reporter's Life* (New York: Alfred A. Knopf, 1996), 127–128.

34. Telford Taylor provided one of the most comprehensive retrospective analyses on the tribunals by a participant. See note 13 above. Hannah Arendt's analysis, "Eichmann in Jerusalem: A Report on the Banality of Evil," is important to consider in the context of reporting on Nuremberg. For a contextual and helpful analysis of Arendt's Eichmann study, see Kathleen B. Jones, "The Trial of Hannah Arendt," *Humanities* 35, no. 2 (2014).

35. U.S. Constitution, Artl. S9.C3.2, Ex Post Facto Laws. See Constitution Annotated, available at https://constitution.congress.gov/browse/essay/artI-S9-C3 -3-5/ALDE_00013195/ (accessed 19 October 19, 2022).

36. Taylor, *Anatomy of the Nuremberg Trials*, 59. I. T. Nikitchenko was also an army advocate general in the Soviet Army and vice president of the Soviet Supreme Court.

37. Francine Hirsch, *Soviet Judgment at Nuremberg: A New History of the International Military Tribunal after World War II* (New York: Oxford University Press, 2020), 60.

38. Ibid.

39. Ehrenfreund, *The Nuremberg Legacy.*

40. Bernard Fall Papers (BBF), series 2.3, box W-3, John F. Kennedy Library (JFKL), Boston, MA.

41. For more on the IBM translating system, see Robert E. Conot, *Justice at Nuremberg* (New York: Carroll and Graf, 1984), 59–60.

42. Persico, *Nuremberg: Infamy on Trial*, 127.

43. Markus Urban describes life at Stein Castle in detail and indicates that complaints existed. See Urban, *Nuremberg Trials*, 52.

44. Stanley Kramer, *Judgment at Nuremberg* (United Artists, 1961).

45. Urban, *Nuremberg Trials*, 53.

46. Ibid., 46–47.

47. Photos of these facilities are located in Bernard B. Fall's papers, series 2.3, box W-01, BBF, JFKL.

48. Cronkite, *A Reporter's Life*, 127. The 1907 Hague Convention also served as a critical basis for the Nuremberg Charter. See International Military Tribunal (IMT), XI. Judgment, A. Opinion and Judgment of Military Tribunal III, 1338. 1340. Also see Bernard Fall, *"Trois Rapports sur l'Armament et la Cavaleria du IIIe Reich,"* series 2.3, box W-03, BBF, JFKL.

After the Shooting Stopped | 257

49. Cronkite, 127.

50. Ken Zumwalt, *The Stars and Stripes: World War II and the Early Years* (Austin, TX: Eakin Press, 1989), 106, 236.

51. Ehrenfreund, *The Nuremberg Legacy*, 3.

52. Zumwalt, *Stars and Stripes*, 4.

53. Ibid., 44.

54. Ibid., 29.

55. Urban, *Nuremberg Trials*, 70.

56. Hirsch, *Soviet Judgment at Nuremberg*, 254.

57. Ibid., 210.

58. For a detailed account, the Nazi armaments minister, Albert Speer's collected documents are illuminating. See "Albert Speer: Miracle Man," in Adam Tooze, *The Wages of Destruction: The Making and Breaking of the Nazi Economy* (New York: Viking, 2006), 552–589.

59. Cronkite, *A Reporter's Life*, 125–126; William L. Shirer, *The Rise and Fall of Adolf Hitler* (New York: Random House, 1961), 139–140.

60. Two useful bibliographies are located in Taylor, *Anatomy of the Nuremberg Trials*, 679–682, and Persico, *Nuremberg: Infamy on Trial*, 457–460.

61. See Benjamin B. Ferencz, *Less Than Slaves: Jewish Forced Labor and the Quest for Compensation* (Cambridge, MA: Harvard University Press, 1979). For Ferencz's discussion on the Krupp-Nazi alliance, see "Chapter 3: Accounting with Krupp." For more on Krupp-Nazi collusion, see Bernard Fall, "World War II/ Nuremberg Trial Materials," Series 2.03, Box W-02, BBF, JFKL.

62. The website for Alfried Krupp von Bohlen und Halbach-Stiftung is available at https://www.krupp-stiftung.de/ (accessed January 20, 2021).

63. See Harold James, *Krupp: A History of the Legendary German Firm* (Princeton, NJ: Princeton University Press, 2020). For evidence about the Krupp-Nazi/SS connection, see Ferencz in note 61.

64. For more information about the Krupp Tribunal, see Nuremberg Military Tribunal (NMT), XI. Judgment, A. Opinion and Judgment of Military Tribunal III. See also William Manchester, *The Arms of Krupp, 1587–1968* (Boston: Little, Brown, 1968).

65. Urban, *Nuremberg Trials*, 38–44.

66. Persico, *Nuremberg: Infamy on Trial*, 419.

67. Ibid., 428.

68. Ehrenfreund, *Nuremberg Legacy*, 35, 104–105.

69. Bernard B. Fall, CV, series 1.1, box F-1, BBF, JFKL.

70. Ibid. The UN Tracing Service is a point of origin for the International Tracing Service in Bad Arolsen. Information about this service is available through the Arolsen Archives, International Center on Nazi Persecution. See https://arolsen-archives.org/en/ (accessed April 22, 2021).

71. Bernard Fall, "The Keystone of the Arch: A Study of German Illegal Rearmament, 1919–1936," MA thesis, Maxwell School of Citizenship, Syracuse University, 1952, series 1.5, box P-2, BBF, JFKL.

258 | Nathaniel L. Moir

72. Ehrenfreund, *Nuremberg Legacy*, 65.

73. Janet Flanner, *New Yorker*, March 30, 1946, quoted in Ehrenfreund, 66, and Persico, 270.

74. On the Tokyo Trials, see Totani, *Tokyo War Crimes Trial.* On recent research in Soviet archives, see Hirsch, *Soviet Judgment at Nuremberg.* Elizabeth Borgwardt, currently at Washington University in St. Louis, has also written extensively on the Nuremberg Principles and Human Rights.

75. On the UN Convention on the Law of the Sea (UNCLOS), see Aditya Singh Verma, "A Case for the United States' Ratification of UNCLOS," *Diplomatist,* May 2, 2020; regarding U.S. relationship with the International Court of Justice, see Sean D. Murphy, "The United States and the International Court of Justice: Coping with Antinomies," in *The United States and International Courts and Tribunals*, ed. Cesare Romano, GWU Legal Studies Research Paper No. 291, GWU Law School Public Law Research Paper No. 291 (2008), https://ssrn.com/abstract=1000391.

Acknowledgments

The editors of this anthology have incurred a number of debts that we are grateful to acknowledge. Originally, we had planned to hold a two-day conference on frontline journalism at the Intrepid Sea, Air, and Space Museum in New York City on April 23 and 24, 2020. A significant number of commitments were secured, and in early March 2020 we were accepting registrations, had booked hotel rooms for participants, determined the menu for receptions, and were soon going to print with the program. Alas, by the end of March we had to initially postpone the conference as a result of the Covid-19 pandemic, and by the summer we realized rescheduling was untenable. We appreciate Elaine Charnov, senior vice president of Exhibits, Education, and Public Programs, and Lynda Kennedy, vice president of Education and Evaluation of the Intrepid, for offering their steadfast support of this conference and for embracing partnerships with other institutions. Except for nominal fees for custodial and security services, the Intrepid offered us a venue without charge and served as one of the conference co-sponsors. Gerrie Bay-Hall, director of School and Teacher Programs at the Intrepid, served as our principal point of contact and coordinated a number of logistical details. Despite many of the demands on her time, Gerrie's professionalism and attention to detail were outstanding.

In organizing the conference, the Contemporary History Institute at Ohio University and the Institute on World War II and the Human Experience at Florida State University were joined by *Stars and Stripes* and by Fordham University Press. We had wanted this conference to highlight the invaluable contribution that *Stars and Stripes* under the leadership of Max Lederer plays in ensuring today's servicemen and servicewomen have access to objective news reporting wherever deployed in the world. Major financial support for the conference was offered by the Iron Mountain Corporation that had also funded the digitization of the Cornelius Ryan Papers at Ohio University. Through the efforts of Julia Zimmerman, dean emeritus of the Florida State University Libraries, and former dean of the Ohio University Libraries we secured a significant pledge of support from the Office of the

260 | Acknowledgments

Provost at Florida State University. The embrace of the project by the provost at the time, Sally McRorie, after meeting with Kurt Piehler and Julia in Fall 2019 was especially heartening. At Ohio University, the Baker Peace Studies program added to the funds the Contemporary History Institute allocated for the planned conference.

Despite the cancellation of the conference, we decided to proceed with this anthology. The support of Fred Nachbaur, the director of Fordham University Press, proved pivotal in ensuring that an anthology emerged from our efforts. We are especially grateful to Fordham for securing two excellent outside readers, Todd DePastino and Allan M. Winkler, who offered invaluable critiques of the introduction and essays that make up this volume.

Anne Marsh, administrative assistant at the Institute on World War II, served as the principal coordinator for the planned conference and went on to serve before her retirement in March 2022 as editorial assistant for this anthology. Anne was the principal point of contact for contributors and played a pivotal role in securing illustrations for this volume. Holly Ann Hogaboom, who served as an editorial intern for Fordham University Press, assisted Anne and the co-editors in ensuring that this volume entered production in a timely fashion. At Ohio University, Connie Hunter, the events coordinator of the Contemporary History Institute, and the late Mike Sweeney, who helped us select conference participants, put their imprint on the program and, therefore, on this book. The Contemporary History Institute has long served as a center that enhances the master's and doctoral programs of history and journalism. Journalism history has a stellar tradition at Ohio University. Thanks to Aimee Edmondson, who has taken up the baton from Mike Sweeney, we hope to build on this tradition.

G. Kurt Piehler
Ingo Trauschweizer

Contributors

Steven Casey is a professor of international history at the London School of Economics and is the author of *War Beat, Europe: The American Media at War against Nazi Germany* (New York: Oxford University Press, 2017) and *When Soldiers Fall: How Americans Have Confronted Combat Losses, from World War I to Afghanistan* (New York: Oxford University Press, 2014).

Kendall Cosley is a doctoral candidate at Texas A&M University. She studies the relationship between war correspondents and American soldiers in World War II.

Douglass K. Daniel is a writer and editor for the Washington bureau of the Associated Press. He is the author of *Harry Reasoner: A Life in the News* (Austin: University of Texas Press, 2007), and he edited *The Korean War*, volume 6 of The Greenwood Library of American War Reporting (Westport, CT: Greenwood Press, 2005).

Alan Delozier is Special Collections Educations Coordinator and University Archivist at Seton Hall University. He holds a D.Litt. in Arts & Letters from Drew University and an MA in history from Villanova University.

Carolyn M. Edy is a media historian and associate professor at Appalachian State University. After working in journalism for ten years, as a magazine writer and editor, Edy completed her doctorate at the University of North Carolina–Chapel Hill. Her first book, *The Woman Correspondent, the U.S. Military, and the Press, 1846–1947* (Lexington Books), was a finalist for the American Journalism Historians Association's Book of the Year Award of 2018.

Karen Garner is a professor of historical studies at SUNY Empire State College. She is a Fulbright Scholar (Veszprém, Hungary, 2014; Vilnius, Lithuania, 2003), whose most recent monographs include *Friends and*

Enemies: The Allies and Neutral Ireland during the Second World War (Manchester, UK: Manchester University Press, 2021) and *Women and Gender in International History, Theory and Practice* (London: Bloomsbury Academic Publishing, 2018).

Larry A. Greene is a professor of history at Seton Hall University. A Fulbright scholar (Germany), he has written extensively on African American history and teaches courses on World War II. He is a co-organizer of several major conferences, including "Crossovers: African Americans and Germany" (University of Muenster, Germany, March, 2006). He co-edited with Anke Orlepp, *Germans and African Americans: Two Centuries of Exchange* (Jackson: University Press of Mississippi, 2011).

Alexander G. Lovelace is a scholar in residence at the Contemporary History Institute at Ohio University. His first book, *The Media Offensive: How the Press and Public Opinion Shaped Allied Strategy during World War II* (University Press of Kansas, 2022), explores how the media influenced military decision-making during the Second World War.

Nathaniel L. Moir is a research associate in the Applied History Project at the John F. Kennedy School of Government, Harvard University. Previously, he was an Ernest May Postdoctoral Fellow in history and policy at the Kennedy School. He is the author of *Number One Realist: Bernard Fall and Vietnamese Revolutionary Warfare* (Oxford University Press, 2022).

Henry Oinas-Kukkonen is a university lecturer in history and is a docent in the History of International Relations and Information Networks at the University of Oulu, Finland. He has worked on the history of the U.S. Occupation of Japan, U.S.-Finnish relations, and American plans to resettle Finnish World War II refugees in Alaska. His current research interests also include the history of information and communication technology, innovation, and the social web.

G. Kurt Piehler is the author of *A Religious History of the American GI in World War II* (2021) and several reference works related to war and society. He is a member of the editorial board of the *Service Newspapers of World War II* digital publication (Adam Mathews) and on the advisory board of the NEH-funded American Soldier Project at Virginia Tech University (americansoldierww2.org).

James Austin Sandy is an assistant professor of history at the University of Texas, Arlington. His dissertation is titled "A War All Our Own: The American Ranger and the Emergence of the American Martial Culture."

Victoria Sotvedt is a PhD candidate at the University of Calgary. She works primarily on Canadian military experiences in the Second World War and the early social history of the Canadian prairies.

Ingo Trauschweizer is a professor of history at Ohio University. He is the author of *The Cold War U.S. Army: Building Deterrence for Limited War* (Lawrence: University Press of Kansas, 2008) and *Maxwell Taylor's Cold War: From Berlin to Vietnam* (Lexington: University Press of Kentucky, 2019), and he is the editor or co-editor of three volumes in the Baker Series in Peace and Conflict Studies (Athens: Ohio University Press).

Index

Abwehr (German military intelligence), 36, 38

African Americans, 3, 8, 107–25, 184; reports by Marine Corps Combat Correspondents, 143, 153

Afro-American, 107, 108, 114–16

Aftonbladet (Swedish newspaper), 71–72

Aiken Frank, 38, 39, 42–43

Allen, Terry, 184

American Council of Learned Societies, 66

American First, 42

American Red Cross, 55, 70, 119, 123

American Society of Newspaper Editors, 152

Anglo-Irish Navy (1921), 35

Anglo-Irish Treaty (1938), 35

animals, 23, 143, 147

Anzio, 6, 206

Associated Press (AP), 5, 16; beefs up Polish presence, 19; combat correspondents with, 181; deploys reporters to Finland, 22, 24, 25; favors shorter stories, 88–90; fires David Kennedy, 97; gain advantage in reporting Soviet news, 27; hires David Nopper as reporters, 141; impacts women reporters, 176; invokes war clauses, 17; limits on reporting, 93; maintains overseas bureaus, 86–87, 91, 95–96, 98–103; reports on Marine combat correspondents, 137; transfers Jewish reporters, 92; Don Whitehead correspondent for, 85, 180, 206

Atlantic Charter, 43, 237

atrocities, 149, 166, 248–49

Ault, Phil, 202

Auschwitz, 249

Austin, A. B., 198–99, 205

Austria, 90, 94

Axelrod, Alan, 227

Baillie, Hugh, 16

Baldwin, Hanson, 240

Baldwin, James, 125

Baltimore Afro-American, 8, 115, 116, 117, 120–21, 124–25

Baltimore, Maryland, 122

Baltimore Sun, 141, 199

Barr, Francis H., 149

Battle for Aachen, 9, 179, 218–20

Battle for Caen, 7–8, 160, 165–67

Battle for Saipan, 142, 150–51, 152

Battle for Tarawa, 132–34, 148–49, 151, 154

Battle for Wake Island, 136, 140

Battle of Belleau Woods, 134–35

Battle of Bougainville, 148–49

Battle of Britain, 28–29, 40, 46

Battle of Guadalcanal, 139, 142, 148–49

Battle of Hurtgen Forest, 179–80

Battle of Iwo Jima, 144–45, 149, 150–51

Battle of Normandy, 165, 168, 175–76

Battle of Okinawa, 148, 151

Battle of Stalingrad, 70

Battle of the Bulge viii, 2, 3; fosters Anglo-American discord, 9, 220–22, 227; leads racial integration, 8; women reporters report on, 181

Beattie, Ed, 19, 20, 25, 28–29

Belgium, 6; invasion of, 28, 39, photographic exhibit in, 64

Beech, Keyes, 144–45

Beevor, Antony, 236

266 | Index

Bell, Martin, 34
Berg, vii
Berge, Wendell, 117, 118
Berger, David, vii
Berlin, Germany: American reporters life in, 95; AP news bureau in, 86, 87, 90, 91, 92, 93, 97, 98, 99, 101; bombing of, 100; *Chicago Daily News's* bureau in, 20; reacts to news of German army's capture of Paris, 88
Bernays, Murray, 237
Biddle, Francis, 116, 118, 122
Bilbo, Senator Theodore G., 124
Blair, Clay, 227
Blechman, Solomon, 149
Boni, Bill, 181
bombing: impact on Irish public opinion, 41–42; of Berlin, 100; of Britain, 119; of Dresden, 241; of Helsinki, 40, 59; of London, 5, 28–29, 40; reporting on, 122
Bonney, Therese Mabel, 6, 55–75
Boston Globe, 172, 173, 181, 185
Boston, Massachusetts, 178–79
Bourke-White, Margaret, 1
Boyle, Hal, 181
Bradley, Omar, 7, 9, 213–23, 225–29
Brennan, Robert, 40
British Broadcasting Corporation (BBC), 69, 72, 194, 221–22
British navy, 35, 37, 39, 43, 96
Buchenwald, 37, 47
Budapest, Hungary, 86, 87, 90, 95, 100
Buffalo Evening News, 3
Buhler, Kitty, 227
Bulow, Friedrich von, 249–50
Butcher, Harry, 9, 216, 223, 225

Camden *Courier-Post*, 144
Capra, Robert, 1
Carnegie Corporation, 64
Carpenter, Iris, 172–74, 177, 178–79, 181, 184, 185–86
Carson, Lee, 172–77, 178, 179–81, 182, 184–86
Carter, Art, 123
casualties, vii, 5; among Canadian reconnaissance unit, 164; among U.S. Rangers, 202, 206–7; during

raid on St. Nazaire, 197; during Russo-Finish War, 24; German, 179; of war reporters, 173, 177, 180; on Iwo Jima, 145, 149; on Tarawa, 151–52; reporting of, 133
casualties, psychiatric, 150
censorship: by British government, 28; by Finnish government, 23, 24–25, 61–62; by German government, 9–10, 20, 28, 93, 101; by Irish government, 38, 42; by Polish government, 19; by SHAEF, 97; by Soviet government, 25–27; by U.S. War Department, 46, 123; of Black press, 116–118; of Marine correspondents, 146–53; of reconnaissance operations, 169; of visual images, 3; widely practiced, 4–5, 96
Chamberlain, Neville, 28, 35–36, 37, 38, 94
Chappell, Ernest, 194
Chicago Daily News: audience for, 16–17; deploys Helen Paull Kirkpatrick overseas, 35, 39, 40, 42, 44, 45, 46; deploys reporter to Finland, 22, 23; deploys reporters to London, 18; employees James W. Hurlbut, 137; hires Lee Carpenter as feature writer, 174; maintains bureau in Berlin, 20; publishes story of Marine Corps correspondent, 133
Chicago Defender, 115, 118
Chicago, Illinois, 3–4, 16, 124, 134, 167
Chicago Tribune: audience for, 16–17; comments on naval communique, 136; deploys reporter to Finland, 22, 23; employees Edward Kennedy, 90; employees James W. Hurlbut, 137; employs Arthur Noyes, 247
children: books for, 248; in Finland, 63, 74; in German concentration camps, 75; in Nuremburg, 244; of journalists, 90, 98, 167, 174; literature for, 55; as refugees, 68, 70; resilience of, 76
China, 15, 117–18
Chivers, C. J., 252
Christian Science Monitor, 74
City College (NYC), 26

Churchill, Winston: calls for raiding program, 194, 208; gives radio address, 45; meets Franklin Roosevelt, 43; regarding color bar in Great Britain, 120; warnings of, 227

Clark, Gerald, 7–8, 165–66

Clark, Mark, 205, 213

Clarke, Dudley, 193–94

Coleman College, 107

Collier's, 73, 74, 75, 141

Collingwood, Charles, 121

Collins, J. Lawton, 220

Columbia Broadcast System (CBS): broadcast remarks of Ollie Stewart, 121; collaborates with OSS, 67; covers Nuremberg war crime trials, 239; drafts joint code, 18; employs Harry Butcher, 216; Edward R. Murrow's broadcasts for, 3; relations with Therese Bonney, 71, 72, 73; rivalary with NBC, 17; Andy Rooney's career with, 87

Columbia, Tennessee, 108, 125

commandos (British), 10, 193–201, 205–6, 207–8

concentration camps (German), 37, 47, 75, 184, 185

Cooper, Edwin H., 56

Cooper, Kent, 89, 99

Cowles, Virginia, 40

Cronkite, Walter, 240, 242, 246–47, 249

Dagens Nyheter (Swedish newspaper), 60, 62

Daily Telegraph, 35

Daily Worker, 75

Daniel, Clifton, 183

Danzig, 95

Darby, William O., 198, 200, 202, 203–4, 206

Day, Donald, 23

D-Day (June 6, 1944): Lee Carson reporting on, 176; change press coverage of special forces, 10; history of, 1–2; Helen Kirkpatrick reports on, 47; press coverage of, 164–65, 166–67; Ollie Stewart coverage of, 123

Dean, Gordon, 243–44

DeFelice, Jim, 227

Defense Information School, 153

De Gaulle, Charles, 124, 178

Denmark, 39

Denig, Robert L., 135–39, 140, 152

Denny, Harold, 23, 24, 25–26

DePastino, Todd, 3–4

Der Stürmer, 248

D'Este, Carlo, 216

Detroit, Michigan, 122, 139

Deuel, Norman, 25

de Valera, Eamon: American pressure on, 45–46; assessment of, 47; negotiates with Chamberlain government, 35–37; negotiates with David Gray, 39, 40–41; seeks end to Irish partition, 38; seeks to sway American public opinion, 42–44

Dieppe Raid, 198–200, 207

Dill, John, 193–94

Dimond, Douglas , 73

Dockins, William H., 124

Donovan, William J., 72–73

Dos Passos, John, 239

Dresden, 241

Dreyfus, Alan, 247

Drum, Hugh A., 163

Duell, Sloan and Pearce, Inc., 67–68

Duffield, Marcus, 23–24

Economist (magazine), 35

Ehrenfreund, Norbert, 240, 243, 247, 251

Eisenhower, Dwight: army of, 202; attends Casablanca Conference, 122; commands SHAEF, 160; criticism of, 120; ensures editorial independence of *Stars and Stripes*, 9, 214–16, 220, 222, 224, 225–26, 228; establishes *Stars and Stripes*, vii; issues nonfraternization order, 219; mandates equal treatment for Black soldiers, 112; orders integration during Battle of the Bulge, 8; places U.S. Armies under command of Bernard Montgomery, 221; relationship with reporters, 5

Elisofon, Eliot, 58–59, 60

Elizabeth, Queen, 46

Estoff, Bill, 223

268 | Index

Ethiopia (Abyssinia), 16, 109, 117
Exercise Tiger, 163–64

Falco, Robert, 237, 238
Fall, Bernard, 244, 251
Federal Bureau of Investigation, 8, 67, 72
Federal Housing Administration, 135
Finland: as co-belligerent of Germany, 67, 73–75; fights Soviet Union, 59–62; on eve of war, 58–59; ties with Therese Boney, 55, 56–57
First Marine Division, 137, 139
Flaherty, John E., 139
Flanner, Janet, 239, 252
Fort Bragg, 116
France: Americans dealings with Vichy officials, 6; British raids against, 194, 196–97; devastation in, 100; fights war in Indochina, 240; German invasion of, 62, 88, 91, 93; partici-pates in Nuremberg war crime trials, 238; racial tensions in, 120; surrender of, 28, 38
Fussell, Paul, 217

Galen, Clemens August Graf von, 89
Gallagher, Frank, 44
Gedye, G. E. R., 26, 27
Gellhorn, Martha, 22, 60, 240
Geneva Conventions, 241, 247
Gentile, Don, 174–75
George, King, 56
Germany: anti-Semitic policies of, 92, 98–99; attacks Irish shipping, 41–42; ends Phony War, 28–29; invades Poland, 15–17, 18–21, 58; invades Soviet Union, 91, 249; maintains diplomatic relations with Ireland, 36–37; occupies Rhineland, 35; reporting on, 90, 94–95; seeks stronger ties with Finland, 68; sends spies in Ireland, 39–40, 45, 41–42; slaughters Jews, 37; surrender of, 97; troop deployments in Finland and Lapland, 69–70, 74
Gestapo (Geheime Staatspolizei), 70, 89
Globe and Mail, 164
Goebbels, Joseph, 9–10

Goertz, Hermann, 45
Good Photography (magazine), 64
Goodfellow, Millard Preston, 67, 72–73
Goodfriend, Arthur, 219, 220, 226
Göring, Hermann, 92, 238, 241, 248, 250, 252
Gourley, Catherine, 62
Grant County Herald, 234
Gray, David, 39–40, 41, 43–45, 47
Great Britain: African American deployments to, 118–19; participates in Nuremberg war crime trials, 238; relationship with war reporters, 28; seeks to improve relations with the Irish government, 35–36
Gripenberg, G. A., 68
Grossman, Vasily, 235–36, 247
Gulf War, viii
Gunther, Gustave B., 73

Hague Conventions, 241, 247
Haiti, 117
Halliwell, E. R. Davis, 72–73
Hamburg, 241
Hansen, Chester B., 217, 222–23
Harper's Bazaar, 62
Harington, Ollie, 125
Harvard Law School, 26
Hawkins, Thomas F., 24, 25
Hemingway, Ernest, 10, 176, 178, 181, 240
Heppner, Richard P., 73
Hersey, John, 10
Hess, Rudolf, 238
Higgins, Marguerite, 239
Himes, Chester, 125
Hiroshima, 10, 234
Hirsch, Francine, 243, 248
Hispanic, 143
Hitler, Adolf, 193, 195, 196; AP report-ers distrust of, 98; declares war on the United States, 101; delivers speech in Danzig, 95; eulogies of, 248; gives interview, 92; govern-ment's propaganda efforts, 28; makes belligerent statements, 19; marches against Poland, 15, 17; meets with Chamberlain, 94; oppo-nents of, 89; receives support from

Krupp family, 249–50; reporting on, 99; visits Mannerheim, 68
Hodges, Courtney, 220
Holcomb, Thomas, 135, 137
Holman, Gordon, 195, 196–97, 199, 200–1, 207
Holocaust, 235–36, 247
Holt, Thomas, 198
Hoover, Calvin B., 72
Hoover, J. Edgar, 8, 115, 116, 117, 118, 122
Hoss, Rudolf, 249
Householder, E. R., 117
Howard University, 123
Huebner, Clarence R., 219–20
Hughes, Everett, 215
Hugman, V. W., 164
Hull, Cordell, 68
Hurlbut, James W, 137, 139
Hutton, Bud, vii
Hutton, Graham, 35

International News Service (INS), 22, 136, 174–75, 179, 182, 184, 250
internment, 101
India, 119
IRA (Irish Republican Army), 36, 38, 39, 43, 46
Ireland: maintains policy of neutrality, 36–46, 46; negotiates with Great Britain, 34–35
Irvine, Robert, 180
Italy: African American troops in, 108, 111, 120, 123; Allied campaign in, 47, 167; Allied invasion of, 203, 205–6, 208; censors media, 96; impact of war on civilians in, 122; intervenes in Spanish Civil War, 35; invades Ethiopia, 117–18; maintains diplomatic relations with Ireland, 37; Bill Mauldin's experiences in, 223–24
Izvestia, 26

Jackson, Allan, 184
Jackson, Robert H., 236, 237–38, 240, 242, 243, 250, 252, 253
James, Edward L., 28
James, Harold, 249–50
Japan, 37, 96, 117–18, 234

Jews: attacks on, 35, 37, 99; barred from German media, 92; reporter aids, 98
Jodl, Alfred, 238
Johnson, Douglas, 166
Johnson, Lyndon B., 125
Johnston, Nelson Riff, 167
Justice Department, 116–17

Kallio, Kaisa, 60
Kallio, Kyosti, 60
Kaltenbrunner, Ernest, 238
Katzenberg, Lauren, 252
Katyn Massacre, 241, 248
Kaufman, Millard, 151
Keller, Maj. Gen. Rodney F. L., 164–65
Kellogg-Briand Pact, 241, 246
Kennedy, Edward P., 86, 90, 95, 97, 102
Keyes, Roger, 195, 196
Kiley, Chares, vii
Kiley, Dan, 239–40
Kimbel, Bill, 73
Kirkpatrick, Helen, 5, 34–47
Knightley, Phillip, 4, 9–10
Knox, Frank, 18, 39, 46
Korean War, 86, 251
Kornweibel, Theodore, Jr., 116
Kristallnacht, 5, 98, 99
Krupp, Alfred, 249–50
Krupp Corporation, 239, 249–50, 251

Lang, Will, 223–24
Latvala, W. K., 56
Lawrence, Geoffrey, 238
League of Nations, 34–35, 117
Lear, Ben, 226
Leclerc, General, 47
Lee, John C. H., 223
Lend-Lease, 40, 45
Lennox, Victor Gordon, 35
Lehrbas, Lloyd, 19, 20
Lehmann, Carla, 200
Levin, Dan, 149
Lewiston Evening Journal, 168
Liberia, 117
Liberty (magazine), 108
Library of Congress, 64
Libya, 164
Liebling, Joe, 217

270 | Index

Lieber Code, 241
Life (magazine), 6, 58–59, 216, 239
Lincoln University, 123
Lippmann, Walter, 34
Lipton, Norman C, 64
Listener, The, 193
Lochner, Louis P., 86, 90–91, 92, 94, 96, 98, 99–100, 101, 102, 240
London: African American troops in, 11; AP bureau, in, 86, 87, 97, 100; bombing of, 5, 40; as media center, 20, 28
London Daily Herald, 172, 174, 179
London Sunday Express, 174
Louisiana Maneuvers, 163
Lovat, Lord, 198–99
Lowman, Lawrence, 67
Lucas, Jim, 132–34, 150–51

MacArthur, Douglas, 148, 213, 225
MacGowan, Alexander, 199
MacKenzie, Fred, 3
Maffey, John, 44, 46
Maginot Line, 91, 100
Mahurin, Walker, 175
malaria, 147
Manchester Guardian, 198–99
Manchester, William, 225
Manley, James E., 122
Mannerheim, Gustaf Emil, 58, 68, 69
Mannerheim Line, 22, 23, 24
Mansfield, Walter R., 72–73
Marshall, George C., vii, 197, 201, 227
Matjasic, Raymond, 133
Matthews, Ernest A. Jr., 133
Matthews, Herbert, 19
Mauldin, Bill, vii, 3–4, 9; clashes with George Patton, 214, 223–225, 226, 228–29
Mayborn, Frank, 178
McClintock, Robert M., 70
McGowan, John, 168–69
McGowan, Peter, 168–69
McLean, Robert, 16
McNair, Leslie, 204
McNamara, Bill, vii
medical care, 177
Meier, Larry, 199
Mercuriali, Gino, 198

Merillat, Herbert C., 137, 139
Miller, Francis Pickens, 72
Miller, Webb, 22, 24
Ministry of Information (British), 174, 177
Mitgang, Herbert, 3, 215
Molotov-Ribbentrop Pact, 248
Montgomery, Bernard, 9, 163–64, 221–22, 227
Montreal, 7–8, 163, 165–66
Montreal Star, 167, 168
Morocco, 122, 202
Moscow, 25–26, 28, 97
Moscow Conference (1943), 237
motion pictures, 1, 56, 73–74, 140, 144, 200
Mountbatten, Lord Louis, 201
Mount Vernon Daily Argus, 151
Mowrer, Richard, 19, 20
Moyn, Samuel, 252
Munich Agreement, 90, 94
Murphy, Richard, Jr. 152
Murrow, Edward R., 3, 5, 67, 240
Museum of Modern Art, 64
music, 60, 124
Musical America, 60

NAACP, 123
Nation Broadcast Company (NBC), 17, 18
National Editorial Association, 138
Navajo Indians, 148
Neville, Robert, 215
Netherlands, 2, 28, 39
Newark, New Jersey, 115, 123
New Jersey Afro-American, 116
New York City, 108; as media center, 16, 21, 87, 134, 141; world's fair in, 56
New York Amsterdam News, 108
New York Daily News, 16–17, 151, 247
New York Herald Tribune, 16, 19; assesses Finish publicity, 23–24; deploys reporters to Finland, 22, 24; publishes Therese Bonney photographs, 60, 62, 64; reports on Nuremberg war crime trials, 239, 250
New York Post, 47
New York *Sun*, 60

New York Times, 4; caters to well-educated audience, 16; deploys reporters to Finland, 22, 23, 24; maintains bureau in Moscow, 25–28; publishes photographs of Therese Bonney, 62, 64; publishes story of Marine Corps correspondent, 133; quotes Ollie Stewart, 125; reports on British commandos, 196; reports on D-Day landing, 160; reports on Nuremberg war crime trials, 248, 250, 252; reports on TORCH landing, 202; reports on U.S. Rangers, 193; reporters with, 19; runs story on Roer River crossing, 183

New Yorker, 217, 239

Newsweek, 62, 68, 173, 216; reports on Omar Bradley, 216; reports on Rhine maidens, 173

Nikitchenko, Iona T., 237–38, 242

Ninety-Second Division (U.S. Army), 111

Nopper, David E., 141

North Africa, 121, 201–3

Norway: British raids against, 194–96; German invasion of, 28, 39, 74

Noyes, Arthur, 240, 247

Nuremberg Charter, 238

Nuremberg war crime trials, viii, 10–11, 47, 186, 234–54

O'Brien, Cyril J., 138, 144, 146, 147

O'Connor, James J., 167

O'Connor, Jeanne, 167

Oestreicher, Jack, 181–82

Office of the Coordinator of Information (COI), 67

Office of Naval Intelligence, 72

Office of Strategic Services (OSS), 6, 67–68, 70, 71–72, 76, 240

Office of War Information (OWI), 69

Ohlendorf, Otto, 249

Oldfield, Barney, 176, 178

Operation Market Garden, 2

Operation Overlord, 6; Omar Bradley's characterization of, 217, 227; Ranger units participate in, 206–7; women reporters report on, 174, 175

Ossad, Steven L., 227

Ottley, Roi, 8, 107–14, 125–26

Palmer, A. Mitchell, 116

Paris, France: AP bureau in, 95, 100; attracts Black expatriates, 125; German capture of, 88; liberation of, 47, 124, 177–78

Patton, George S., 2, 160, 247; abuses soldier, 5, 9; clashes with Bill Mauldin, 213–14, 221, 223–26, 228; participates in Carolina maneuvers, 163

Pearl Harbor, Japanese attack on, 45

Pearson, Drew, 5

Persico, Joseph, 239–41, 243, 250

Philadelphia, Pennsylvania, 115, 123

Philippine American War, 134

Pinkley, Virgil, 226

Pittsburgh Courier, 107, 108, 109, 113, 115, 117, 118

Pittsburgh, Pennsylvania, 145

Pittsburgh Press, 162

PM (newspaper), 8, 107, 108, 109, 215

Poland: invasion of, 4, 15–16, 19–21; German atrocities committed in, 37; refugees flee from, 100; travel routes to, 18, 21

Popular Photography, 62

prisoners of war, 100, 166, 168–69, 203

Pritzker Military Museum and Library, 3–4

Pyle, Ernie, vii, books of, 3; characterizes Omar Bradley, 213, 217; critical of dealing with Vichy French, 6; lives with soldiers, 91, 102; praises Black journalist, 121; publishes popular book, 86; reports on U.S. Rangers, 203, 207; skillful narration of, 89–90; style characterized, 178

Quisling, Vidkun, 28

race riots, 108, 115–16, 122

Radcliffe College, 55

radio, 5, 102, 137; broadcast by Ollie Stewart, 121; as major source of news, 18, 87

Ramsden, Jack, 195

Rangers (U.S. Army), 10, 193, 198–208

272 | Index

Reader's Digest, 115
Red Star, 235
refugees, 99–100
Reinhardt, Django, 124
religion, 39, 58, 121, 133, 216
Remagen Bridge, 182
Rhodes Scholar, 137
Robertson, Bill, 46
Roeder, George H., Jr., 3
Roman Catholic Church, 36, 40, 89, 107
Rommel, Erwin, 121
Rooney, Andy: career of, 86–87; enters Paris, 178; flirts with communism, 215; lacks biography, 3; writes for *Stars and Stripes*, vii; writing style of, 89, 102
Roosevelt, Eleanor, 39
Roosevelt, Franklin D.: asked to end segregation in armed forces, 120; attends Casablanca conference, 122; attitude toward Black press, 117; contributes essays for *Chicago Defender*, 118; issues warnings, 227; meets with Frank Aiken, 42–43; promotes economic mobilization, 40–41; provides letter, 22; receives advice on race relations, 122; relatives of, 39; seeks to revise neutrality law, 15; support for, 215; supports war crime trials, 237
Rosenthal, Joseph, 1
Rosenwald Foundation, 109
Royal Air Force, 40, 119
Royal Canadian Armoured Corps, 164
Rudder, James, 207
Russo-Finnish War, 4, 15, 21–28, 59–64, 75–76
Rust, Edward S., 139
Ryan, Cornelius, 1–2
Ryti, Risto, 70

St. Bonaventure College, 107
Salisbury, Harrison, 1
Salomon, Sidney, 206–7
Saturday Evening Post, 141, 247
Schmidt, William, 205
Schoenfeld, H. F. Arthur, 68, 70, 71
Second Armored Division, 162, 163, 167

Seventh Canadian Reconnaissance Regiment, 160, 161–62, 163–65, 168, 169
Shanke, Edward, 86, 88, 89, 90–91, 92, 93–94, 95–96, 98, 99–100
Shapiro, Henry, 26–27
Sheean, Vincent, 29
Sherrod, Robert, 3
Shirer, William L., 1, 239, 249
Sibelius, Jean, 60
Sicily, invasion of, vii, 108, 123, 206, 216, 223
Signal (German magazine), 69
Skarie, Robert, 202
Smith College, 174
Smith, Howard K., 239
Smith, Kingsbury, 250
Smith, William Gardner, 125
Solbert, Oscar N., 223, 225–26
Sorbonne University, 55
Soviet Union: as an American ally, 215–16; attacks Poland, 58; difficulties of Western reporters in, 25–28; invades Finland, 4, 15, 21–25, 59–62; and liberation of Treblinka, 235–36; limits access to frontlines, 4; participates in Nuremberg war crime trials, 237–38, 242–43; prisoners of war from, 70; seeks British declaration of war against Finland, 67
Spanish American War, 134
Spanish Civil War, 15, 16, 19, 35
SS (*Schutzstaffel*), 70, 98, 101, 238, 249
Stalin, Josef: attacks Finland, 21, 24; carries out purges, 25; holds show trials, 243, 248; savors victory, 27
Standard (Montreal), 8, 165
Stars and Stripes, vii–viii, 4; establishes printing facilities in Germany, 247–48; permits longer stories, 89; relationship with Omar Bradley, 9; reports on Nuremberg war crime trials, 251; Andy Rooney writes for, 86
State Department, U.S., 6, 42, 67, 72, 73
Stavisky, Samuel E., 149
Steinbeck, John, 240, 247
Steinkopf, Irene, 86, 96, 100, 101

Index | 273

Steinkopf, Alvin J., 86, 90, 92, 95, 96, 100–01
Stewart, Ollie, 8, 107, 114–26
Stimson, Henry, 120, 237
Stockholm, Sweden, 21, 63–64, 86, 87, 98, 100, 101
Stoneman, William, 46
Stowe, Leland, 22, 23, 24–25, 28
Streicher, Julius, 248
Stringer, Ann, 172–74, 181, 182–185, 186
Stringer, Bill, 173, 174
Supreme Headquarters of Allied Expeditionary Force (SHAEF), 160; accredits women correspondents, 174–76; loosens restrictions for Lee Carson, 179; restricts women correspondents, 177, 178; seeks to discipline Ann Stringer, 184; suspends AP from reporting, 97
Sweatt, Heman, 125
Sweden, 70, 73, 74, 96–97
Sweeney, Michael, S., 146, 153
Switzerland, 96–97

Tanner, Vaino, 68, 70, 71
Tass (newspaper), 26–27
Taylor, Telford, 238, 241, 245, 253
Tennessee Agricultural and Industrial College, 107
Third Armored Division (U.S.), 181
Third Canadian Infantry Division, 160, 164–65
Time (magazine), 19, 216
Tobin, James, 3
Toivola, Urho, 56
Tokyo war crime trials, 235, 236, 238, 253
Torgau, Germany, 184–85
TORCH landing, 201–2
Toronto Star, 161
Town Talk (Alexandria, Louisiana), 160–61
Treblinka, 235–36, 247
Tree, Roland and Nancy, 45
Tregaskis, Richard, 3, 179
Truman, Harry, 124
Truscott, Lucian, 197–98
Tulsa Tribune, 133

United Nations alliance, 45, 67, 237
United Nations Organization, 237, 253
United Press (UP), 16, 17, 19, 25; deploys reporter to Moscow, 26; hires Ann and Bill Stringer, 174; reports on Carolina maneuvers, 162–63; Ann Stringer heads London desk, 183
University of California, Berkeley, 56
University of Chicago, 135
University of Helsinki, 64
University of London, 174
University of Michigan, 107
University of Texas at Austin, 174
University of Texas Law School, 125
University of Wisconsin, 240
U.S. Air Force, 153
U.S. Army: clashes with Marine Corps, 148; coins term GI, 142; creates Information and Historical Services, 140; creates school of journalism, 153; deploys to Northern Ireland, 44–46; G-2 interrogates Therese Bonny, 72; imposes segregation in occupied Italy, 122; provides logistical support for Nuremberg war crime trials, 258, 240; refuses to alter racial policies, 117; reports on racial tensions in, 115–16
U.S. Army Air Force, 5
U.S. First Army, 162, 163, 174, 179–80, 181, 182, 184–85, 219–20
U.S. Marine Corps, vii, 193; recruits combat correspondents, 10, 132–54
U.S. Military Academy (West Point), 197, 198
U.S. Navy: clashes with Marine Corps, 148; creates school of journalism, 153; discriminates against African American women, 122
U.S. Ninth Air Force, 176
U.S. Ninth Army, 176, 183–84, 221
U.S. Seventh Army, 223
U.S. Third Army, viii, 247, 250

V-2 rockets, 185
Vabres, Donnedieu de, 238
Vanderbilt, William H., 67, 72

274 | Index

Van der Hoef, George, 135–36, 137, 138–39, 152
Vatican, 46, 56, 74
Vienna, Austria, 26, 90, 94
Vietnam War, 4, 125, 186, 240, 253
Volmer, Norbert, 91
Von Papen, Fritz, 251
Vyshinksy, Andrei, 242–43, 248–49

Waddell, Hugh B., 71, 72
Walker, Frank, 117
Walker, John, 19, 20
Walling, Ralph, 195–96
Wall Street Journal, 4
Walshe, Joseph, 39, 40, 41, 42, 43, 44
War Department: accredits journalists, 46; accredits women correspondents, 173–74; drops women war correspondent category, 186; plans for war criminal trials, 237
Washington Daily News, 121
Washington Post, 4, 141, 136, 143
Washington Evening Star, 136, 152
Whitehall Letter, 35, 38
Whitehead, Don, 3; reports on U.S. Rangers, 206, 207; rides into Eschweiler, 180; skillful narration of, 90;

uses humor, 102; works as AP correspondent, 86, 87
Wiesel, Ellie, 47
Williams, Hugh, 200
Wilmot, Chester, 221–22
Wilson administration, 135
Winant, John, 43, 45
Wolf, Tom, 205
women: discrimination against, 122; as slave laborers, 249; storylines regarding, 143–44; as war reporters, 8–9, 34–76, 172–86
Woodhouse, Arthur W., 161
World War I, 95; Black press in, 121; censorsip during, 116; establishment of *Stars and Stripes* during, 247; Finish war debts repaid, 21, 36; U.S. Marines role in, 134–35, veterans of, 225; war reporters during, 16
Wright, Frank J., 145
Wright, Richard, 125

Yale Law School, 137
Yank (magazine), 4, 9, 89, 207

Zemke, Hubert, 175
Zilmer, Bertram, 24

World War II: The Global, Human, and Ethical Dimension
G. Kurt Piehler, *series editor*

Lawrence Cane, David E. Cane, Judy Barrett Litoff, and David C. Smith, eds., *Fighting Fascism in Europe: The World War II Letters of an American Veteran of the Spanish Civil War*

Angelo M. Spinelli and Lewis H. Carlson, *Life behind Barbed Wire: The Secret World War II Photographs of Prisoner of War Angelo M. Spinelli*

Don Whitehead and John B. Romeiser, *"Beachhead Don": Reporting the War from the European Theater, 1942–1945*

Scott H. Bennett, ed., *Army GI, Pacifist CO: The World War II Letters of Frank and Albert Dietrich*

Alexander Jefferson with Lewis H. Carlson, *Red Tail Captured, Red Tail Free: Memoirs of a Tuskegee Airman and POW*

Jonathan G. Utley, *Going to War with Japan, 1937–1941*

Grant K. Goodman, *America's Japan: The First Year, 1945–1946*

Patricia Kollander with John O'Sullivan, *"I Must Be a Part of This War": One Man's Fight against Hitler and Nazism*

Judy Barrett Litoff, *An American Heroine in the French Resistance: The Diary and Memoir of Virginia d'Albert-Lake*

Thomas R. Christofferson and Michael S. Christofferson, *France during World War II: From Defeat to Liberation*

Don Whitehead, *Combat Reporter: Don Whitehead's World War II Diary and Memoirs*, edited by John B. Romeiser

James M. Gavin, *The General and His Daughter: The Wartime Letters of General James M. Gavin to His Daughter Barbara*, edited by Barbara Gavin Fauntleroy et al.

Carol Adele Kelly, ed., *Voices of My Comrades: America's Reserve Officers Remember World War II*, foreword by Senators Ted Stevens and Daniel K. Inouye

John J. Toffey IV, *Jack Toffey's War: A Son's Memoir*

Lt. General James V. Edmundson, *Letters to Lee: From Pearl Harbor to the War's Final Mission*, edited by Dr. Celia Edmundson

John K. Stutterheim, *The Diary of Prisoner 17326: A Boy's Life in a Japanese Labor Camp*, foreword by Mark Parillo

G. Kurt Piehler and Sidney Pash, eds., *The United States and the Second World War: New Perspectives on Diplomacy, War, and the Home Front*

Susan E. Wiant, *Between the Bylines: A Father's Legacy*, Foreword by Walter Cronkite

Deborah S. Cornelius, *Hungary in World War II: Caught in the Cauldron*

Gilya Gerda Schmidt, *Süssen Is Now Free of Jews: World War II, The Holocaust, and Rural Judaism*

Emanuel Rota, *A Pact with Vichy: Angelo Tasca from Italian Socialism to French Collaboration*

Panteleymon Anastasakis, *The Church of Greece under Axis Occupation*

Louise DeSalvo, *Chasing Ghosts: A Memoir of a Father, Gone to War*

Alexander Jefferson with Lewis H. Carlson, *Red Tail Captured, Red Tail Free: Memoirs of a Tuskegee Airman and POW, Revised Edition*

Kent Puckett, *War Pictures: Cinema, Violence, and Style in Britain, 1939–1945*

Marisa Escolar, *Allied Encounters: The Gendered Redemption of World War II Italy*

Courtney A. Short, *The Most Vital Question: Race and Identity in the U.S. Occupation of Okinawa, 1945–1946*

James Cassidy, *NBC Goes to War: The Diary of Radio Correspondent James Cassidy from London to the Bulge*, edited by Michael S. Sweeney

Rebecca Schwartz Greene, *Breaking Point: The Ironic Evolution of Psychiatry in World War II*

Franco Baldasso, *Against Redemption: Democracy, Memory, and Literature in Post-Fascist Italy*

G. Kurt Piehler and Ingo Trauschweizer, eds., *Reporting World War II*

Printed in the USA
CPSIA information can be obtained
at www.ICGtesting.com
JSHW021834250324
59870JS00011B/122